TECHNIQUES OF THE MODERN ARTISTS

TECHNIQUES OF THE MODERN ARTISTS

Judith Collins • John Welchman David Chandler • David A. Anfam

GREENWICH EDITIONS

CITY COLLEGE

MANCHESTER

ARDEN LARNING

RESOURCES SENTRE

061 957 1725

709.04 TEC

P4485 18/11/97 \$9.99

A QUANTUM BOOK

This edition published by Greenwich Editions 10 Blenheim Court Brewery Road London N7 9NT

Copyright © 1983 Quarto Publishing plc

This edition printed 1997

All rights reserved.

This book is protected by copyright. No part of it may be reproduced, stored in a retrieval system, or transmitted in any form or by any means, without the prior permission in writing of the Publisher, nor be otherwise circulated in any form of binding or cover other than that in which it is published and without a similar condition including this condition being imposed on the subsequent publisher.

ISBN 0-86288-190-0

QUMMOD

This book was produced by Quantum Books Ltd 6 Blundell Street London N7 9BH

Printed in Singapore by Star Standard Industries Pte. Ltd

CONTENTS

	Piet Mondrian Composition with Red, Yellow and Blue	82	1961 ONWARDS	
1900	Edward Wadsworth L'avant port, Marseilles	86	Introduction	146
1920	Pierre Bonnard - La fenêtre	90	Morris Louis Spawn	156
Introduction 2 Paul Cézanne 3	Paul Klee	94	Robert Rauschenberg First Landing Jump	160
Still life: Apples, Bottle and Chairback	Max Ernst The Petrified City: Le Puy, ne	98 ar	Andy Warhol Marilyn Diptych	164
André Derain 4 The Pool of London		102	Frank Stella Hyena Stomp	168
Henri Rousseau 4 The Dream			Roy Lichtenstein In the Car	172
Georges Braque 4 Clarinet and Bottle of Rum on a Mantelpiece	\$\frac{1941}{1960}		David Hockney A Bigger Splash	176
Pablo Picasso 5	2 Introduction	106	Sol Lewitt Fifteen Part Drawing using	180
Wassily Kandinsky 5 Small Pleasures	Francis Bacon Figure in a Landscape	118	four colours and all variations (straight parallel lines, each colour in a different direction)	
	Jean Dubuffet O Dhotel nuancé d'abricot	122	Lucian Freud Large Interior, W.9	182
Marcel Duchamp 6	Jackson Pollock Full Fathom Five	126	Glossary	186
The Bride Stripped Bare by Her Bachelors, Even	Henri Matisse L'escargot	130	Index	188
1921	Alberto Giacometti	134	Bibliography	193
1940	Annette assise		Acknowledgements	192
Introduction 6	Jasper Johns Target with Four Faces	138		
Joan Miró 7 Personage Throwing a Stone at a Bird	8 Peter Blake On the Balcony	142		

FOREWORD

The story of art in the present century is a fascinating one, not just in terms of the creative output of artists throughout the world, but also in terms of the materials and techniques they have used to give birth to their creations. Today, these vary more widely than ever before. Since the advent of Cubist collage in 1912; any material, in theory, is grist to the mill of the artist; though it is surprising how frequently the traditional approach of oil on canvas has sufficed for even the most radical examples of contemporary art, it is equally clear that not everything a modern painter wants to say can be expressed in such a manner.

Thus, techniques and materials are the starting point and focus for this study. What has been attempted is a representative selection of the work of the major — and most influential — painters of the twentieth century, so that the reader can see clearly how and why the created what they did, see what have been the most important styles and understand what have been the most significant advances in the use and development of materials and techniques in the search to express ideas and feelings. The core of the book is the 30 main paintings selected for detailed analysis from these standpoints, the various introductions setting these works firmly in the broad artistic context.

The underlying aim has been to discover what is valuable about the nature of modern art. The aim has also been not to produce a didactic textbook, making, in the vain hope of completeness, listings of *outré* working methods, bizarre materials, or unusual tools, but to produce something that will stimulate, inform, entertain and, sometimes, even provoke its readers.

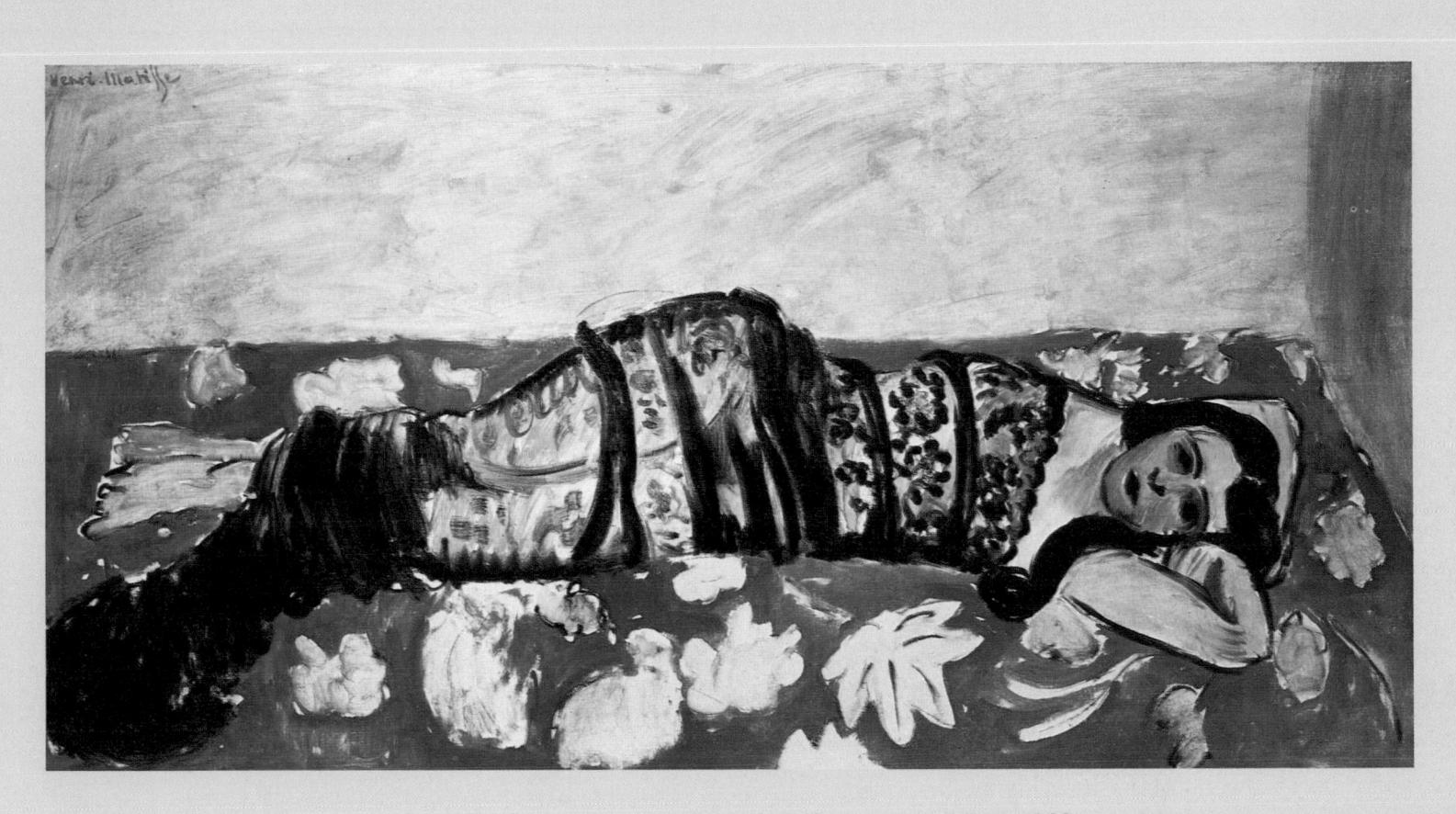

Lorette VII (L'écharpe noire) by Henri Matisse (1869-1954) © SPADEM Paris 1983

Introduction and Background

This book is an introduction to the vast subject of twentieth-century art, from the important perspective of the painters' techniques; a perspective that art historians, until very recently, have tended to ignore. Since the work of modern artists is almost inexhaustibly varied – in terms of vision, concept, style, form, content, materials and tools – this approach may seem at first to be unnecessarily limited. But, on closer examination, it proves a fruitful way of examining the changes that have characterized the art of this century.

In this age of artistic freedom and experiment, it might be expected that easel painting, for centuries the most important of all the artist's means of expression, would have been almost completely abandoned. Surprisingly, it survives, partly, at least, because it is a convention – the convention of the flat surface or rectangle. As such, it provides the type of limitations which often spur rather than inhibit creative activity.

Technique goes beyond mechanical and manual processes; it is a useful standpoint from which to view artists' overall intentions. This is not just because choice of materials and working methods reveals crucial attitudes, but has more to do with the way in which modern artists have redefined not only the object of their creativity, but also the process by which it is produced. Indeed, an important contribution of artists in this century has been to emphasize the critical mental aspects of technique, as opposed to the merely physical application of paint, for example, to a support.

Painting and its opponents

No book on twentieth-century painters (as opposed to twentieth-century painting) can or should avoid at least touching on methods and materials outside the scope of painting. On a mundane level, many painters have also been sculptors and vice versa – Henri Matisse (1869-1954), Pablo Picasso (1881-1973), Alberto Giacometti (1901-1966). For others, however, choice of materials goes beyond a desire to experiment with different media. Marcel Duchamp (1887-1968), having achieved fame and success as a painter, virtually gave up conventional painting in 1913 at the age of 26, the same year his *Nude Descending a Staircase* (1912) took New York by storm at the Armory Show.

For Duchamp, the idea of the artist as a sort of magician was much more important than the notion of the artist as mere painter. By abandoning painting so abruptly after so much success, both as a conventional and as an avant-garde painter, he demonstrated his doubt about the validity of painting as a modern art medium.

From 1913 on, Duchamp made a series of devastating attacks on the notion (among others) that the artist needed to have a technique at all. All the artist had to do was to

appropriate the techniques of mass production by, for example, setting a Bicycle Wheel (1913) upon a stool and exhibiting it as art. In the same spirit Duchamp purchased a Bottle Rack (1914), in his own words, '... as a means of solving an artistic problem without the usual means or processes ...', and a 'readymade' Fountain (urinal) (1917). This last was turned on its back signed 'R. Mutt' and sent into the 'Salon des Indépendants' exhibition. It was refused. In response to the criticisms Duchamp wrote: 'Whether Mr Mutt with his own hands made the fountain or not has no importance. He chose it. He took an ordinary article of life, placed it so that its useful significance disappeared under the new title and point of view - created a new thought for that object.'

It could be said that Duchamp wanted to prove that, in theory, an artist's technique could be 100 percent a mental technique. The hands were not necessary; the eye and the brain would manage without them. Duchamp was in a strong position to attack painting: he had already demonstrated his proficiency in the medium during the period from 1902 to 1913. He was also in a strong position to attack manual technique because between 1915 and 1923 he produced one of the twentieth century's most technically elaborate works of art, *The Bride Stripped Bare by Her Bachelors, Even (The Large Glass)*; a work which cannot be properly described as a painting, nor as a sculpture.

Marcel Duchamp is not the only major exponent of easel painting to envisage its demise. Piet Mondrian (1872-1944), a theosophist, an idealist and the creator of geometrical abstract painting, looked forward to the day when society as a whole would show more creative visual attitude – that pioneered by the De Stijl group of artists and architects of which he was a member – and would transform the environment, making easel painting redundant.

Recently, various artists have criticized the art object, including easel painting, on the grounds that it is a 'bourgeois' form. They have social and political objections to the way paintings have been used for purposes unintended by the artist; in other words as investments or speculations. Sol LeWitt (b 1928) a key figure in both the Minimal Art and Conceptual Art movements, neatly sidesteps such problems by producing temporary wall drawing. A small design on paper by LeWitt is magnified onto a wall. It can be viewed by people near and far, and any transport costs are reduced to postage. Like Duchamp, LeWitt has more or less delegated 'technique'.

In the face of such wide-ranging attacks it is a wonder that easel painting has survived at all. But it has more than survived. Not only is it still the stock-in-trade of the academic artist and the purveyor of boardroom portraits, it has also contained and conditioned a high

RIGHT Larry Rivers (b 1923) took up painting in 1945, and studied with Hans Hofmann from 1947-1948. His work is pitched squarely between Pop Art, of which he is held an important precursor, and Abstract Expressionism, whose loose, improvised brushstrokes he put to his own original use. Parts of the Face (1961) was painted in Paris and represents the artist's wife, Clarice, whom he had recently married. It has its source in a labelled language school drawing and the painting here is one of an intermittent series which varies both in length, pose and identity of sitter, as well as the languages used for labelling (English, Italian, Polish and Persian). Technically, Rivers has worked up a partially realistic head which is surrounded by thickly brushed swathes of colour — yellow, green, white and black which have been allowed to run and scuff over the surface. A commercial stencil (recalling the Cubists) and ruled lines have been used to itemize the head's parts. The painted area also extends around the sides of the stretcher, a technique used by Jackson Pollock.

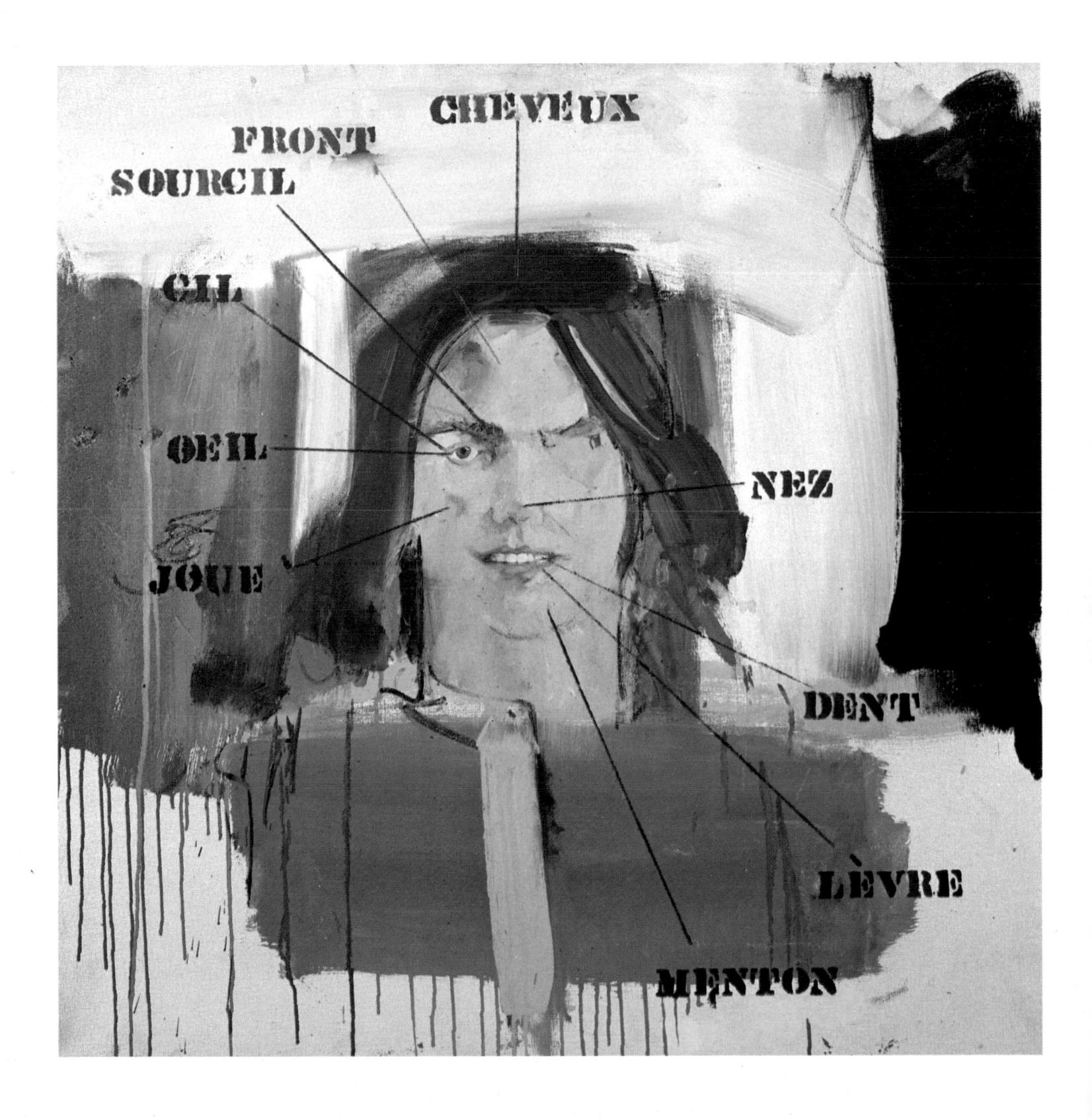

BELOW Stuart Davis (1894-1964) was born in Philadelphia, USA. After studying with Robert Henri he became a member of the so-called 'Ash Can School' of American-scene realism which championed the depiction of low-life social subject matter. The Armory Show of international modern art in 1913 made a tremendous impact on the young artist, who was captivated by the technical and tonal innovations of Post-Impressionism, Fauvism and Cubism. House and Street (1931) is one of a number of 'stereoscopic paintings which portray different views of a similar area. There is a complex (modernist) interaction here between technical decisions and subjectmatter which can be found, for example, in Edward Hopper's series.

proportion of the major statements of the modern movement in art, including Picasso's Les demoiselles d'Avignon (1907) and Matisse's The Red Studio (1907). Many of the works discussed in this book go beyond a literal or pedantic definition of easel painting. Pierre Bonnard (1867-1947) preferred to pin his canvases to the wall while painting and Jackson Pollock (1912-1956) put his large canvases on the floor. The results belong to the same class of object.

The reasons for the survival of such painting techniques are in part historical, social and economic and in part aesthetic.

When easel painting came into existence during the Renaissance, oil paint and canvas were beginning to be used in place of tempera and panel. Easel painting was supplanting the church fresco and reflected the rise of the secular patron, an individualist who wanted an easily transportable image, often a portrait, and who could easily afford to pay for it at a time of advancing prosperity. The Renaissance patron was often a passionate participator in the creation of art. The twentieth-century patron has tended, rightly or wrongly, to insist on the absolute freedom of the artist. But easel painting continues to survive, partly because

it still satisfies the same sort of demand that was established during the Renaissance.

Perhaps the 'aesthetic' reason for the survival of easel painting in an age of almost complete artistic freedom is that it provides a constraint. Its basic characteristics provide the sort of limitations that often stimulate rather than hinder artistic endeavour. These characteristics are so elementary that their special qualities are easily underrated or forgotten. They condition the modern artist just as the cave wall conditioned the prehistoric artist. The easel picture has a flat surface and it is usually rectangular. In other words, easel painting stands for the convention of the flat surface and the rectangle.

Although increasingly since the nineteenth century, a premium has been set on originality and the modern artist is supposed to abhor convention, 'originality' is only a relative term. When Frank Stella (b 1935) breaks the rectangle with his shaped canvas, or Richard Smith (b 1931) contradicts the notion of flatness by his sloping canvas, they are playing their role in what the critic Harold Rosenberg has called 'the tradition of the new'. If the spectator did not continue to carry the notion of the flat rectangle in his or her head, such

RIGHT Juan Gris has been described as the most 'refined and classical' of the four Cubist masters (with Picasso, Braque and Léger). Certainly he reintroduced colour into the analytical experiments of Picasso and Braque from 1910-1912. Still life (The Violin) (1913) is painted entirely in oils, so that we notice at once the technical imitation of wood panelling, of the wood of the violin, of the white 'chalk' lines which continue the instrument and of the pink patterned wall-paper. This imitation is more suggestive than eye-fooling, and alternates with the thickly painted monochrome or undetailed areas. Vertical and diagonal plane lines, disrupt and silhouette the still-life elements

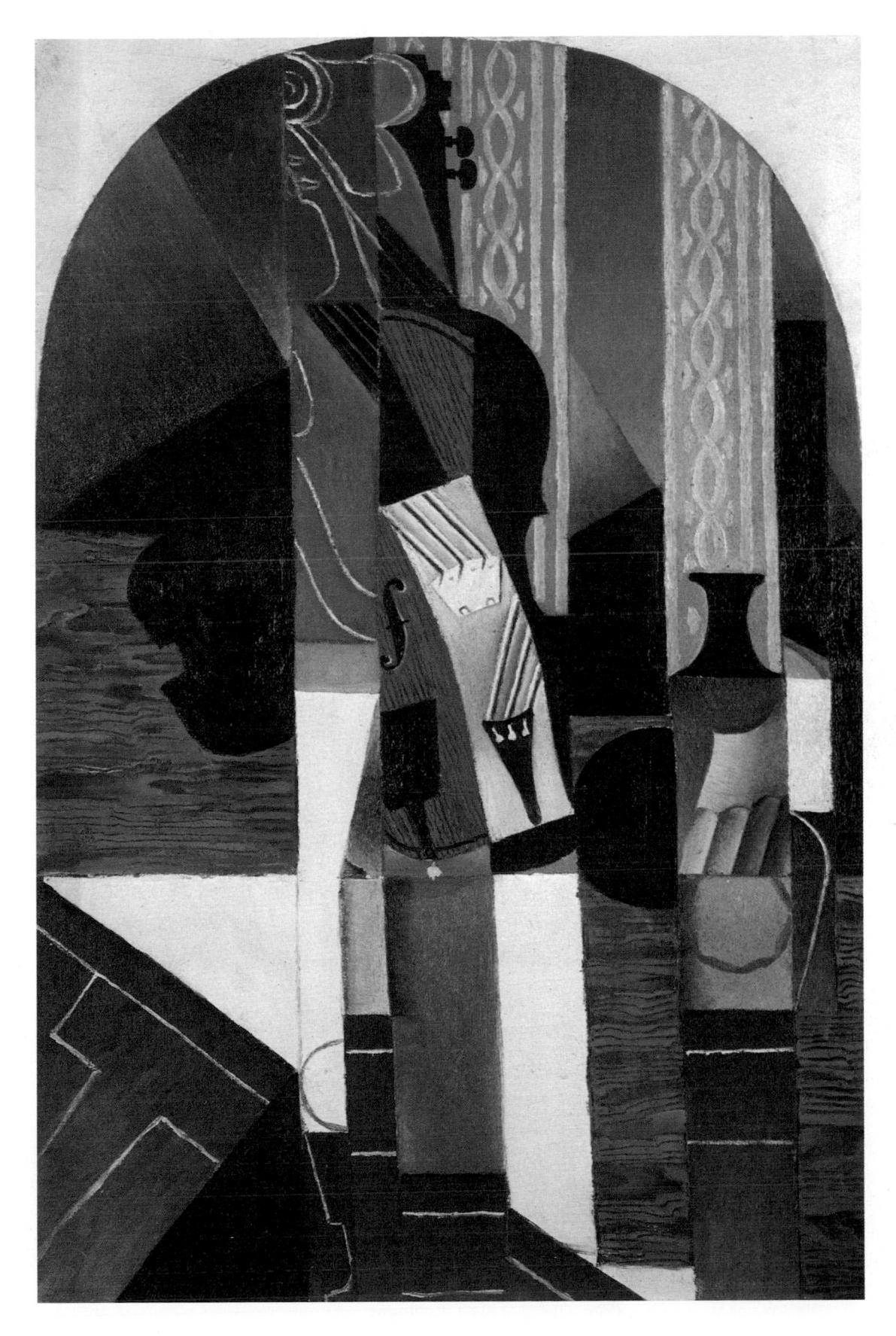

RIGHT Raoul Hausmann (1886-1971) was the cofounder of the Berlin Dada movement in 1917, and the creator of photomontage in the following year. Photomontage is the art of arranging and glueing photographs or other found illustrative material onto a surface. Strictly speaking it is a type of collage, and it is included here because it is a process of selection, placement and sometimes embellishment, which sets it apart from photographic record, no matter how much this 'record' is distorted by the photographic apparatus or by subsequent techniques of developing. Hausmann actually gave up painting in 1923 and became more interested in various experimental photographic procedures. In The Art Critic (1919-1920) the orange-brick background is probably from one of Hausmann's phonetic poem-posters intended to be stuck on walls all over Berlin. The figure with giant head and pen is stamped Portrait constructed — of George Grosz 1920, and is probably a magazine photograph of Hausmann's colleague, Grosz.

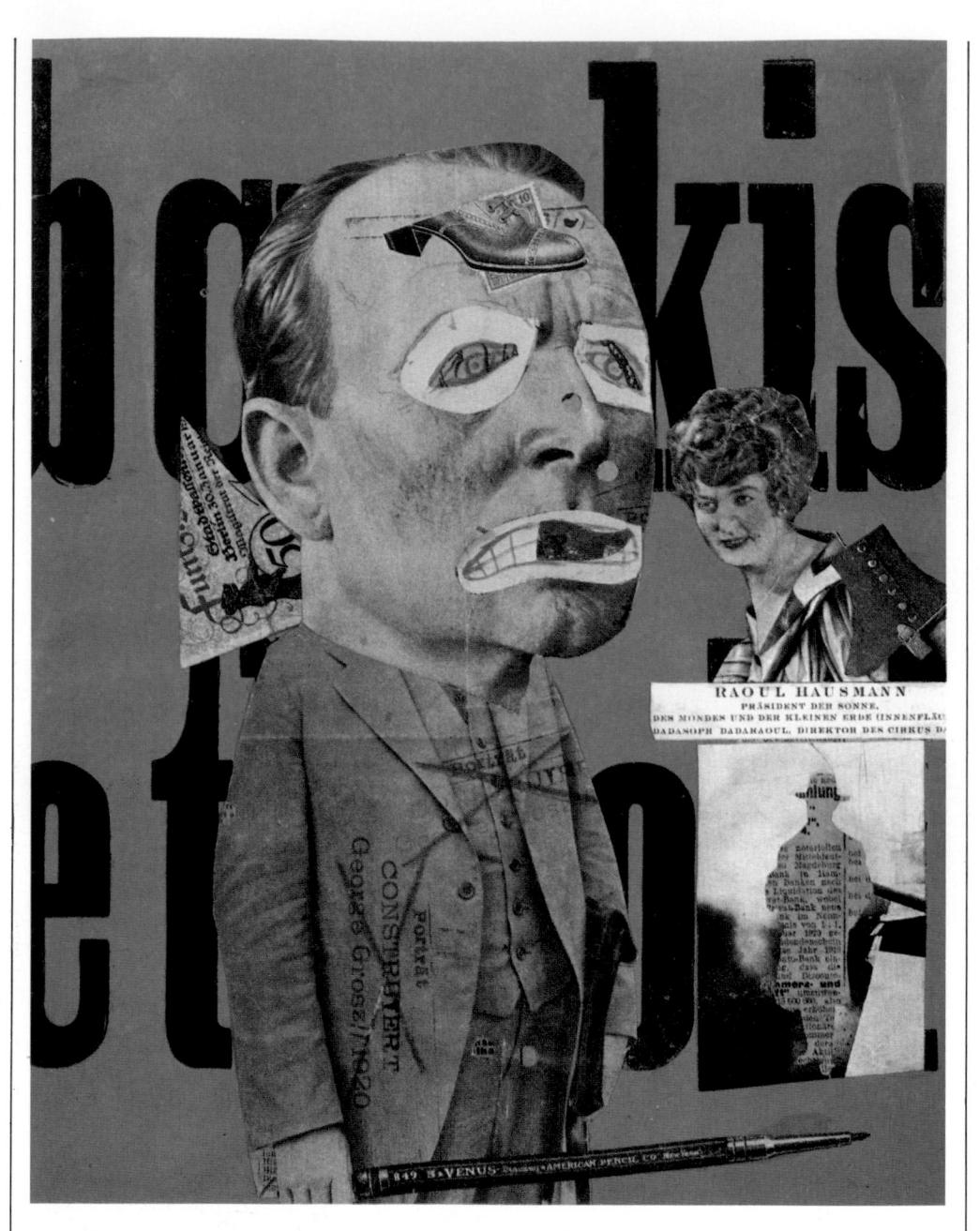

'originality' would be meaningless. While no artist is obliged to paint easel pictures, easel painting may well have survived and flourished precisely because artists have instinctively needed order and tradition at a time of violent conflict in the visual arts.

Technique

One of the central problems which arises out of any discussion of artists' techniques is the difficulty of establishing exactly what is meant by the term itself. The work of twentieth-century painters is immensely varied and, consequently, the part played by technique is different for each artist. While to know an artist's materials is to know something of his

or her technique, a complete understanding could never be achieved by cataloguing equipment and media. The manual and mechanical processes by which artists employ their materials is also implied by the term but, as Duchamp demonstrated, mental processes or intentions cannot be ignored when discussing methods of execution. What must be established in the case of each artist, therefore, is the nature of the relationship between the three elements: the raw materials; the manual and mechanical processes, and the intention.

A striking portrait of the painter Derain by Balthus (b 1908) provides a useful starting point for a discussion on the definition of technique. The subject of the picture is an

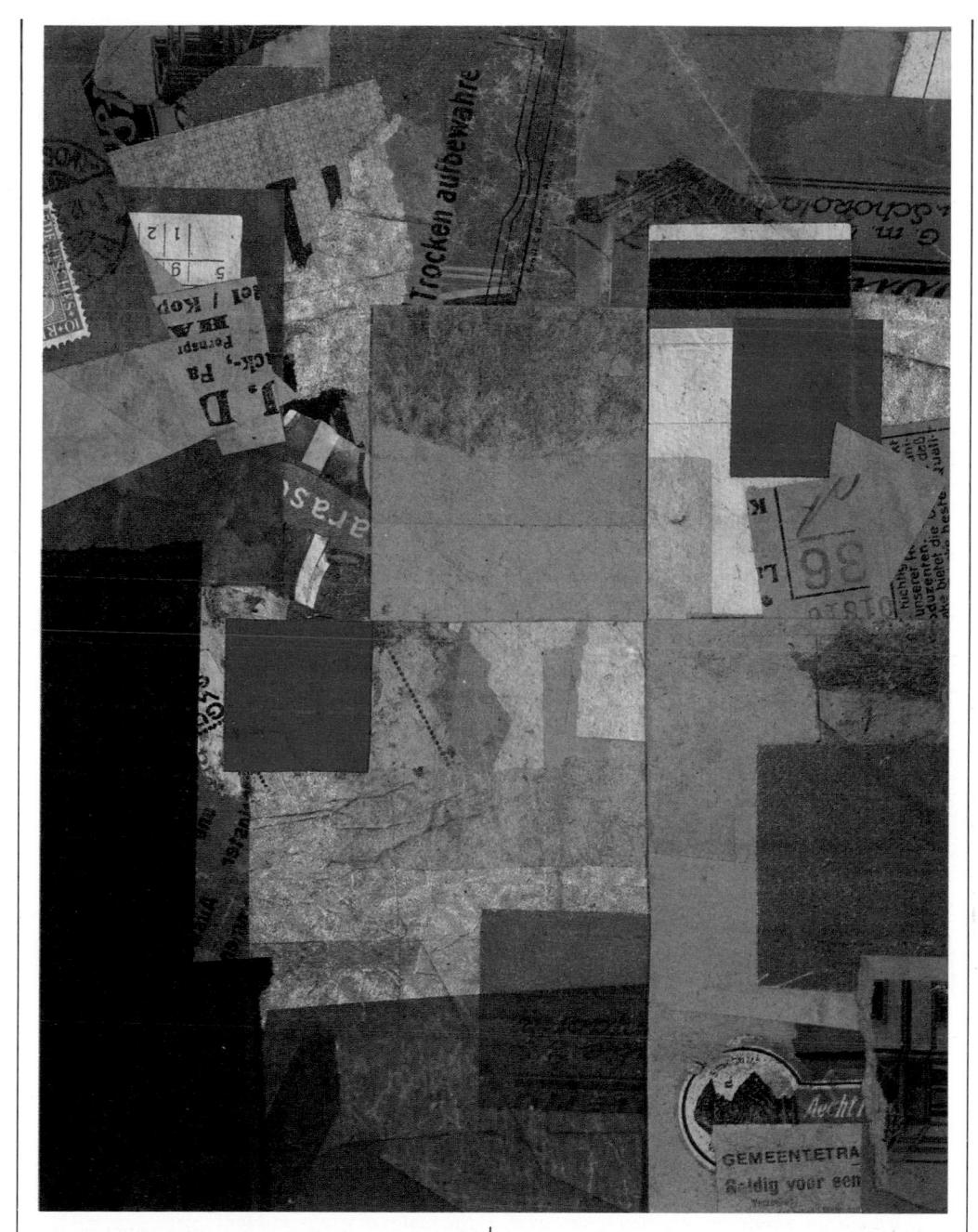

LEFT After the First World War, Kurt Schwitters (1887-1948) took up the Cubist's technique of collage and made it the basis of his life's work. Like so many of his generation, he moved through a succession of painting styles from Academic to Expressionist, Cubist and Abstract before, in 1910, he created the first of his MERZpictures. In the artist's words those consisted of 'disparate elements merged into a work of art, with the help of nails and glue, paper and rags, hammers and oil paint, parts of machinery and bits of lace'. Schwitters also produced MERZ writing based on the same principle as his painting, where extracts and snatches from a wide variety of printed material were assembled together. Fernspr (1926) is a fine example of the minute craftsmanship and original sense of design that Schwitters brought to his work of collage. A miscellany of printed and other paper material is disposed on a cardboard base and articulated in relation to more definite regular cut-out shapes, to produce a dense and original abstract composition.

artist, portrayed in his studio, with canvases leaning against a wall and a model sitting on a chair: the artist is placed where he belongs, at the centre of the stage.

Albert Camus, referring to the technique of Balthus, wrote that it was the distinction of painters to be able to pin down fleeting images glimpsed briefly on a journey upstream towards forgotten springs. For Camus, the true painters were those who, like the great Italians, conveyed the impression that this act of 'pinning down' had just taken place, just as if an aeroplane had stopped in mid-air. All the *figures* in great painting made Camus feel, as he put it, 'that they have only just stopped

moving and that, through the miracle of art, they go on living and yet are no longer perishable'.

What does Camus mean by the word 'technique' here? If we substitute for 'technique', 'method of execution' (Webster's definition), the sentence barely makes sense. To substitute the word 'achievement' makes better sense but something is lost. Assuming that the word was chosen carefully, it seems likely that Camus uses 'technique' because of the nuance it has of what he calls, 'the miracle of art'. A painting lives in two different worlds – the mental or spiritual, and the physical – at one and the same time. The patient approach of

Balthus, the slow painstaking realization of the image in paint is the result of a long study of masters such as Piero della Francesca (*c* 1410/20-1492) and Nicolas Poussin (*c* 1594-1665). Camus' use of 'technique' points to the intellectual intention of Balthus at least as much as to the materials he uses, or to his 'method of execution'.

The American critic, Clement Greenberg defines Modernism in painting as 'the use of the characteristic methods of a discipline to criticize the discipline itself ... to entrench it more firmly in its area of competence'. These 'methods' can only be considered part of the painter's technique. For Greenberg, Modernist painting is that which not only acknowledges its physical constraints but regards them as distinguishing virtues: flat surface, properties of pigments and shape of support are much more than just the grammar or substructure of art. In certain cases, for example the action painting of Jackson Pollock, the painter's subject and the only discernible content of his or her work is the act of painting itself.

The painter Frank Stella said in 1964: 'My painting is based on the fact that only what can be seen there is there. It really is an object ... What you see is what you see ... I don't know what else there is. It's really something if you can get a visual sensation that is pleasurable.' Stella's statement leads, of course, to certain difficulties. Mondrian, the inventor of modern geometrical abstraction, sometimes known as Concrete Art, pointed out that even a blank square or circle is an image of something. Jean-Paul Sartre, in L'imaginaire (1940) demonstrated convincingly that an abstract painting is an imagined object, rather than a real one, its aesthetic life being feigned by the pigments just as a representational picture feigns reality.

Stella is implying that art and technique are indistinguishable, virtually one and the same thing. It is reasonable to assume that Stella paints instinctively without knowing the sources of his inspiration. Whatever the motive force, his work demonstrates what painting can do that no other art-form can compete with, at a time when cinema has taken over the role of the history painting, the photograph is a substitute for certain types of naturalistic painting and so on.

Certainly introspective tendencies have been exhibited by all the arts, including drama in both theatre and film. Sir Charles Eastlake, in the preface to his pioneering work *Materials for a History of Oil Painting* (1847), wrote that 'the author trusts that details relating to the careful processes which were familiar in the best ages of painting will not lead the inexperienced to mistake the means for the end; but only teach them not to disdain the mechanical operations which have contributed to confer durability on the productions of the

greatest masters.' In the twentieth century, with some artists, the *durability* has been deliberately disdained and the *mechanical* operations have grown enormously in significance. It is clear in this context that 'technique' is much more than a 'method of execution'.

A Dictionary of Art Terms by Reginald S. Haggar (1962) defines technique as a 'complex of manual and mechanical operations that act upon the raw material to organize, shape and mould it according to specific artistic intentions'. If we give this meaning to the word 'technique' in the passage on Balthus by Camus, the sentence makes sense. It furnishes a working definition for technique with respect to the art in the past and art now.

As far as intention is concerned, in many cases not even the artist can describe what actually took place inch by inch, minute by minute, precisely because the process (however much it may rely on experience) is largely instinctive. A picture may have been conceived and painted very rapidly in a state of high emotion or trance. The general intention may be remembered, but the order each area was painted, each brushmark made, is likely to have been forgotten. The intention may have changed as the artist proceeded.

Francis Bacon (b 1909) said that, especially as he got older, '... all painting ... is accident. So I foresee it in my mind ... and yet I hardly ever carry it out as I foresee it. It transforms itself by the actual paint. I use very large brushes, and ... I don't in fact know very often what the paint will do ...'

'In painting, you know, there is not a single process that can be made into a formula', Pierre Auguste Renoir (1841-1919) once told the dealer Ambrose Vollard. 'For instance I once attempted to fix the quantity of oil that I add to the paint on my palette. I couldn't do it. Each time I have to add my oil at a guess.'

The modern artist tends to start with ideas and feelings and has to come down to the mundanities of craft in order to express them. Some artists start as craftsmen – for example Renoir (who painted figures on porcelain) and Georges Braque (1882-1963) – and move on to the realm of ideas and feelings.

Art or craft?

The notion of the 'craftsman' is intimately connected with the artist's methods and materials. It also raises the problem of the social role of the artist in a given society; a role which has changed from period to period and from place to place. Some societies have created or assigned a definite place for both artist and artisan, or regarded them as one and the same.

The intention of the cave artists is thought to have been one of magic. By drawing a beast of prey, a bison or a deer pierced by an arrow, psychological power was gained for the purpose of hunting. Since hunting meant sur-

RIGHT Patrick Caulfield was born in 1936, and his work from the mid-1960's constitutes an individual contribution to British Pop Art. His familiar procedure evolved from about 1968-1970. during which time, like other artists before him, he changed from working in oil paint to acrylic paints, which promote greater flatness and colour contrast and whose solubility can make changes and revisions invisible. After Lunch (1975) represents the interior of a restaurant done up in a 'Swiss' style. The design was transferred and enlarged by means of a grid from an initial drawing onto polythene which was placed onto the bare canvas. After the canvas had been covered with a ground colour the design was traced onto it with bold, black lines. Touches of colour or infill were then added where necessary, the waiter's bow-tie or the orange goldfish, for example. The photo-mural of the Château of Chillon was originally intended to be glued into the picture directly onto the canvas. When this proved technically impossible, the artist decided to execute a minutely exact copy of the original photomural, again using the grid-transfer method. The result is a striking confluence of modernist style, and illustrates the technical competence and resourcefulness of some recent painting.

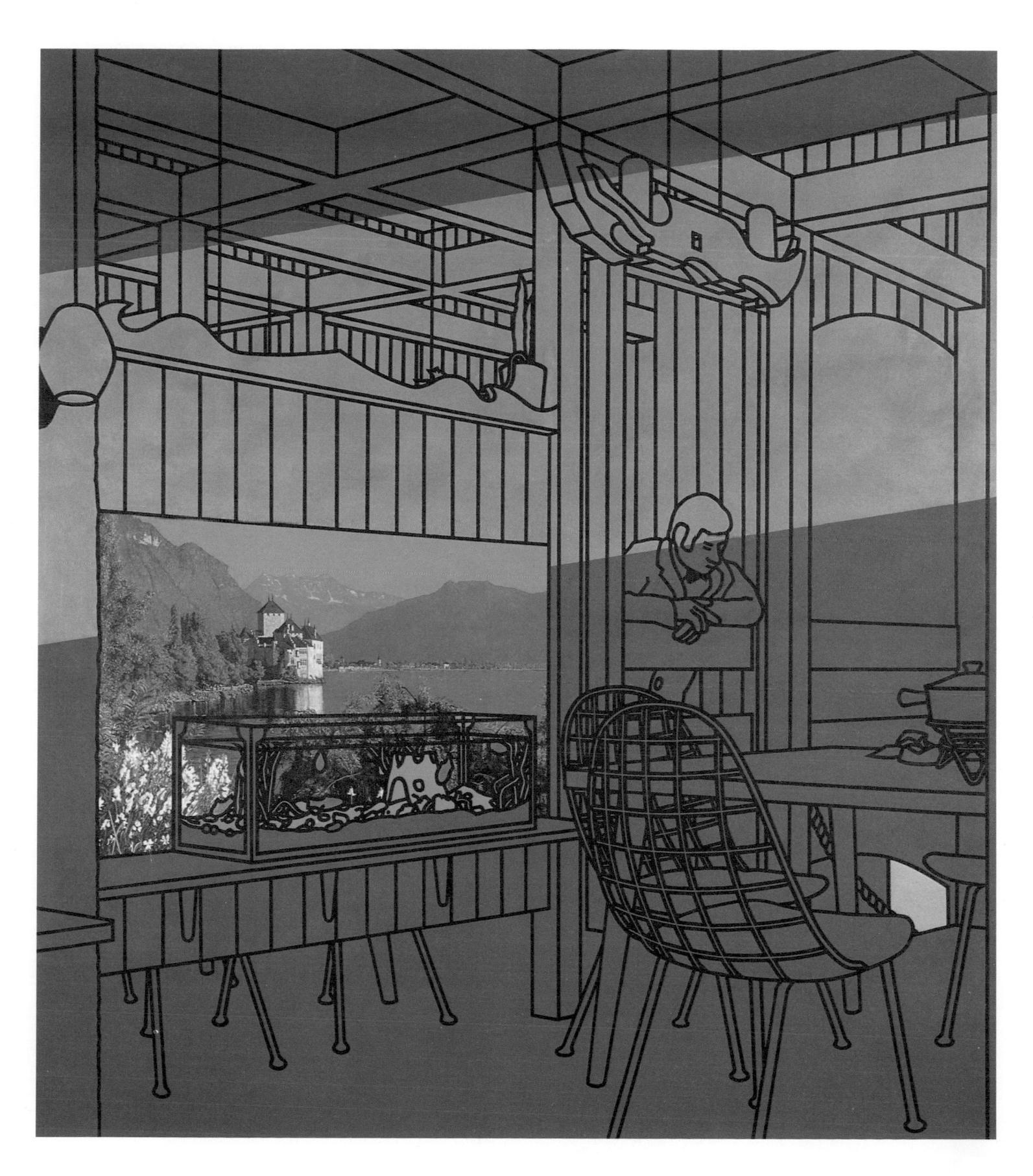

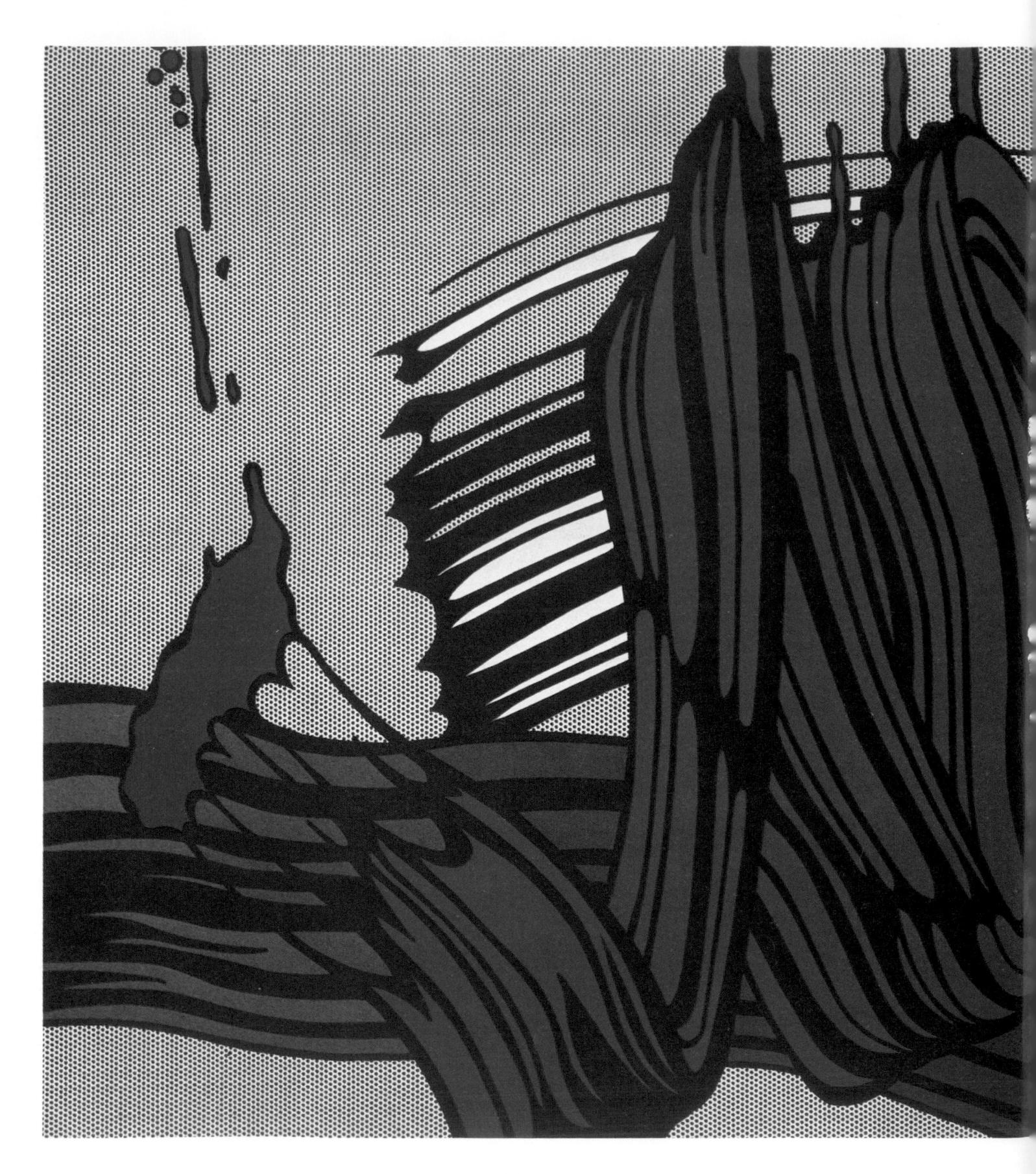

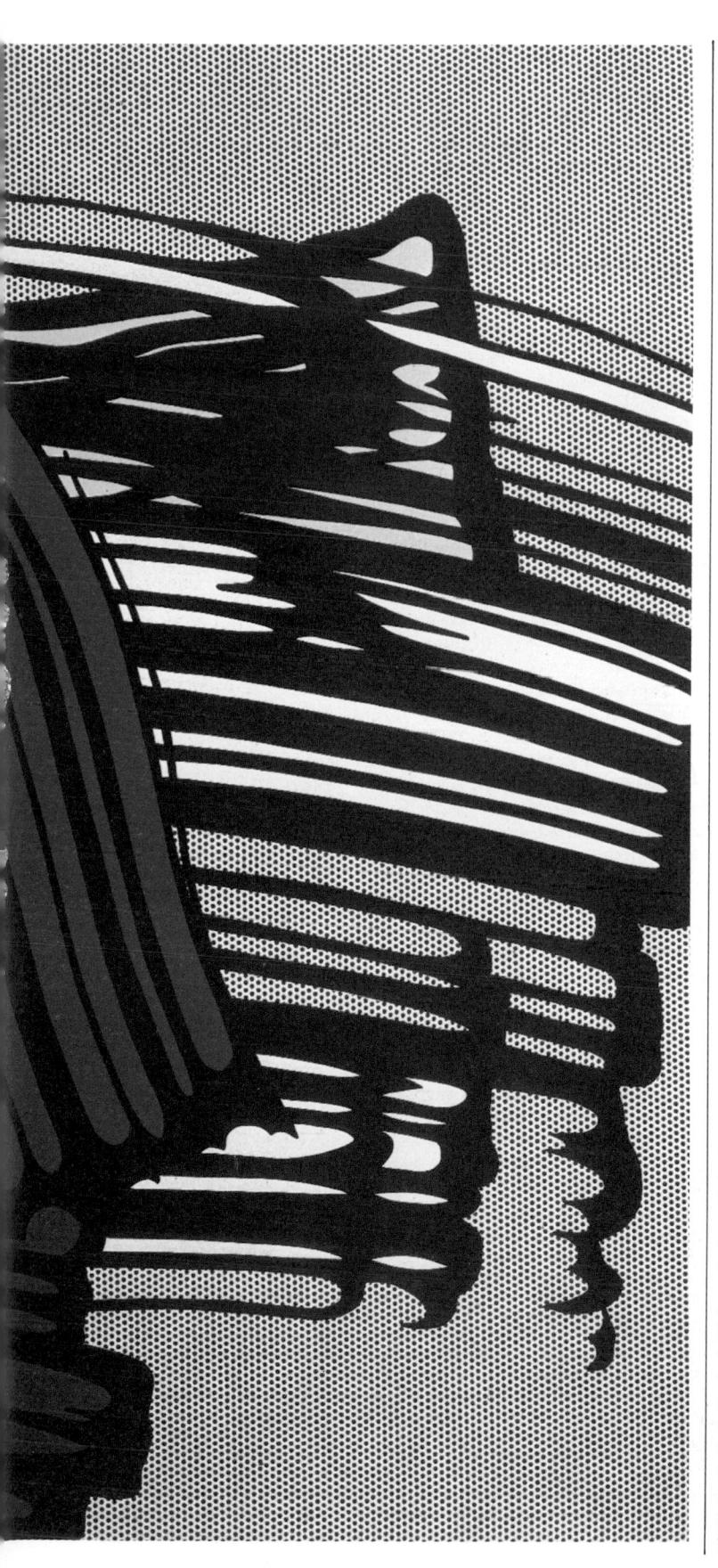

vival, the artist's role must have been closer to the witch doctor than the craftsman. The role of the artist in prehistoric times seems to have been more fundamental to the life of the group than that of the artisan in modern times. Perhaps this is why certain artists of the twentieth century, especially Duchamp and the Surrealists, have tried to recapture a magical role for the artist.

By way of extreme contrast, in fourth century BC Athens, Plato in The Republic seems to have considered a painter of pictures as inferior in certain ways to a carpenter. This idea is reinforced by the Greek language: the word teuxy meant an 'art' and it was akin to tekton, a carpenter. According to Plato, a carpenter produced something useful like a table which was an honest copy of the idea of an (idealized) table. (The whole of the physical world, according to Platonic philosophy, was a kind of shadow of an ideal world.) The painter portraying that table was only making a copy of a copy of the idea of a table. Such a painter was a mere purveyor of illusions. Plato also believed that the artist was inclined to be socially disruptive, however admirable individually, and had the potential to inspire fear among a society's authorities.

In the Middle Ages, the artist was generally thought of as a sort of craftsman. In addition, from the seventh to the twelfth centuries, the clergy guarded the technical secrets of painting as they guarded the secrets of medicine. In the thirteenth century, artisans' guilds were formed and technical knowledge became more widely accessible. In about 1390 Cennino Cennini, a somewhat obscure artist himself, wrote his famous treatise, Il Libro dell'Arte (The Craftsman's Handbook) which gives an account of the tempera technique of the school of Giotto (c 1266-1337). Cennini noted that there are two attitudes among those entering what he calls 'the profession': some enter it through poverty and domestic need, or for profit; others, whose 'intellect will take delight in drawing' are moved by 'the impulse of a lofty spirit. His words already reflect the difference that was being discerned between the artist and artisan (and perhaps the artist and the commercial artist of today). It was the difference between the everyday world and that of the intellect and the senses.

During the High Renaissance, the position of the artist changed, strongly influenced by humanism and individualism. Some artists were also intellectuals; Piero della Francesca was a mathematician as well as a painter. And clearly Michelangelo (1475-1564) and Leonardo da Vinci (1452-1519) were two of the great minds of the time: manifestly superior to a simple craftsman from some medieval artisans' guild. Interestingly, Antonio Pollaiuolo (1431-1498), Andrea Verrocchio (1435-1488), Sandro Botticelli (1445-1510) and Domenico

LEFT Big Painting No 6 (1965) is one of a number of large-scale works representing brushstrokes that Lichtenstein executed in the mid-1960s. By isolating and amplifying a single or a small number of brushstrokes the artist is drawing attention to the basic unit of most painting techniques, as well as casting an ironic glance back at the methods of the Abstract Expressionists. The irony is augmented by the fastidious technical procedure that . Lichtenstein engineered in order to paint these works on such a scale. The images were arrived at by applying loaded brushstrokes of black Magna colour upon acetate, allowing the paint to shrink on the repellent surface and to dry, and then overlapping the sheets to find a suitable image, which was finally projected onto a canvas and redrawn.

Ghirlandaio (1449-1494) all started their careers as goldsmiths.

The Renaissance view of the artist had a profound and lasting effect on technique in painting. The enquiring mind of the Renaissance extended to technical experimentation. Hilaire Hiler, in his Notes on the Technique of Painting (1934), took a pessimistic view of the results: 'It [the Renaissance] was a great period of experiment, and technically the rush of revolutionary ideas crying for expression made painters seek for new techniques fitted to express them. In spite of the prodigies performed by individuals whose very names have come to be normalities in the history of art, such fame did these tours de force bring them, it must be considered from a standpoint of material technique as a period of decadence. Technically speaking, we are still in it.'

Hiler's points are as relevant to this century as to the fifteenth and sixteenth. He is not questioning the right of the artist to experiment but lamenting some of the results from the point of view of durability. Leonardo da Vinci's Last Supper (1495-1497) is a notorious example of a great fresco which began to disintegrate shortly after it had been painted. The wall in Milan on which it was painted was first covered with a mixture of resin, mastic, gesso and other materials. This coating proved insufficient for an unusually damp wall in an area prone to flooding. But Leonardo more than compensated for his unfortunate technical error. Sir Charles Eastlake (in Materials for a History of Oil Painting) credits him with introducing the following changes in the practice of oil painting:' i) The exclusion of the light ground by a solid preparatory painting. ii) The use of essential oils together with nut oil in that preparation. iii) The practice of thinly painting and ultimately scumbling and glazing over the carefully prepared dead colour, as opposed to the simpler and more decided processes, or sometimes the single alla prima operation of the Flemish masters. iv) The reservation of thick resinous vehicles (when employed to cover the lights) for fixed operation, so as to avoid as much as possible a glossy surface during the earlier stages of the work. v) The use of essential oil varnishes.'

This list gives us an insight into how a great innovatory artist proceeds with the practicalities of his work. Leonardo's pictorial achievement was literally to create a new way of seeing, by inventing or perfecting *chiaroscuro* (light and shade to produce an effect of modelling), *sfumato* (the subtle blending of colours into a misty effect) and aerial perspective, which gives an illusion of distance by grading tones and subtle colour relationships.

Increasingly, the artist was being thought of as a scholar and a gentleman. This coincided with the foundation of academies where painting could be studied, not primarily as a

craft but as a branch of learning like mathematics, literature or philosophy. The Académie Royale de Peinture et de Sculpture was founded in Paris in 1648, the Royal Academy of Arts in London in 1768. The use of line, which is an abstraction, was thought to be more intellectual than the use of colour, which is more obviously present in nature and more sensual. Students were taught to concentrate on the human figure and to idealize it. In the middle of the eighteenth century when excavations at Herculaneum and Pompeii dramatically underlined the interest that the Italian Renaissance had shown in the ancient civilizations of Greece and Rome, the Neo-Classical Movement gathered strength. Neo-Classicism boosted not only classical style and subject matter but also the influence of the academies; as late as the end of last century, art students learnt to draw by copying plaster casts of antique statuary before graduating to the live nude.

There is little doubt that during the early nineteenth century the cause of craftsmanship suffered greatly. Jacques Louis David (1748-1825), whose ideas dominated art education from 1790 into the early decades of this century, spurned the traditional expertise of crafts and guilds and in the cause of Neo-Classicism discouraged his students from studying the Baroque and Rococo styles or methods. The tradition of revolt, which is inimical to the passing on of technical knowledge, had begun to get under way. In addition, the preparation of artists' materials was done outside the studio. As soon as the artist stopped grinding and preparing colours according to proven recipes, he or she became the dupe of the colour merchants.

There was a general resentment on the part of artists such as Eugène Delacroix (1798-1863) that the technical secrets of the great late medieval and early Renaissance oil painters, whose work has proved so astonishingly durable, had been lost forever. Even seventeenthand eighteenth-century practices were not handed on to succeeding generations. To take one example, the nineteenth-century use of bitumen in underpainting, a purpose for which it is not suited, has been responsible for damage to innumerable pictures. Its poor drying power has tended to crack the layers above, causing the asphaltum to press through. In the seventeenth century, bitumen was correctly used as a glaze - by Rembrandt (1606-1669) for example - and it did no damage. Fortunately, as has been seen in Leonardo da Vinci's Last Supper in Milan, it takes more

At the end of the nineteenth century, the debate about the status of the artist was resurrected. William Morris (1834-1896), the English poet, artist and socialist, wanted to return to the medieval view of the artist as artisan. He refused to accept the Industrial

than one technical error to spell disaster.

RIGHT Marcel Duchamp (1887-1968) was one of the most technically inventive of modern artists. But unlike Picasso, for example, he was not dedicated to the procedures, however innovative, of the fine art tradition. By 1913 he had abandoned conventional media such as oil on canvas, for experiments in three-dimensions, ready-made, constructions and 'machines'. After 1923 he virtually gave up work as an artist altogether. Nude Descending a Staircase No 2 (Jan 1912) caused a sensation at the Armory Show in America (1913), and has been claimed as 'one of the watersheds of twentieth-century art' Duchamp admitted the influence of chronophotography (figures, animals and objects recorded photographically in motion), and white points in the area of the hands recall the dots in chronophotographs which resulted from torches carried by the protagonists to aid the recording of their movement. But so complex are the sources for this work and its place in the chain of Duchamp's activity up to the early 1920s, that the viewer is constantly aware of the crucial interface between technique, form and the world of ideas.

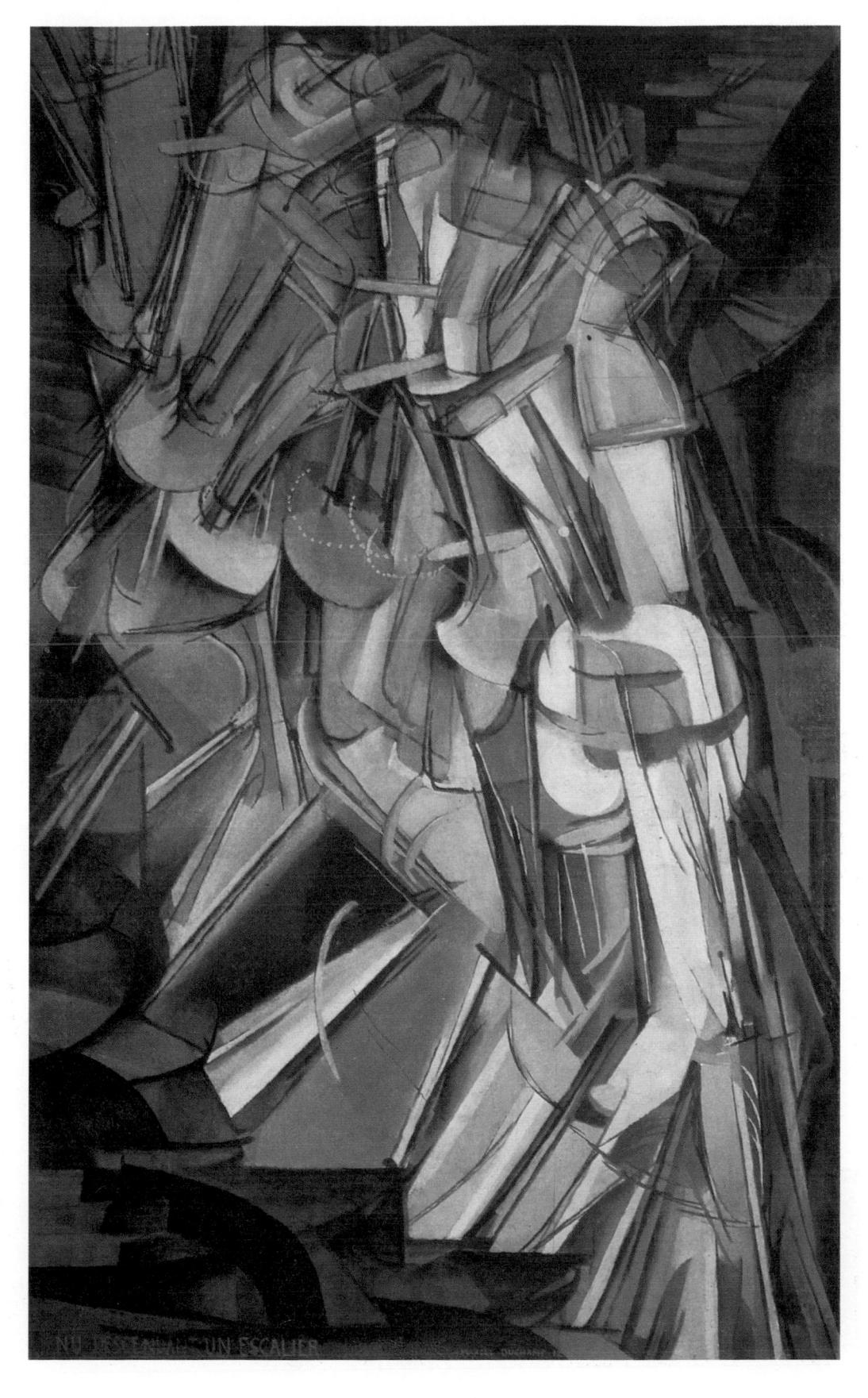

BELOW The Conservationist (1978) by Boyd Webb (b 1947) is a recent example of the kind of challenge issued to painting by other media, but notably by the photographic image, either still or moving. Boyd has arranged a scene, a tableau, and then recorded the information at a crucial moment; here before the painter (decorator) reduces the interior to blankness.

Revolution and advance of technology and dreamed of reviving the handcrafts of weaving, pottery and furniture making. In 1862 he started a designing and furnishing business and used his private printing press, the Kelmscott Press, for artistic productions. If society were to restyle the artist as craftsman, Morris felt, there would be a welcome relief from the pressure to be an individualist, an intellectual living up to a Michelangelo or aspiring to the Romantic notion of the passionate genius.

Morris had a great influence on late Victorian art and decoration in both England and on the continent, and his idealism continues to provoke discussion today. But he was not himself a painter of any importance, unlike

the Pre-Raphaelite painters Dante Gabriel Rossetti (1828-1882) and Edward Burne-Jones (1833-1898) (an artist who at one point influenced Picasso); and he was in no position to change society radically. Possibly when describing the artist as craftsman, he was merely describing himself.

The twentieth century

Another art and craft movement, more successful and enduring than Morris's, was the Bauhaus Movement of the 1920s. It, too, took inspiration from the Middle Ages, wanting to fuse art and craftsmanship and lead art back into daily life. But its methods and style were essentially modern. The painters Paul Klee

RIGHT Lucio Fontana (1899-1968), in his Manifesto Bianco (1946), developed a theory known as Spazialismo (Spatialism). Spatial Concept 'Waiting' (1960) is a work where the natural canvas has been slit. This mode of working grew out of his attempt to repudiate the illusory space of conventional painting and propose, in his own words, 'a new dimension beyond the canvas, time and space'.

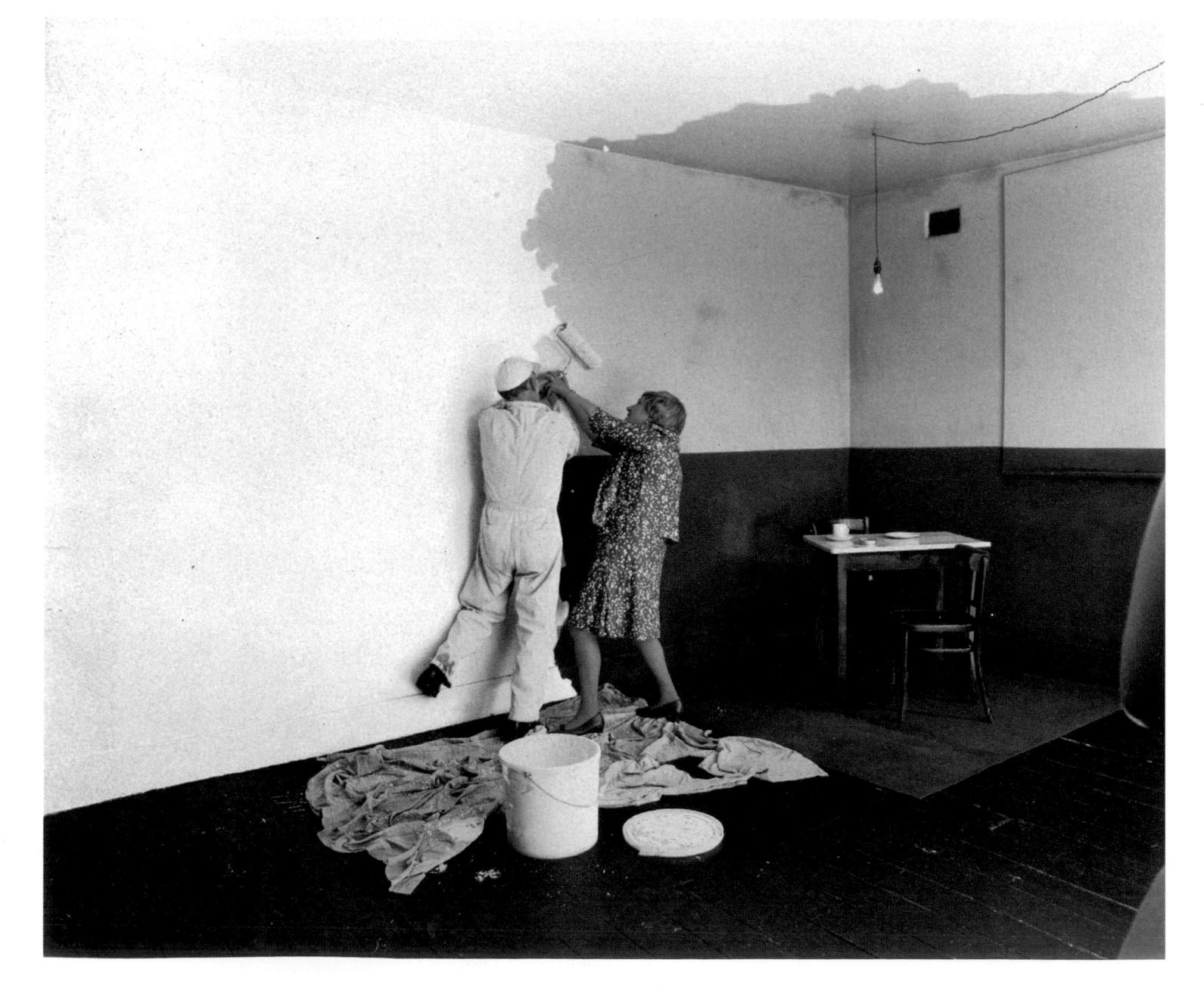

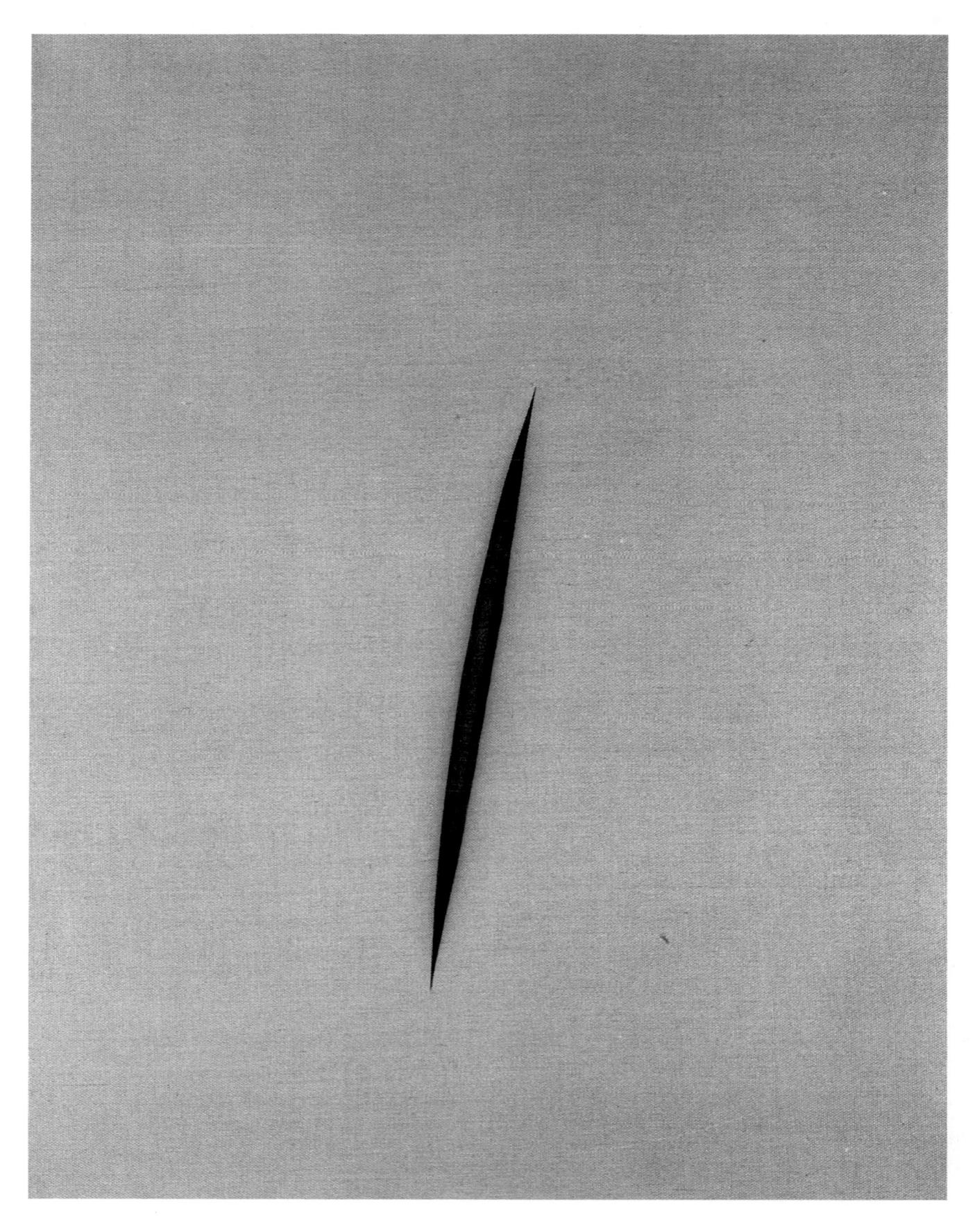

BELOW Henri Matisse (1869-1964) produced The Painter and his Model (1916-1917) at the end of his own 'period of experiment', and suggests that for him 'painting was ultimately life-painting, recording an instinctive reaction of the living model posing in the studio.' Passages of densely worked black and white are relieved by the decorative Baroque mirror, but the work is deeply reflective, too, on the complex relation between artist, model and picture, and between the interior and exterior worlds represented.

(1879-1940), Wassily Kandinsky (1866-1944) and Piet Mondrian were all involved in the Bauhaus, which still influences art.

The Bauhaus school placed its notions of art and craft firmly in the context of contemporary life, while Morris had a romanticized view of the medieval artist, which was misleading. Interestingly it is Plato's view of the artist that turns out to have been prophetic. Plato's Republic, his Utopian, closed society, could not tolerate the disruptive individualism of the artist. The same has proved true of the closed societies of this century. In Nazi Germany in the 1930s the Expressionists were declared decadent, and persecuted. In Russia immediately after the 1917 Revolution artists, many of whom had backed the revolutionaries, were accepted or at least tolerated. As soon as the Bolsheviks were in full control, they stamped out what Lenin called the 'puerilities of the leftists' and the works of pioneering artists such

Fortunately for the development of modern art, a significant number of important artists escaped the closed societies engendered by the Stalinists in Russia and by Nazism in Europe. Many ended up in America during the 1940s, giving an impetus to the modern movement of art which had begun to grow there since the Armory Show of 1913.

A painter in the twentieth century has a highly individualistic approach to technique and to craftsmanship. It is instructive to compare Picasso and Braque in this respect, since at one point in the creation of Cubism, their work was so close. Braque is often referred to as a good craftsman. I make the background of my canvases with the greatest care', he wrote in 1954, 'because it is the ground that supports the rest; it is like the foundations of a house. I am always very occupied and preoccupied with the material because there is as much sensibility in the technique as in the rest of the painting. I prepare my own colours, I do the pulverizing ... I work with the materials, not with ideas.' Braque, like his father and grandfather, was employed as a house painter as a young man, and certain principles and practices of the craft stayed with him. He developed a sound technique patiently. Picasso was often a good craftsman too but it does not seem to have been one of his primary concerns; he was more interested in ideas and the company of poets than painters. Restlessly inventive in the area of technique, Picasso was gifted with an instinctive knowledge of how to handle all kinds of materials. If sometimes his craftsmanship was less sound than Braque's, it is a small price to pay for his protean inventiveness. Highly visible cracks have developed in the left centre area of Picasso's painting The Three Dancers (1925), due to the contraction of the thick top layer of paint over the years. 'The paint is solid enough and will not flake off', Picasso commented. 'Some people might want to touch them [the cracks] out but I think they add to the painting. On the face you see how they reveal the eye that was painted underneath.

For Picasso, vitality was the measure of art. For him a 'finished' painting, in the sense of being highly finished like nineteenth-century glossy varnished Salon paintings, was a dead painting. In fact, the technical difference between Picasso and Braque, although seeming extreme, involves only a shift of emphasis.

It may be concluded therefore that for both

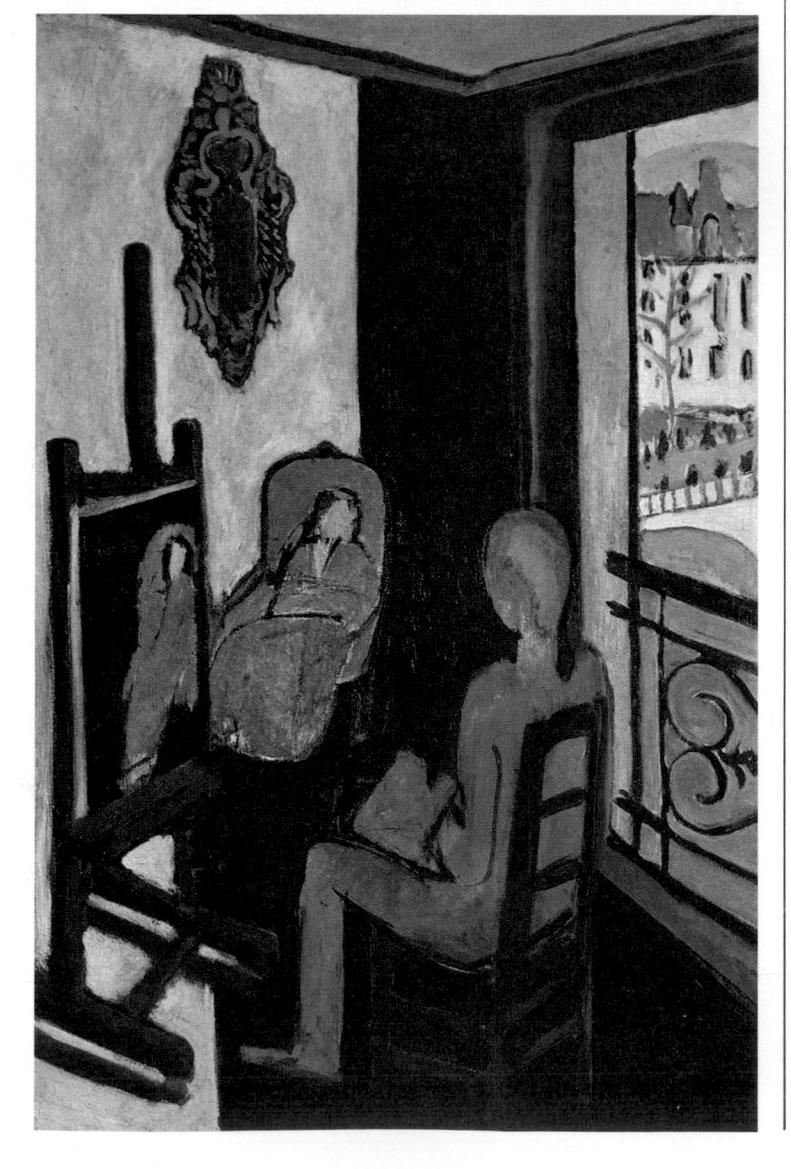

philosophical and historical reasons the craftsmanship of a craftsman is unlike the technique of a painter in important ways. A major distinction between the artist and craftsman is that we expect the artist, whose aims are more ambitious and complicated, to be more experimental in terms of technique.

The issue of craftsmanship boils down to two main elements: the problem of durability or permanence, and the problem of facility with materials. Commonsense decrees that a painter should build a painting to last as long as possible; but the history of twentieth-century art is not the history of commonsense. One of the characteristics of the consumer society is that of inbuilt obsolescence in goods such as cars and even apparently in houses, in blocks of flats and offices. A number of mod-

ern artists have reflected this irony and have borrowed from it, deliberately stressing the impermanence of their own work. Obsolescence featured in the historic 'This is Tomorrow' exhibition at the Whitechapel Art Gallery, London, 1956, which showed the artists Richard Hamilton (b 1922) and Eduardo Paolozzi (b 1924) as the precursors of Pop Art. The German artist, Diter Rot (b 1930), later made works of art out of substances such as cheese and chocolate.

Such *advertising* of obsolescence cannot be criticized on the grounds of dishonesty. It may be a perfectly valid comment for an artist to incorporate into a work and when the work itself disintegrates, a photograph preserves its memory. Such work must be valid as far as it corresponds with the intention of the artist.

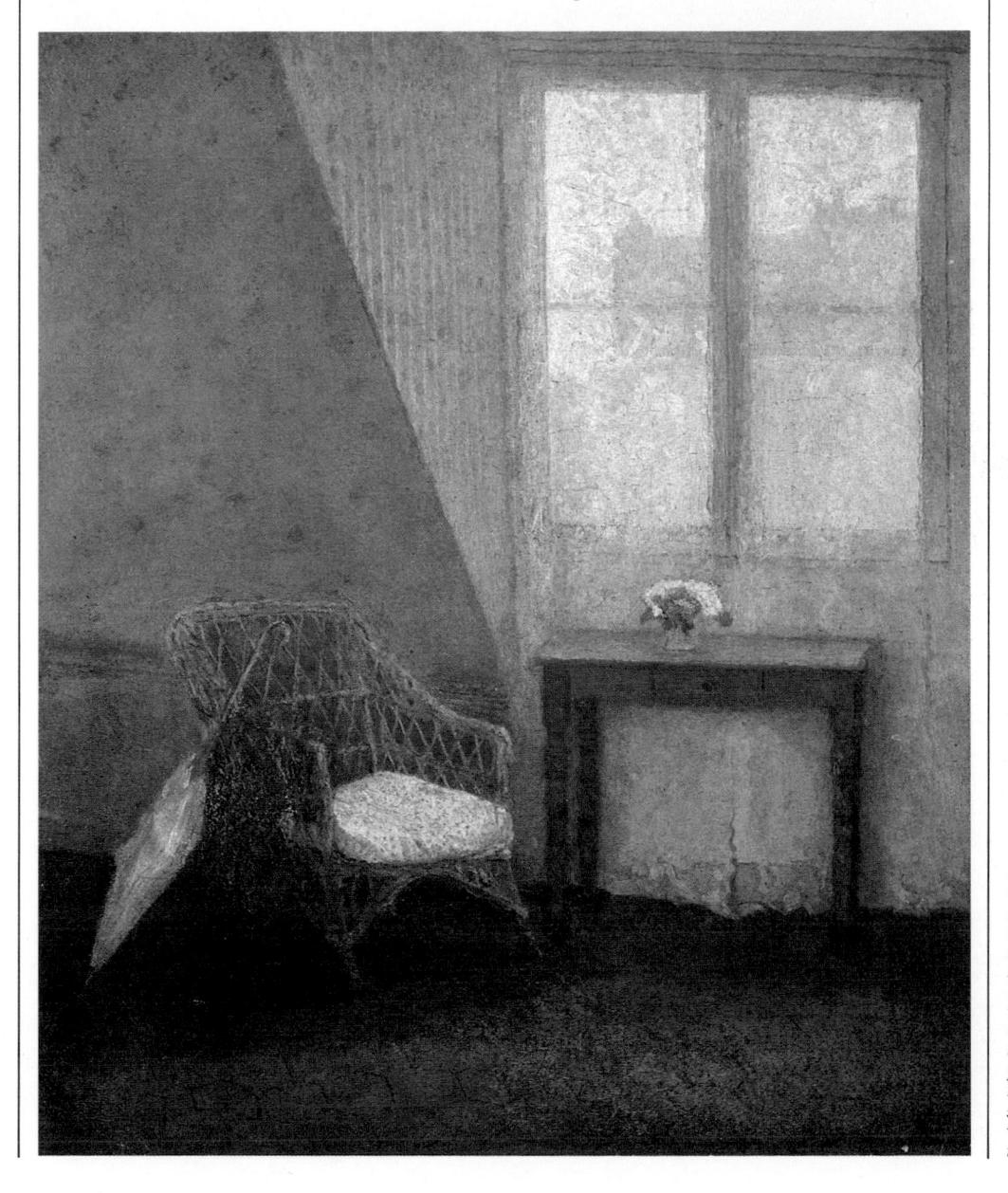

LEFT A Corner of the Artist's Room in Paris (1907-1910) by Gwen John (1876-1939) reveals the strong influence of the American James Whistler (1834-1903) with whom she studied in Paris. John's work consists mainly of figure paintings and landscapes executed in a simple retiring style, which display an almost neurotic sensibility.

Introduction

1900 1920

Influence

The crucial years for the modern movement in painting are from 1905 to 1914. It is more straightforward to analyze the whole first half of the nineteenth century in terms of movements, styles and techniques than these early years of this century. But the twentieth century only rejected the values of the nineteenth when it had received as much stimulus as it could take.

From 1800 to 1850 in France the three out-

standing styles were the Neo-Classicism of Jacques Louis David (1748-1825) and Jean-Dominique Ingres (1780-1867) which, from a technical viewpoint, invariably reveals a smooth paint surface beneath the glossy varnish and a look of high finish; the Romanticism of Théodore Géricault (1791-1824) and Eugène Delacroix (1798-1863) which generated a more imaginative and expressive use of oil paint; and finally the Realism of Gustave Courbet (1819-1877) in which paint was ap-

LEFT Ingres created a personal, sensual style that moved away from the grand manner of late eighteenth-century Neo-Classicists, using line with a new expressiveness and replacing the dramatic cross-lighting with soft, full-face light and opaque shadows (which used non-traditional white). The exposed canvas texture in Oedipus and the Sphinx (1828) was an Ingres innovation; it was unconventional among the Neo-Classicists who preferred a smooth finish.

plied thickly in a straightforward, direct way. As the century progressed, many artists felt less and less need to build a painting up in successive layers according to the methods of the late medieval and early Renaissance masters.

Neo-Classicism continued to influence the teaching methods of the academies and the practice of academic artists. Very few nonacademic modern artists have imitated the smooth, highly finished surface of Neo-Classicism. The masters of twentieth-century painting have tended to reject or ignore such methods and practices. A few, including Henri Rousseau (1844-1910), Max Ernst (1891-1976) and Yves Tanguy (1900-1955), did not even attend art academies or schools. On the other hand, an older more potent tradition of classical art, which stresses form rather than subject matter and is represented in seventeenthcentury France by Nicolas Poussin (c 1594-1665), embedded itself in the modern movement in a new guise with Paul Cézanne (1839-1906), who insisted on structure in painting. At least one art historian, R. H. Wilenski, writing in 1927, regarded Cézanne and the modern movement as fundamentally classical. But Cézanne cannot be summed up by the word 'classical' and the highly effectic modern movement owes more to Romantic painters.

The aim of Romanticism was the expression

of emotion directly and subjectively through colour and the actual handling of paint; an idea which Fauvism and German Expressionism brought to twentieth-century painting. The Romantic Movement also led by a different path, that of the imagination and literature, in the direction of Surrealism.

The idea behind Courbet's realism, the shockingly novel idea that art should be concerned with what is before the eyes and should be contemporaneous, found a twentieth-century counterpart, in a less legible stylistic form, in Cubism (a fundamentally realist form with classical and Romantic affinities). But the way that Courbet applied paint was almost heavy-handed in its directness.

The second half of the nineteenth century in France is a much more complex period. There was an acceleration in the pace of stylistic change; styles and techniques began to multiply. The vocabulary of art criticism and art history responded with terms such as 'Impressionism', 'Post-Impressionism', 'Expressionism', 'Symbolism' and 'Neo-Impressionism' which tend to oversimplify what happened.

Year by year, painter by painter, the Impressionists modified their aims and techniques. In the area of brushwork the densely applied brushstrokes of Claude Monet (1840-1926) (in whose work Impressionism reached its highest point) have gained new signifi-

LEFT Gustave Courbet, the most influential Realist painter, chose subjects alien to both public and critics middle- and workingclass provincial people and rural themes — and employed a lively and uncompromising painting technique which was highly innovative. In La Rencontre, painted in 1854, Courbet has omitted his normal practices of laying in a dark ground over the pale commercial priming, in order to convey the luminosity of the bright light of southern France. Courbet's paint surfaces were robust and he painted his shadows thickly and darkly. But his technique was based on the tradition of chiaroscuro. He worked from dark to light; as a painter, he was, he remarked, the equivalent of the sun lighting up a dark landscape.

BELOW Greek Slave (c 1896) by the French academist, Jean Léon Gérôme. As a young man, Henri Rousseau was impressed by Gérôme's work, and he gave every inch of his canvases the same punctilious attention and loving execution. This example of ébauche in oil on canvas, displays Gérôme's excellent draughtsmanship and his careful establishment approach to art. cance in the light of American Abstract Expressionist procedures of the 1940s. In the field of colour, by lightening the palette, dismissing muddy and murky tones in favour of an array of clear, bright pigments, the Impressionists opened up immense colour possibilities. These were exploited in different ways by four great painters reacting against the naturalistic aims of Impressionism namely Cézanne, Vincent van Gogh (1853-1890), Paul Gauguin (1848-1903) and Georges Seurat (1859-1891). Cézanne turned Impressionism into something solid, monumental and profound which provided a basis for the Cubist revolution of 1907-1914. Impressionism drew van Gogh into a passionately expressive style which was highly influential on the Fauvist bombshell of 1905. Gauguin, by exploring the symbolic possibilities of colour, was a precursor of the Symbolists.

The Symbolist painters, Pierre Puvis de Chavannes (1824-1898), Odilon Redon (1840-

1916), Gustave Moreau (1826-1898) and their followers, aimed to express literary ideas by associations of form and colour. They foreshadowed the dream images of Surrealism. Gustave Moreau, whose own technique was idiosyncratic and prophetic of Surrealist procedures, encouraged an individualistic and experimental attitude in his atelier among pupils such as Henri Matisse (1869-1954) and Georges Rouault (1871-1958). In 1891 Symbolist Maurice Denis (1870-1943) wrote, 'It must be recalled that a painting, before it is a war horse, a nude or some anecdote, is essentially a flat surface covered by colour assembled in a certain order.' The importance of this oftenquoted doctrine cannot be overestimated. A flat surface means a support. Colour means paint. By focusing attention on the painter's materials and support, the statement contributed both to the theory and practice of modern painting. It provided a theoretical justification of so-called 'abstract art'; in the absence of a figurative image, a painter is almost bound to explore the properties of materials with intensity.

The Neo-Impressionists or Divisionists, Seurat and Paul Signac (1863-1935), reacting against what they considered the Romantic element in Impressionist naturalism, developed the more scientific technique of Pointillism, in which colour was applied to the canvas in separate dabs or dots of colour. From the strictly technical point of view this method of applying oil paint to canvas was the most radical departure of all in the nineteenth century; more radical than Fauvism to which it helped give birth. The procedure had as much in common with the method of the mosaic artist as with traditional oil painting. Seurat's use of the dot technique was probably inspired by such contemporary developments in colour printing as the chromotypogravure.

The Fauve explosion

Fauvism was the first major shock to be administered by painters to the twentieth-century public. The 1905 Salon d'Automne exhibition of work by Maurice de Vlaminck (1876-1958), André Derain (1880-1954), Matisse and their followers was dubbed an 'orgy of pure colours' by critic Louis Vauxcelles, who went on to name the group Fauves (wild beasts) when he described a restrained sculpture of the torso of a child as 'Donatello among the fauves'.

The Fauves were a loose association of painters: Matisse, Albert Marquet (1875-1947), Charles Camoin (1879-1965) and Henri Manguin (1874-1949) worked in the studio of Gustave Moreau; Georges Braque (1882-1963), Raoul Dufy (1877-1953) and Othon Friesz (1879-1949) were from Le Havre; Derain and Vlaminck were from Chatou; Kees van Dongen (1877-1968) came from Rotterdam; Jean Puy (1876-1960), a relatively tame Fauve

had met Matisse at the Académie Carrière in 1899. Fauvism's later influence was international, affecting Expressionism in Germany and such artists as Alfred Maurer (1868-1932) in America, and the English painters Augustus John (1878-1961) and Matthew Smith (1879-1959).

The various individual styles and techniques of the Fauves reflected a common aim, the subjective expressiveness of colour. Fauvism can be seen not only as an attack on the official art of the academies, but also as yet another reaction against Impressionism in the wake of a series of Paris exhibitions of the great Post-Impressionist painters in the early 1900s. Although considered revolutionary, Fauvism was little more than a combination of the culminating elements in the work of Cézanne, van Gogh, Gauguin and Seurat. No new subject matter was introduced and the subjects - landscape, portrait or still life - remained legible despite the nondescriptive liberties that were taken with colour. Like Impressionism, Fauvism was largely a matter of oil on canvas, the whiteness of the primed canvas often being allowed to enhance the intensity and consequent drama of colour.

This colour was not used for symbolic purposes, nor was it used arbitrarily; it was used in response to pictorial demands such as the construction of space. Representational demands continued to be set and Fauve paintings often retained a rough tonal accuracy in relation to naturalistic vision, an accuracy that is easily apparent when Fauve paintings are reproduced in black and white. Although Matisse, the leader of the Fauves, did sculpture during this period, the term Fauvist is not used to describe sculpture, because colour *not* form was the instrument of Fauvism.

Derain, who introduced Vlaminck to Matisse, looked back on Fauvism as in part a violent response to the challenge of photography. It was, according to the critic and poet Guillaume Apollinaire (1880-1918), the period of Derain's 'youthful truculence'. The intention of the Fauves was to use colour like 'sticks of dynamite' (to use Derain's own words); to express the joy of life (*Joie de Vivre* [1905-6] was the title of one of Matisse's early paintings);

BELOW By the time he painted Large Bathers (1898-1905), Cézanne had broken down everything he painted a landscape, a still life, the human figure into a series of facets in order to express the relationship between three-dimensional reality and twodimensional representation. Each facet expressed the object's colour, the effect of light and shade on it, and moulded it so that it had a realistic feel. As well, each facet imposed a certain order on a fundamentally abstract structure.

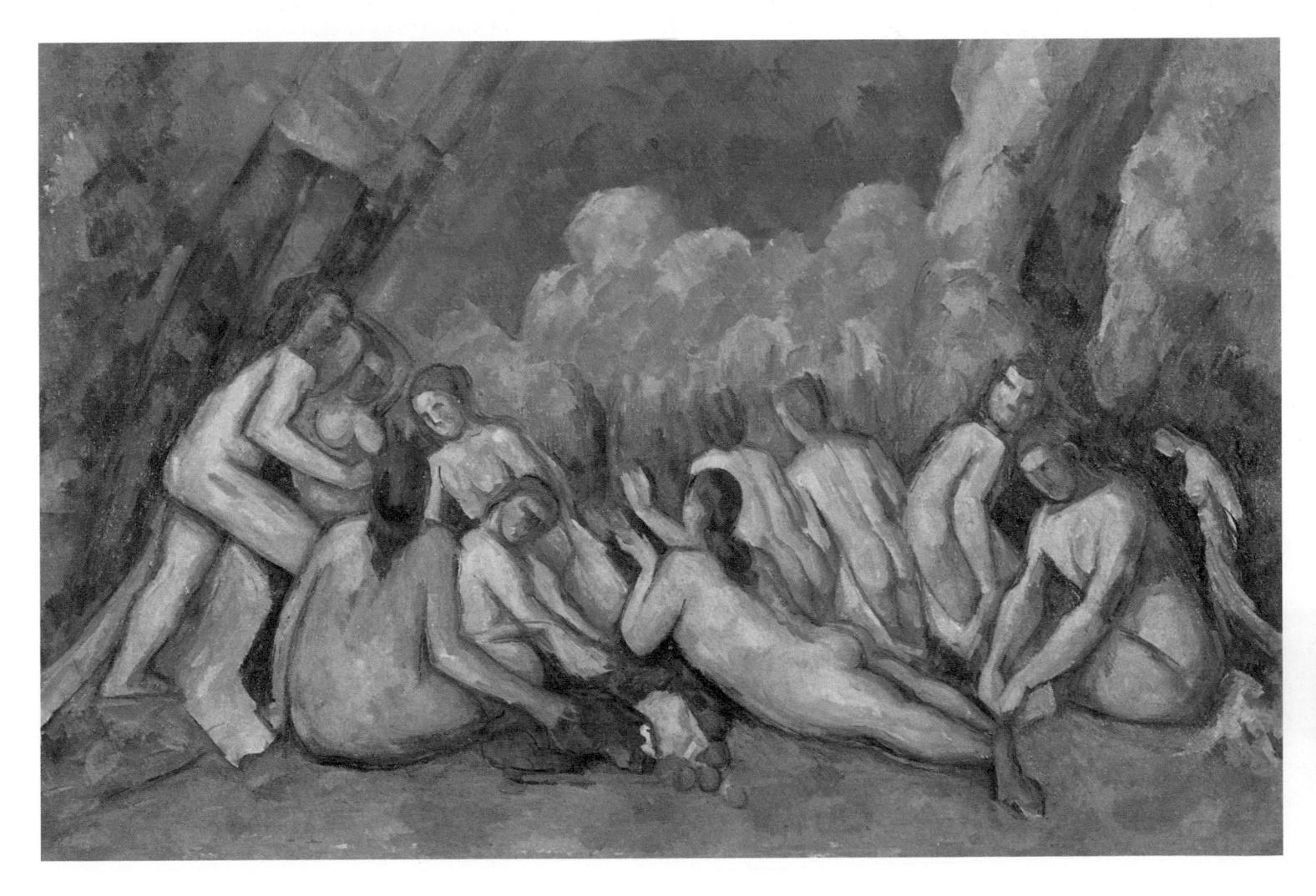

and to prove a dictum of Matisse's that 'exactitude is not truth'.

The emergence of Cubism

A radically new vision tends to produce a new style and a new technique. Cubism, as it came to be known, has been the outstanding revolution of vision and style in this century. It rejected the monocular perspective that had dominated Western art since the Renaissance and created a new kind of pictorial space.

Cubism was the invention of two men, Pablo Picasso (1881-1973) and Georges Braque. A third important figure, Juan Gris (1887combined a strong conceptual (as opposed to a perceptual) element, with the expressive power exerted by magic. Les demoiselles d'Avignon is a figurative work showing five nudes in a room in a brothel. The painting underwent numerous changes in progress. Originally there was to have been a sailor seated among the nude women and a man carrying a skull symbolizing death. The pictorial space remains shallow. The colour is less explosive than in Fauvism, but is not so far from Gauguin. Having completed this exploratory and expressive painting, Picasso put it away and it remained unseen for years.

RIGHT By 1905 when Paul Signac painted Saint-Tropez, the Customs House Pathway, he had been much influenced by the work of his friend Georges Seurat. Like Seurat and the other Neo-Impressionists, Signac displayed a scientific approach to painting. Because light penetrates transparent colours before being reflected back to the eye, matt opaque hues were used to obtain far greater light-reflective luminosity. Signac applied mosaic-like blocks of colour, varying in tone and hue, which built up the formal structure of the subject. The object was to obtain brighter and clearer secondary colours.

RIGHT Gauguin painted Girl Holding a Fan in 1903, the year he died in the Marquesas Islands in the Pacific. He was disillusioned with the Western world and its relentless destruction of other civilizations in order to impose its own ideas. He conveyed this deepseated pessimism in his paintings, where other artists, confronted with the same subjects, would have seen only the romantic and the exotic. The brooding, inert figure in Girl Holding a Fan is painted in the pure expressive colours typical of Gauguin, and later seen in the work of the Fauvists.

1927) joined them in 1911, about four years after Cubism began. Thereafter, the list of painters in Paris and abroad who either became overt Cubists or were influenced by the movement up until 1920 becomes enormous. Cubism was a movement that developed dynamically from painting to painting.

Early Cubism

Historians have divided the Cubist revolution into three main phases. To the early phase belong two oil paintings: Picasso's *Les demoiselles d'Avignon* (1907) and a famous Braque *Nude* (1907). These paintings show the influence of Cézanne in the analysis and simplification of form. In *Les demoiselles d'Avignon* there are other more 'primitive' aspects which can be traced back to an Iberian sculpture and North African masks. Such primitive and exotic sculpture

In the second phase of Cubism (the first phase perhaps of Cubism proper), known as Analytical Cubism, the use of colour was restrained as Picasso and Braque concentrated on form. In 1908 Braque went to L'Estaque, near Marseilles and the landscapes he produced show, in a less dramatic way than Picasso's *Les demoiselles d'Avignon*, the combined influences of Cézanne's analytical method and the force of African sculpture.

The jury of the Salon d'Automne, which included Matisse, rejected these landscapes. Matisse mentioned to Louis Vauxcelles that Braque had sent in paintings with 'little cubes'. Vauxcelles referred to them as bizarreries antiques (cubical oddities) and the movement was soon christened Cubism.

By 1908 Picasso's still lifes had reached a point near to Braque's landscapes, and the two

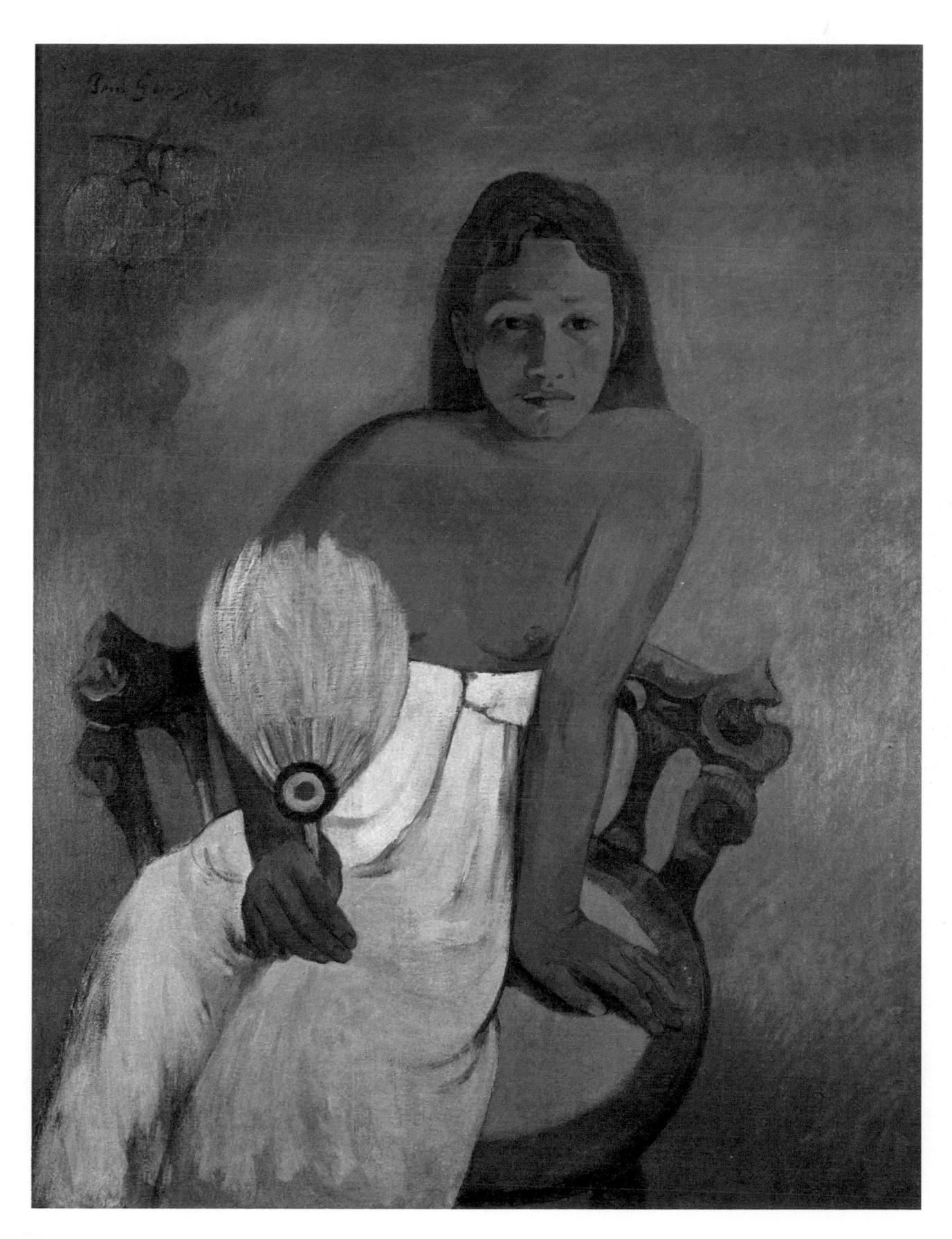

painters began to work closely together in a spirit of friendship and creative rivalry. The austere, at times almost monochromatic, element in Analytical Cubism, the restriction of the palette to black and white, subdued ochres, greys and greens was a revolt against the sensuous appeal of the Expressionist styles current, including the Fauves.

Analytical Cubism

Analytical Cubism was concerned with representing nature in the sense of taking a given subject to pieces then reconstructing it again. From various viewpoints it took elements from a still life and then rearranged them in a new order. In the process, a whole new pictorial architecture of interlocking planes was created. This new code for reality in-

cluded elements of precision and Picasso boldly challenged the Renaissance with his work and the words: 'It is impossible to ascertain the distance from the tip of the nose to the mouth in Raphael. I should like to paint pictures in which that would be possible.'

In 1911 Braque began to introduce letters into pictures. A letter belongs to another information code system. At the same time printed words are very much a part of ordinary visible life casually observed in a café window or a newspaper headline. From here it was a small step to include a real object in the picture.

Cubist collage and Synthetic Cubism

The second, or synthetic phase of Cubism evolved out of the new technique of papier collé

BELOW AND RIGHT This detail of Seurat's Seated Boy with a Straw Hat (1883-1884), was a study for one of the seated figures in Bathing, Asnières. The black crayon drawing on coarse paper shows his rigorous tonal modelling technique. Instead of precise outline and distinct hatching, there are subtle gradations of tone, achieved by varying the pressure of the soft, dense crayon.

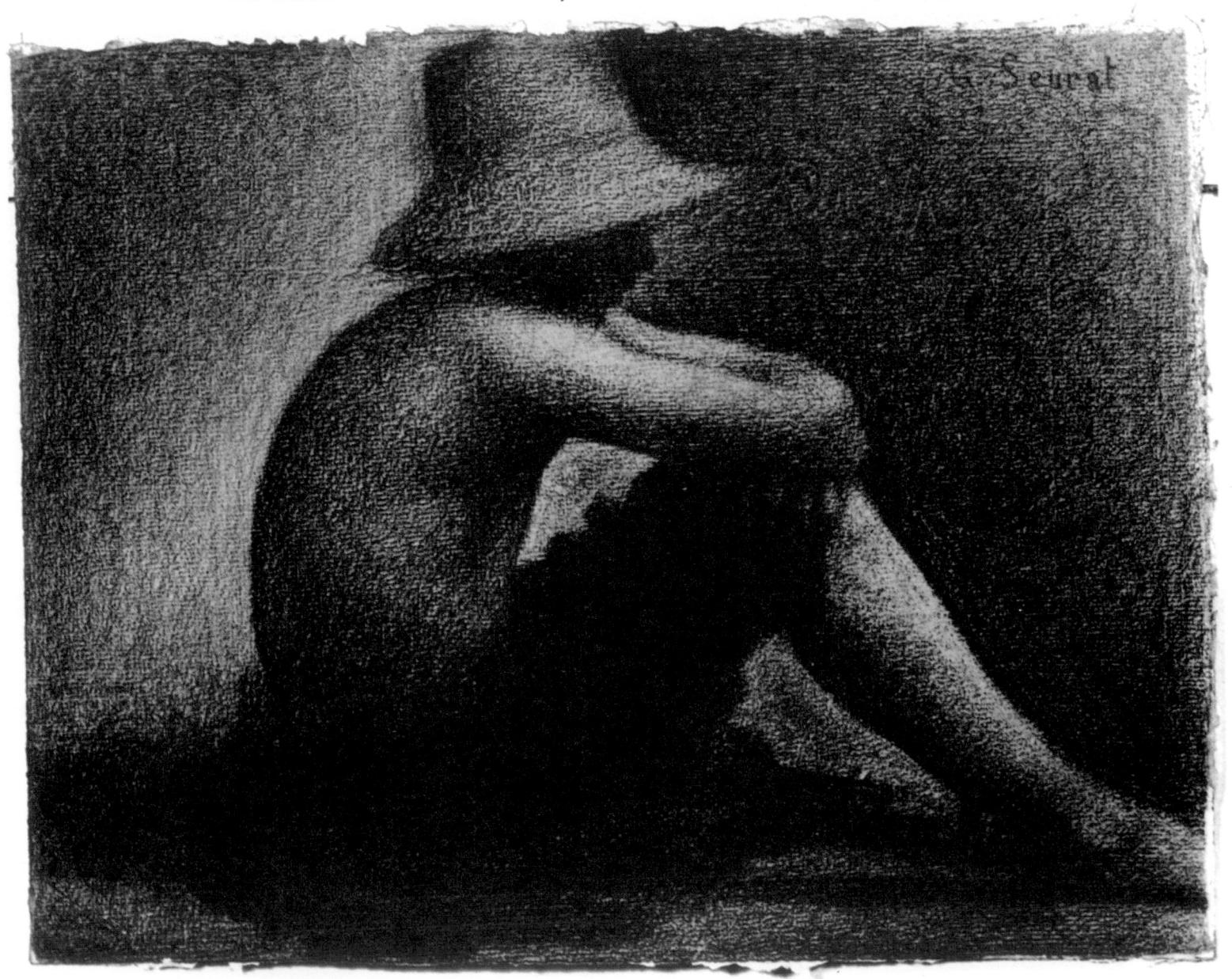

While Seurat's drawings concentrate on sculpting tonal form, his early oils such as Bathing, Asnières (1883-1884) celebrate colours in nature. Seurat used his already distinctive and individualistic crosshatching of colour. This detail shows how Seurat worked the foreground figures and garments heavily in opaque layers, while the background is thinner and paler.

(colle means glue) begun by Braque in 1912. Newspaper was a favourite early ingredient, and wallpaper, oil cloth, matchboxes and programmes followed. Picasso added other elements such as plaster. Braque combined the new materials with drawing in charcoal or pencil, while Picasso and Gris combined them with oil painting. The almost monochromatic colour soon gave way to bright colours.

Gradually pictorial composition became more important than representation, although Cubism was always a realist movement. The physical objects used in the paintings were real in themselves, rather than merely a coded imitation (image). An important later development was the ambiguous game the artists playe I when they returned to painting in oil: they *simulated* the *papiers colle's* or col-

lages. Here the interaction of technique and style reaches a climax. A further development was the thickening of pigment with sand and other materials.

From 1918 onwards, Braque began to explore the expressive textural qualities of his materials, but by 1920 – although still influential over half a century later – the movement of Cubism itself had run its course.

Futurism

On first investigation the possibility of giving a summary account of the techniques of the Futuristic movement in painting looks promising. On 11 April 1910 the Futurists Umberto Boccioni (1882-1916), Giacomo Balla (1871-1958), Luigi Russolo (1885-1947) and Gino Severini (1883-1966), published the *Technical*

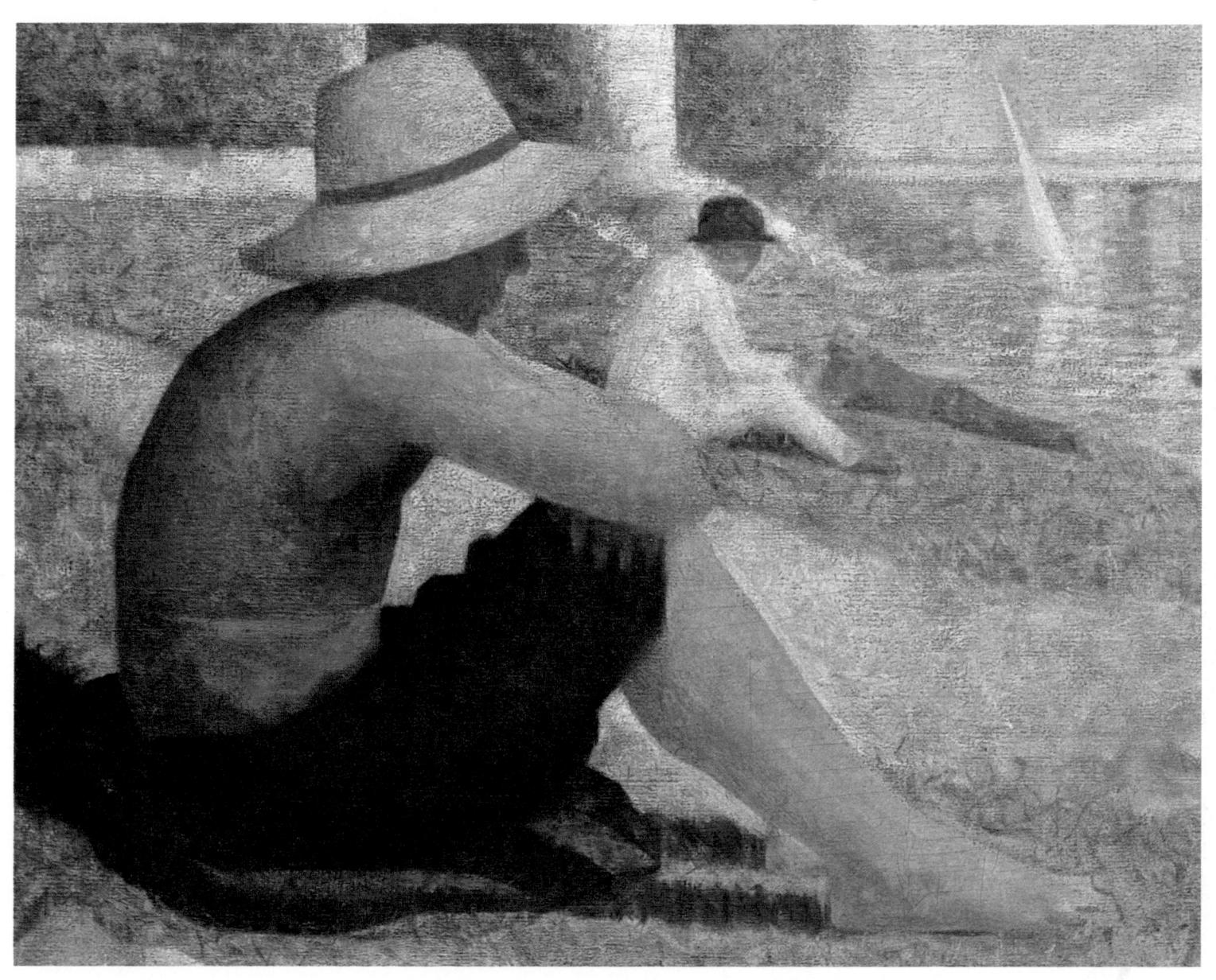

Manifesto of Futurist Painting. Unfortunately for present purposes there is nothing technical in the practical sense about this manifesto. The closest it gets to expressing plastic aims are in such phrases as: 'The gesture for us will no longer be a fixed moment of universal dynamism: it will be decisively the dynamic sensation made eternal ... a galloping horse has not four legs, but twenty and their movements are triangular ... a portrait in order to be a work of art cannot and must not resemble the sitter ... To paint a figure you must not paint it: you must paint the atmosphere around it.' These phrases are a clue to the styles of Futurism painting, but to understand the absence of practicality or rhetorical tone, it is necessary to know the origins of Futurism.

Both Fauvism and Cubism, though very different, were movements rooted in the visual arts. In contrast, Futurism was a polemic explosion, an attack on Italy's cultural stagnation initiated by a poet and propagandist. F. T. Marinetti (1876-1944) published his first Futurist manifesto on 20 February 1909 in the newspaper Le Figaro. It applauded speed, the machine and violence, including war, and scorned traditional social values. Professors, archeologists and antiquarians were especial targets. Marinetti declared that: 'A racing motor, its frame adorned with great pipes, like snakes with explosive breath ... which seems to run on shrapnel, is more beautiful than the Victory of Samothrace'. The 1914-18 war was to put an end to the movement. While it lasted, Futurism took many outward forms including a hybrid form of writing; painting such as Free-word Painting (1915) by the Neopolitan poet Francesco Canguillo; and the sculpture of Boccioni, whose Unique Form of Continuity in Space (1913) is widely regarded as Futurism's outstanding work of art. The movement extended into theatre and cinema, music and architecture. The architecture of Antonio Sant'Elia (1888-1916) never left the drawing board, but its concepts influenced the artists of the Russian avant-garde. Sant'Elia envisaged a modern city where, he said, 'the houses will last for a briefer period of time than ourselves. Each generation will have to build its own city.'

Futurist painting was stylistically diverse, too diverse to permit useful generalizations. In the realm of technique, but buried beneath the rhetoric and bombast of the *Technical Manifesto*, was at least one original plastic aim, which distinguished Futurist painting from rival styles or 'isms'. This aim was to represent actual movement by repetition of the image in a given painting, aided by an Italian version of Seurat's Divisionism. Interestingly, the Futurist painters denied that they had been influenced in their depiction of movement by the photographs of Eadweard Muybridge (1830-1904) and E. J. Marey (1830-1904).

If the Futurist contribution to the tech-

niques of painting is slight, their achievement in the sphere of techniques of propaganda is more assured. Futurism was speedily internationalized. Its repercussions were felt in Russia, in England and in France; it has even been claimed that Futurist ideas gave a fillip to the development of Synthetic Cubism. Certainly, Futurist painting was an attempt to bring art up to date with what the movement considered to be modern life.

Other movements in Paris and Munich

Only when Fauvism (expressive colour), Cubism (form) and Futurism (movement) have been understood is it possible to appreciate the many subsequent developments in style and technique during the first two decades of the twentieth century. Every subsequent movement has points of contact with these three styles, particularly Cubism.

In Paris, Guillaume Apollinaire coined the term Orphism to describe the paintings of Robert Delaunay (1885-1941), exhibited at the Section d'Or in 1912, which he saw as an offshoot of Cubism and moving in the direction of non-representational colour abstraction. However, Delaunay himself saw his interpenetrating and revolving areas of pure colour as originating more in the Neo-Impressionism of Seurat than in Cubism. Sonia Delaunay (1885-1979), Francis Picabia (1878-1953), Duchamp, Fernand Léger (1881-1955) and Frank Kupka (1871-1957) were also associated with the movement.

German Expressionism

Stylistically, German Expressionism has much in common with Fauvism, including an interest in Neo-Impressionism and van Gogh,

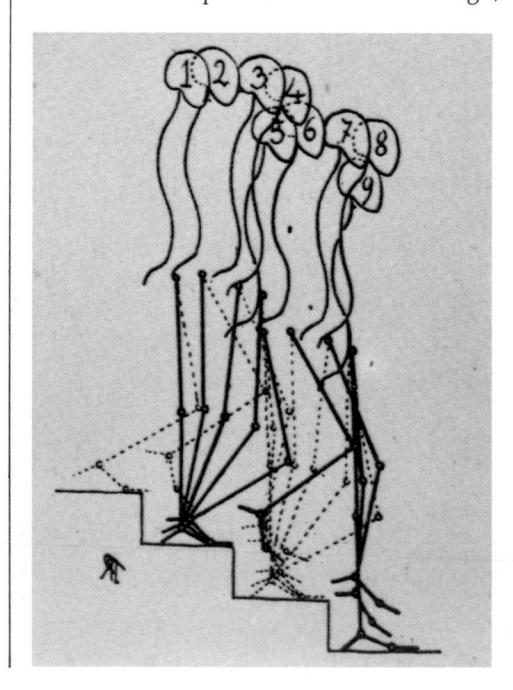

LEFT Marcel Duchamp used various references when working on Nude Descending a Staircase (1912), in which the segmented figure is reduced to simple geometrical forms, and the fragmented nude is multiplied and elaborated to suggest spiraling movement. Preliminary studies and the painting itself clearly show the influence of the work of Etienne Marey, Paul Richer and Eadweard Muybridge. Richer published his Physiologie artistique l'homme en mouvement in 1895. The drawing, Figure Descending a Staircase, based on chronophotographs from the book, reveals how influential such work was to Duchamp.

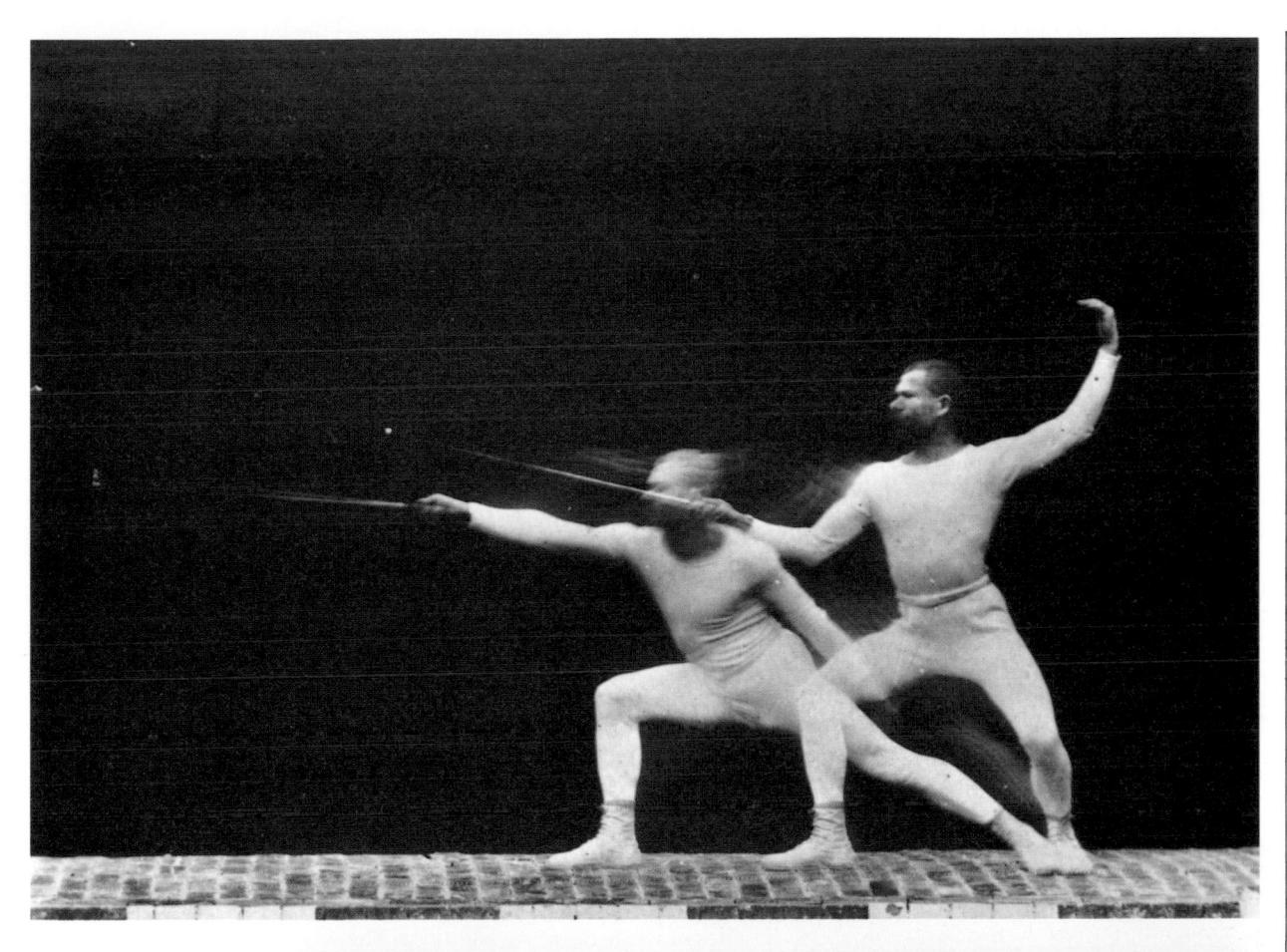

Chronophotographie d'un escrimeur (1891), is by the French photographer Etienne Marey who developed the technique of chronophotography. It is a method of producing multiple images on a single plate which made it possible to record the movements of a man boxing, a bird in flight, or a child jumping. Marey drew graphs tracing the patterns and rhythms of movement recorded on the chronophotographs. These became the source of inspiration for a number of artists. Duchamp made no secret of the fact that Marey's chronophotographs and subsequent diagrams provided the initial impetus for the paintings he produced which attempted to record movement, and also the passage of time.

RIGHT Man walking down an inclined plane by Eadweard Muybridge, the photographer who pioneered the recording of movement. His first experiments, published in 1878 and 1879, analyzed the locomotion of a galloping horse in a series of consecutive photographs. He then went on to record the movements of humans and animals involved in various everyday activities.

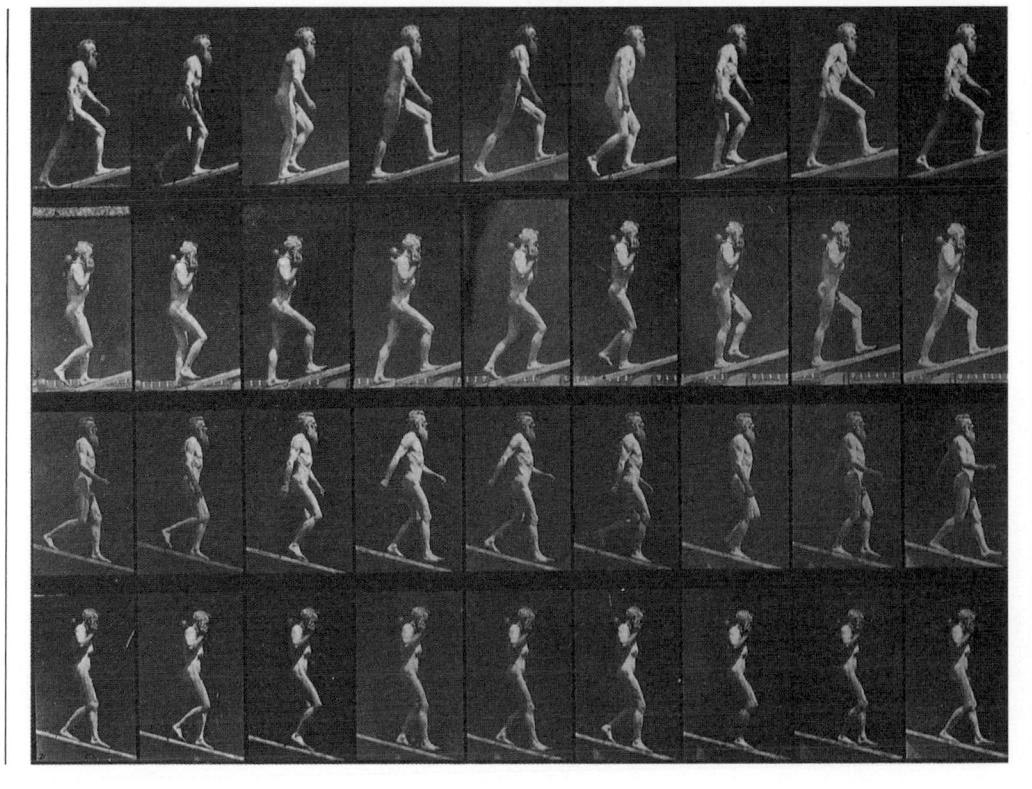

although the artists of Die Brücke, an associalater joined by Emil Nolde (1867-1956).

The German Expressionist Movement reached a high point in Munich in 1911 on the formation of the Blaue Reiter group. The principal artists were the Russian emigré Wassily Kandinsky (1866-1944), Franz Marc (1880-1916), Gabriele Münter (1877-1962), August Macke (1887-1914) and the Swiss artist Paul Klee (1879-1940). Marc and Macke died during World War I and the group disintegrated.

Vorticism

Vorticism in England, like Futurism in Italy, was an attack on local cultural apathy. It was similar in tone to Futurism in some of its verbal manifestations, such as the thick combative magazine with a red cover, Blast! A Review of the Great English Vortex known as the 'Puce

tion established in Dresden in 1905, were as much influenced by the great Norwegian Ex-

pressionist painter, Edvard Munch (1863-1944). The founder members of this group included Ernst Ludwig Kirchner (1880-1938), Erich Heckel (1883-1970) and Karl Schmidt-

Rottluff (1884-1976), three architecture students who turned to painting, lithography and woodcuts. With the exception of Kirchner they were self-taught as artists and they were

painter Wyndham Lewis (1882-1957). ing style in which the diagonal was stressed rather like an imaginary plastic equivalent of a vortex. It was a style that took much from Cubism and Futurism.

The artists involved included Wyndham Lewis, Edward Wadsworth (1889-1949), Frederick Etchells (1886-1973), David Bomberg (1890-1957), William Roberts (1895-1980) and in sculpture, Henri Gaudier-Brzeska (1891-1915) and Jacob Epstein (1880-1959). A high proportion of the Vorticists' oil paintings, gouache and watercolours have been lost or destroyed, but virtually all Wadsworth's black and white and coloured woodcuts survive.

Monster', which was edited by writer and

Vorticism developed a characteristic paint-

Developments in pre-Revolutionary Russia Rayonnism was the style practised by Mikhail Larionor (1881-1964) and Natalia Gontcharavo (1881-1962) from 1912 to 1914. It aimed to be a synthesis of Cubism, Futurism and Orphism.

In 1915 Suprematism was launched by Kasimir Malevich (1878-1935), who believed that the expression of pure artistic feeling was all that was of value in art. Social and political events and representation were thought to be outside its sphere. Malevich acknowledged a debt to Cubism and Futurism but concentrated on elementary geometric shapes in his paintings - the purest of which he considered to be the square. Between 1913 and 1919 he graduated from using black and white to a series of white on white paintings. The white square can only be distinguished from its white ground by the different textures created by the brushstrokes.

Another Russian movement, Constructivism, can be seen as having grown out of Cubist collage. Vladimir Tatlin (1885-1953), the founder of the movement, was familiar with developments in painting in Western Europe. Tatlin used a variety of materials such as wood, plaster, tin and glass in order to do away with pictorial illusion. He developed a doctrine of the 'culture of materials'. The two other important Russian Constructivist artists were Antoine Pevsner (1886-1962) and his brother Naum Gabo (1890-1977). They too took their cue from Cubism but supported the Futurist emphasis on movement in space rather than volume, and favoured transparent materials such as perspex. By 1922 the Constructivist Movement lost its place as the dominant style in post-Revolutionary Russia.

Abstraction

Many artists and commentators have stated that there is no such thing as pure abstraction in art: a picture must be based on something in the visible world. Another argument is that all good art (given that art depends partly on formal qualities) is abstract. The major and

BELOW Auguste Forel (1910) was painted in oils on canvas by Oskar Kokoschka (1886-1980). Although the artist was only 24 when he completed this portrait, it is a surprisingly intimate study of the old man. Later in life, Kokoschka's aims altered quite dramatically: using bright, even luminous colours, he developed an Expressionist style, and before the outbreak of the Second World War produced some imaginative political allegories.

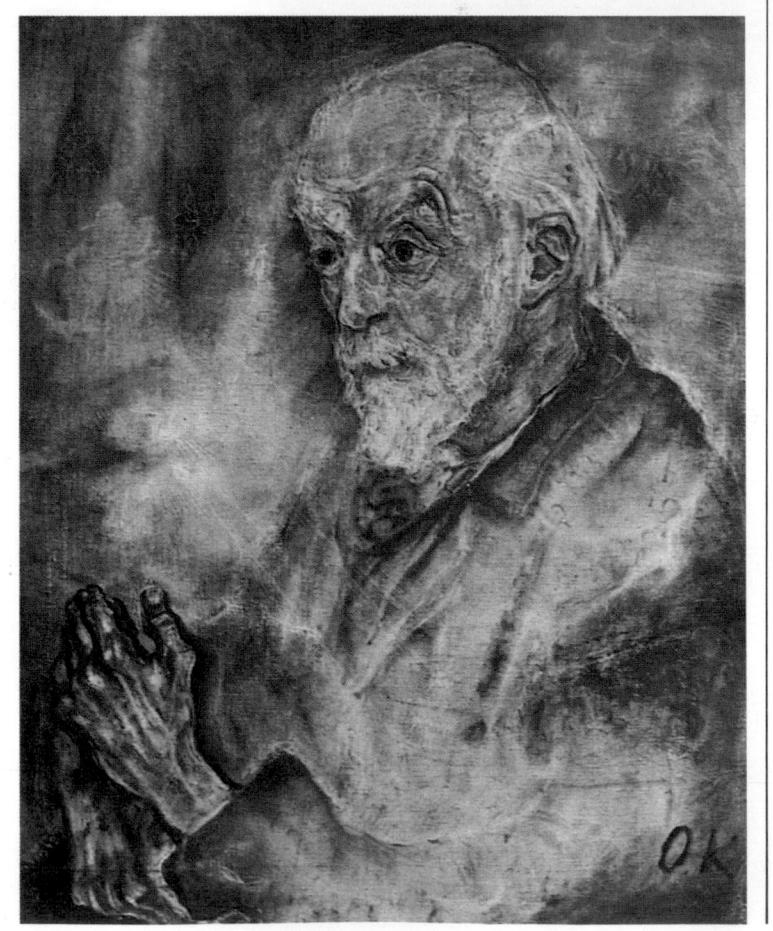
INTRODUCTION

characteristic difference between ancient nonfigurative decorative painting and twentiethcentury art has been non-figurative abstraction. It is useful to divide this sort of abstraction into two parts: the Expressive or Expressionist, and the Geometrical.

Expressive Abstract can trace its origins back to late nineteenth-century ideas, but Wassily Kandinsky in about 1911 is generally credited with being the most important artist to produce a consciously abstract work, a work which in the artist's view is freed from land-scape or figure or still life – the usual subject matter of painting. For Kandinsky such a work approached the condition of music.

Geometrical Abstraction originated in Russian Suprematism and Constructivism, and found its greatest figure in the Neo-

Plasticism of Piet Mondrian (1872-1944). From the technical point of view, there are as many ways of applying paint to a surface as there are abstract painters; abstract art before 1920 produced no technical change as radical as that of Cubist collage.

Dada, Duchamp and Metaphysical painting Marcel Duchamp, a leading force in Dada, has often been called a one-man movement. Dada originated before 1920 but it is more convenient to discuss it in relation to Surrealism. Metaphysical painting (Pittura Metafisica) dates from 1916 when Giorgio de Chirico (1888-1978), perhaps the greatest single non-Surrealist influence on Surrealist painting, met Carlo Carrà (1881-1966) in the military hospital at Ferrara.

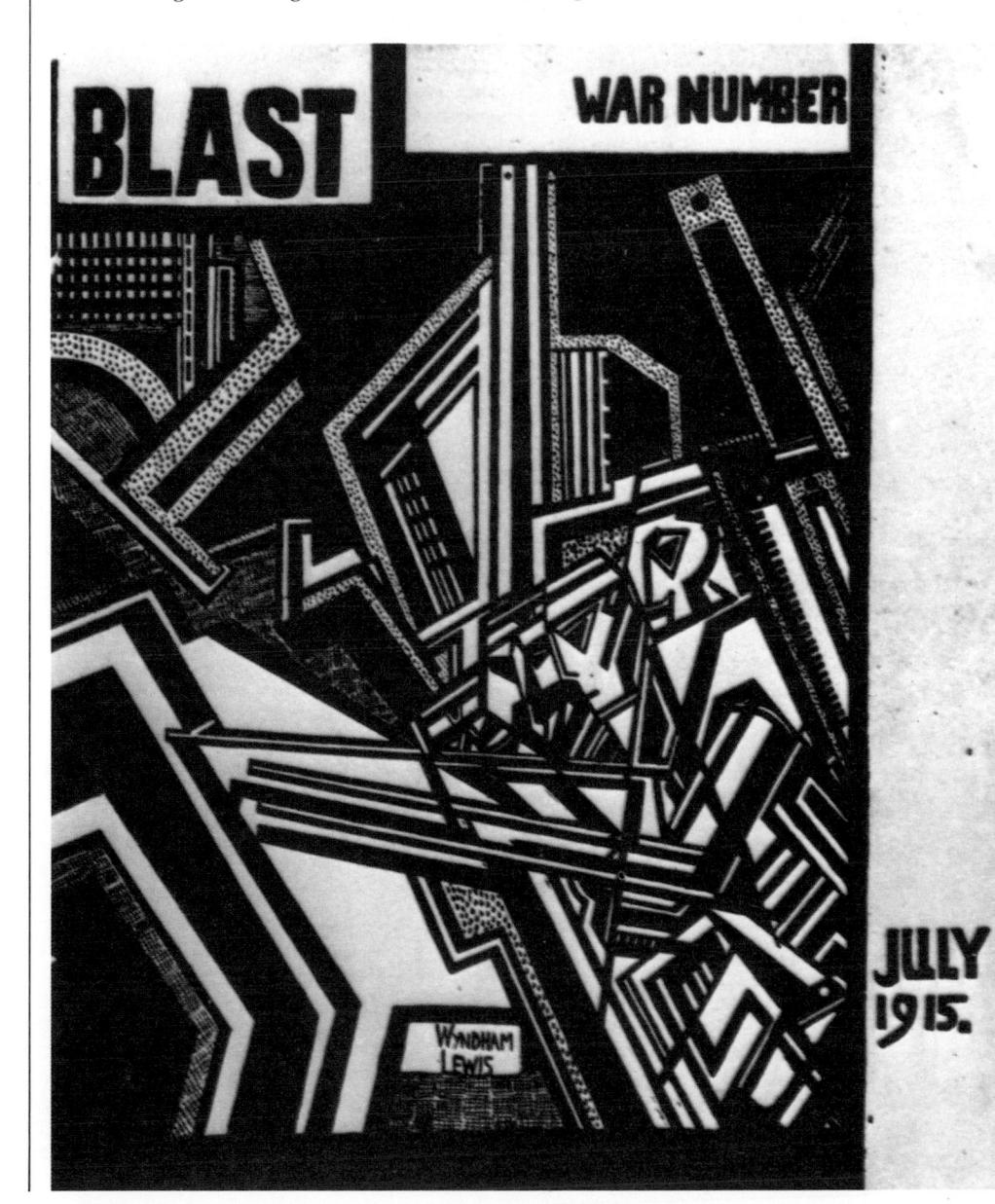

LEFT Wyndham Lewis's cover for the second and last issue of the Vorticists' magazine Blast!, which he edited. Stimulated partly by exhibitions of Italian Futurists in 1912 and 1913, and the personal appearance of Marinetti in London, the British Vorticist movement was short-lived. Its name came from a statement of Boccioni, that all artistic creation must originate in an emotional vortex.

Still Life: Apples, Bottle and Chairback (1902-1906)
Pencil and watercolour
44.3cm x 59cm/17½in x 23¼in

Cézanne's painting provides a link, possibly the most vital link, between the naturalism of the nineteenth century and the conceptualism of the twentieth. Largely because his work pointed in the direction of Cubism and, in the opinion of some observers, in the direction of Abstraction, Cézanne has earned the title 'the father of modern painting'

father of modern painting'. Cézanne was born at Aix-en-Provence in 1839, the son of a local banker. He was the schoolfriend of the novelist Emile Zola (1840-1902) and in 1861 he went to Paris to study painting. Influenced by Delacroix, Honoré Daumier (1808-1879), Courbet and Edouard Manet (1833-1883), Cézanne's early paintings in oil, unlike his late works, are often dark in colour, and violent in both subject matter and the handling of paint which he plastered on thickly. It was not until the 1870s that he began to find his own direction. In 1872 he joined Camille Pissarro (1830-1903) at Pontoise, later moving to Auvers. Here he learnt the principles and practices of the Impressionists, aided by Pissarro, although he applied them to different ends. Above all, he learnt the importance of pure colour and the study of nature. He later remarked that the Louvre was 'a good book but only a means to an end' and that he wished to 'do Poussin over again after nature'. Nature was the obsession and the key.

Dissatisfied with the fleeting atmospheric effects of the Impressionists, Cézanne was interested in rendering the volume and the solidity of objects, using planes translated into colour. This feeling for form expressed in his work and in his much quoted advice to see objects in nature in terms of 'the cone, the cylinder and the sphere' was matched by an equally strong sense of the structure of the painting itself.

Cézanne passed much of his life working in isolation at Aix-en-Provence. Although he was moderately successful in his lifetime, it was a retrospective exhibition held in Paris in 1907 which had a profound, immediate and lasting impact. In the first place, it influenced Picasso and Braque who were struggling to work out a way of painting which would represent visible reality in a new way, namely Cubism. Secondly, Matisse was very interested in Cézanne; he purchased *Three Bathers* (1879-1882) which was to remain a long-lasting inspiration to him.

Cézanne worked mainly in oil on canvas or in watercolour on paper. For Cézanne, the spontaneity required by the medium of watercolour seemed at first to be a relaxation from producing works in oil, what he considered the painter's great vocational responsibility: 'The picture is not going badly but the days seem long,' he wrote to Zola on 30 June 1866. 'I must buy a box of watercolours so that I can paint when I am not working on my picture.' Lionello Venturi ends his book on

Cézanne watercolours, Cézanne: Son Art, Son Oeuvre (1936), with the words 'And to those who love Cézanne, his watercolours are the dearest creations of his imagination.' In them the artist is caught at his most intimate.

'To read nature is to see it, as if through a veil, in terms of an interpretation in patches of colour following one another according to a law of harmony. These major hues are thus analyzed through modulations. Painting is classifying one's sensations of colour,' Cézanne wrote at about the time he painted Still Life: Apples, Bottle and Chairback.

This work belongs to the artist's last and mature period. The subject, a still life with apples, was a favourite one; although, paradoxically, the specific subject was probably of little importance to Cézanne, despite his obsession with nature. The still life was painted at the beginning of the twentieth century which has witnessed a great exploration of the visual and emotional effects of colour. Cézanne's sense of colour was impeccable and often discreet, but in this particularly rich painting the two primary colours, blue and red, are used with boldness. A distinctive technique of Cézanne's, which was considered a daring innovation at the time, was leaving part of the paper blank: here, the warm-toned paper indicating those areas of the apples which catch the most light. In this way the artist suggests volume while representing light. Such a device was part of Cézanne's struggle to break away from what he considered to be the insubstantial atmospheric effects of the Impressionists.

The picture exemplifies another important aspect of Cézanne's vision, style and technique. When the viewer tries to join up the right and lefthand rims of the apple bowl, he or she discovers that Cézanne has been looking at and rendering the scene in front of him from more than one angle, thereby breaking with the typically monocular vision of Renaissance perspective. More important, this shifting of viewpoint may be seen as a step in the direction of Cubism.

The brushstrokes vary in size more considerably than in Cézanne's oil paintings. The marks which complement and emphasize the pencil contour round the apples are literally drawn with a brush – a small sable brush or perhaps the tip of a large one. Cézanne did not lay on washes successively covering whole areas of the paper. He placed large and small planes of pure colour in a manner that keeps the forms open. The transparent watercolour has been laid on in a way that keeps the whole pictorial architecture in a state of pleasurable continuity.

The painting is, as it were, complete at every stage. Aware of the potency of suggestion, Cézanne always stopped long before the paper looked overworked.

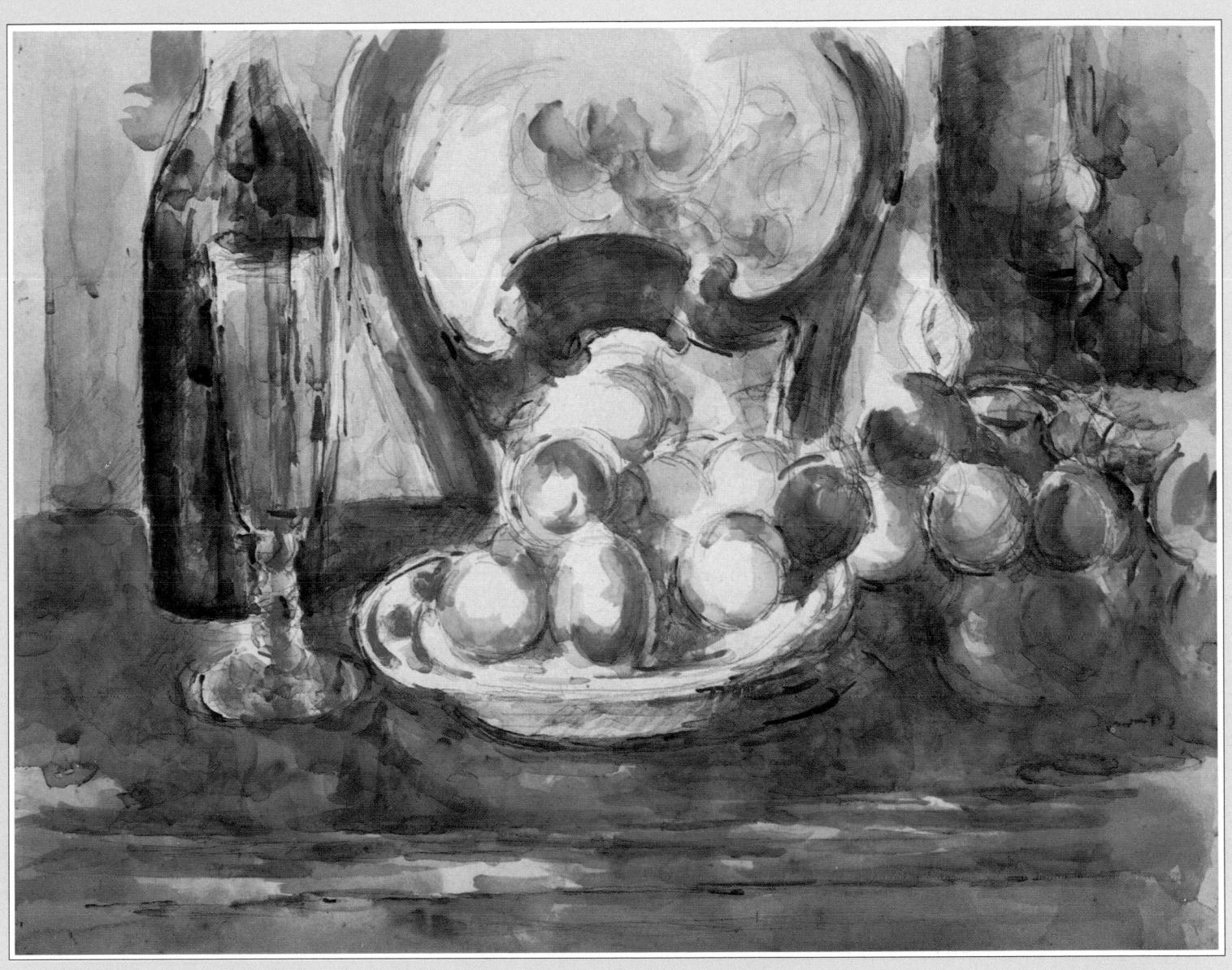

Criss-crossed red strokes suggesting reflection

Spatially ambiguous triangle

Left to right pencil hatching

Dab of green 'taken over' from the same colour area to the right

Unfilled-in central area, revealing paper surface

. Fruit forms echoed in the table surface

Three black 'form asserting' lines

Cézanne's scrupulous but exciting sense of design, his obsession with the relation between forms on a flat surface and in the round, produces in this late work a remarkable confrontation between the swirls and flurries of pencil marks, the painstakingly worked translucent touches of watercolour, and the gaps, cracks and open spaces between these two modes.

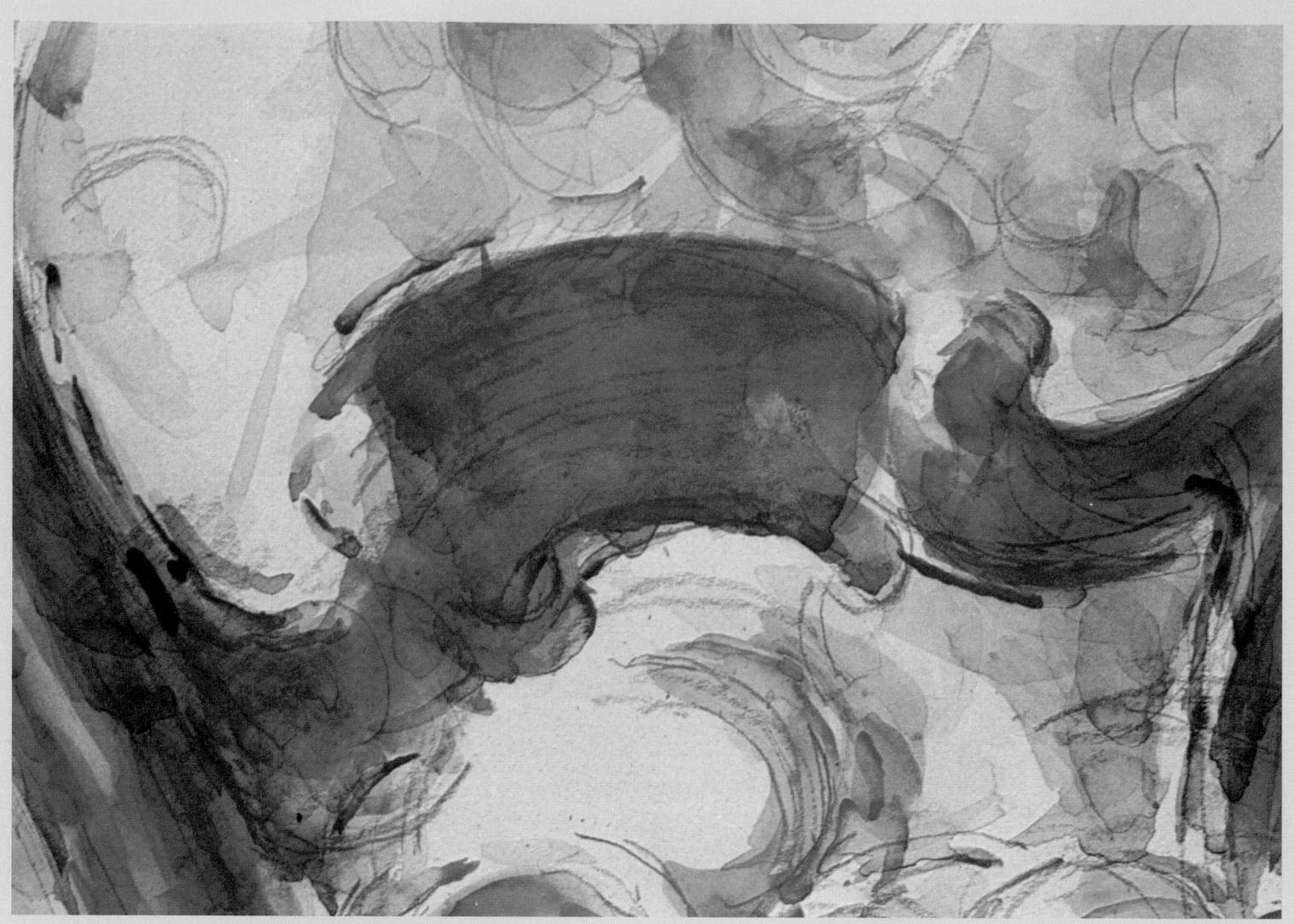

ACTUAL SIZE DETAIL
Cézanne focused on the
central area of interest
in this composition with
intensity. The sinuous
forms in the chair are
pursued in a series of
loosely parallel
curvilinear pencil lines,
while a flux of marks
and colour dabs echo
these in the space on
either side of the
wooden frame.

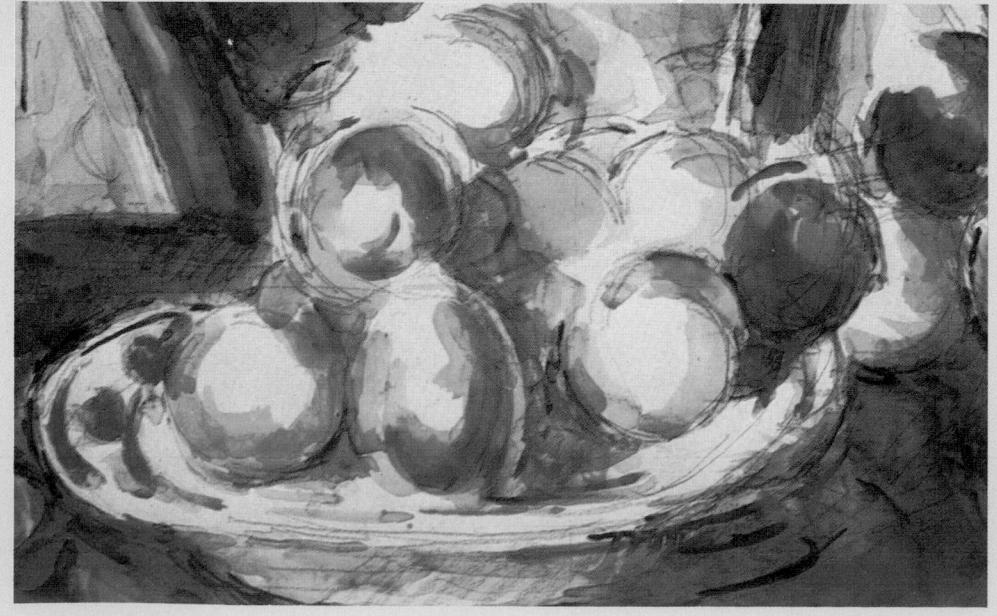

LEFT The treatment of the bowl of fruit itself illustrates the effectiveness of Cézanne's technique of incompletion'. The pattern of the bowl is initiated on the left, but relinquished as the angle of vision makes only the lip visible, and hides the rim. The apples, too, are in various states of finish, their forms exhilarated by the penumbra of ghosting pencil curves.

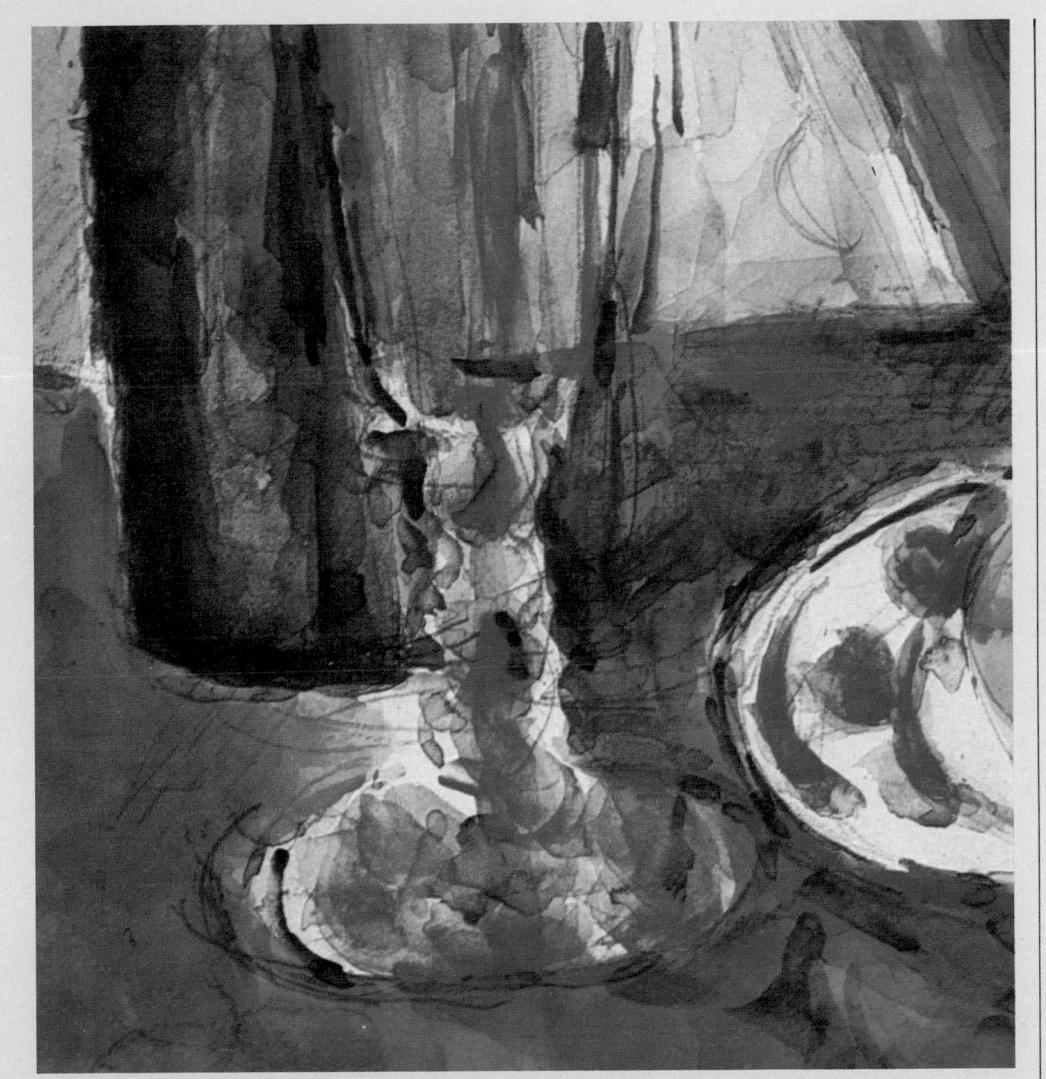

LEFT More intense than the reflections on wood, and on the fruit, the sheen of bottle and glass is worked up in vertically aligned brushstrokes which hug the contours of the two containers and which oppose the diagonal and horizontal pencilling. Particularly effective is the discrete treatment of the globes of glass in the stem with appropriate knobs and curls of watercolour, which fan out below to produce the shallow disc-like base. There is especially intense working in the area of sputial uncertainty between the edges of the glass, bottle, chair and dish.

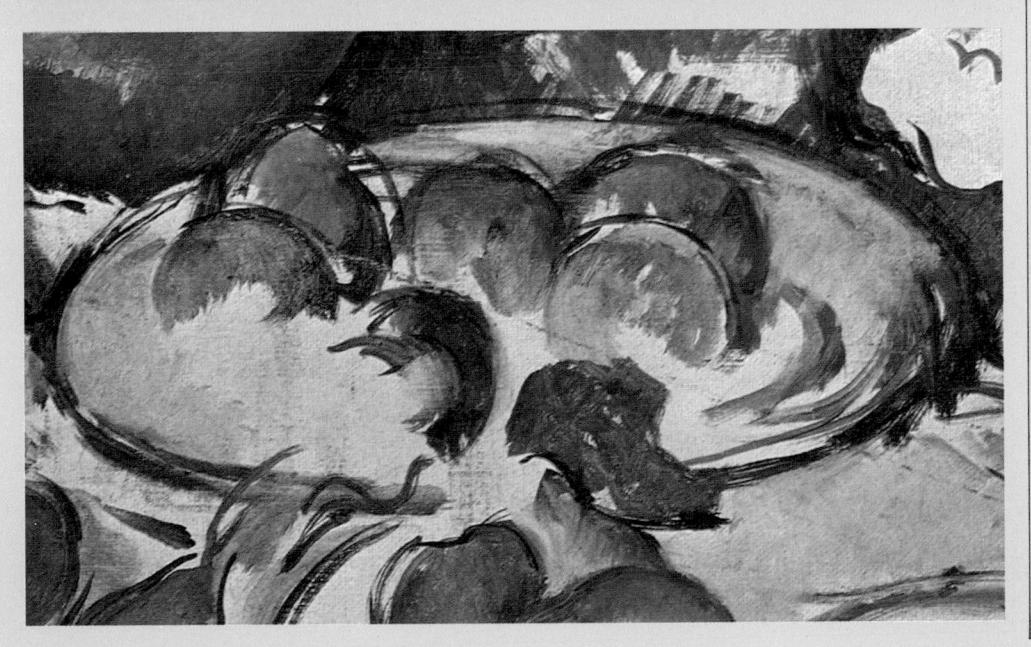

treatment of a similar subject in oil paint reveals an exaggeration of many of the effects handled with such delicacy of touch in the watercolour. The material thickness of the oil imparts a greater sense of volume to the apples but at the cost of a luminous colour range and the substitution of bolder painted black lines for the animated buzz of pencil marks.

Andre Derain

The Pool of London (1906)
Oil on canvas
65.7cm x 99.1cm/26in x 39in

With Matisse and Vlaminck, André Derain was one of the three prime movers of the loose group of Parisian artists who became known as the Fauves ('wild beasts'). The high moment of Fauvism was during the years 1905 and 1906; a period which saw exhibitions at the Salon d'Automne and the Salon des Indépendants and, also, the crucial collaboration between Matisse and Derain at Collioure on the French south coast in the summer of 1906. While Matisse has been celebrated as one of the foremost artists of the twentieth century, his work often seems to evade certain of the defining characteristics of Fauvism. Vlaminck, similarly, has been seen as Fauvist more through the impetuous force of his wayward and anarchistic personality than his actual painting. It is therefore to Derain that we should turn for typical Fauvism.

Derain was born in June 1880 at Chatou on the Seine, a few miles to the west of Paris. He was sent to Paris to become an engineer but he was more interested in painting which he had taken up in his middle teens. He drifted in and out of Symbolist circles meeting both writers and painters, including Matisse whom he encountered at the Académie Camillo. Of more immediate significance was a chance meeting with Maurice de Vlaminck in a derailed suburban train. They had a fascinating attraction for one another which spawned an intense collaboration called the School of Chatou. The period 1904 to 1907 was one of animated discussion and experiment among the Fauves who painted in various permutations.

When Derain turned to figure painting in early 1907 the colouristic exuberance of Fauvism was already draining from his work; and while from about 1908 to 1910 he seemed to pursue a sort of classical realism based on an advanced and individual interpretation of Cézanne, thereafter his painting steadily bypassed the innovations of Cubism. His later work, uneven in quality, was painted in the nineteenth-century French academic style.

Both technically and historically Fauvism as a movement, and the work of Derain in particular, may be regarded as a summation of Post-Impressionism. The techniques and triumphs of Seurat, van Gogh, Gauguin and Cézanne were rehearsed and exaggerated by the Fauves in virtuoso displays of the potent expressiveness of oil on canvas. The Neo-Impressionism of Seurat and Signac prompted Matisse's experiments with smallish dabs of pure colour disposed over the whole canvas surface, as well as the 'broken-touch' Fauvism which characterized the earlier work of Derain, Matisse and Braque. Gauguin's 'flatcolour' technique dominated Fauvism from about 1905 to 1906, though many paintings exhibit a combination of these methods (called 'mixed-technique' Fauvism). The influence of Cézanne cut across these divisions to a certain

extent, but when it became pervasive in 1906 to 1907 Fauvism lost its coherence.

Colour and expression monopolized the conversations of the Fauves and filled their pictures: Derain and Matisse debated Vlaminck's injunction to paint 'with pure cobalts, pure vermilions, pure veronese'; Derain wrote to Vlaminck in July 1905 of his 'new conception of light consisting of this: the negation of shadows', of the need to 'eradicate everything involved with the division of tones', and of his new concern with 'things which owe their expression to deliberate disharmonies'.

Painted during Derain's second visit to London in 1906, *The Pool of London* was 'one of the high points of his Fauve career', according to art historian John Elderfield. The whole series of his London works manifests a considerable variety of techniques and subject matters, ranging from the Divisionist-derived pyrotechnic display in *Big Ben* (1905), to the suave almost anecdotal whimsy of *Hyde Park* (1906), the vigorous bustle of *Regent Street* (1906) and the more loosely brushed 'mixed-technique' of *Charing Cross Bridge* (1906) with its complementary paint flecks in the water and diluted colour patches in the sky.

The Pool of London shares with many of the London paintings, including three of those mentioned above, the same horizontal dimension, 99.1 cm (39 in); the vertical measures 65.7 cm (26 in). The slight lateral emphasis promotes Derain's interest in wide-angled effects and accentuates the bold, diagonal intrusion of the carrier boat from the bottom right into the centre of the work; it was a formal device which he exploited frequently in opposition to well-managed up and down lines, and to subtly disposed subsidiary diagonals.

As often with the Fauves, the employment of certain techniques of paint application is directed by recognizable contingencies of subject matter. The surface of the water, for example, with its natural tendency to scatter and reflect light becomes the main arena for broken touches and dabs of greens and yellows, while the complexity of equipment and cargo on the boat suggests a more block-like mosaic patterning of bright, pure hues.

Elsewhere, variously shaped patches of colour are spread fairly evenly to define continuous surfaces such as the sides of the main vessel and portions of the barges and tugs which surround it. Colour intensity is focused on the foreground areas, and the lefthand and top margins of the canvas are more loosely brushed in paler, vibrant shades. This murkiness of the distant scene is promoted, naturalistically and symbolically, by smoke rising in three places in the upper third of the work. Dominating the whole is the potent clash between sharp reds and deep blues which in many ways was the essential colouristic contribution of the Fauvist enterprise.

ANDRE DERAIN

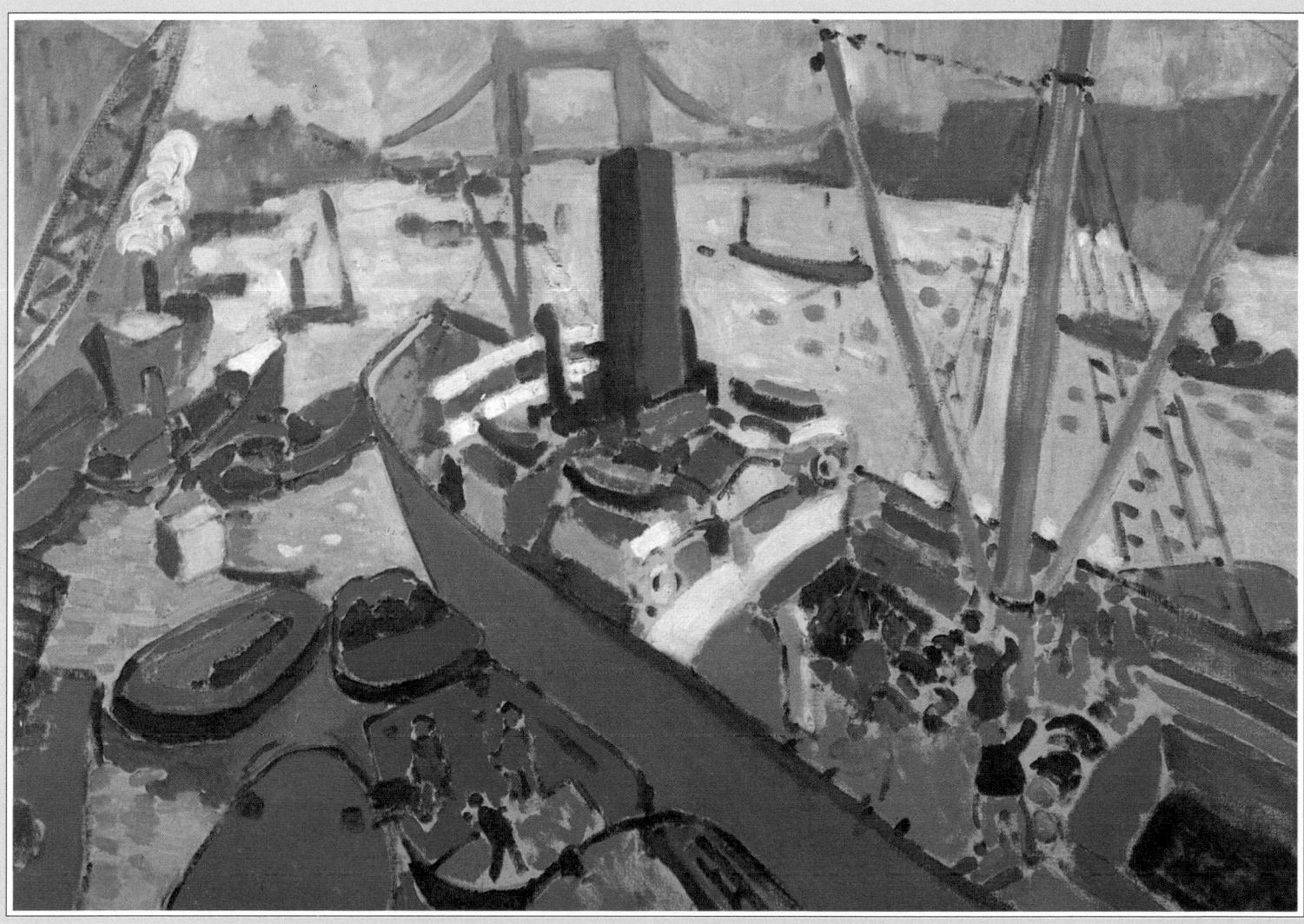

Smoke plume with scrubby multi-directional brushstrokes

Sparsely brushed band of colour in the dominant red/blue opposition

Violet graded in intensity along the side of the ship

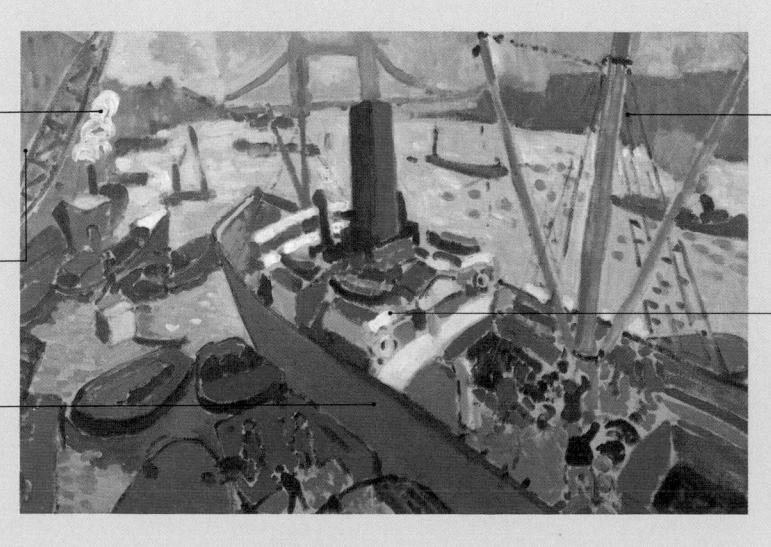

Overtones of vermilion red accentuate the lines of the rigging

Furrows of lead white contain and offset the tessellation of colour blocks around the central funnel

Derain's The Pool of London (1906) exemplifies the chromatic exuberance which is the defining characteristic of Fauvist painting. Shape, volume, depth and design are subordinated to the foreground of complementary colour patches. Ample flashes of the white ground indicate the typical Fauvist combination of haste, accident and control from which the compositional shape of the work evolves. More than with Cézanne's 'constructive' brushstroke or the Neo-Impressionist colour spot, our attention is arrested by the variety of individual paint marks and the vibrancy with which they cohere and collide over the canvas surface.

ANDRE DERAIN

RIGHT Monet's The Houses of Parliament (1903) is an exploration of atmospheric conditions in paint. The canvas has a kind of 'all-over' unity of paint application not sought by the Fauves in most of their works. Monet has blended, smudged and slurred his paint touches to present a pale, nuanced surface in which forms are dissolved by the remorseless saturation of light as well as by the intervention of patchy fog. The colours are muted and often worked up in layers inch by inch, to produce complex tonal of atmospheric produce complex tonal gradations.

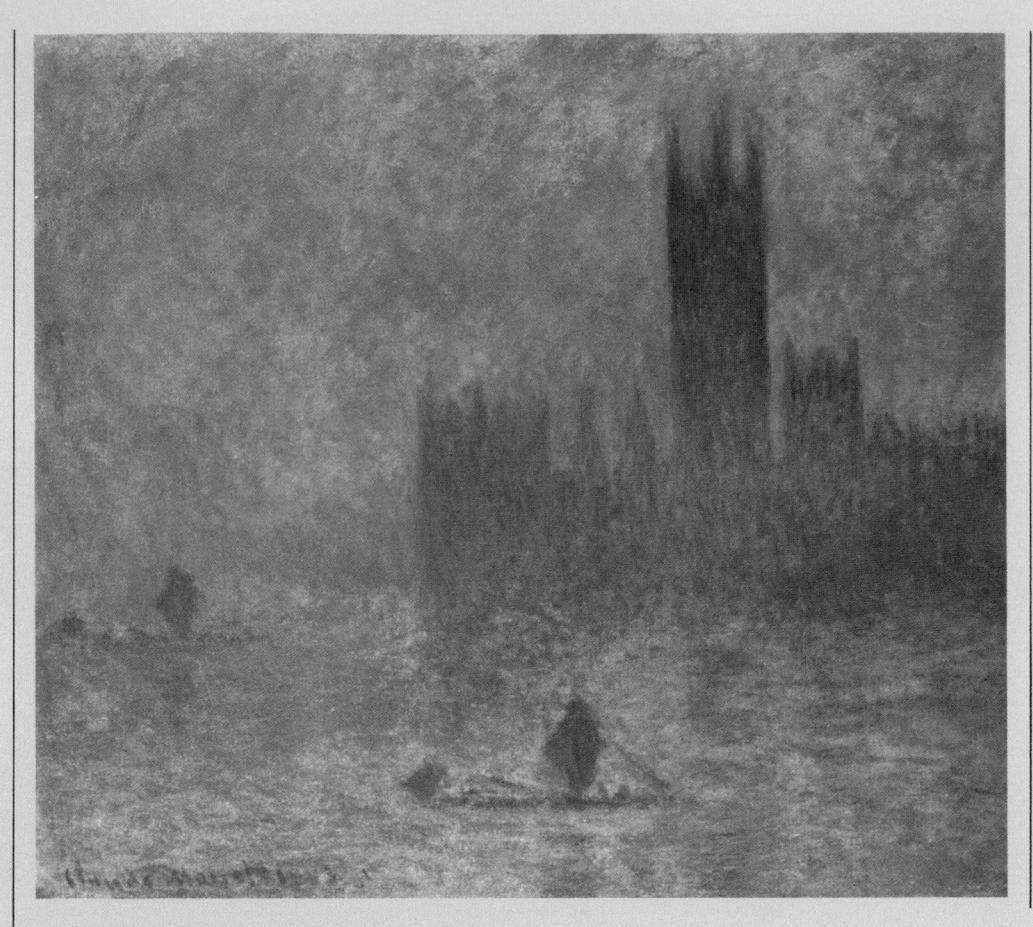

ACTUAL SIZE DETAIL
This striking
detail illustrates the
tension between
figurative and coloristic
impulses. Brushstrokes
are remarkably thinned
and unladen for Derain;
there are random
impasto ridges, and
only a small proportion
of the painted areas in
this detail indicate the
direction of brush
movements. The
pinhead nodes of the
canvas weave are
almost constantly
visible. Virtually the
full spectrum of
Derain's palette is
employed here, mostly
in discrete patches, as if
in response to the
naturalistic complexity
of at least five men
striking attitudes of
work amid a welter of
deck machinery and
items of cargo.

RIGHT Derain has worked up effects of distance at the top extremity of his composition, featuring the symbolic geometry of Tower Bridge, through the skilful dilution of viridian green in a succession of pale and creamy 'subtones' vigorously brushed, and, in general, less yellow with distance. In addition, certain of the more structural concerns of the artist can be appreciated in the calculated vertical alignment of the central funnel and the right bridge turret, and the prow masts and the left turret, the subsidiary mast striking a complementary angle to the bridge support.

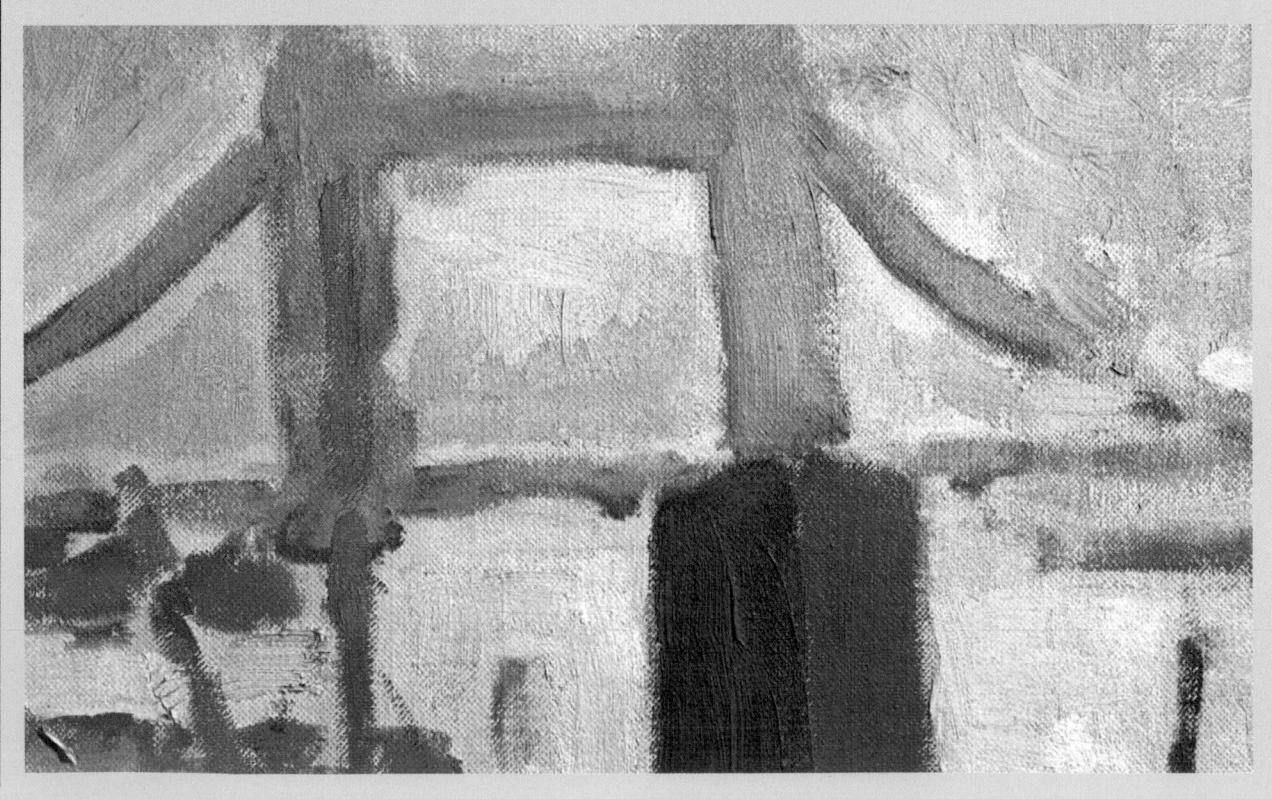

ANDRE DERAIN

The Dream (1910)
Oil on canvas
204.5cm x 299cm/79½in x 117¾in

The Dream was one of Henri Rousseau's last paintings, and certainly the last he sent for exhibition. The final months of his life were marred by an unrequited love affair. He had fallen in love with a woman 12 years his junior, the daughter of one of his former colleagues and she did not return his affection. It has been proposed that the subject matter of The Dream, a naked woman stretching out her hand, reflects the confused emotional state which Rousseau was suffering at the time. However, all the elements in the painting can be discovered in works of previous years. When it was sent for exhibition in March 1910, a poem was attached to its frame: 'Yadwigha in a beautiful dream/While sleeping peacefully,/Heard the notes of a pipe/Played by a thoughtful snake charmer./While the moon casts its light/On the flowers and verdant trees/The wild snakes listen/To the gay tunes of the instrument.

Rousseau was born in Laval in 1844, the fourth child of a tinsmith, and as a youth he won prizes at school for both art and music. Because his family was poor, he was unable to attend an art school; he worked as a solicitor's clerk and also joined the army. His main career was that of a second-class toll-collector in the Municipal Customs Service in Paris. Determined to become a professional artist, Rousseau retired in 1885 on a tiny pension and set himself a disciplined course of action. Selftaught, he drew and painted 'alone with only nature as a teacher and some advice received from Gérôme, and Clément.' Clément (1826-1888) was an academic painter, director of Fine Arts at the Ecole de Lyon, who exhibited at the official French Salon, and who introduced Rousseau to his colleagues - Gérôme (1826-1904), Cabanel (1823-1889) and Bouguereau (1825-1905). Gérôme, an important teacher at the Ecole des Beaux-Arts, upheld the value of technical ability of the highest standard, and exhorted his students to render exactly and clearly even the smallest details in their canvases.Brushmarks were not to be apparent.

Rousseau believed Egyptian art was supreme. He is reported to have told Picasso 'We are the two great painters of the age, you in the Egyptian style, I in the modern style', which must have accorded some kind of compliment towards Picasso's art. He thought less of Cézanne, venturing the memorable comment at the 1907 Cézanne memorial exhibition – 'You know, I could have finished all these pictures.'

Finish is most certainly one of the qualities of *The Dream*. A painting of this scale would have taken Rousseau up to three months to execute, and he is known to have worked in his studio seven days a week, from morning till night. He always began at the top of his canvas, and slowly and carefully worked his way down to the bottom. Ardengo Soffici

(1879-1964), an Italian painter who watched him paint and who wrote an article about his work in 1910, recalled how Rousseau would work with one colour at a time and fill in all those areas where he wished it to occur, and only then would he turn to the next colour. Usually he began with the greens: there are over 50 variations of green alone in *The Dream*, which indicates the application needed to produce such a large work.

Judging from a photograph which shows him at work on a canvas of 1909, The Muse Inspiring the Poet, Rousseau completed the background foliage before he began on the two figures in that work. The area they were to occupy was simply drawn in, probably with a paint brush, with only their smooth external contours evident, and it is quite probable that he adopted the same method for The Dream. The naked woman and the sofa have a hard edge and give the impression of being a cutout, so much do they stand out from the rest of the composition. The strong contrast in tonal values between the light flesh of the nude and the dark red of the sofa help to create this impression - they are also reminiscent of the stark tonal contrasts in Edouard Manet's Olympia (1863). Rousseau gave this explanation: 'The sleeping woman on the sofa dreams that she is transported into the forest, hearing the music of the snake charmer. This explains why the sofa is in the picture."

Certainly, the positioning of the sofa with its sensuous passenger near the edge of the canvas and behind a somewhat *coulisse*-like plane of dense luxuriant foliage, gives a slight impression of a theatrical tableau or stage set. Invisible and silent stage hands have just sidled the sofa into the picture.

However dreamlike or theatrical the painting may appear, its motifs are taken from life. Rousseau liked to refer to his paintings with dense luxuriant foliage populated by wild beasts and brightly coloured birds as his 'Mexican' pictures, and he initiated a legend about spending part of his army service in Mexico. But the luxuriant foliage was the result of many hours spent studying exotic plants in the conservatories of the Jardin des Plantes in Paris, and most of the animals and birds were directly observed at the zoo.

Only Yadwigha is new, and it is impossible to say whether a real-life nude model was the source, or a photograph or print in a popular journal, material from which Rousseau regularly drew inspiration. Rousseau told critic André Salmon that 'The sofa is there only because of its glowing red colour.' Thus the painter offered two reasons for the inclusion of the sofa, one lyrical and the other formal.

In *The Dream* Rousseau contrives a magical balance between form and content, between complementary colours, and between detail and the evenness in the composition.

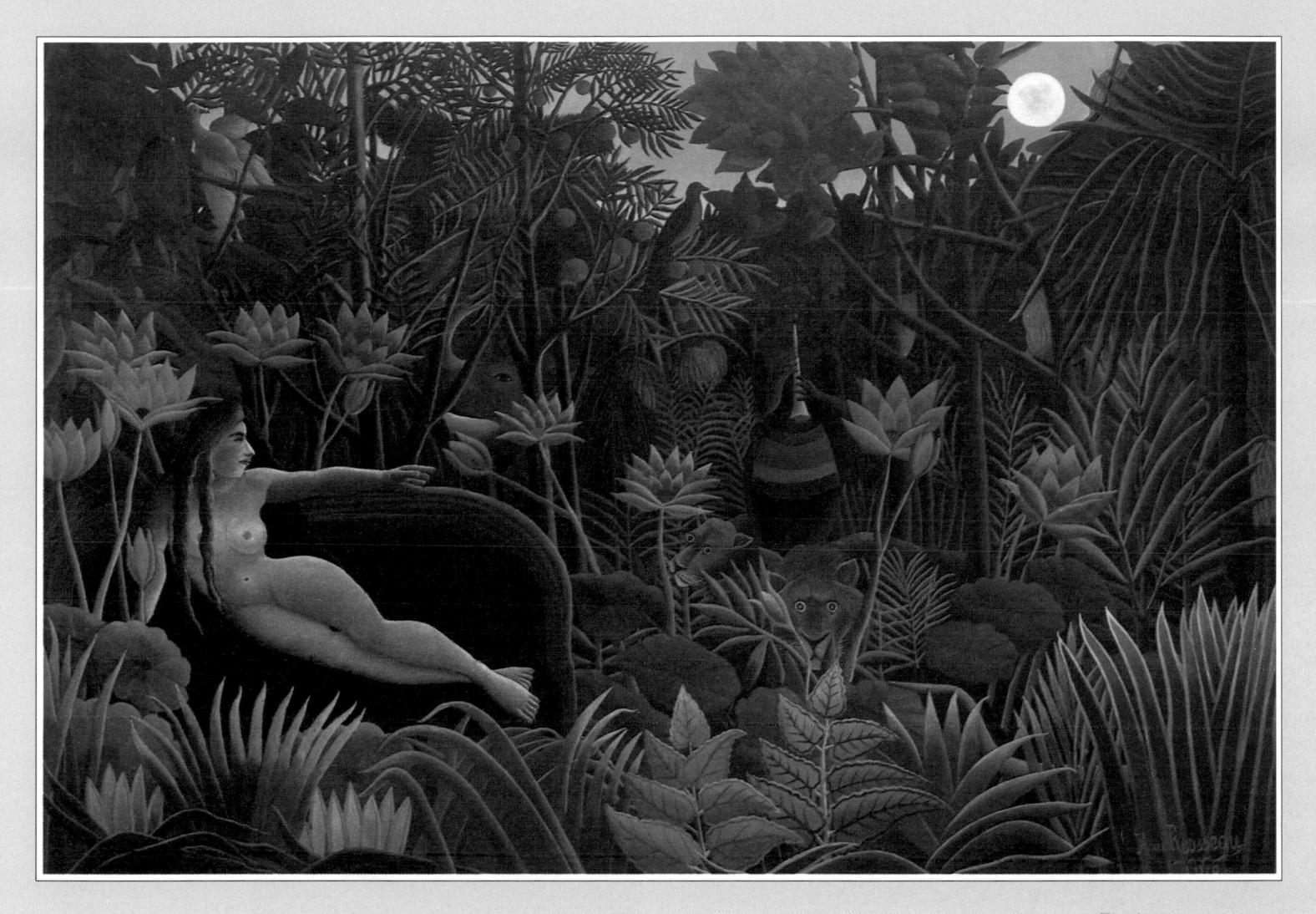

The first example of Rousseau's use of exotic subject matter was his Storm in the Jungle of 1891. The Dream, the largest of all his exotic 'Mexican' works, was the culmination of this series. The composition contains elements which had appeared before on their own.

Sofa no longer 'glowing red', due to fugitive quality of the red pigment used

Area of maximum tonal opposition which serves to highlight the nude figure

Line visible showing alteration in lower contour of right leg

Pink waterlily-like flower painted on top of green plant, a variant on Rousseau's usual method of working

Pure black used for snake; Gauguin admired Rousseau for his use of blacks

RIGHT White is mixed with the fleshtones to produce an area of reflected moonlight on the lower thigh; it is applied unmixed as a single brushstroke line along her profile.

BELOW These leaves are given a flat coat of paint, the colour having been mixed in quantity on the palette, and the brushmarks are hardly visible.

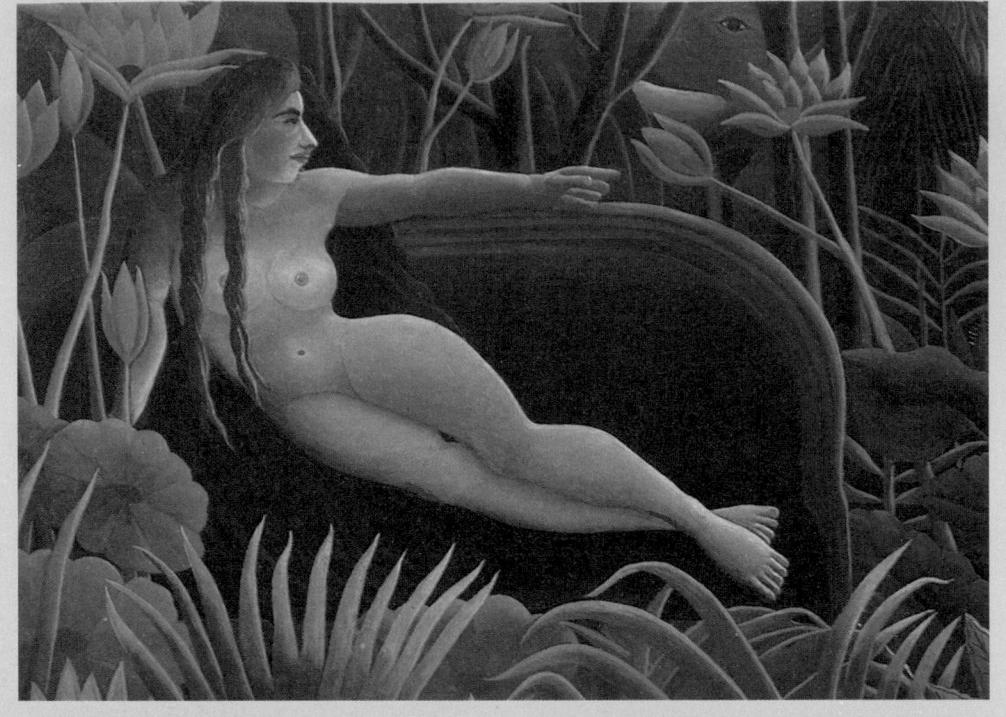

ACTUAL SIZE DETAIL The entire area of the animal's head has first been given a layer of umber mixed with white, then the highlights and shadows have been laid on top. The paint is applied quite thinly, and a sense of volume is built up from the hatched brushstrokes, particularly below the animal's left eye, where the paler ground shows through in part.

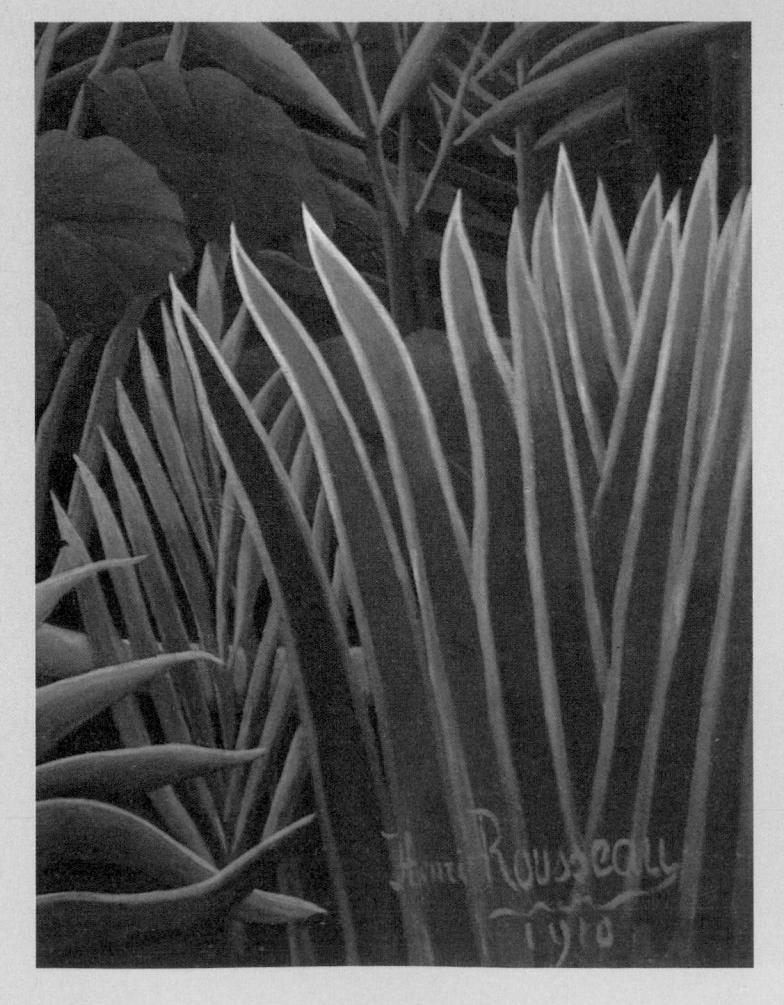

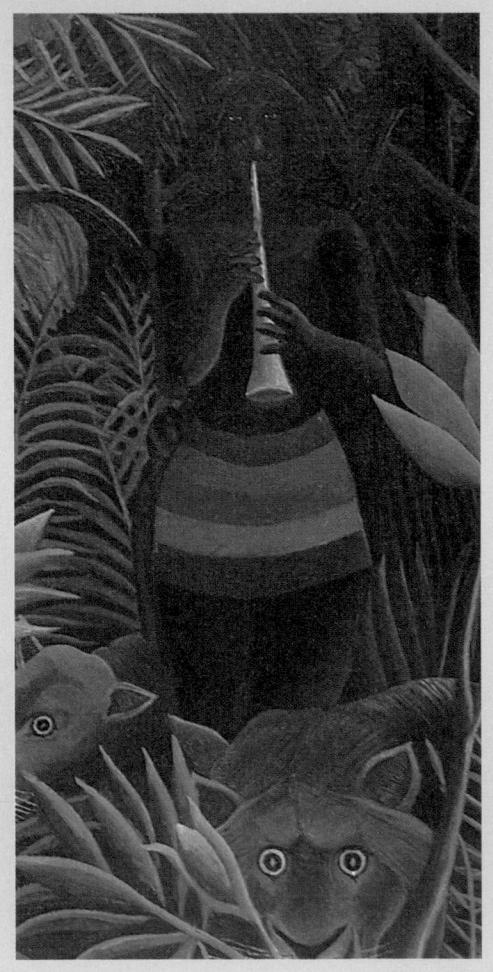

LEFT The snake charmer is brought into prominence by tonal and colouristic contrasts. In a 1907 painting entitled The Snake Charmer Rousseau paints him with only an umber flute as a prop. As if to enrich his presence in The Dream, Rousseau gives him a yellowgreen clarinet and a multi-striped loincloth, the vermilion stripe being the hottest colour note in the whole painting. Although most of the motifs were taken from life or from printed illustrations, that of the snake charmer arose from Rousseau's imagination, sparked by Robert Delaunay's mother's reminiscences of India.

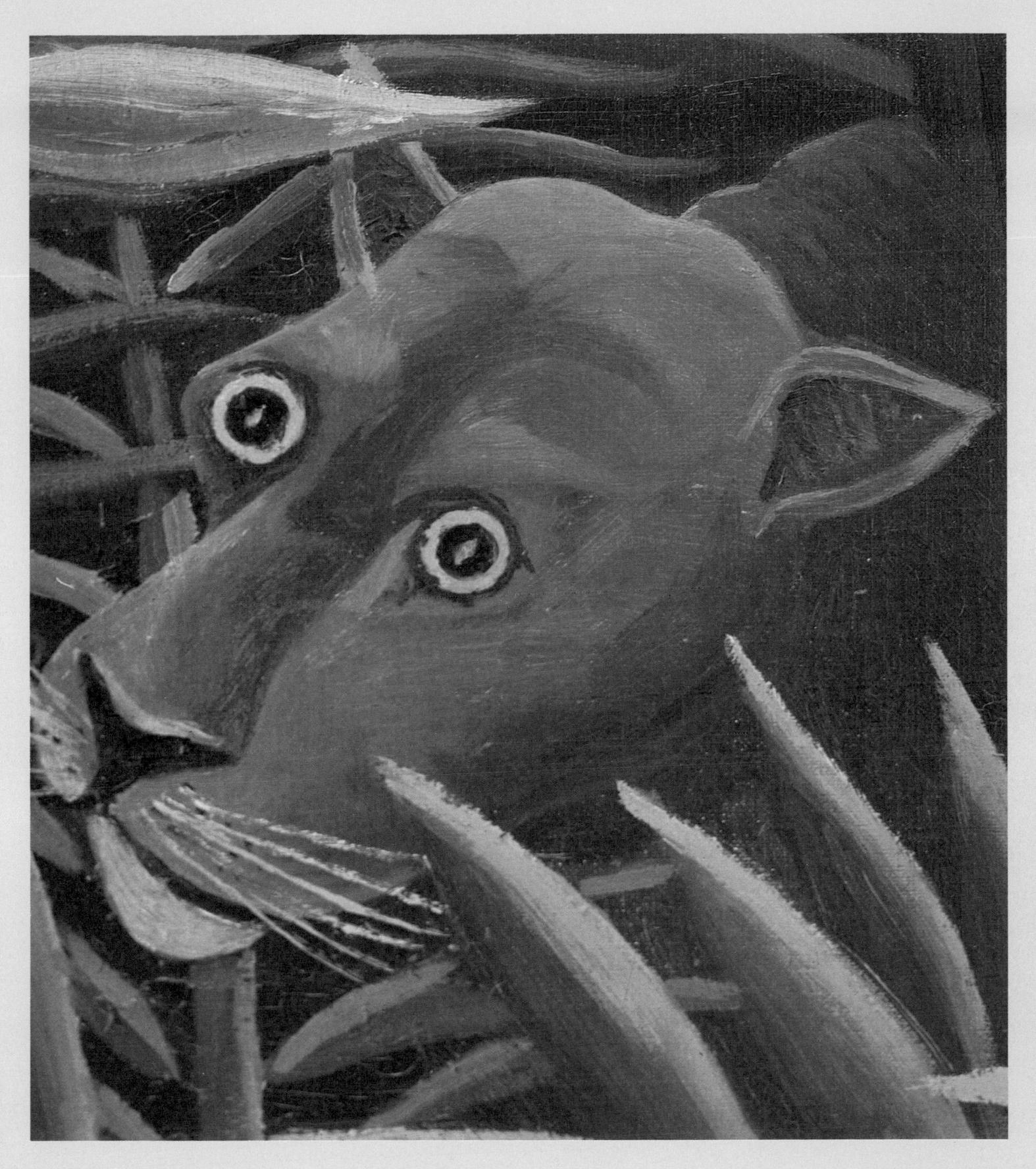

Clarinet and Bottle of Rum on a Mantelpiece (1913)
Oil on canvas
81cm x 60cm/31⁷/₈in x 23⁵/₈in

Georges Braque had not the protean sensibility or the Expressionistic urgency of his friend and colleague Pablo Picasso; yet he may be considered as the most important and innovative painter of still life in this century. His dedication to the 'pictorial fact' led him to explore, more fully perhaps than any other artist, the environment immediate to his practice.

Braque was born in May 1882 at Argenteuil on the Seine near Paris, but his family moved eight years later to Le Havre on the north coast, where his father started a domestic painting business. Braque himself began an apprenticeship in this trade while studying at the Ecole des Beaux-Arts in Le Havre. He established a long friendship with the Dufy brothers, Raoul (1877-1953) and Gaston, at this time. His move to Paris in 1900 was interrupted by military service from 1901 to 1904. Back in the capital, Braque spent the next two years at the Académie Humbert and at the Ecole des Beaux-Arts, often painting with the Le Havrais artists Othon Friesz and Raoul Dufy. In 1906 and 1907 his painting embraced a stylized Fauve manner, before his crucial encounter with Picasso and Picasso's recent painting Les demoiselles d'Avignon in 1907. The history of the association of these two great painters is the early history of Cubism; until 1914 they worked intensely to co-produce the most revolutionary visual style since Renaissance perspective.

Unlike Picasso, for whom the 1920s and 1930s were decades of prolific eclecticism, Braque grafted and consolidated his previous ideas. In the last years of his life (he died in 1963), Braque produced two astonishing series, Ateliers (1948-1955) and Oiseaux (1950-1958); and he was fêted ceremonially as the grand master of French twentieth-century painting. The dominant influences on Braque's early career were Cézanne and Picasso. (Braque's metaphor for his relationship to Picasso at this time is revealing: he spoke of them as roped together like 'mountain climbers'.) Having rejected Impressionism and his own decorative, curvilinear version of Fauvism, Braque moved away from colouristic excess, in pursuit of greater structural coherence across the picture surface.

The impact of Braque's painting on younger generations has, of course, been immense. Juan Gris, Fernand Léger (1881-1955) and the 'Salon Cubists' attempted to imitate, often directly, the Analytic and Synthetic periods of Braque and Picasso. But the stylistic influence of the years 1909 to 1914 became more diffuse.

During the first part of Braque's career – up to 1920 – he worked almost exclusively as a painter and producer of collages. But the formative significance of his early interior decorating work, possibly the major impetus behind the incorporation of pasted paper and other materials on to the canvas surface,

appears to have fuelled his appetite for technical experiment. He tested different materials and processes in periodic bursts of activity, which recurred throughout his later career. In 1920 he produced his first real piece of sculpture, *Standing Nude* in plaster, and woodcuts for *Piége de Mèduse* by the composer Erik Satie (1866-1925).

Braque has been credited with many of the most important technical 'inventions' of Cubism during the movement's early years, 1907 to 1914. He was the first to introduce lettering; to make use of a paint comb; to introduce passages of imitation wood graining and marbling; to vary the texture of paint by mixing with sand and other ingredients, and finally to discover the technique of *papier collé*. During this period Braque's commitment to intense pictorial experiment was considerable.

Clarinet and Bottle of Rum on a Mantelpiece is a fully convincing, mature example of the style of Analytical Cubism which Picasso and Braque developed between 1909 and 1912. Analytic Cubism is so called because of the division (or analysis) of the work's subject (usually still life, as here, or portrait) and the space which surrounds it, into a series of angular planes (or facets), which record various types of information as the motifs are seen from more than one point of view.

There are several phases of Analytical Cubism, and Clarinet and Bottle – almost certainly painted in the summer of 1911 in Cèret in the Pyrenees where both Braque and Picasso were staying – comes in the last and most complex of these, appropriately called 'Hermetic Cubism, where the subject becomes often very hard to identify, but never fully disappears. In this work, for example, the clarinet and glimpses of sheet music can be readily discerned; as well as a nail or pin and its shadow; a variety of 'scroll-like corbets'; and several letters stencilled onto the surface, 'VALSE' being the only complete word.

The canvas used is linen and is of a simple weave. It has been primed in grey primary oil, and worked over with brushstrokes ranging in direction and register. The overall configuration of the objects and the dominant diagonally orientated facet marks were probably mapped on to the canvas first, possibly from a sketch, followed by the versatile 'stippling' technique with the brush, which is typical of works from this period and produces a mottled effect that can act both as a kind of shading device, and a mode of partial colouring in.

Braque's palette is characteristically reduced to white, black, raw sienna, with a touch of lemon and a stroke of red in the bottom right. These pigments are laid on fairly densely in places, with some quite considerable gradients of impasto. As a final touch Braque appears to have added a few slim lines in charcoal, perhaps structural afterthoughts.

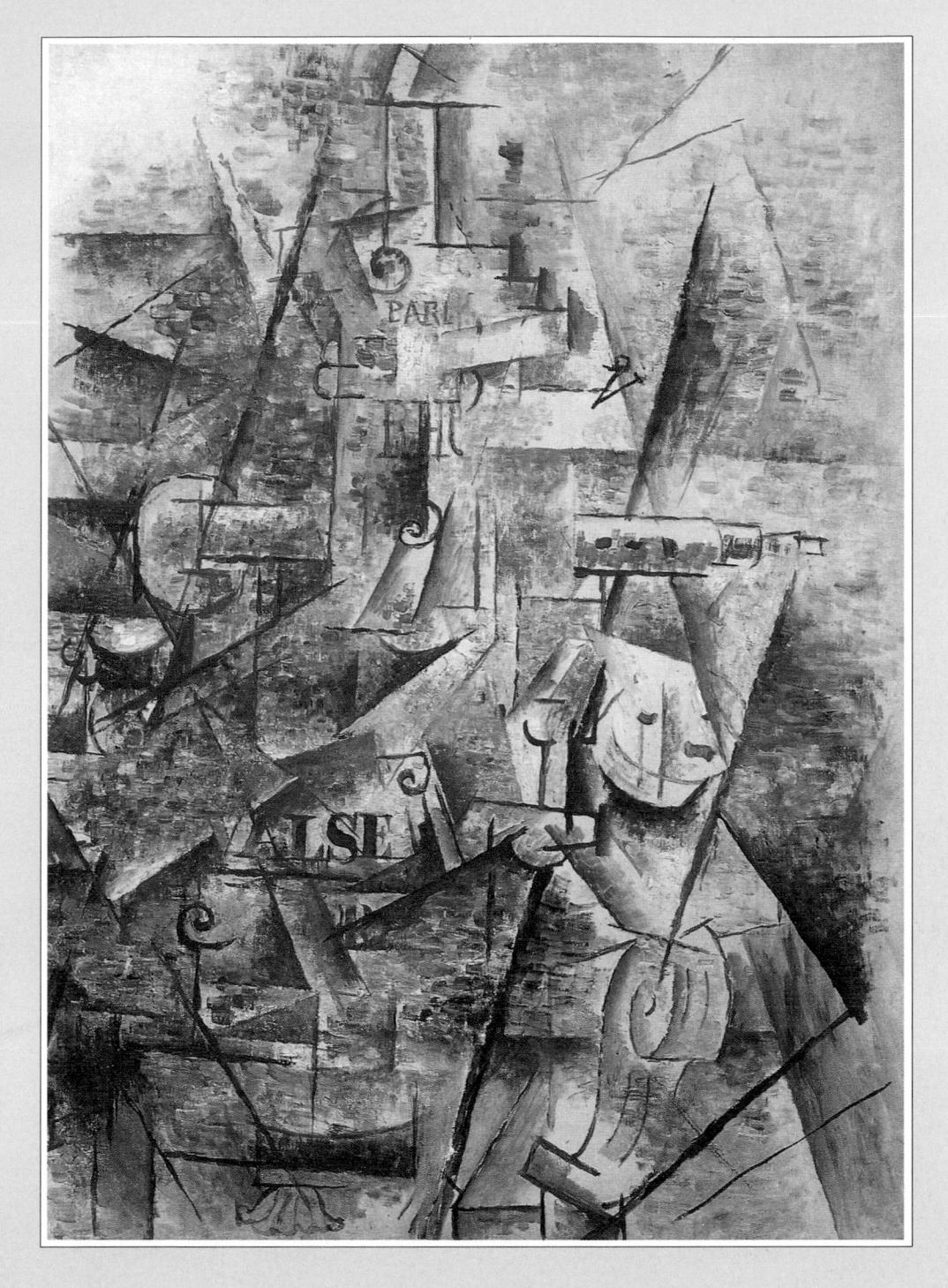

The subject matter here is ostensibly a still life, but, taking his lead from Cézanne, Braque . gives such priority to an abstract and intellectual analysis of the spatial structure of the mantelpiece, clarinet and bottle of rum which is his motif, that both

style and technique are dominated by this informing logic. In comparison with other Analytic Cubist works of the same period Clarinet and Bottle of Rum is less densely worked and its ochre patches flatter and more sparse.

Lettering probably done without stencil

Stencilled lettering RHU(M) — 'rum', the bottle label

Sienna unevenly scumbled over a black/ white slurring

Black 'triangulation' line of varying thickness

Lines deliberately extended beyond the limits of surface areas produce a kind of grid or scaffolding system

Unpainted surface showing ground

Clarinet realistically represented

Stone bracket or corbel probably supporting the mantelpiece

RIGHT This section from the top right extremity illustrates the thinness and uncertainty of touch which often characterizes the peripheries of Cubist compositions. The fragile linear geometry seems on the threshold of dissolving into the canvas priming itself.

VALSE' (waltz) has been written onto the canvas surface, probably using a commercial stencil. This instantly recognizable word is surrounded by a field of merging and intersecting planes with straight, definite boundaries, and framed by two clef-like spirals. There is wealth of minutely adjusted brushwork, often wet on wet, which forms the texture of the planes, but which appears to have no real descriptive reference. Lead white is used effectively to enliven the muted greys and browns. Above and to the left of the 'V' are thick clumps of impasto.

ACTUAL SIZE DETAIL The boldly painted nail with its cast shadow is an obvious but important manifestation of the visual wit and inventiveness of the Cubists. The illusionism of this motif probably inspired the eventual use of real materials in Cubist collage. The implication of a light source may have led to the thickening and blurring of the black boundary line to the right. The lightly brushed line slightly above the beginning of the nail, is discontinuous and irregular, showing that Braque was not interested in flawless geometric precision, but rather in an accurate disposition of lines and marks with an expressive purpose.

Guitar (1913)
Collage (charcoal, wax, crayon, ink and pasted paper)
67cm x 49cm/26½in x 19½in

Pablo Picasso is the most important, most celebrated and the most productive artist of the twentieth century. He was born in October 1881 at Malaga in southern Spain and began to draw and paint when he was only seven years old, under the eye of his father, Don José Ruiz, a teacher of painting. During the late 1890s Picasso studied and painted in Barcelona. In 1900 he made his first visit to Paris, and for the next few years commuted between Paris, Madrid and Barcelona.

By 1901, the beginning of his so-called 'Blue Period', Picasso's work had become fully convincing and mature and from 1904 he was established in the Bateau Lavoir area of Montmartre and consorted with the leaders of the Parisian avant-garde. For the next two decades, Picasso was the driving force of the visual avant-garde. He exhibited, for example, in the first Surrealist exhibition at the Gallery Pierre in Paris in 1925, but was never fully comfortable with the spirit and aims of Surrealism. Instead his work manifests a remarkable stylistic originality, whether in the naturalistic portraits he painted after the First World War, in the Neo-Classicism of the early 1920s or in the savage pictures of women, which preoccupied him in the early 1930s.

From about 1940, however, while there is constant vigour and renewal, Picasso's extraordinary capacity as a draughtsman, together with his uncanny talent for convincing formal experiment and his life-long resistance to fully abstract tendencies, had become the core of his contribution to modern art. But the majority of his technical excursions postdate Picasso's most revolutionary visual achievement – the Cubism he created with Georges Braque. But as art historian Pierre Daix put it, 'He forged an immense critical vocabulary out of the whole heritage that Classical art had rejected: pre-Hellenic and pre-Roman art from the Mediterranean, medieval, African and South Sea Island [art]. Of the recent Post-Impressionists he only borrowed consistently from Cézanne."

The innovations in form and style perpetrated by Cubism changed in proportion, as the technical pressure which fragmented and faceted the canvas surface became too great for oil on canvas alone. 'I want to get to the stage where nobody can tell how a picture of mine is done,' Picasso commented in 1923. 'What's the point of that? Simply that I want nothing but emotion given off by it.'

Collage, developed in the period of Synthetic Cubism (c 1912 to 1914), is the incorporation of ready-made objects and images into the picture plane. Papier collé is a variety of collage and specifies the addition of 'pasted paper'.

Picasso's *Still Life with Chair Caning* (May? 1912) was probably the first collage by virtue of the piece of oil cloth glued to the surface. But

Braque seems to have initiated *papier collé* in early September 1912. Typically, Picasso immediately took up the new idea with gusto and his most intense period of work in *papier collé* lasted until May 1913 while he was in a studio in the boulevard Raspail, Paris. His early efforts (for example, *Man with a Hat* [1912-1913]) were more severe than *Guitar*, often on a white or off-white ground, with quite heavy charcoal outlines and a minimum of collage.

Guitar dates from the Spring of 1913 and has been described as one of the most majestic and sumptuous of Picasso's papiers collés. His way of working for these compositions appears to have been based on preliminary drawings. There is a photograph of Picasso's studio, showing numbered drawing schemes for forthcoming papiers collés; one sketch relates closely to the finished Violin (1912-1913), and indicates that Picasso predetermined his outline and then sought appropriate shapes and textures with which to amplify the design.

The procedure for *Guitar* appears to have been slightly different, but is analogous. Here the black charcoal lines were probably the first marks on the translucent blue paper. Some of these would have been masked off by the pasted paper strips, then reinstated with a white wax crayon, probably the last medium to be used. These white lines also produce new structural suggestions towards the edges of the composition.

The material units of this work can be isolated: a roughly edged rectangle of blue transparent paper; a series of black charcoal lines; two approximately equal rectangles of black ink; pasted paper, and a series of white wax crayon lines. The pasted papers can be further divided into categories: two areas decorated with an acanthus-like pattern; five various shapes of ivory-coloured paper with an intermittent square based geometrical design; a sharply white area, sensitively edged with charcoal; an ochre-coloured area more boldly edged; and three pieces of newspaper. Two constitute the front page of the Barcelona *El Diluvo*, the third stands for the guitar's sound hole.

Listed in such a way these elements seem banal, but the two skills which animate them selection and arrangement - are uniquely synthesized and encourage a volume of speculation on the significance of the finished composition. Picasso had the ability to build humour and irony into his work and he delighted in turning a blind eye to even the most far fetched of these speculations. In Guitar the rhythmical oppositions between the 'male' and 'female' elements of the instrument are managed with wit and dexterity. But there is possibly a more wicked humour in a newspaper fragment that includes notices for two medical practitioners, Dr Casasa, a specialist in venereal diseases, and Dr Dolcet, an oculist!

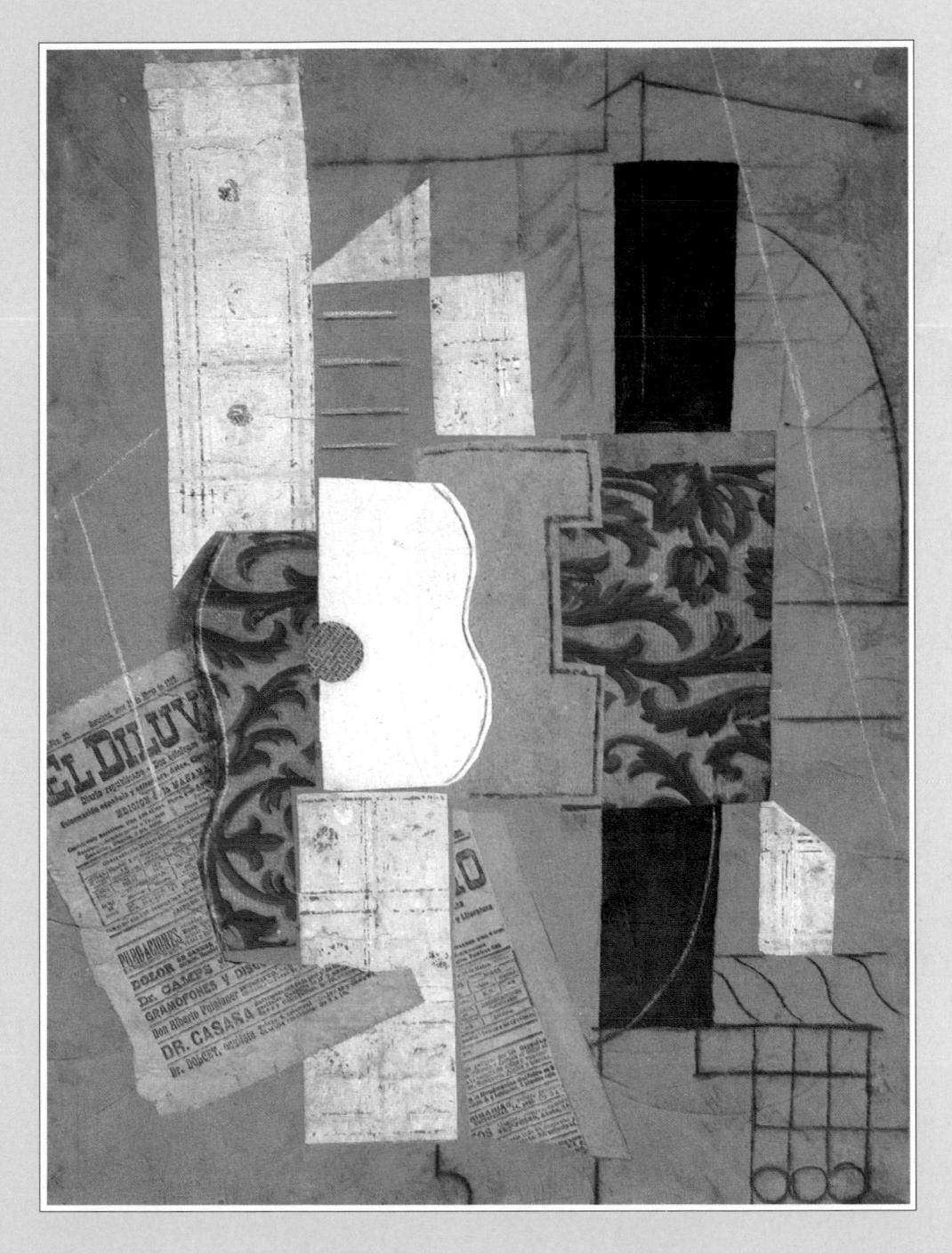

The ramifying shapes of the guitar are the organizing theme of many works by Picasso and by Braque in both the Analytic and Synthetic styles of Cubism. Picasso in particular was alive to both the formal possibilities of the subject and to any

scope for wit and visual punning. All these contingencies were admirably serviced by the innovative technical means that both artists brought to the picture surface. Guitar is a colourful papier collé producing a vibrant union of technique and expression.

Smear marks (made by fingers?)

Blacked-in rectangle showing overlapping layers of application

Half erased charcoal marks, suggesting previous orientation

Thin black charcoal line echoes contour of guitar

White wax crayon line 'framing' the composition

Front page of recent issue of Barcelona newspaper

Crinkle in thin blue pasted paper

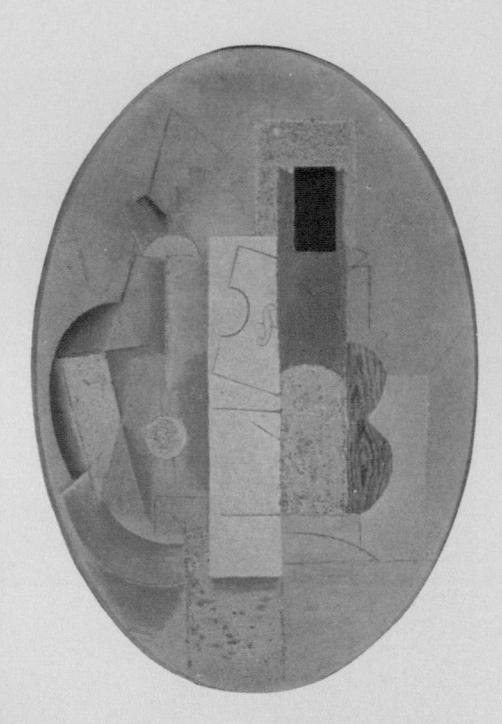

LEFT Violin and Guitar was produced in the same year as Guitar and obviously shares a similar subject matter. Here, however, as if in response to the pairing of musical instruments, the composition is arranged in an oval format to allow the freer play of a double set of sinuously curved surfaces. In addition, Picasso has used a different set of materials, pasted cloth, oil, pencil and plaster, which conveys a drier less sensuous, less colouristic effect, particularly in the abrasive, pock-marked plastered areas.

RIGHT The unruled charcoal grid probably represents the tassels or braiding of a chair (or tablecloth). But all hints of volume are suppressed by the inevitable flatness of the handling and by the common tendency for line to be extended beyond what is expected to be the limits of objects. In the middle, left of the extract, the black arc of charcoal procedes into the inked area and is effortlessly continued in white wax crayon. This peripheral unit then introduces an element of context to the analysis of forms which occupies the centre of the composition.

ACTUAL SIZE DETAIL
Picasso's play of depth
and layering is readily
apparent here, exploited
by the smudged shading
to the left of patterned
paper area, by the
intrusion and
termination of the white
line in the newspaper
page, and by glimpses
of the blue paper
ground in the bottom
right. The five or six
types of pasted paper,
then, set up an effective
counterpoint in terms of
structure and of
pattern. The torn and
cut-out nature of these
collaged elements is not
effaced, but rather
foregrounded,
especially under the
sound hole of the guitar
where there is a slightly
inset snip line.

Wassily Kandinsky

Small Pleasures (1913)
Oil on canvas
110cm x 120.6cm/43½in x 47½in

Kandinsky was probably the first, the most important and, in the end, the most influential of the pioneers of abstract art. He was the focal point for the converging forces of German Expressionism, and the measure of its achievement against a Paris-centred avant-garde.

Wassily Kandinsky was born in Moscow on 4 December 1866. He received a classical education at school in Odessa and went on to study law and economics at the University of Moscow. After this scholarly beginning, Kandinsky moved to Munich in 1896 where he studied art under Anton Azbé and later Franz von Stuck. But he maintained crucial links with his mother-country and retained a constant, if residual faith in the Russian Orthodox Church. In 1901 he co-founded the artists' association Phalanx and spent the next two years organizing, travelling, painting and writing while based in Munich. In 1911 he formed Blaue Reiter with Franz Marc, and in the following year published his key text On the Spiritual in Art and had his first one-man show. During the first years of the Great War he travelled in Scandanavia, before settling in Moscow from 1917 to 1921 where he was active in the artistic debates of the Russian state. He became an influential teacher at the Bauhaus school in 1922, and continued working there until it closed in 1933. Kandinsky spent the last years of his life in Paris. He died in 1944.

Kandinsky's painting falls into two notable periods of activity, but it is in the first of these – an explosive series of works from about 1909 to 1914, precisely the epic years of Cubism – that he sought to liberate line and colour from the imposing weight of representation. These paintings are often pushed to the limits of disorganization and amorphousness, their calligraphy darting across colour patches.

Paradoxically, in many ways, the pictorial rationalization of his language which ensued in the later works during his Bauhaus years was its undoing: line shape and colour were straightened, geometricized and smoothed as if some semantic magnet had pulled them into psychological order. It was Kandinsky's textual and pedagogic activity that became his most important contribution to the modern movement in the 1920s.

The influences on Kandinsky's 'impulse to abstraction' are notoriously difficult to assess. There is no doubt that the Munich milieu was crucially formative, but even during collaboration on the Blaue Reiter project, there is always the impression that Kandinsky is working out his ideas, a view confirmed by a lack of continuity with Marc's work of the same period. Apart from textual influences, only Paul Klee had a direct visual impact on Kandinsky.

Having decided to become a painter relatively late in life, Kandinsky gave most of his energies to this particular medium. There is a problem involved in any consideration of his oil technique, a problem which he himself drew attention to in a letter of 1937: 'I have listed six hundred and forty-five "oil-paintings" and five hundred and eight-four "watercolours". . . . this division is a conventional one because in the case of oil there are often other media at work (eg tempera, watercolours, gouache, indian ink) and equally so with watercolours.'

It is extremely difficult to tell exactly how and when Kandinsky mixed his various media, but many of the great range of effects that he managed to achieve in his work from 1909 to 1914 seem in part attributable to the dilutions, combinations and 'impurities' which he conjured from his palette.

Small Pleasures was preceded by a number of studies and related works, the earliest of which, With Sun (oil and tempera? on glass) appears to date from about 1910. The composition of Small Pleasures is centred round two hills, each crowned by a citadel. On the right-hand side is a boat with three oars which is riding a storm under a forbidding black cloud. To the bottom left it is possible to make out a couple at a steep angle to the hill, and above them three horsemen arrested in full gallop. A fiery sun flashes out wheels of colour.

The actual interpretation of these elements has been the subject of much controversy; especially since the recent discovery of an unpublished essay on the painting written by Kandinsky in June 1913. This document appears to discourage the irony which some have read into an imagined discrepancy between the title and the actual work, and reduces the heavy apocalyptic signification of the imagery. Indeed Kandinsky writes of the 'joyfulness' of execution. It is legitimate then, to see the work as a celebration of Kandinsky's style during this period, as affirming the spiritual and practical pleasures he manifestly derived from painting; he speaks of 'pouring a lot of small pleasures on to the canvas'.

While giving the impression of heavenly chaos, Small Pleasures is obviously not the product of pure spontaneity. The various modes of paint application, and the complexity of pigment selection and mixing are enormous. The way colours are washed and blurred together, and seldom contained by bounding lines is typical of Kandinsky's work at this time. The predominantly curvilinear aspect of the work, however, is undermined by the angular geometry of the citadel, perhaps presaging Kandinsky's Bauhaus style. There are few monochrome patches in the composition, underlining the local scale of execution, and part of Kandinsky's pleasure in the work was his reflection on a number of minor technical achievements. He wrote of the 'fine, very fine lines' scrupulously worked in with an extrathin brush, and of his successful suppression of 'lustre' from the gold and silver areas.

WASSILY KANDINSKY

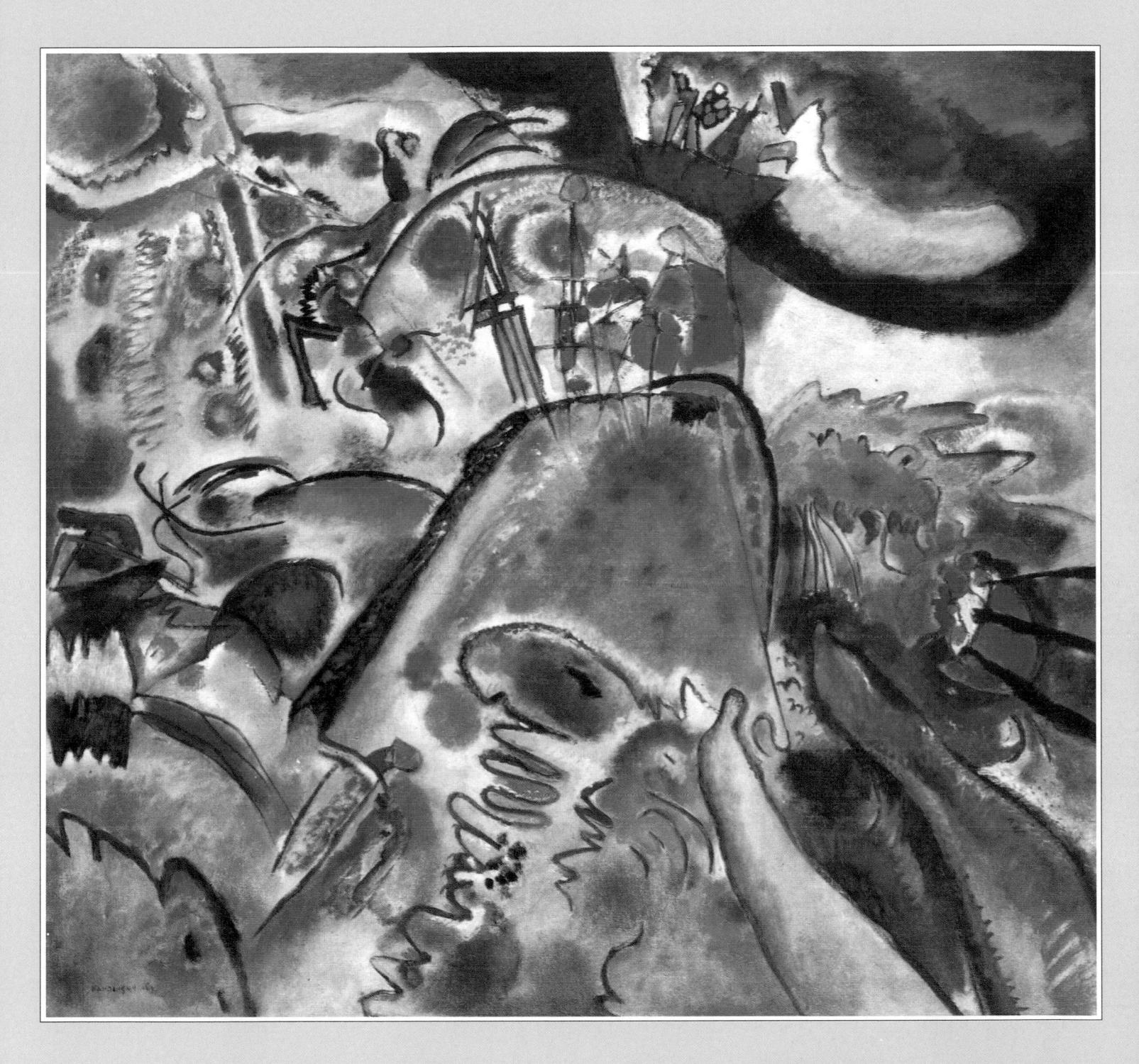

At first sight Small Pleasures seems like an abstract but exuberant polychromatic display. In fact colour, line and other formal components are expressive agents in the service of a highly charge apocalyptic imagery, which is revealed unevenly across the picture surface. Some of these symbols are identified in the text.

WASSILY KANDINSKY

Sun with concentric heat or light bands emitting rays and beams

Calligraphic stroke suggesting horse's tail

Ochre stippling

Curvilinear crests, quickly worked, signifying an agitated sea-wave

Very fine red and yellow dots

LEFT The straight-line construction of the buildings on the hill is conspicuously out of phase with the apparent formal and colourist anarchy of the rest of the composition. They are an attempt to reduce the features of the walled town to a geometric skeleton which yet contains its essential signifying features. The relation of colour to this structure, however, suggests that Kandinsky was not interested in rigid infilling or strict equivalence; it is not applied subordinately and describes its own shape and forms.

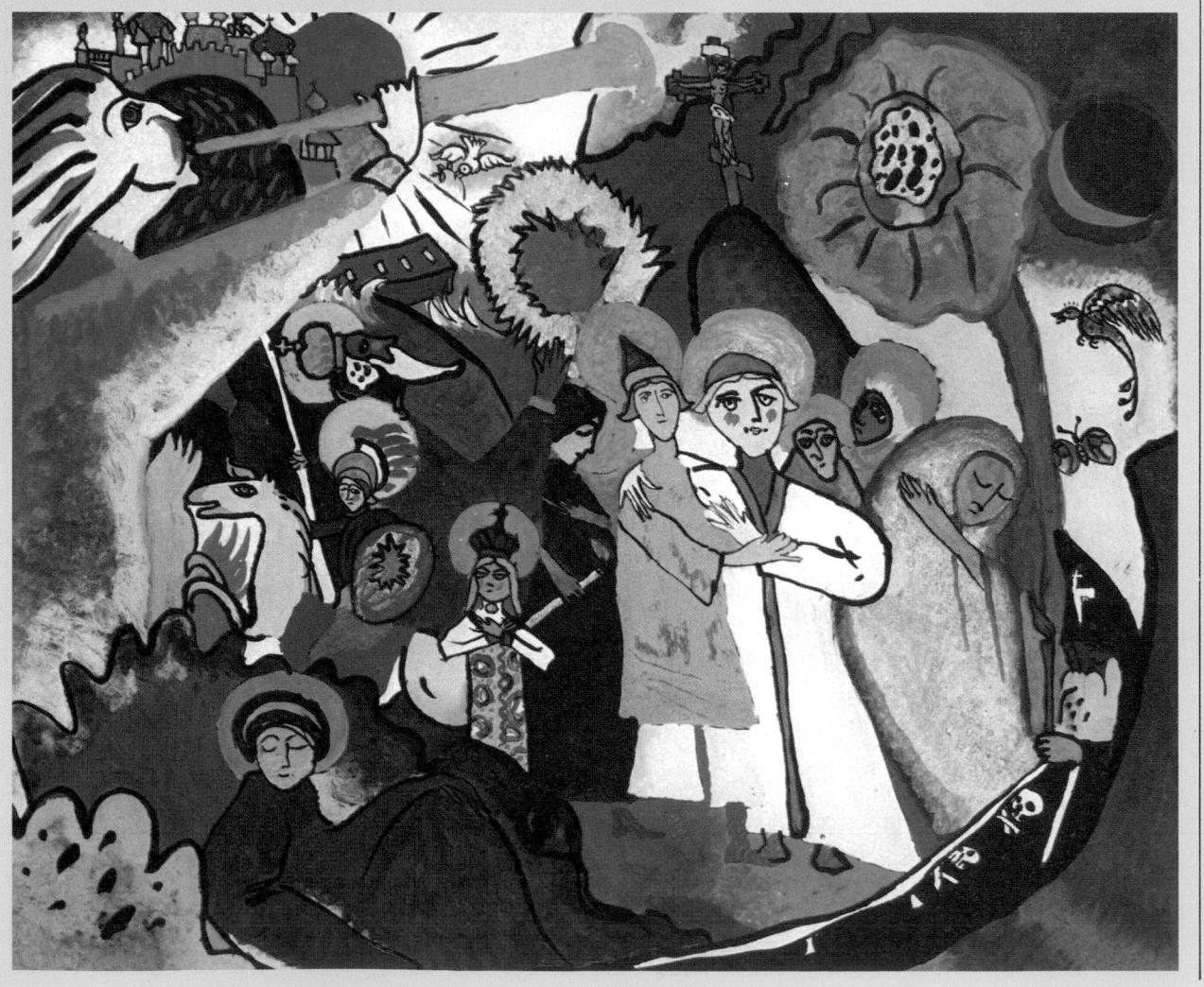

LEFT Painting on glass was still a flourishing folk art in some of the villages around Munich and Kandinsky was evidently inspired by this technique. In many respects, All Saints I (1911) and Small Pleasures represent complementary poles of Kandinsky's activity 1910-1914. There is a bold, almost humorous realism in All Saints, matched by the use of relatively unmixed clear colour patches. This work is a pool of images and motifs which Kandinsky abstracted and abbreviated in his later work, the trumpeting angel, St George on horseback, and other saints. Small Pleasures too has a Kremlin on a hill, and the fiery red sun, but two years later these motifs are veiled behind a frenzy of expressive painting devices.

WASSILY KANDINSKY

ACTUAL SIZE DETAIL
The horse and rider
featured here is
probably Kandinsky's
leading motif in his
pre-1914 work. It can
be traced through a
multitude of technical
and stylistic transitions
from the heavily
textured The Blue Rider
(1903), the jewelled and
romantic Couple on
Horseback (1906), to
the archer on horseback
in 1909 and the
exquisite brevity of
Lyrical (1910).

Centrifugal Expansion of Light (1914)
Oil on canvas
69cm x 49.6cm/27½in x 19¾in

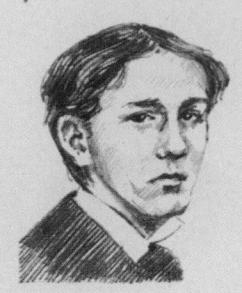

Gino Severini was one of the leading painters of the Futurist Movement, which supplied much of the inspiration and theoretical stimulation that sustained his output.

Born at Cortona on 7 April 1883, Severini began his artistic studies in Rome where he became a close friend of the young Umberto Boccioni, who was to be instrumental in the formulation of the first Futurist painters' manifesto in 1910. Like his friend, Severini found himself drawn to the art of Giacomo Balla, which he felt was a new exciting way of painting the modern world. These connections placed him at the centre of the *milieu* in which Futurism was germinating, but he left Italy for Paris in 1905, missing the movement's birth.

Paris became Severini's adopted city and he absorbed himself in the recent major developments in the visual arts there, producing, firstly, canvases in the Neo-Impressionist style, and then, through acquaintance with the avant-garde circle of Picasso, Max Jacob and Guillaume Apollinaire, experimented with the discoveries of Cubism.

Temperamentally more suited to formalist investigations than many of his literaryinclined colleagues in Italy, Severini found the rigorous grid-like structure and shifting viewpoints of Cubism attractive and, moreover, extremely useful as a disciplined compositional technique: within it he could pursue the Futurist interest in portraying the speed, vigour, colour and bustle of modern life. He tightened the fragmented jaggedness of Analytical Cubism into a more straightforward geometric mosaic of movement. The result was both persuasive and forceful. The showpiece of this technique is the Dance of the Pan-Pan at the Monico (1910-1912), which Apollinaire described as 'the most important work painted up to now by a Futurist brush'. But the pursuit of a more lyrical luminosity of colour led him away from Cubism to the influence of

Severini was the first to introduce the peculiar strain of Futurist excitement and verve to Paris. More importantly, he was instrumental in bringing the Italian artists to the French capital to see the new styles of painting.

the Orphists.

Severini worked predominantly in oil, but to produce looser, freer brushwork he occasionally used gouache. His contact with the Cubists, and more especially Apollinaire, encouraged him to experiment briefly with papier collé and collage. More significant, however, was his use of multi-coloured sequins, metallic dust and a sheet of painted aluminium as part of the exploration of light, colour and movement.

In the 1920s Severini produced a series of frescoes for the decoration of the Sitwells' castle at Montegufoni in Tuscany in which the nostalgic subject matter of the *Commedia dell' Arte* (a type of theatre production developed in

sixteenth-century Italy by travelling actors), treated in a monumental manner, complemented the use of a traditional medium. More frescoes followed, mostly in the apses of churches; they display an increasing interest in Byzantine and Early Christian art, which was to provide an important stimulus to the mosaics Severini produced in the 1930s.

The Centrifugal Expansion of Light was painted at the height of Severini's involvement with the formalist experiments of Parisian art during 1913 to 1914. This was when he produced his first abstract works, clearly influenced by Apollinaire's enthusiasm for Orphism, and more particularly by the pioneering Fenêtres simultanées prismatiques series (1912) of Robert Delaunay (1885-1941). Like the Fenêtres, this piece has been worked on the canvas itself without any involved preparation, and of necessity its colour relationships grow one from another across the surface. The genesis of the work owes much to Severini's own idea of 'plastic analogies of dynamism', made concrete in Sea = Dancer and a Vase of Flowers (1913) where the abstract pattern of light on the sea's surface suggested to him the rhythm of dance and the title. Centrifugal Expansion of Light is another product of the same period spent by the sea at Anzio.

Describing his technique at this time, Severini wrote of: '... colours which were as pure as possible and applied to the canvas with great concentration on nuances and contrasts of tone ... The typical characteristic of my way of working consisted in the carrying to the extreme limits the independence of Neo-Impressionism in relation to exterior reality. I did not wish the mélange optique to be realized either close to, or at a distance from the observer; I wanted the colours, instead, to remain orchestrated and coloured modulations. With this technique I stabilized the successive series of movements ... architecturally arranged and chosen by me with the aim of obtaining an overall harmonic effect.'

Within the confines of the complicated surface structure, ultimately Cubist in origin, the Divisionist brushstrokes are applied with freedom and varying degrees of sparsity, in order to allow the foundations of white or, in the case of the darker pigments, the plain ground alone to breathe through and increase the impression of lightness and movement between the dabs of colour. Towards the edges, the plain ground is increasingly evident as an effective diminuendo to the central core of the most vibrant hues and thickly applied paint.

Complex modulations of tone are also manipulated within each form, where clearly discernible second layers of the brushwork 'mesh' have been applied, both allowing the base to shine through, if not actually to comingle, and often effecting a definite mix on the canvas with the undried pigment beneath.

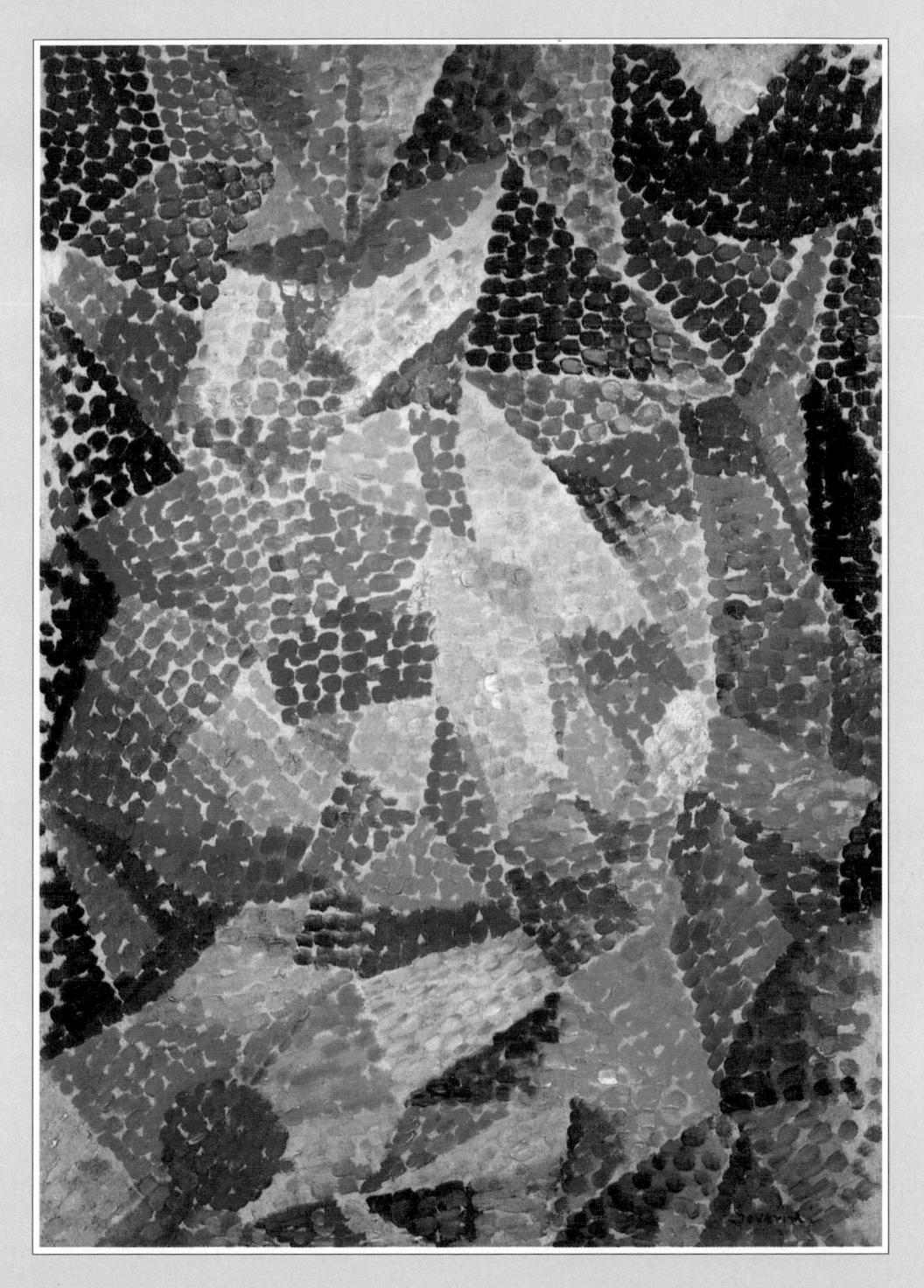

The tessellation of coloured forms — triangles, pentangles, diamonds, rhomboids and irregular and curved shapes — achieves a surface cohesion through the

use of exaggerated dots. A dynamic expansion of light is envisaged from the centre of the work to the peripheries which are inhabited by black and other darker tones.

Second colour superimposed without mixing

Paint patches merge to form a continuous 'line

Impasto scars around paint spots

Second colour mixed wet into wet

Priming and ground visible along the edges

Colour gradient within one colour shape (dark — light green)

RIGHT Severini, an enthusiastic dancer himself, found in the dance theme an exemplary motif for the exploration of movement and rhythm. The Dynamic Hieroglyph of Bal Tabarin (1912) is crowded with incident and anecdote, but the individual items are reduced and abstracted into 'hieroglyphs' structurally dependent on the luminosity and faceting of Analytic Cubism. As Picasso and Braque began to add foreign material to their canvas producing the first collage in 1912, so Severini here affixes sequins to the swirling dresses which glamorize the pulsing jamboree of form and colour.

LEFT The centre of the composition is occupied by a diamond-shaped lozenge whose position and shape suggest the prismatic scattering of light. There is a cluster of yellow dots around this diamond whose hues are darkened into orange.

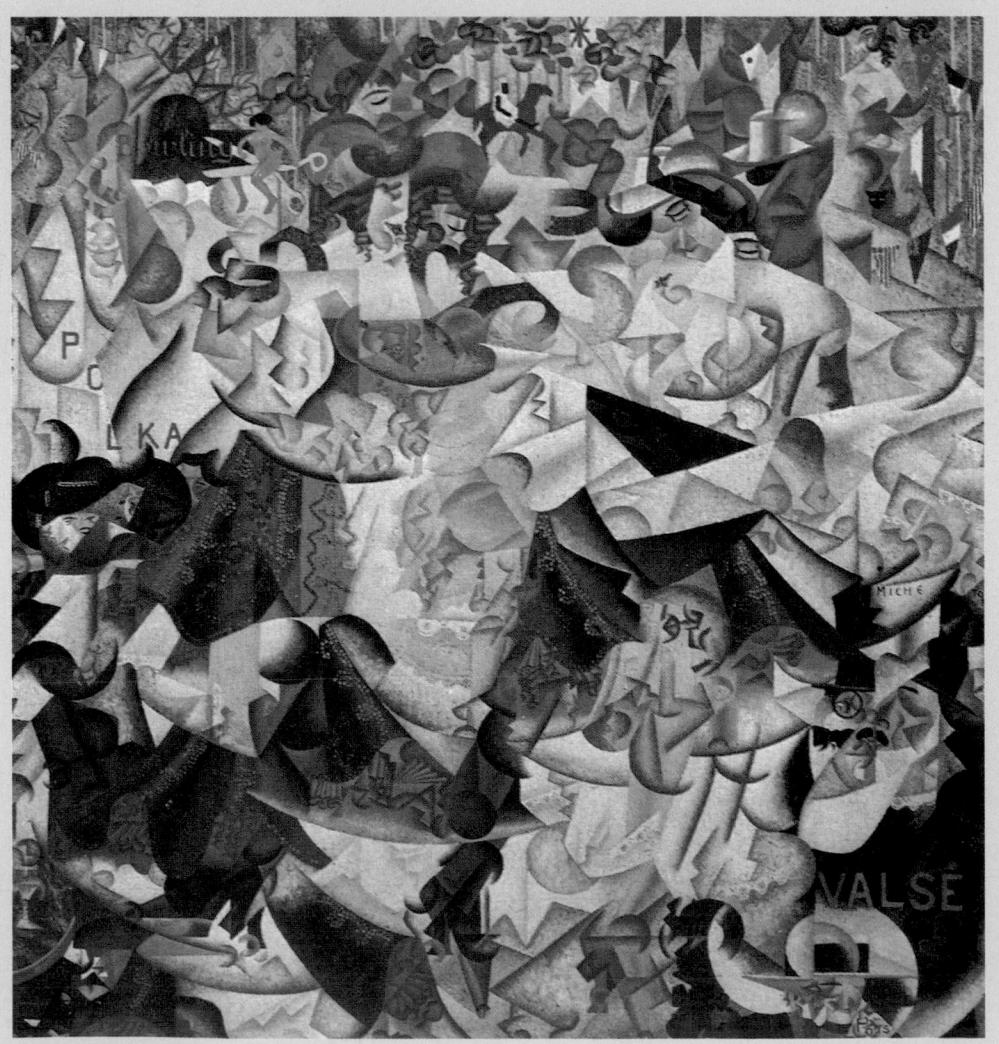

ACTUAL SIZE DETAIL This detail demonstrates the coarseness of finish of an area along the margins of the work. The thick off-white ground on the extreme left does not reach the edge of the canvas. The top left sector is top left sector is occupied by a battery of black dots, through which the ground is occasionally glimpsed, and on which are a few hints of blue and green, probably carried over from nearby dot clusters. Elsewhere the colour patches are not so discretely handled: they either merge together with impasto ridges, as in the smeared turquoisegreen area, are creamed with white in the red and blue zones, or are mixed wet into wet as in the paler colours.

Marcel Duchamp

The Bride Stripped Bare by Her Bachelors, Even (1915-1923)
Reconstruction Richard Hamilton (1965-1966)
Oil, varnish, lead wire, lead foil and dust on two glass panels
277.5cm x 175.8cm/109½in x 69¼in

Marcel Duchamp began planning *The Bride Stripped Bare by her Bachelors, Even,* or *The Large Glass* for short, in the summer of 1912, and made numerous notes, and drawings concerning its iconography and its execution. The notes, which are even more complicated than the physical work, were considered by Duchamp to be an equal work of art. A facsimile edition of these notes from 1912 to 1923 were published as *The Green Box* in 1934.

Marcel Duchamp was born near Blainville in 1887. At school he showed intellectual promise in a number of fields, including mathematics. His grandfather was a painter; two brothers and a sister were artists. When he was 15 he showed precocious accomplishment as a painter with the oil on canvas, *Landscape at Blainville* (1902). Duchamp studied painting at the Académie Julian from 1904 to 1905 where he worked in the manner of the Neo-Impressionists, Fauvists and Cézanne.

In 1911 he began to absorb and experiment with some of the very recent developments of Cubism and Futurism, producing the painting *Nude Descending a Staircase* (1912), which was the first successful attempt in painting to depict movement and the passing of time on a static flat canvas. In 1913 he turned his back on conventional painting in order to concentrate on the conceptual aspects of art. He wanted to recognize and initiate art that was a product of the mind rather than a formal sensual manipulation and even wastage of standard artistic materials.

The scenario for The Large Glass, although complicated, can be condensed. The Bachelors in the guise of nine Malic (Duchamp's own word) moulds or uniforms emit a gas which passes along tubes and through the cone-like Sieves, becoming a liquid which must then be imagined to be directed upwards into the Bride's domain. The horizontal dividing line between the two panels is the area which Duchamp designated as the Bride's garments and the gilled cooler. This area cools the ardour of the Bachelors and they fail in their attempt to win the Bride. The Bride - the stick insectlike configuration at the left of the top panel – has meanwhile issued her commands, threefold, in the form of a 'blossoming' semaphore at the very top of her panel. The purpose of the large Chocolate Grinder, to the right of the centre of the Bachelors panel, is to occupy the Bachelors grinding their own chocolate and thus temper their disappointment.

He used glass as a support and, with its utter receptive transparency, would provide its own background ready-made from its immediate environment. The Large Glass was to have a back and a front however. Because Duchamp worried about the impermanence of the oil medium, he conceived the notion of trapping oil pigment between the glass support and a sealing layer of lead foil pressed on

to the wet paint, to prevent oxidization. But, of course, an observer looking at *The Large Glass* from the side on which the paint and its cover of lead foil was applied would be unable to see the oil pigment. Also this process did not arrest deterioration since the lead of the foil reacted with the lead in the white paint, and the colour of the Malic moulds, for example, has darkened considerably.

To paint the glass, Duchamp fixed a full-scale working drawing to one side of it. Lead wire (in fact contemporary fuse wire) was then bent on the other side to mark the contours of the areas to be filled. The lead wire was stuck to the surface of the glass with mastic varnish.

The only shapes to look the same colour from both sides are the seven Sieves, which describe an arc in the centre of the Bachelors panel. Since a sieve is permeable in real life, Duchamp decided that they should be permeable in his artistic system too. But with the logic that was his art, the Sieves are represented by a non-porous material. He chose dust. He mapped out the contours of the Sieves with lead wire, let the dust of three months settle within the area (the glass was lying flat to allow him to work on it), and then fixed the dust with varnish.

As the working notes reveal, Duchamp wanted to use different techniques in the Bride panel. He tried to fix the image of the Bride upon the glass by projecting a negative of a previous oil painting of the Bride onto an area prepared with photographic emulsion, but the result was unsatisfactory. He had to return to the lead wire and foil process, but he introduced shading by tone and by hue instead of laying the paint on as a flat colour field, which was the method of the Bachelor panel. The painting of the Bride and her 'blossoming' is quite sensual in its handling.

The three Oculist Witnesses, situated to the right of the Bachelor panel, were the last forms to be completed. This was an area of the work which was meant to dazzle the efforts of the Bachelors and to encourage the close inspection by the viewer. Duchamp used technical and optical means to achieve this. The three shapes were copied from charts used by French opticians and Duchamp prepared careful perspectival drawings which were then traced on to a silvered area of the glass. The silver was then scraped away.

Finally the nine holes or Shots, at the extreme right of the Bride panel, were achieved by firing matches dipped in paint from a toy cannon aimed at the glass. Where the matches struck, a hole was then bored through. The Shots are the only attempt by the Bachelors to impose their mark upon the panel of the Bride.

Duchamp's *Large Glass* is a work of vital importance in twentieth-century art, with its immense technical, philosophical and iconographical implications.

MARCEL DUCHAMP

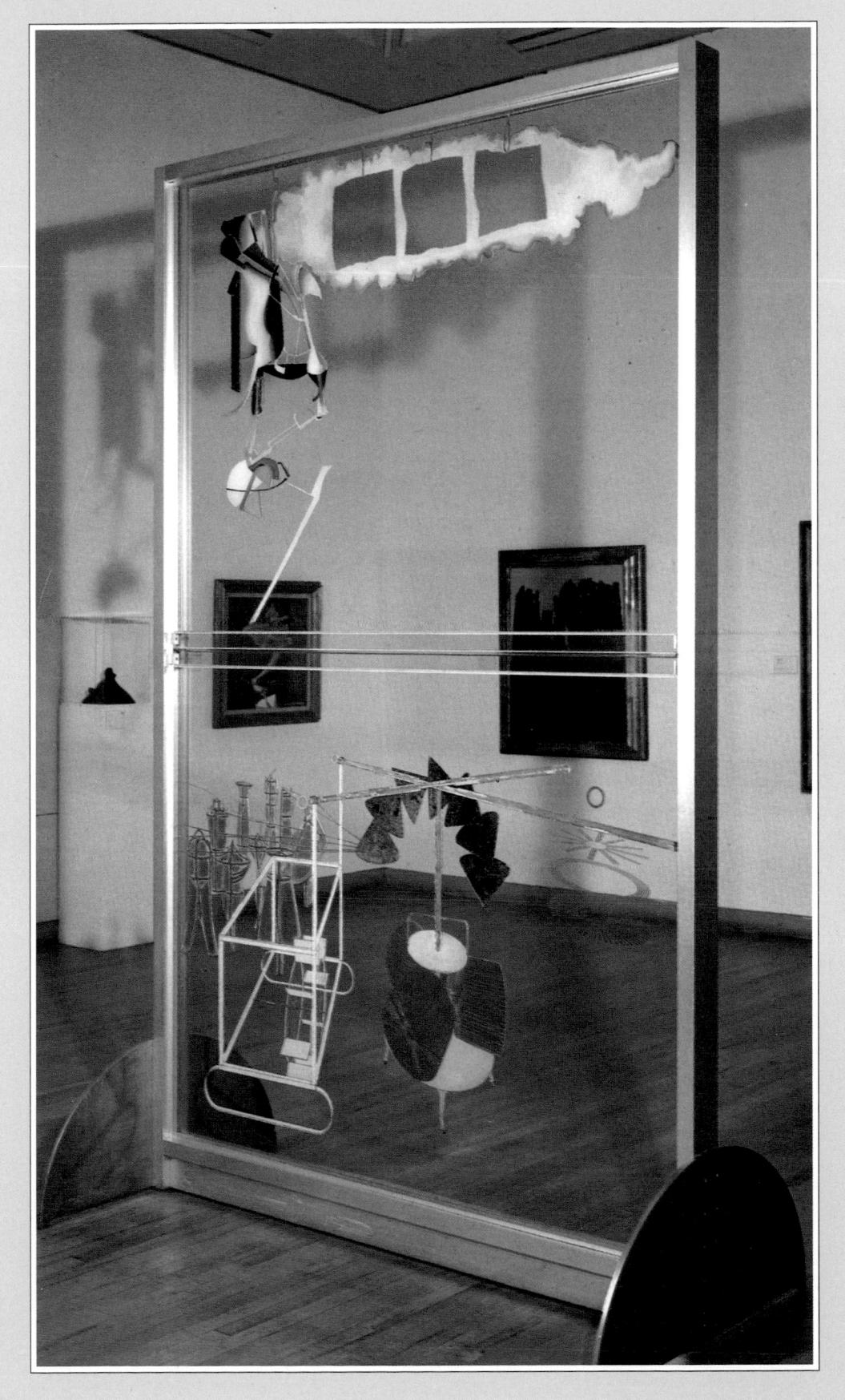

After the initial shock of the complete transparency of the glass support, which in this situation allows a Max Ernst painting to be viewed at the same time. The Large Glass settles into some kind of solidity and normality with the forms dispersed over its bipartite structure. Although the support is transparent the work does have a front and a back because of Duchamp's unique technical procedures which only allow the pigment to show through on one side, the front. Renaissance artists who developed the system of one-point perspective thought of the picture planes as a transparent window and Duchamp here ironically takes this notion to its logical but unexpected conclusion. The lower section, the realm of the Bachelors, contains all sorts of illusory perspectival constructions, whereas the upper section, The Bride, appears much flatter.

MARCEL DUCHAMP

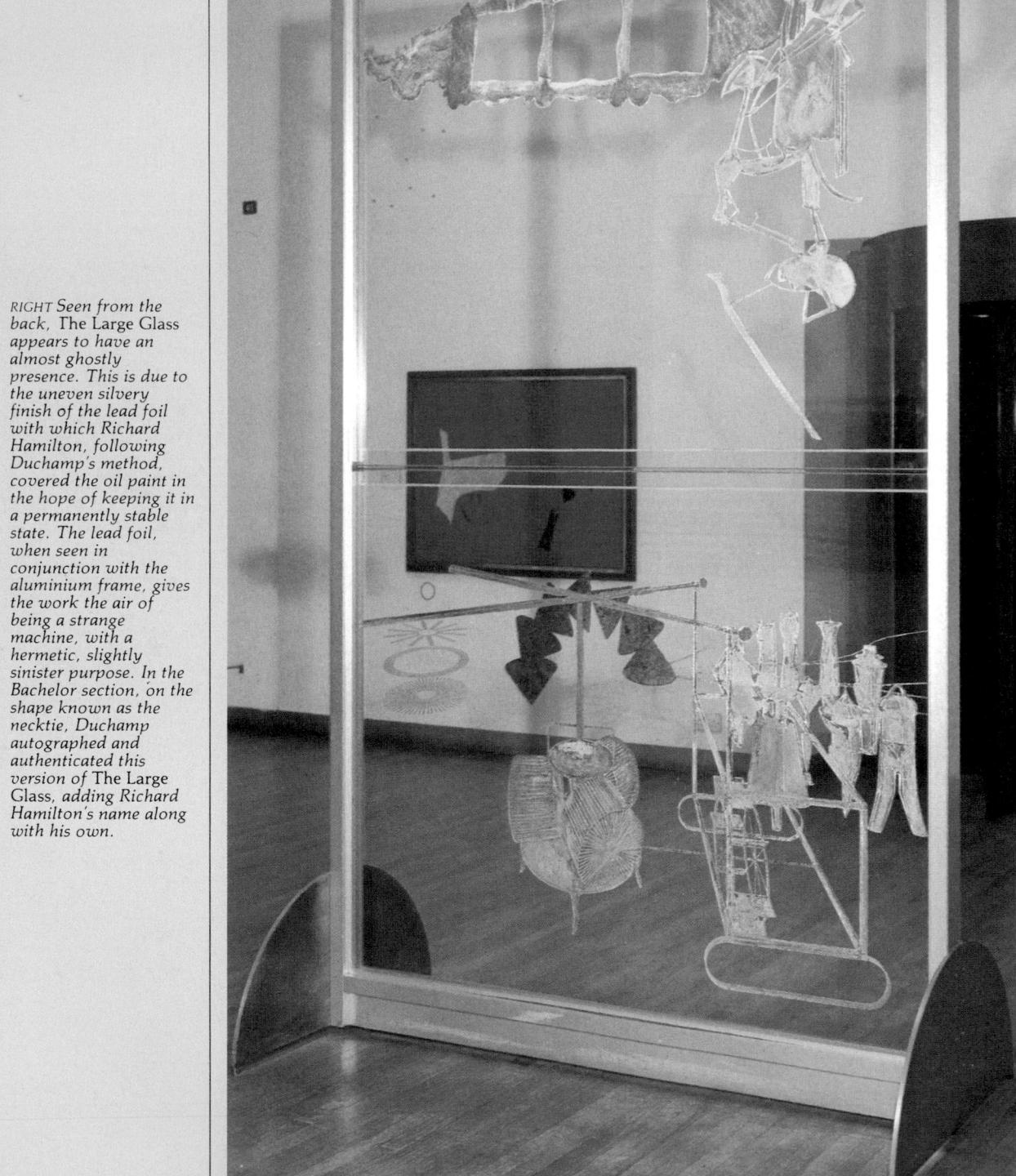

MARCEL DUCHAMP

BELOW This, the Chocolate Grinder, is the most prominent machine in the Bachelor section. It comprises three rollers, with a flat disc christened the 'necktie' above, and a 'Louis XV nickeled chassis' below. The metal chassis and the Louis XV legs are given a sumptuous peach hue which countermands their iron strength, whereas the three rollers are painted a burnt sienna which does come closer to the idea of milk chocolate.

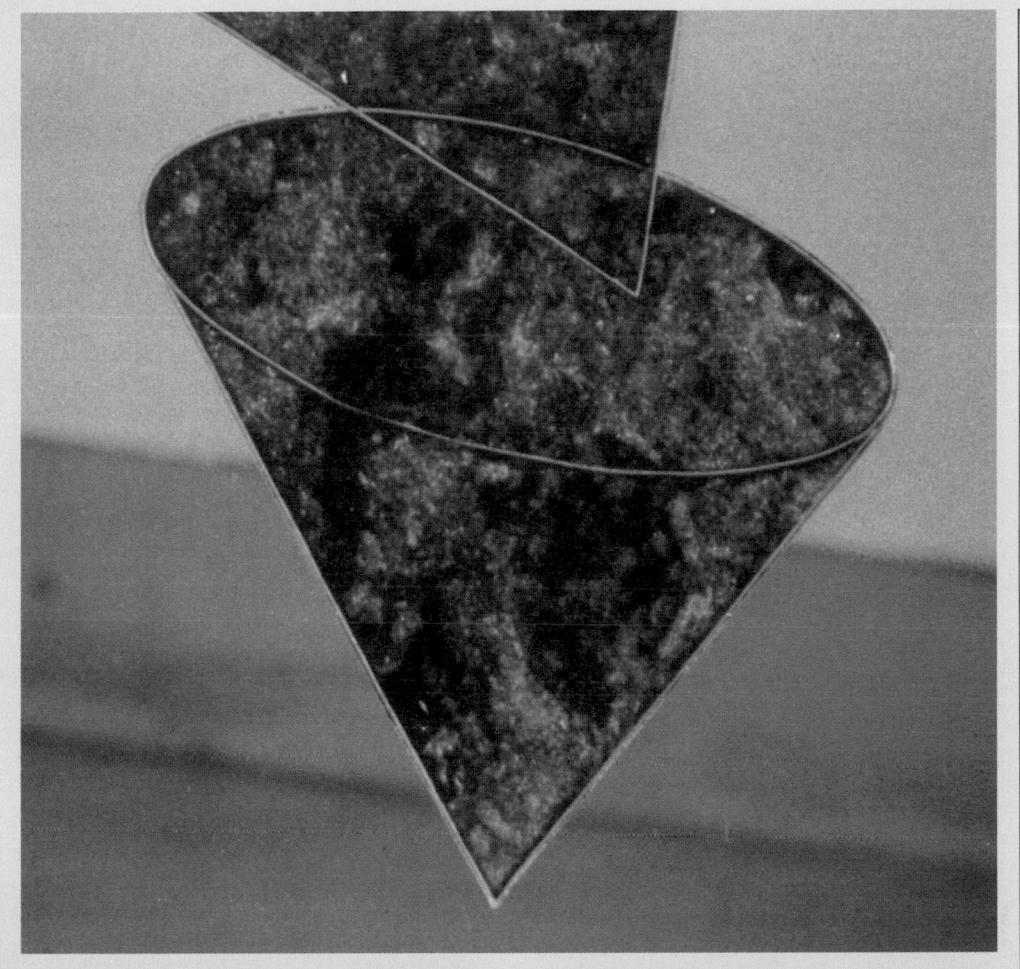

ACTUAL SIZE DETAIL
Duchamp organized a
dust breeding process in
his studio, which helped
to raise the dust
necessary for the
colouring matter for the
seven Sieves. This is the
last of the Sieves, which
get progressively darker
from left to right.
Duchamp wanted the
dust to be 'a kind of
colour (transparent
pastel)', and the
combination of dust
fixed by mastic varnish
produces a rich umber
pigment.

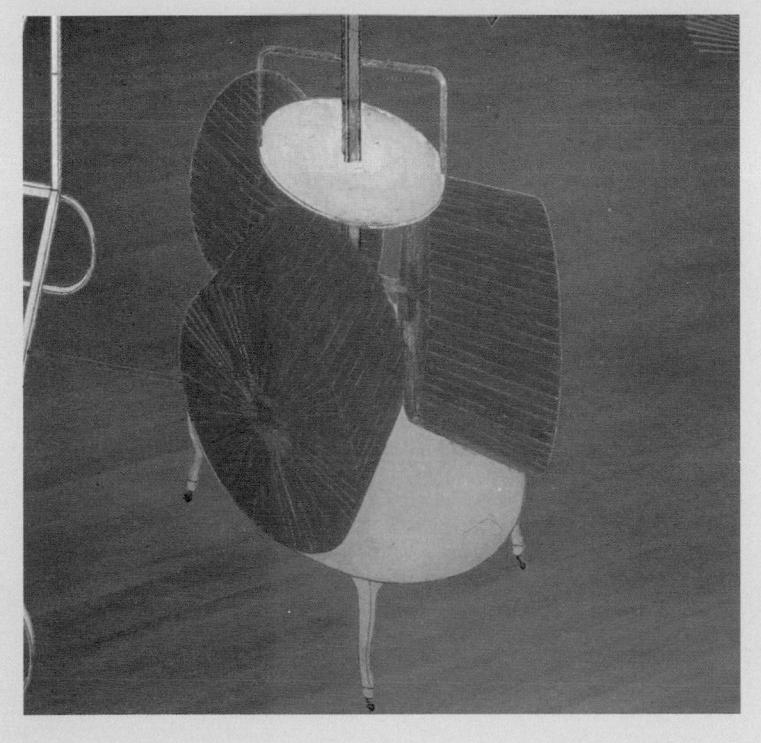

LEFT This shows five of the nine Malic Moulds, different categories of Bachelor identifiable as, reading from left to right, Priest, Delivery boy, Gendarme, Cavalryman and Policeman.

1921 1940

Dada and Surrealism

The Dada-Surrealist Movement is now part of art history more in spite of, than because of, its initial aims. Dada began as an anti-art movement or, at least, a movement against the way art was appreciated by what considered itself the civilized world; Surrealism was much more than an art movement and it thrust home Dada's subversive attack on rational and 'civilized' standards. Whether people are aware of it or not, the Dada and Surrealist revolt has helped to change modern consciousness.

Dada had no formal aesthetic, virtually disregarding easel painting, but the Dadaists shared a nihilistic ethic. The word 'Dada', ambiguously denoting both 'hobby-horse' and 'father', was arrived at by chance and gained immediate acceptance by its suitably childish and nonsensical ring. An international movement originating in Zürich and New York at the height of the First World War, it quickly spread to Berlin, Cologne, Hanover, Paris and, to some extent, Russia.

This revolt was against the senseless barbarities of war. It pinpointed the hypocrisy of those who felt that art created spiritual values. Civilization – despite Christianity, despite museums – had indeed broken down when thousands of grown men shelled each other day after day, from muddy trenches. It was no use for the person 'of sensibility', one of Dada's early targets, to take refuge in beauty.

The first step was to make negative gestures; to attack the icons of the old culture. It was in this iconoclastic spirit that in 1917 Marcel Duchamp put a moustache and beard in black crayon on a coloured reproduction of Leonardo da Vinci's *Mona Lisa* (c 1502).

The Dadaist', said the German poet Richard Huelsenbeck (1892-1974), 'is a man of reality who loves wine, women and advertising.' The Berlin Dadaists, such as Raoul Hausmann (1886-1971), particularly liked the technique of photomontage, using illustrations and advertisements cut out of popular magazines. The Dadaists adapted the Cubist idea of collage to new purpose, that of making puzzling or strikingly incongruous juxtapositions of images and letters. The collages of Kurt Schwitters (1887-1948) in Hanover were subversive because they were made of litter - bus tickets, sweet wrappings and other scraps. Duchamp's 'ready-mades' likewise tended to start life as objects of unmitigated ordinariness: the snow shovel, urinal and hat rack.

Other significant artists connected with the Dada Movement are Man Ray (1890-1976), whose basic tool was the camera and who invented the rayograph (an object placed on photographic paper was briefly exposed), Francis Picabia (1878-1953), an eclectic artist; Jean Arp (1887-1966), a poet and a sculptor, and Max Ernst (1891-1976) a collagist who was to become one of the great Surrealist painters.

Writers and poets, such as Hugo Ball (1886-1927) and Tristan Tzara (1896-1963), were at least as prominent as the artists. Dada gave much to the Surrealist Movement and was finally absorbed by it in Paris in the mid-1920s.

Surrealism probably had more influence on twentieth-century art than any other movement except Cubism. It began as a literary movement, involving a special philosophy and lifestyle for its members and has been compared to religion in its aim and practices. It lost no opportunity to attack the Pope as a symbol of the restrictive authority of the established order, and it replaced him with one of its own, the poet André Breton (1896-1966) who was capable of 'excommunicating' those he thought misguided or recalcitrant: Salvador Dali was expelled in 1937. Breton developed a political programme for the improvement of society but in practice, because politics invariably involve compromise, this proved incompatible with the major Surrealist aim of exploring and liberating the creative powers of the unconscious mind.

In 1924 Breton published his first Manifeste du surréalisme defining the movement 'once and for all' as he put it: 'SURREALISM', noun, masc. Pure psychic automatism by which it is intended to express either verbally or in writing, the true function of thought. Thought dictated in the absence of all control exerted by reason, and outside all aesthetic or more preoccupations. ENCYCL. Philos. Surrealism is based on the belief in the superior reality of certain forms of associations heretofore neglected, in the omnipotence of the dream and in the disinterested play of thought. It leads to the permanent destruction of all other psychic mechanisms and to the substitution for them in the solution of the principal problems of

At this stage, in 1924, there was no mention of painting but under the aegis of Breton, the Surrealists developed pronounced likes and dislikes in both the literature and the art of past and present. Breton liked pre-Freudian demonstrations of the 'unconscious', such as the eighteenth-century English gothic novel and the nonsense writings of Lewis Carroll (1832-1898) and Edward Lear (1812-1888).

Admiring the primitive mystery suggested by Gauguin's work in Tahiti, the Surrealists wanted an art to wonder and marvel at, not an art of reason and balance but something miraculous and mystical. They were great collectors of the products of 'primitive' cultures such as Oceanic sculpture. (The Fauves and the Cubists had already 'discovered' African sculpture.) In European painting they looked behind the classical tradition for obsessions and eccentricities of vision and imagination: for example, the views of hell with its hybrid monsters by Hieronymous Bosch (1453-1516);

INTRODUCTION

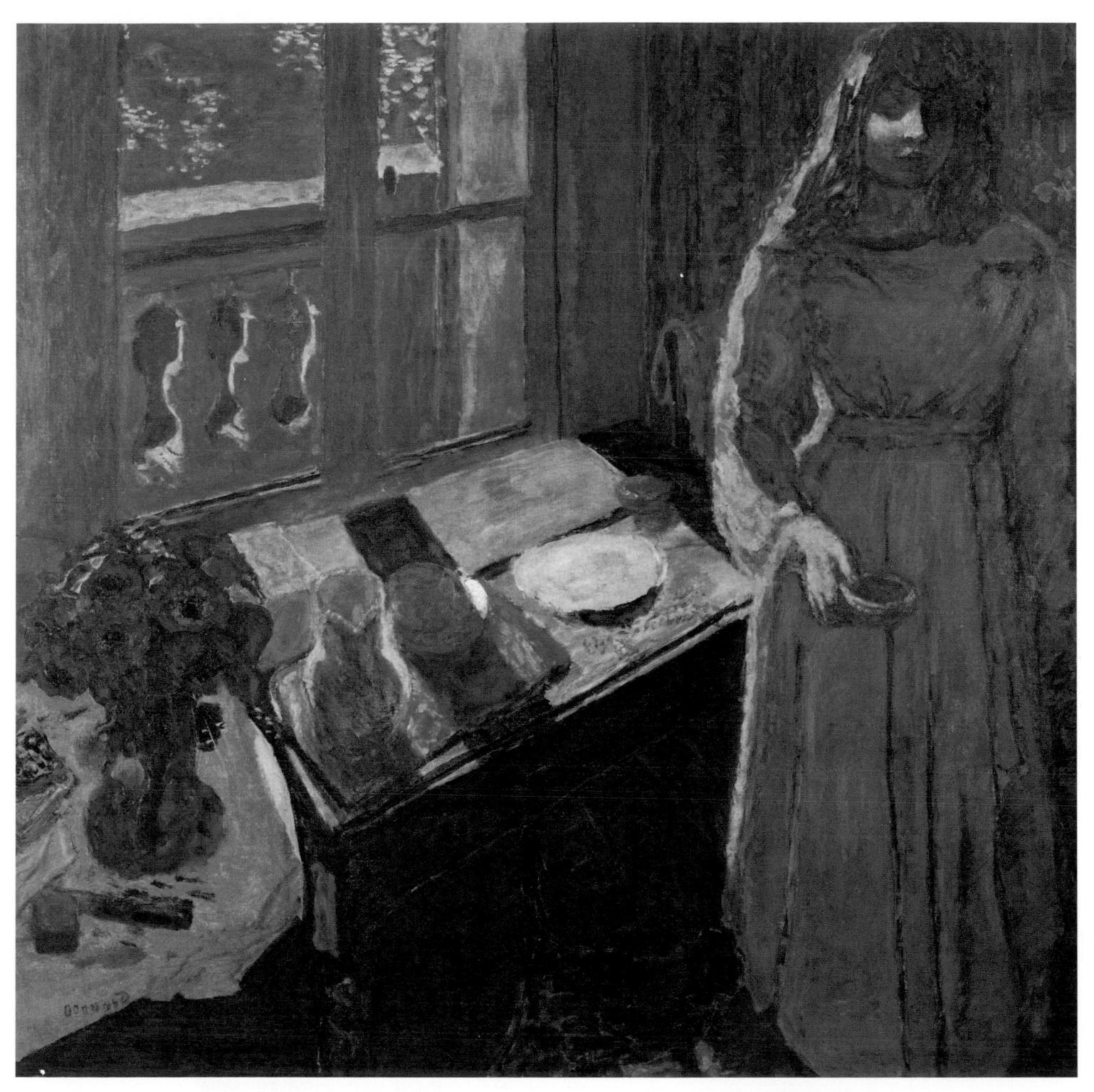

ABOVE Five years before Pierre Bonnard painted Bowl of Milk (1920), he became dissatisfied with his work. I turned against all that had previously excited me, the colour which had attracted me. I had

almost subconsciously sacrificed form to it but it is absolutely true that forms exist and that it is not possible either to arbitrarily reduce or transpose it ... a picture which is satisfactorily composed is half made.'

INTRODUCTION

RIGHT Fernand Léger was obsessed with machines and wanted to develop Cubist ideas into an artistic language to express the machine age. He felt modern life — which he saw as characterized by dissonance, dynamism and movement — could only be painted using contrasts of colour, line and form. In Still Life with a Beer Mug (1921-1922) the flatly painted geometric shapes and the patterns of other forms contrast with the shaded modelling of the curtains, the interior of the mug and the objects on the table. I group contrary values together; flat surfaces opposed to modelled surfaces; volumetric figures opposed to the flat facades of houses ...; pure flat tones opposed to grey, modulated tones, or the reverse.'

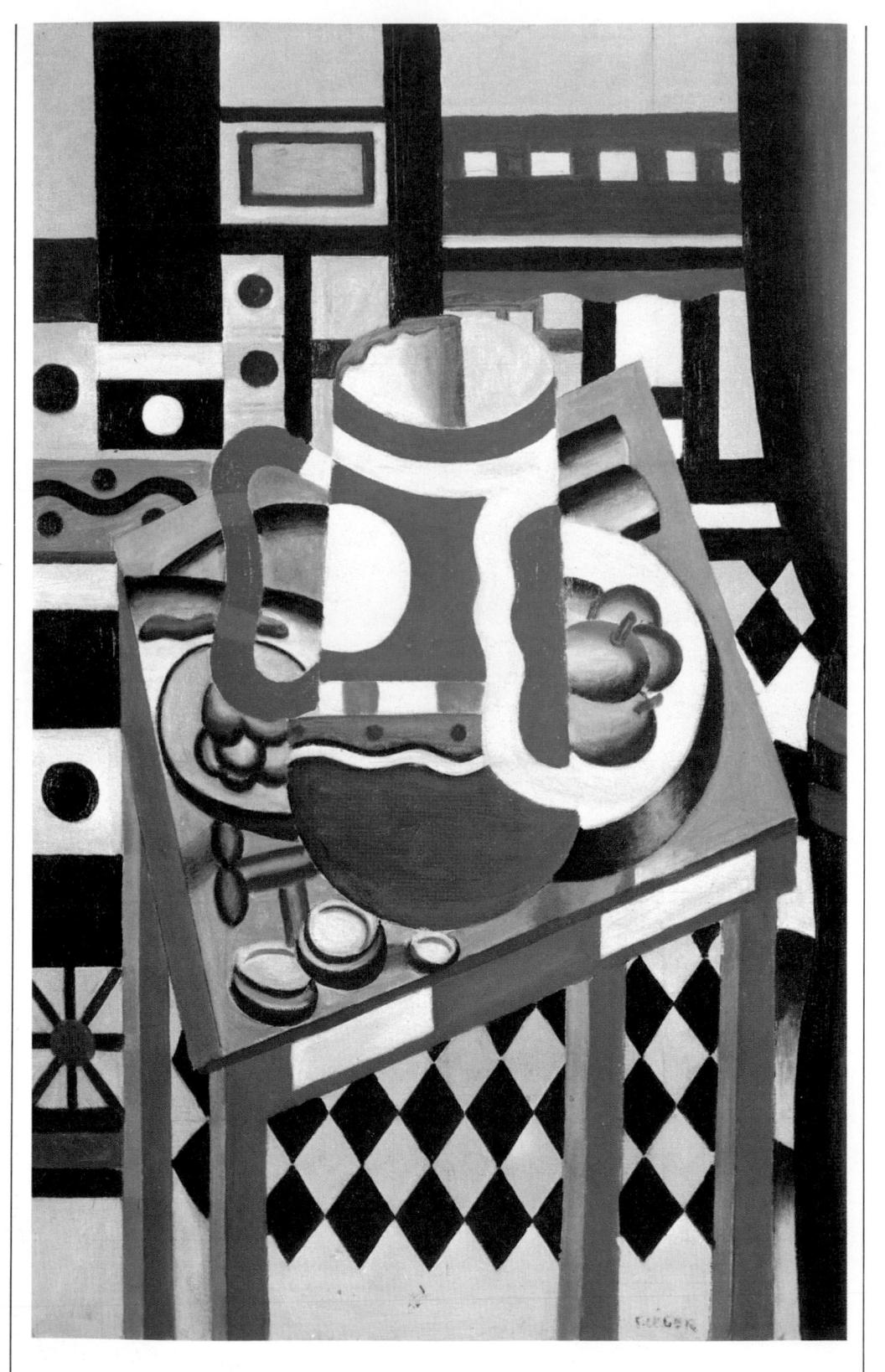
the bizarre results of the obsession of Paolo Uccello (1396/7-1475) with perspective; the fantastic and menacing prisons of Giovanni Piranesi (1720-1778), nightmares of Henri Fuseli (1741-1825) and the black period of Francisco de Goya (1746-1828). In the nineteenth century, they found Impressionism too naturalistic, too rational. They preferred Pre-Raphaelite and Symbolist dreamlike images. Scorning fashion, Breton was a devotee of the visionary paintings of Gustave Moreau (1828-1898), and at a time when art nouveau was disregarded by the *cognoscenti*, the Surrealists marvelled at its wrought iron plants as though the transformation of natural

organic forms into metal was a sort of alchemy. They found Cubism too rational, too logical (although an exception was made for Picasso's totemic proto-Cubist painting *Les demoiselles d'Avignon*. Picasso himself was also a special case, being held in awe as a phenomenon and a sort of unordained priest of Surrealism.) The Surrealists preferred the 'primitive' vision of Henri Rousseau (1844-1910). They rejected Futurism, preferring the Metaphysical painters, especially the haunting enigmas of Giorgio de Chirico (b 1888).

André Breton's phrase 'pure psychic automatism' was intended to apply to the process of writing and Breton even gave practical

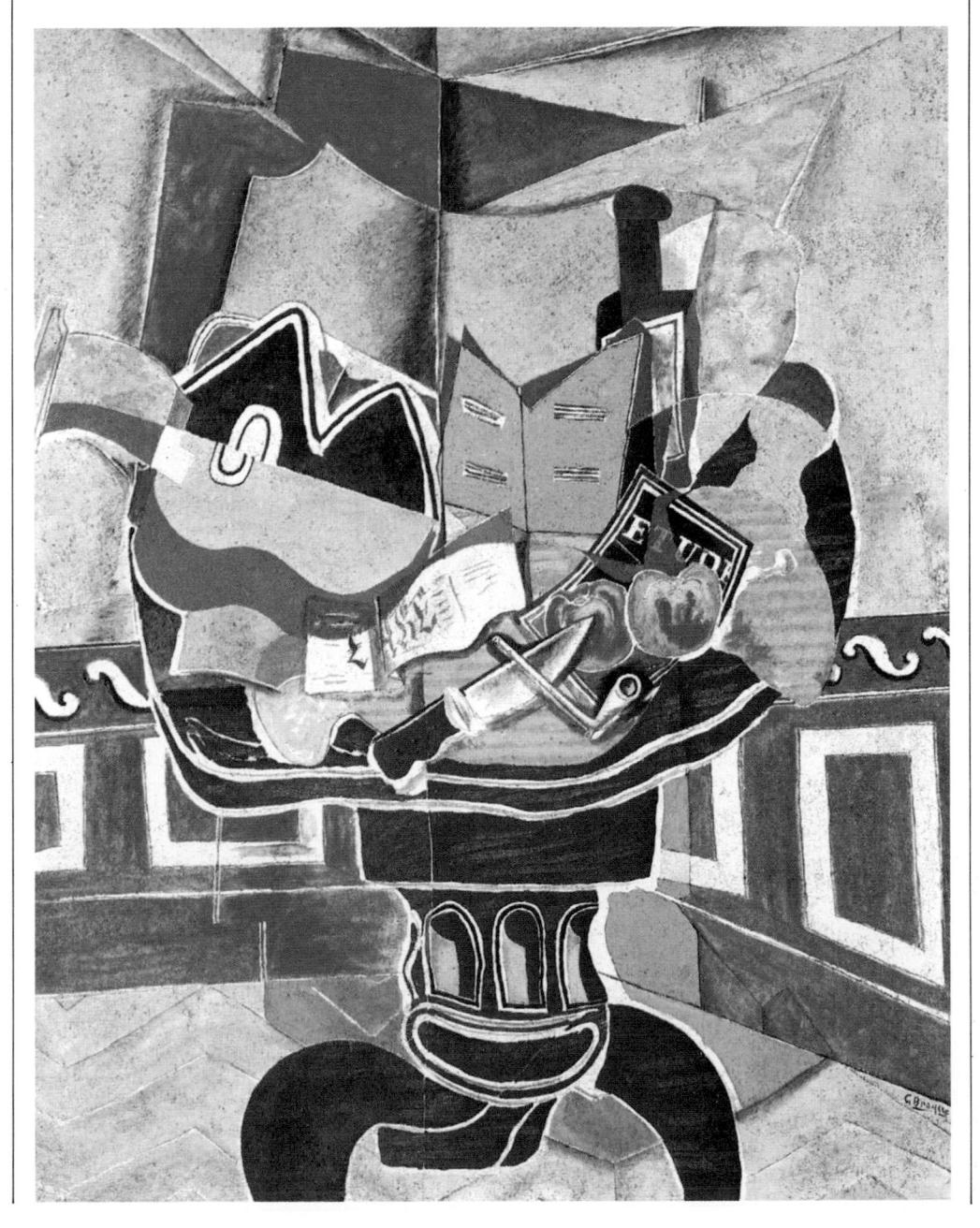

LEFT At the time Braque painted The Round Table (1929), as well as executing nudes and landscapes, he was also concentrating on still lifes in the French classical tradition. Strongly emphasizing structure, Braque's treatment of form had become more realistic and his very restricted palette had become very rich.

RIGHT Picasso drew Nessus and Dejanira in 1920, while he was developing what finally evolved into a classical drawing style, which had a volumetric quality and, at the same time, was subject to the Cubist experiment.

hints on how to do it. In 1930 he published his second *Manifeste du surréalisme* in which he defined 'surreality' as the reconciliation of the reality of dreams with the reality of everyday life into a higher synthesis.

Underlying the interest in automatism and dream lay the Surrealist notion of what was called 'objective chance'. They believed that the existence of coincidences (events for which there were no rational explanations) was evidence and that true reality was not ordered or logical. Access to reality could only be gained through the unconscious mind.

Surrealist painting

Three painters too great to be contained by Surrealism – Picasso, Klee and Miró – produced Surrealist work, while remaining somewhat aloof from the group. Miró and Picasso created improvisatory images and techniques that were ambiguous and suggestive rather than figurative. *The Three Dancers*, painted by Picasso in 1925, is a brilliant example of this kind of painting. Klee's 'poetry of the heart', was a deceptively simple attempt to transcend the gulf between people and nature, and is at once abstract and representational.

There is no dominant painting style in Surrealism. Considered from the point of view of technique it exhibited three main tendencies. The first tendency (which proved in the short term to be the most innovatory in terms of physical working methods) was that of discovering imagery by mechanical techniques where chance was exploited. The purpose was

to 'irritate' the vision, to stimulate the imagination and to force inspiration.

Frottage (rubbing), developed by Ernst and described by him in Beyond Painting (1948), comes into this category: 'On 10 August 1925, finding myself one rainy evening in a seaside inn, I was struck by the obsession that showed to my excited gaze the floor-boards upon which a thousand scrubbings had deepened the grooves. I decided then to investigate the symbolism of this obsession and, in order to aid my meditative and hallucinatory faculties, I made from the boards a series of drawings by placing on them, at random, sheets of paper which I undertook to rub with black lead. In gazing attentively at the drawings thus obtained, the dark passages and those of a gently lighted penumbra, I was surprised by the sudden identification of my visionary capacities and by the hallucinatory succession of contradictory images superimposed, one upon the other, with the persistence and rapidity characteristic of amorous memories.'

Surrealist painting dates from the invention of frottage, although Ernst had used collage in a similarly 'psycho-technical' fashion. He brought together scientific images,'...elements of figuration so remote that the sheer absurdity of that collection provoked a sudden intensification of the visionary faculties in me and brought forth an hallucinatory succession of contradictory signs... These visions themselves called for new planes, for their meeting in a new unknown... It was enough then to add to these catalogue pages, in painting or

drawing, and thereby obediently reproducing only that which was to be seen within me, a colour, a pencil mark, a landscape foreign to the represented objects, the desert, a tempest, a geological cross-section, a floor, a single straight line signifying the horizon, to obtain a faithful fixed image of my hallucination...' A list of the techniques or psycho-techniques of the Surrealists, therefore, is no more than a list of aids to vision in which the spiritual overwhelms the technical.

By the technique of *grattage* (scraping) Ernst transferred *frottage* from drawing to oil painting. In *decalcomania* (transferring) the image was obtained by laying arbitrary patches of colour on a piece of paper. A clean piece was

then rubbed gently on top. When separated, strange grottos, exotic vegetation and underwater scenes suggested themselves to the imagination. A picture was made by chance.

Fumage (smoking) was a technique of automatism invented by Wolfgang Paalen (1907-1959) in the late 1930s. Here the chance imagery was provoked by moving a candle under a sheet of paper; and random areas of soot would develop from which the mind could form images. All these techniques depend for their application upon the hallucinatory mind of the artist.

Dali and the Veristic Surrealists

The second tendency of Surrealist painting,

ABOVE House by the Railroad (1925) by the Realist painter Edward Hopper successfully represents forms modelled in light. The paint surface was built up in layers, scraped down then repainted to create a transparent surface. 'I have a very simple method of painting,' Hopper said. 'It's to paint directly on the canvas without any funny business ... I use almost pure turpentine ... adding oil ... until the medium becomes pure oil.'

sometimes called Veristic Surrealism, was to depict with meticulous clarity and often in great detail a world analogous to the dream world. Before responding to the Metaphysical painting of de Chirico and being brought into the Surrealist Movement in 1929, Salvador Dali had admired the command of detail in artists such as Ernest Meissonier (1815-1891) and the Pre-Raphaelites; his physical technique continued to reflect this admiration. Dali's importance for Surrealism was that he invented his own 'psycho-technique', a method he called 'critical paranoia'. He deliberately

cultivated delusions similar to those of paranoiacs in the cause of wresting hallucinatory images from his conscious mind. Dali's images – his bent watches, his figures, half-human, half chest of drawers – have made him the most famous of all Surrealist painters. But when he changed to a more academic style in 1937 Breton expelled him from the Movement.

The Surrealist paintings of René Magritte (1898-1967) combine convincing descriptions of people and objects in bizarre juxtapositions with a competent but pedestrian physical painting technique. The results question

RIGHT Ernst Kirchner's Artists of the Brücke (1925). Kirchner was the most gifted, sensitive and vulnerable of the Brücke artists, who met in 1903 in Dresden. Influenced by Munch and Oceanic and other primitive art, they evolved a rather wild, archaic German version of Expressionism. They attempted to express psychologically and symbolically a vaguely conceived creative urge and a sense of revolt against the established order. Kirchner wrote:
'We accept all the
colours which, directly
or indirectly, reproduce
the pure creative
impulse.' By the time Kirchner painted this work, the members of work, the members of the Brücke had long been following divergent paths and the group style had disappeared. It was painted at a time when he was recovering from a mental breakdown; he was becoming more and more engrossed in purely painterly problems.

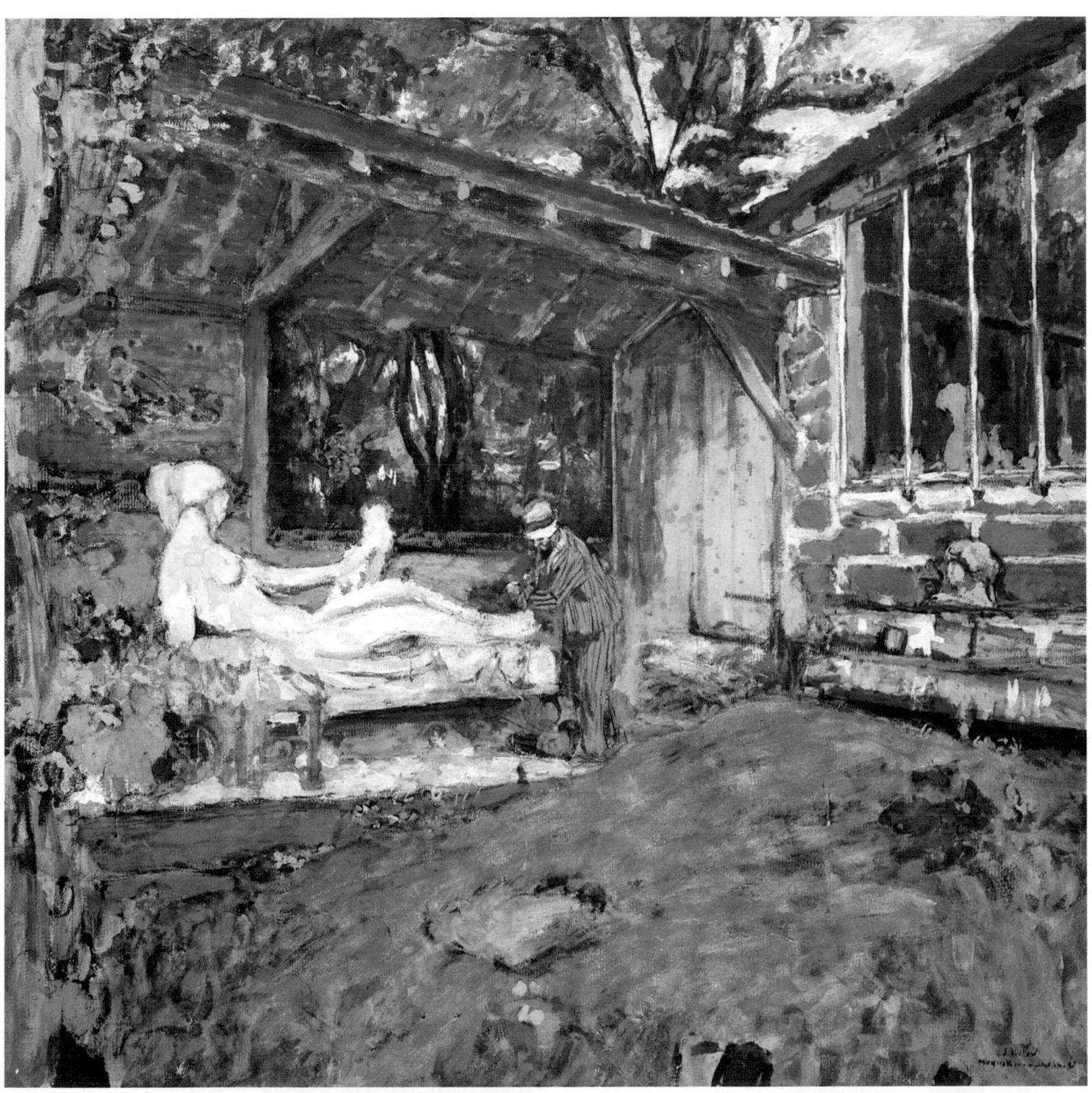

ABOVE A painter paints a sculptor's homage to a dead painter — Edouard Vuillard's Maillol at Work on the Cézanne Memorial (c 1930). It was left to Vuillard and Bonnard to preserve the lyrical

pictorial qualities of nineteenth-century painting during a period of technical experimentation. They both concentrated on the quiet intimacy of their immediate environment.

RIGHT The Persistence of Memory (1931) is one of the most celebrated of a series of works by Salvador Dali, of almost unequalled hallucinatory intensity. It shows a beach lit by a transparent sunset. Dali's technique is, in many ways, similar to the nineteenth-century French academists. He portrays a credible view of reality in a photographic illusionistic manner, while simultaneously distorting (and undermining) conventional ideas of reality. As in The Persistence of Memory, the relative scale of objects is inconsistent, the choice of objects suggestive and disturbing, and the properties of materials and objects have changed — for example, soft objects become hard and vice versa. Each adjustment Dali has made is calculated to stretch the viewer's concept of reality. 'Like fillets of sole,' Dali said of the floppy watches in the painting, 'they are destined to be swallowed by the sharks of time.

everyday reality, stand it on its head and present a new surreality. These odd juxtapositions were explored by the English painter Edward Wadsworth, who used tempera to achieve a dreamlike clarity in his work. Surrealists approved of *desire* in its attack on reason and the Veristic Surrealism of Paul Delvaux (b 1897), in which women appear in the cool surroundings of noble architecture and exude an hallucinatory eroticism.

Veristic Surrealism subdivides into a second main type in the work of Yves Tanguy. The dreamlike visions that Tanguy produced from the unconscious layers of the mind contain meticulously described yet imaginary objects. There are no bizarre juxtapositions. His is a self-consistent world that convinces on its own terms as in a dream. In the work of the Veristic Surrealists, the surface of the painting tends to be flat and glossy: the viewer is reminded as little as possible that the illusion is composed of paint and the hallucinatory effect is thereby enhanced.

'Automatic' techniques

The third main Surrealist tendency drew more attention to the materials used by the artist. This tendency survived the break-up of the Surrealist movement during the Second World War. It began with the 'automatic' drawing technique practised by Miró, Paul Klee and André Masson (b 1896). The line of the pen or other instrument was allowed to rove at will without any conscious planning. Masson tried to achieve the same sort of result in painting, by drawing a mass of lines in an adhesive substance on the canvas, adding colour by coatings of different coloured sand. After the end of the Surrealist epoch, this approach was carried into painting in New York by Arshile Gorky (1904-1948), the 'white writing' paintings of Mark Tobey (1890-1976) and, above all, the vast abstractions of Jackson Pollock which contain a strong element of drawing with paint while the artist was in an ecstatic trance.

Contrasts: Mondrian and Bonnard

Piet Mondrian developed his Geometrical Abstractionism from Cubism and Fauvism. His early work – for example, *The Red Tree* (1908) – shows a Fauvist colour influence. The form, although derived from, and much influenced by, Cubism, had been refined and ordered. Mondrian eventually reduced the representational elements and the pictorial construction into relationships of form and rhythms.

The Post-Impressionist Pierre Bonnard occupies a relatively isolated position in the art of the 1920s and 1930s, and his work appears out-of-step with contemporary developments. But Bonnard's rich luminous palette and his flexible and expressive style (in fact, meticulously painted) was a reminder of the more pictorial possibilities of painting.

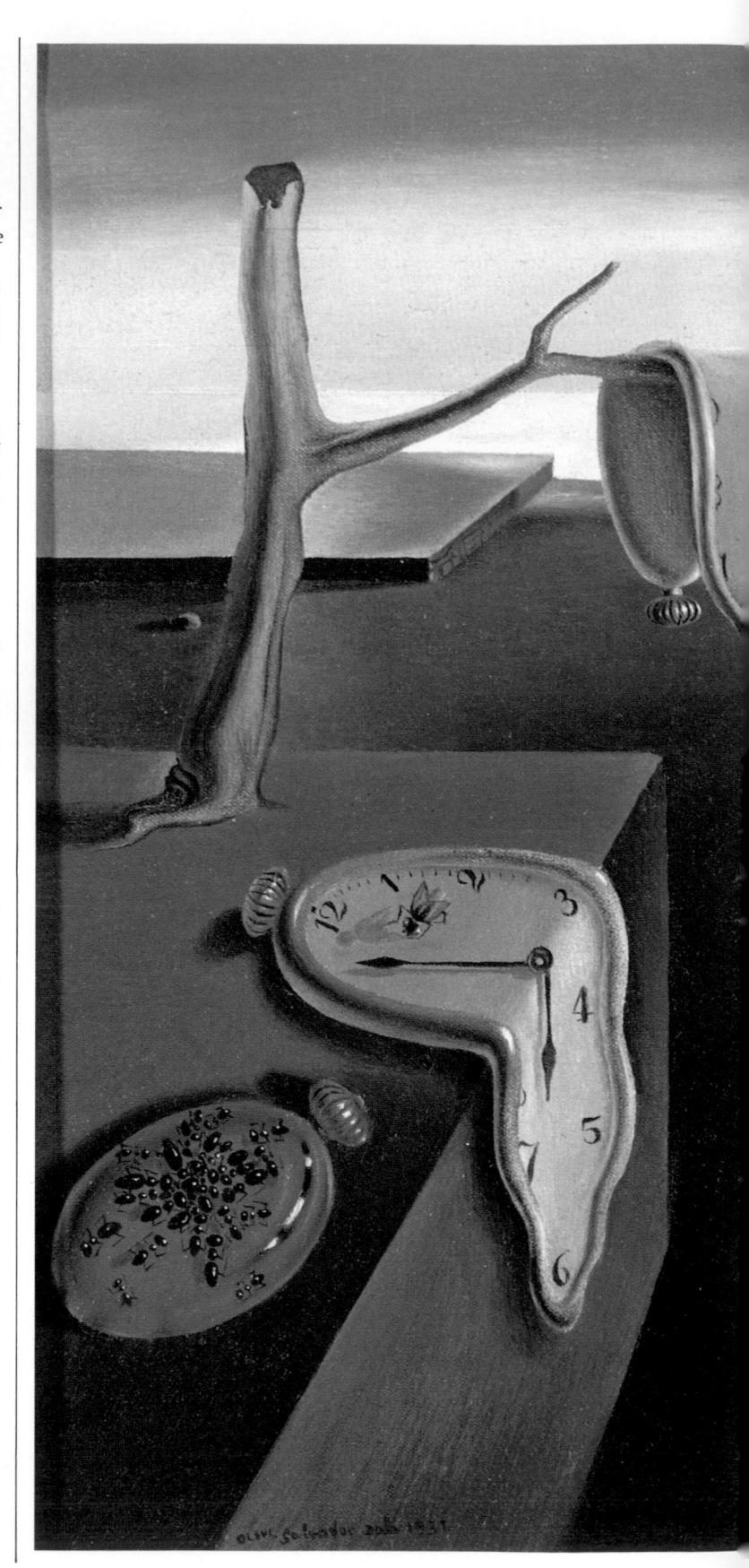

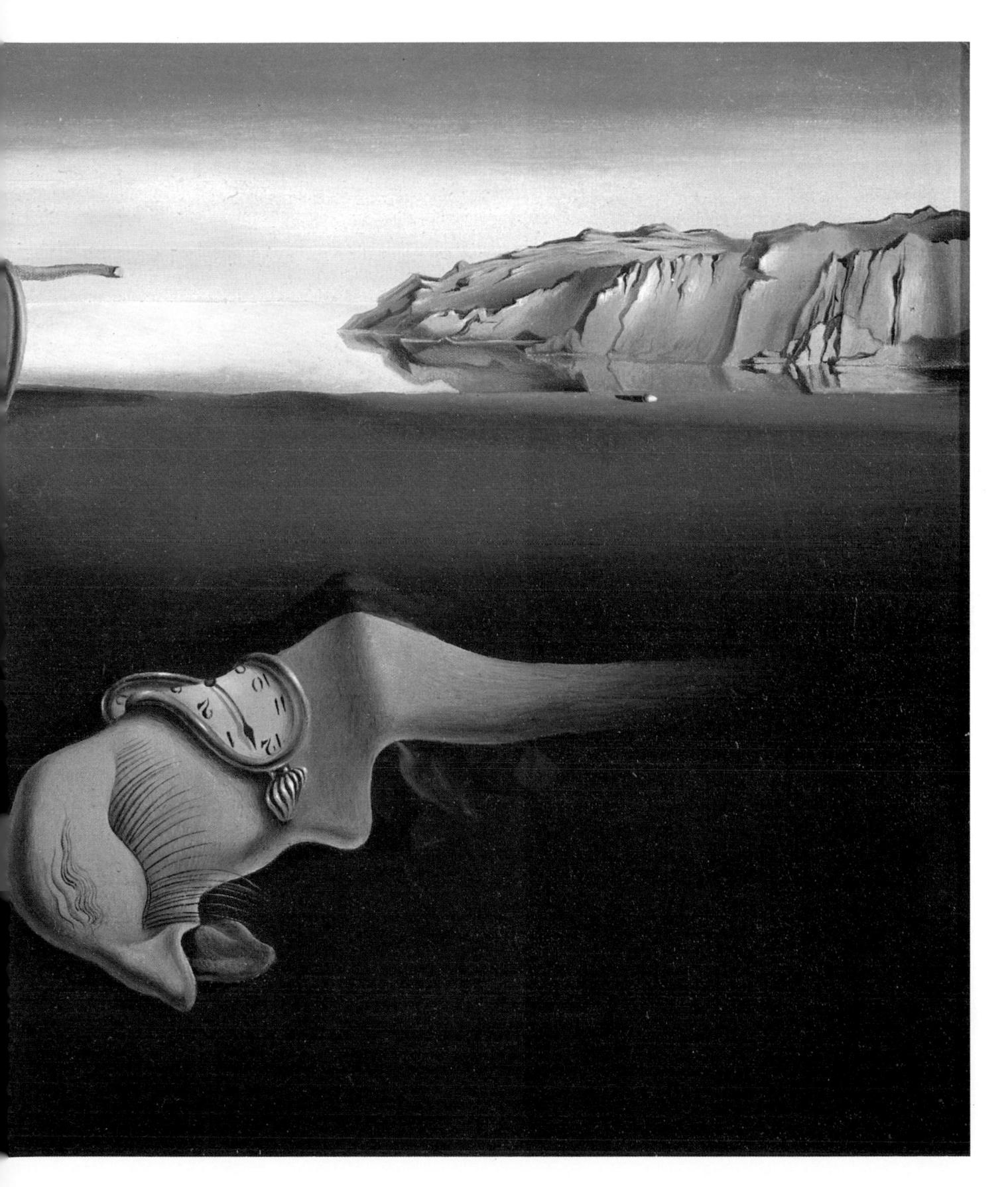

Joan Miro

Personage Throwing a Stone at a Bird (1926)
Oil on canvas
73.7cm x 92.1cm/29in x 36¹/₄in

Within the two dominant types of Surrealist painting, Joan Miró must be counted as the master of the 'abstract' and 'automatic' tendency, while Dali and Magritte dispute pre-eminence in the 'illusionist' style. André Breton, the so-called 'high priest' of Surrealism, was immediately impressed by what he called Miró's 'tumultuous entrance' into the Paris scene in 1924, and by 1925 was lauding him as 'the most Surrealist of us all'. Breton's partisan claims notwithstanding, temperamentally Miró was naturally given to emphasize those aspects of drawing and painting which are promoted by unconscious activity. Over a long career he produced a body of work which constitutes an unparalleled contribution of this kind, but which seems to evade the stylist categories that characterize the period.

Like Dali and Picasso, Miró came from Spain, and gravitated to Paris, the centre of the international avant-garde. He was born in Barcelona in April 1893, and showed an aptitude for painting early. Miró was encouraged by the gallery-owner Dalman, and he visited exhibitions of work by the Impressionists, Fauves and Cubists.

In 1919 Miró made his first visit to Paris, where he called on Picasso, and was warmly received. From 1920 he spent his summers in Montroig where his parents had property, and wintered in Paris, rapidly making the acquaintance of the now famous *dramatispersonae* who created the Dada and Surrealist Movements. He was closest of all to André Masson who moved to the studio next door.

In 1925 Miró had his own show at the Gallery Pierre, and also took part in the first Surrealist Exhibition at the same venue, which included the work of Arp, de Chirico, Ernst, Klee, Man Ray, Masson and Picasso. Thereafter he played a prominent, if distinctly individual, part in Visual Surrealism, maintaining his own style in the face of the challenge of photographic realism. He continued to exhibit in the International Surrealist Exhibitions of the 1930s and 1940s, and there were a number of important retrospectives and travelling shows all over the world.

A highly imaginative man, Miró was very influenced by the landscape and environment which surrounded him; whether the hot, dry farming community at Montroig which inspired his early detailist masterpieces, or the devastating Spanish Civil War which moved him to paint the most realist of his mature works *Still Life with an Old Shoe* (1937). But this is not to deny the importance of his contact with individual Surrealists and their ideas.

Having established himself exclusively as a painter, Miró was drawn, like other Surrealists, to experiment with a much wider range of materials and techniques from the late 1920s. He incorporated sand and rope into his paintings, and turned also to lithography and

papiers collés. Just before the Second World War Miró started working on a much larger scale than he had done before, and for the rest of his career he took up occasional commissions for murals and for wall-scale decorations.

Personage Throwing a Stone at a Bird (1926) was painted at a time when Miró was working at an intense pitch and in a variety of original and persuasive styles.

By 1926 Miró had moved definitely towards calculation and even anecdote. Personage is much more deliberate and posed. Indeed, on one level the work seems to be all about balances and oppositions. The figure throwing the stone, which writer William Rubin aptly characterized as an 'amoeboid biomorph with a cyclopean eye and giant foot', combines the organic contours of its 'body' with the strict linearity of the long straight line that designates its arms. There is a wry enjoyment of the very specific fulcrum in the person's body section, from which the arms lurch in the effort of throwing and which topples the body backwards, drawing attention to the spreadeagled stability of the out-sized foot.

The colour and linear components of the picture operate in localized areas to suggest oppositions of space and scale. The tail feathers of the bird 'invert' the sky and foreground hues, as if to signify the bird as an adept of both media; its chromatic head and crest are strikingly complementary, and this is faintly echoed in the eye of the figure.

Miró demonstrates here enormous technical skill in the management and disposition of the paint in both the larger colour 'fields' and in the minute bands and ribbons of colour. The whole of the green sky area, for example, is deliberately given a scrubby appearance with small, strong brushstrokes aligned predominantly along the diagonal axis described by the 'arms' of the person, but more densely worked in places. This is particularly apparent around the contours of the figure and of the stone, and has the effect of projecting the figure slightly from the surface and of giving it a kind of mock three-dimensionality.

Clearly visible behind this textured area are a series of faint lines, suggesting the original grid from which Miró tended to construct his work. The thin black arm-line terminates precisely against one of these grid markers. Notable also is the miniature signature and date, near the 'wing' of the bird, which stand out against the yellow ground rather like the colour that highlights the mini-cliffs and peaks of the shoreline.

In this work, Miró has allied the skills of the detailist to the larger sweep of Surrealist biomorphism with its continuous curves and contours, and he sets the two within abstract-looking colour fields and geometries. *Personage* is one of the most remarkable syntheses in inter-war painting.

JOAN MIRO

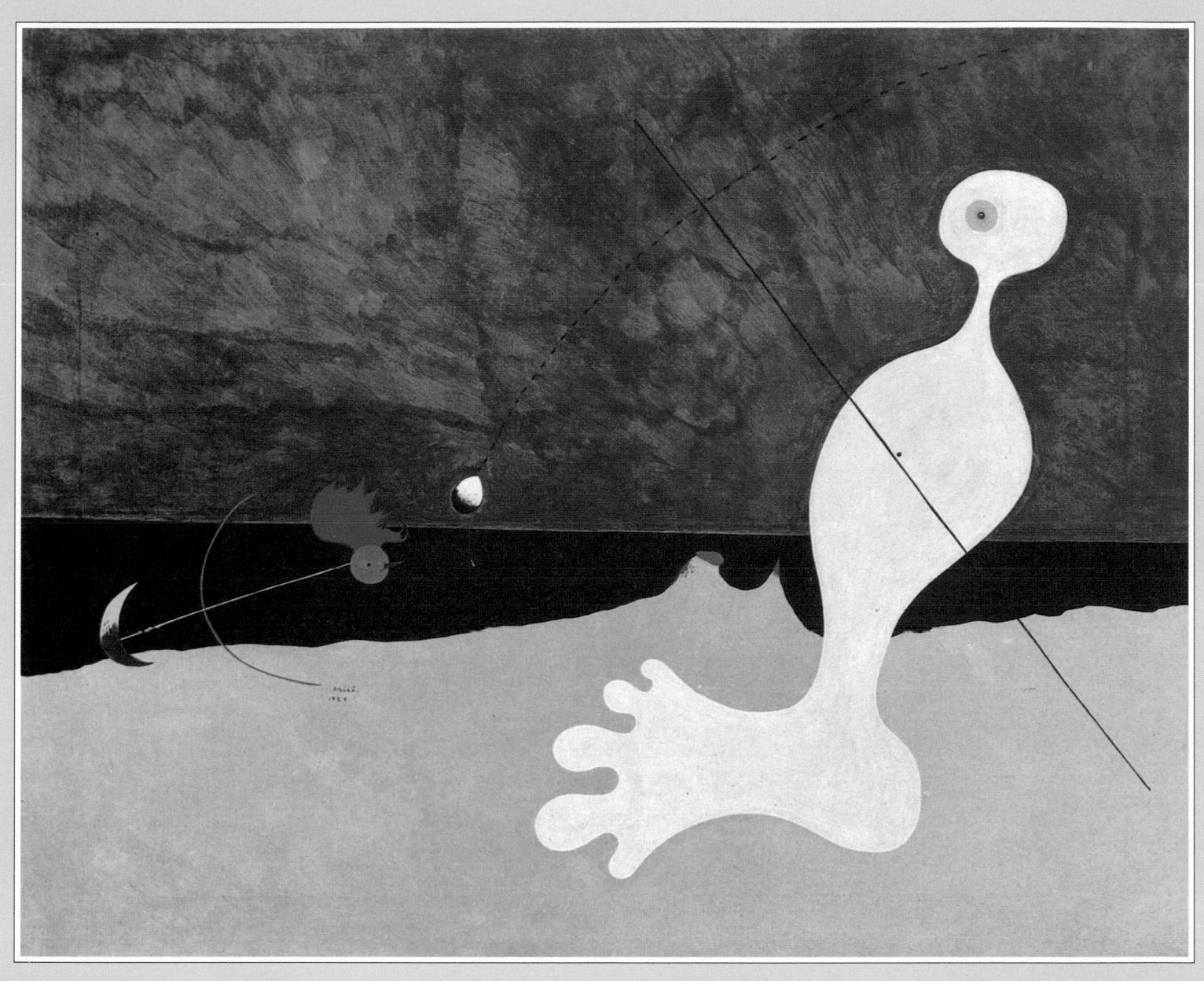

Grid marker showing underneath the green sky

Brushstrokes change direction round body of figure

Flecks of green incorporated in yellow of tail feathers

Signature and date in minute, strategically placed calligraphy

Trajectory of stone indicated by dotted lines, the sketched radius visible underneath

Black spot for body 'fulcrum'

Horizon-line tilts slightly down, left to right

Evenly worked black sea

One of the fascinating series of 'Personage' paintings by various Parisian-based artists in the later 1920s and 1930s, this is divided into three zones — sky, sea and sand — each worked in a different way. There is a delicious visual wit in the articulation of the activity in process, that of 'throwing' which takes place on the shore. A series of very fine touches enhances the poise, balance and placement of the scene.

JOAN MIRO

RIGHT The body of the Personage is brushed with visible, greying white strokes, their directions mostly following the figure's contours. All descriptive reference is reduced, the torso swelling in a bulbous shape, and flowing into the disproportionate foot. Arms are signified by a trim black line which is momentarily 'lost' passing through the similar black of the sea. The horizon line behind the coloured peaks of the shore is flared with white. Slight traces of blue are blurred into the green above and to the right of the purple 'crater'.

RIGHT The head of the Personage is devoid of particularizing features, except for the off-centre eye. Miró has deliberately chosen to echo the dominant hues of the eye work in miniature here, so that the 'white' of the eye, as it were, is the same yellow as the sand, and the inner eye combines the red of the bird's crest with the sky — green and a touch of white in the centre. As elsewhere in the figure, brushstrokes are aligned in accordance with the external form and hug the internal features; here they rotate around the eye and funnel down the neck.

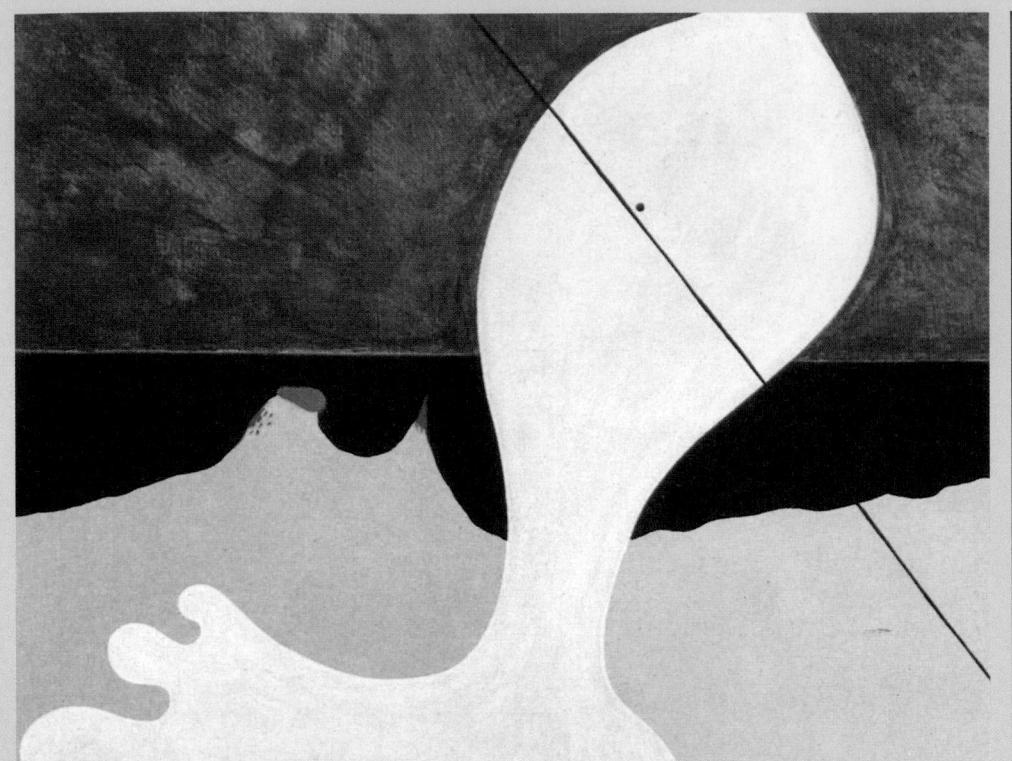

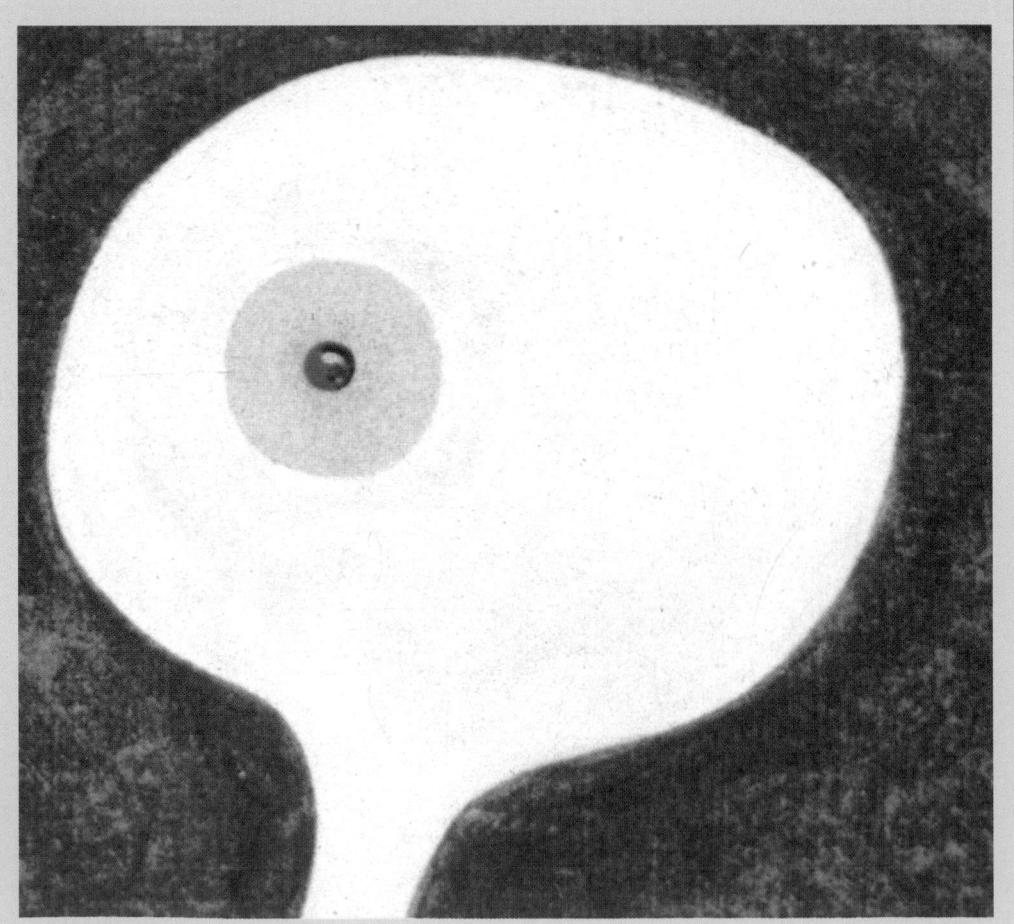

ACTUAL SIZE DETAIL Like the Personage itself, the bird is an amalgam of abbreviated signs, reinforced by an appropriate colour system. Its body section is a pencil-thin shaft of white, the wings, an arc of light blue which cuts through the sky, sea and land zones. This blue is concentrated into the circular head with its eye and beak, while the red crest is skilfully designed as a sweeping curve on the left and a succession of fiery peaks on the right, which actually incorporate strands of sea-black where the two colours intersect.

JOAN MIRO

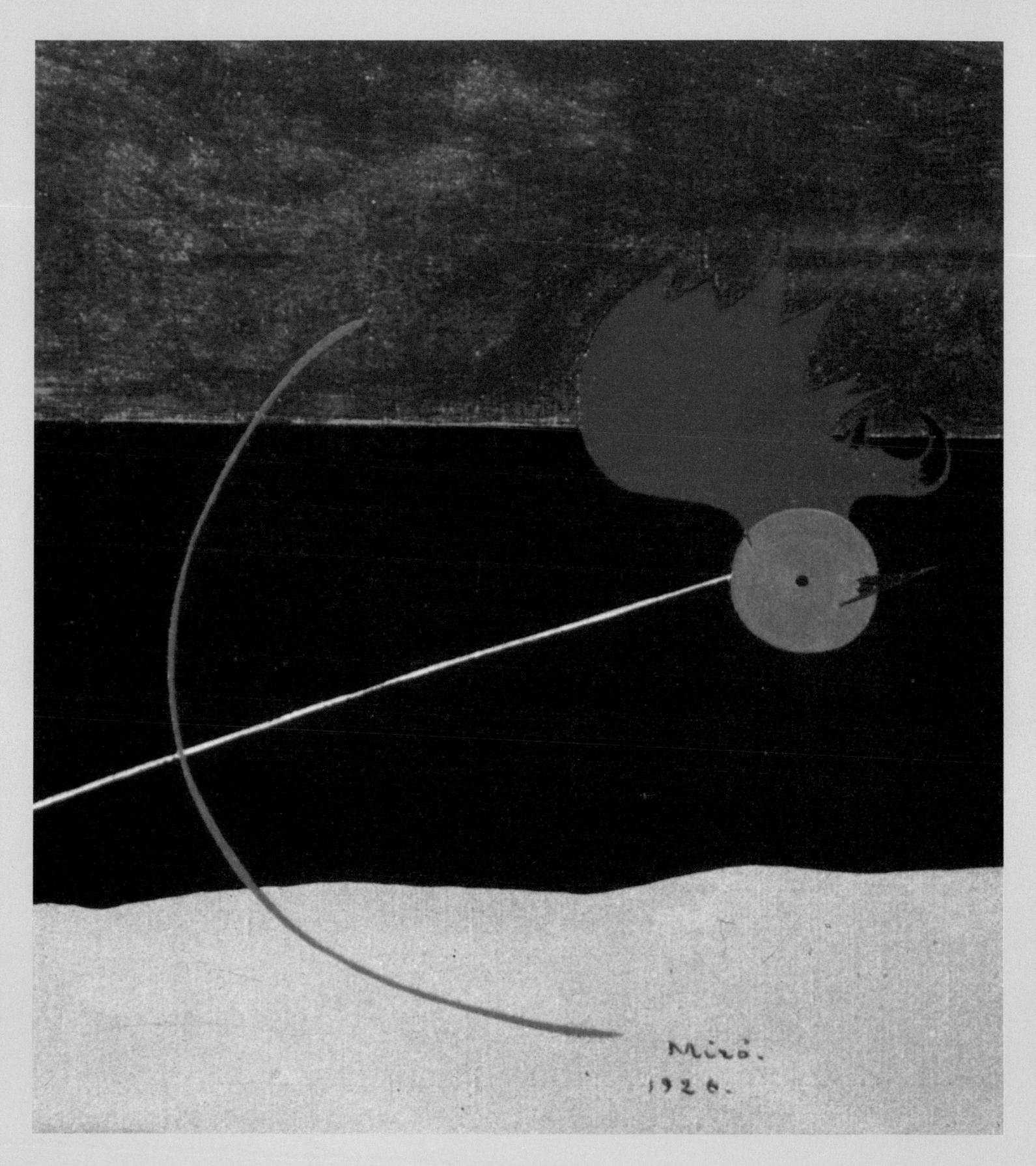

Composition with Red, Yellow and Blue (1921)
Oil on canvas
39cm x 35cm/15½in x 13¾in

Mondrian is the twentieth century's greatest exponent of Geometric Abstraction; the model or frame of reference for most, if not all, subsequent activity in this area. His dedication and purity of vision have become legendary; the sequence of his works in a mature career of some 35 years constitutes the most scrupulous evolutionary progression, within the tightest margins of trial and error, of probably any Western artist in the history of painting. His aims were lofty and spiritual: he fought constantly against materialism, and he was determined that the world would benefit from the creation of purely 'abstract environments'; his paintings were just a starting point - red, yellow and blueprints for a new mode of living.

Piet Mondrian was born in March 1872 in Amersfoort, in the central Netherlands, into a strict Calvinist family. He attended a teacher's training course in drawing at the National Academy of Art in Amsterdam, and then spent most of the 1890s learning and painting influenced by the seventeenth-century Hague school realism. His work for the next 10 years was mainly in landscapes; the River Gein was his favourite scene. From 1908 he made formative visits to Domberg in Zeeland and painted briefly in the style of Dutch Luminists such as Rembrandt and Jan Vermeer (1632-1675) and later in his own version of Fauvism.

As with many important non-French artists in the first half of the twentieth century, his visit to Paris (in 1912) was crucial. He quickly responded to the Cubist painters and was noticed by Apollinaire when he exhibited at the Salon des Indépendants in 1913. Forced to return to The Netherlands in 1914, he made contacts with the theosophist Dr M. H. J. Schoenmaekers, the painter Bart van der Leck (1876-1958) and the ambitious critic and artist Theo van Doesburg (1883-1931). This led to the publication in 1917 of the magazine *De Stijl (The Style)* and to the launch of the movement of the same name.

But at virtually the first opportunity, Mondrian returned to Paris, where, from 1919, he lived an isolated and occasionally poverty-stricken existence throughout the 1920s. In 1920 a summary of his theoretical ideas was published by Léonce Rosenberg; he moved to London in 1938, and spent the last four years of his life (1940 to 1944) in New York, where his work developed remarkably.

As well as being affected by the major modern movements of the 1900s and 1910s, Mondrian was peculiarly susceptible to ideological influences, particularly from theosophists. For him, the opposition of vertical and horizontal lines represented the quintessence of the life-rhythm. Mondrian spent a lifetime exploring this relationship.

But Mondrian was subject to many other important stimuli. His fondness and sympathy for modern music is reflected in an essay he wrote in 1927, Jazz and Neo-Plasticism; and the culminating role which he assigned to architecture indicates his visionary, Utopian nature: 'At present Neo-Plasticism manifests in painting what will one day surround us in the form of sculpture and architecture.' Mondrian's own influence has been enormous, and embraces areas such as architecture, design and advertising.

Piet Mondrian was essentially a painter and a perfectionist. He moved fairly rapidly through a large variety of methods of paint application in his earlier works; the heavily textured impasto work of Dusk (1890), Neo-Impressionist dots and splashes in 1908, and slightly later Fauve colour patches. As he tightened his pictorial structure and reduced his colour under the influence of Cubism between 1912 and 1914, the technical effort of adjustment, concentration and refinement is often visible on the canvas surface as pentimenti or erasure scars. This is visible evidence of experiment and uncertainty, and the practice continued even into the 1920s when he had finally established the basic relational units of his composition as the straight line, the right angle and the three primary colours (red, yellow and blue) and non-colours (white, black and grey).

Late 1921 has been seen as the great threshold in Mondrian's career; the year in which his elementary triad of colours was first organized with confidence and deliberateness, and his lattice-work of lines became thicker and more certain. Other factors were so reduced that his art had become one of placement, balance and equilibrium.

Mondrian's working method is difficult to reconstruct precisely, but there are a number of first-hand accounts of his famous Paris studio with its bright white walls and mobile colour rectangles. He favoured canvas formats which approached squareness, but seldom had sides of exact equivalence. Composition with Red, Yellow and Blue is small in comparison to the bulk of his Paris production. He often worked from small preparatory drawings, and transposed and amplified the system of lines on to the sized canvas with charcoal. The artist and critic Michel Seuphor (b 1901) noted that Mondrian used a ruler and 'ribbons of transparent paper' as his only tools. His biographer J. J. Sweeney embellishes this account: 'How did he approach the picture? Well, I found that he approached it by using collage frequently, pasting papers on the canvas, changing the colours around, organizing them that way, not just in his mind only but also on the canvas.'

'He built his paintings as if they were marquetry', noted one critic. Especially in the 'classical' Neo-Plastic works, colour choices were normally made at a fairly late stage, and may have been quite arbitrary; they were certainly subordinate to the painting's structure.

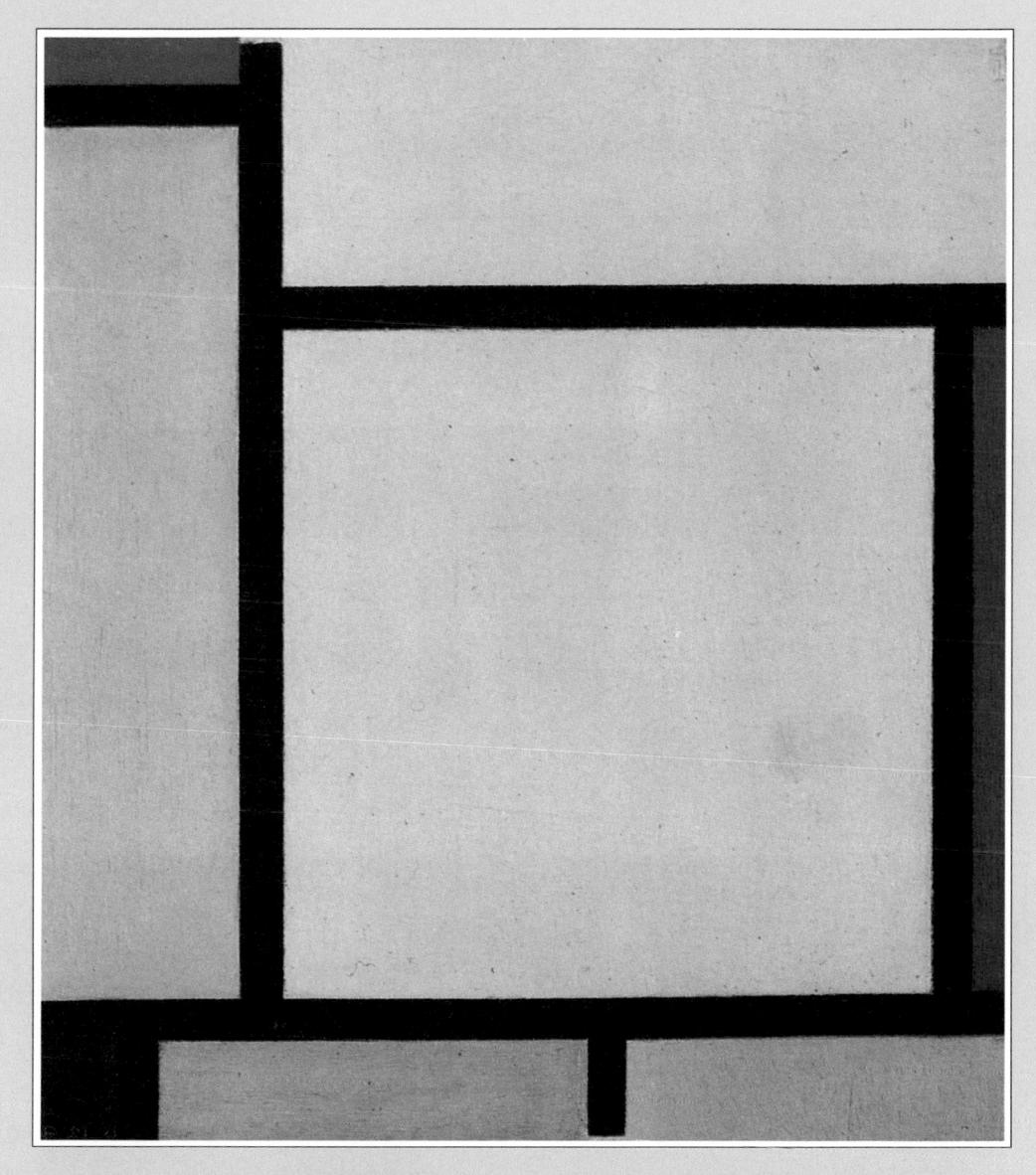

In the first two years of the 1920s, Mondrian finally resolved his compositional structure and the dialogue of colours which was to animate it. But close examination of this painting's surface reveals that fineness of finish is entirely subordinated to the effect of the design: placement is vaunted over neatness of paint application. This may be related to the reduced circumstances in which the artist found himself in Paris, but more important is his passionate assertion of the priority of ideas and spiritual values over the material means of painting.

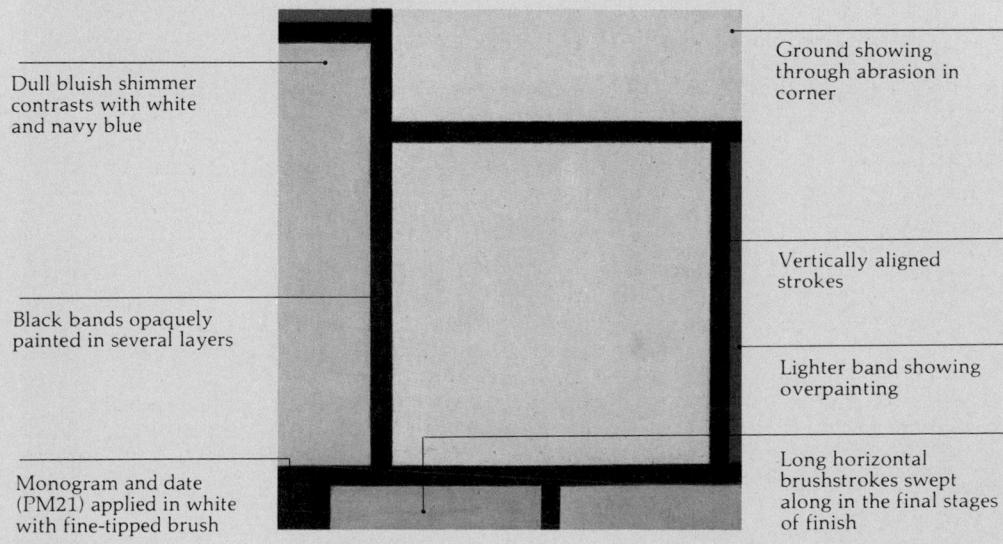

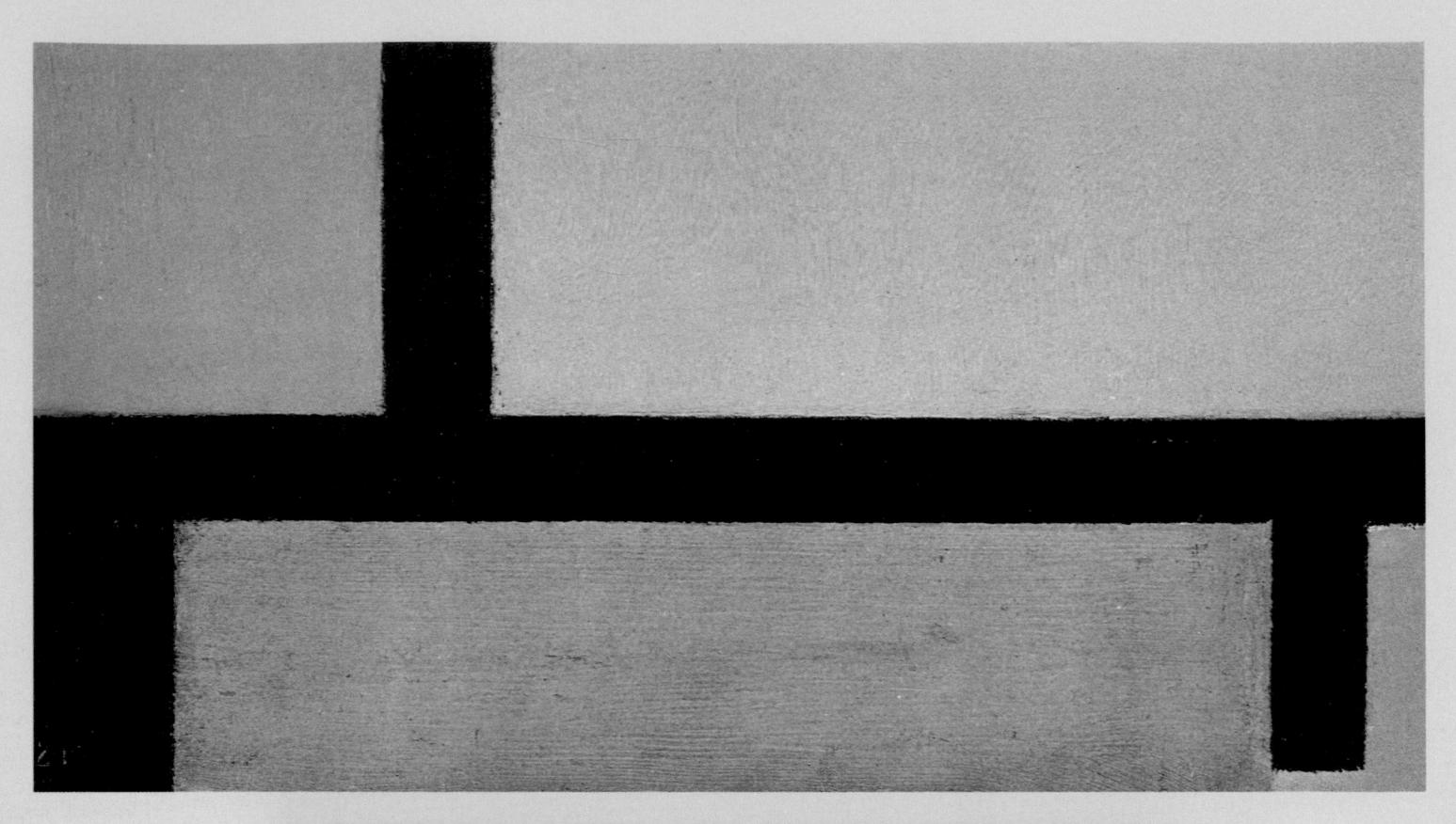

ACTUAL SIZE DETAIL The coarsely painted frame is set back from the edge of the canvas, its white spilling into the picture on the left, and sections of brown wood visible along its outer edge. The yellow rectangle is unevenly filled in, with a discontinuous band of denser pigment round the perimeter and small deposits of impasto in the bottom corners and in the interior. Elsewhere, the brush has furrowed the paint in yellow bands alternating with white ribbons where the ground is visible. Minor flecks and incursions are evident along the black/colour boundaries.

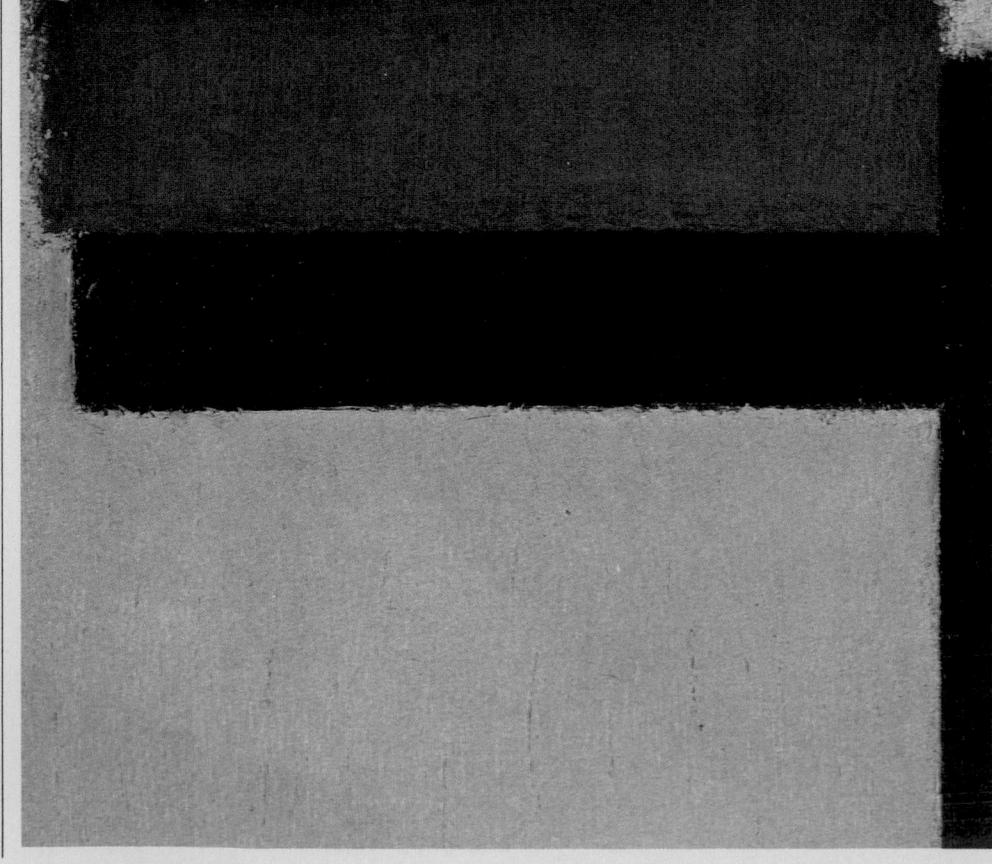

LEFT All the coloured rectangles at the peripheries of the composition are zones of painterly complexity and irregularity, but the red area here is blitzed with uncertain dabs. In three places, Mondrian has deliberately resisted the termination of black lines and of the red rectangle flush with the canvas edge. This disencourages the viewer's imaginary construction of a tessellated continuation of the design. It removes the work from the world of mere pattern and asserts it as a statement in paint about balance and equilibrium, bounded by a painted frame.

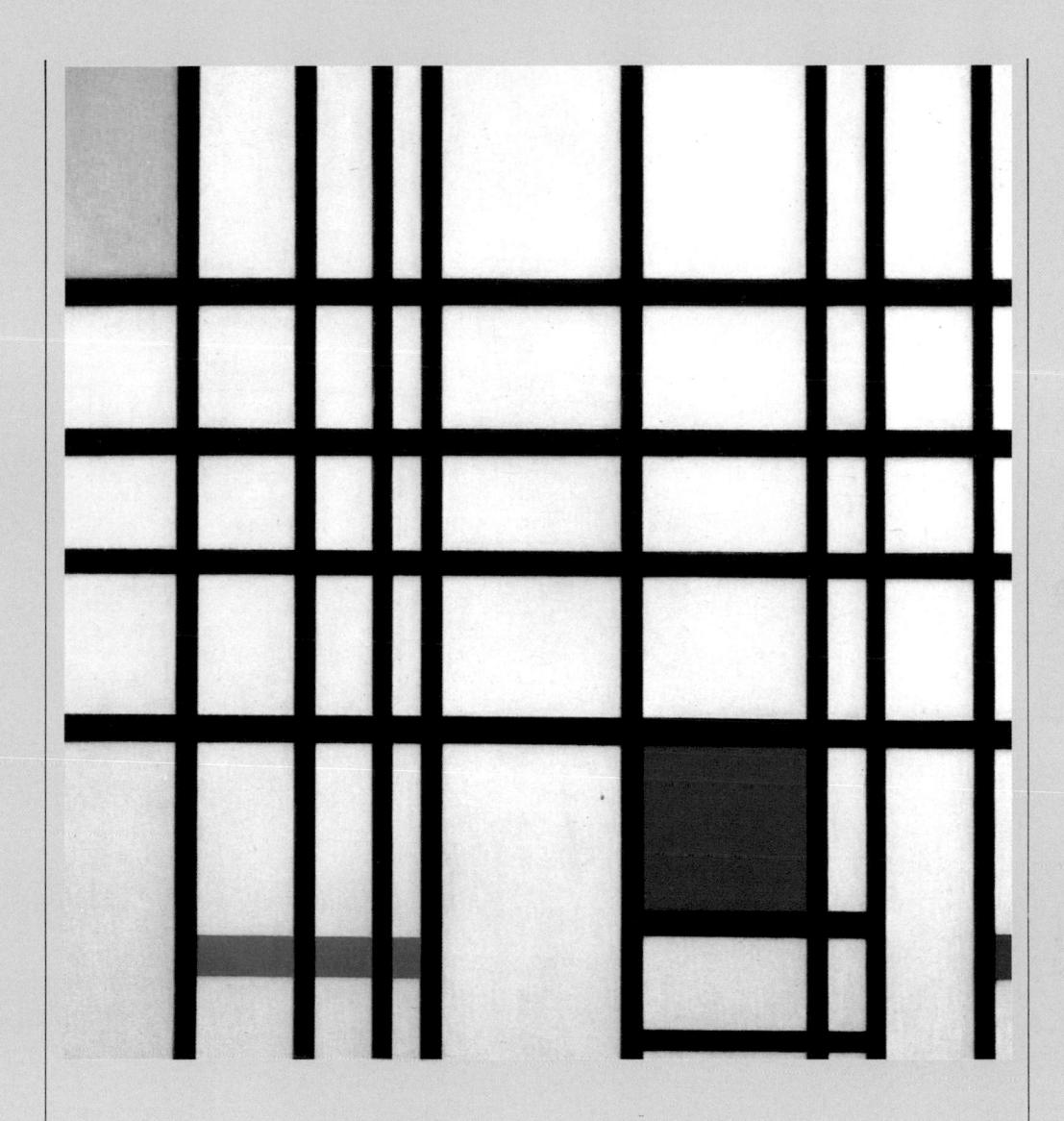

ABOVE Composition with Red, Yellow and Blue was begun in 1937 and worked intermittently until 1942, by which time Mondrian had moved to New York. The lattice-work of lines has been complicated considerably so that eight unevenly spaced vertical black bars mesh with four horizontals and two partial lines. As in the earlier painting of 1921 colour zones

inhabit the centre, but one important modification is the use here of unbounded edges for the long sides of the blue and red rectangle. The blue thus becomes neither colour patch nor line.
Technically the finish of this work is more rigorous and definite than the earlier one, but still is in no way mechanical or completely 'hard-edged'.

L'avant port, Marseilles (1924) Tempera on linen laid on a wooden panel 61cm x 89cm/25in x 35in

Edward Wadsworth's wife recalled how her husband loved to read books about art; indeed he read almost constantly 'on painting, and most of all, books on the technique of painting. As for Cennino Cennini's treatise [Il Libro dell'Arte] he read it again and again - he was always reading it.' Cennini was a Florentine painter who wrote a treatise in about 1390 as a technical textbook for those who wished to enter the profession of artist. It contains, among much else, detailed practical information on tempera techniques. Wadsworth, a painter who cared passionately about technique and craftsmanship, abandoned oil painting in favour of tempera in mid career, and he could not have turned to a better technical guide.

Right from the beginning of his artistic career in 1908, Edward Wadsworth, who was born in Yorkshire in 1889, favoured a style which was precise, ordered and mathematical. He liked to portray subjects with a definite shape and recognizable function. He had studied engineering which he gave up to become a painter. After studying at Bradford School of Art and the Slade, he flirted briefly with Post-Impressionism, and for a time was associated with Wyndham Lewis's Vorticism.

Wadsworth had a deep love of the sea and ships. His first recorded oil painting in 1908 was a view of Le Havre; in 1919 he produced an oil painting of *Dazzle Ships in Drydock at Liverpool*, and he made copperplate engravings, which he then hand-coloured, for a 1926 publication entitled *Sailing Ships and Barges of the Western Mediterranean and the Adriatic Seas*.

1926 was also the year in which he exhibited L'avant port, Marseilles at the Leicester Galleries in London. Five years earlier, on the death of his father, Wadsworth had inherited a fortune. He spent most of his time from then on in the south of France, and several paintings exist with the same subject matter: the port of Marseilles. Wadsworth is known to have planned a series of paintings of the principal ports of Britain but this seems to have been abandoned with his growing interest in France.

Tempera is a medium peculiarly suitable for depicting decorative and detailed forms seen in the clear open-air light, as in *L'avant port*, *Marseilles*. Although Wadsworth loved the sea and ships, the sea, in his art, was always seen in a subordinate role: he portrayed it in perfect calm as a still support for the complicated and detailed vessels which traverse its surface.

L'avant port, Marseilles is painted in tempera on a plywood panel. The plywood has a fine layer of linen canvas stretched over it to provide a base for a thick layer of gesso ground. To temper means to mix with powder pigments a binder or medium, usually the yolk of an egg mixed with a small amount of water, and acetic acid, such as lemon juice (which prolongs the life of the yolk).

The most important aspect of tempera is the

rapid drying of the pigment once it comes into contact with the gesso support. This means that the colour has to be built up gradually by laying one thin coat over another, or that transitions of tone or colour have to be made by hatched strokes. Both approaches can be seen in L'avant port, Marseilles. The cool blue of the sky is laid on so that the white of the gesso ground textured by the linen layer shows through in parts. It also appears to have been rubbed, bringing up white highlights in the sky. (This rubbed quality cannot be due to wear and tear, since the painting seems to be in its original frame behind glass.) The hatching technique is apparent in the shadows, especially in the shaded areas of the three hulls. Wadsworth began work on the panel by drawing his composition in pencil upon the gesso ground. He had a preliminary sketch as a model, and he used the squaring up method to transfer the original sketch, done in front of the motif, into the design for the painting.

The clarity of the composition and the intricate detailing of some of its parts are due in a large measure to the amount of preparation which preceded the actual painting. The art critic S. Kennedy North, who wrote the preface for Wadsworth's first exhibition of tempera paintings at the Leicester Galleries in March 1923, noted that the oil painter 'could think once and draw six times', whereas the tempera painter 'must think six times and draw once'. Some of the finest lines in L'avant port, Marseilles have not only been drawn in before painting, they have also been scored into the gesso ground so as to give Wadsworth the clearest possible guide for his loaded brush. His signature and date have also been scored into the ground.

The range of colours used is subtle and harmonious, with a gamut of earth colours relieved by sharp accents of viridian and ultramarine. Unlike in oil painting, the tempera artist cannot rely upon thick impasto, or upon the texture of the pigment for effect, nor can one colour be fused into another.

For a few months in 1938 and 1939 Wadsworth experimented with Seurat's Pointillist technique in tempera. (A stippling technique – laying colours in by means of dots of paint – was an accepted tempera technique.) Wadsworth's experiment was short-lived, but it did produce *Honfleur: Entrance to Harbour* (1930). This painting is dependent for its choice of subject matter and its composition on Seurat's canvas *Entrée du port à Honfleur* of 1886.

But L'avant port, Marseilles is an example of the technique which dominated Wadsworth's work until his death in 1949. Surrealism was a strong influence and from it he developed his distinctive painting style – notable for its dreamlike clarity and the oddities of scale and juxtaposition of familiar seaside objects.

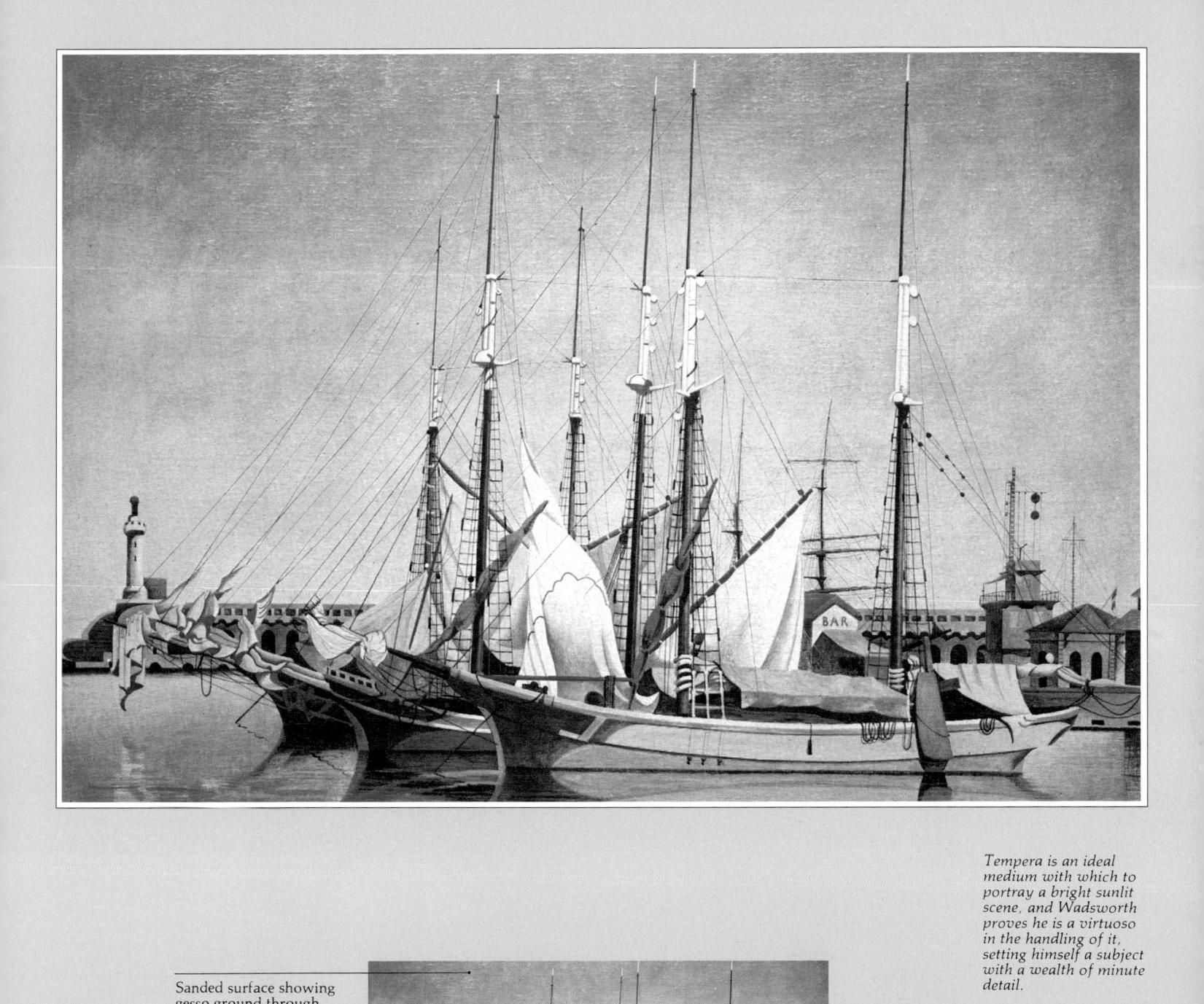

Sanded surface showing gesso ground through the paint layer

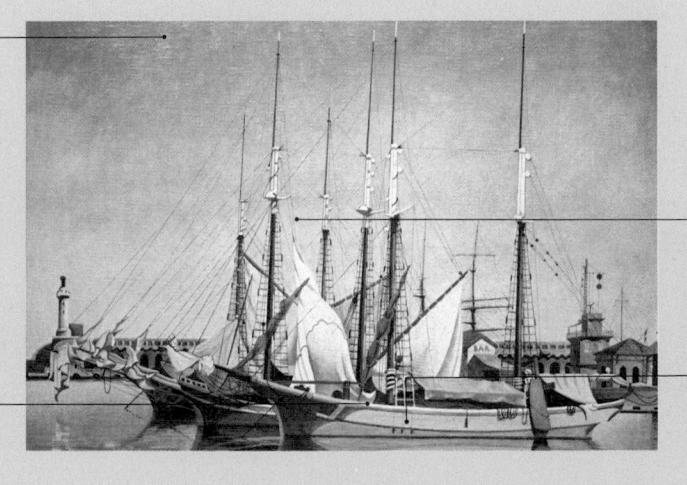

Fine lines of rigging drawn and painted with the aid of a ruler

Hatched brushstrokes create the shadows

Preliminary squaring-up of ground with pencil still visible

RIGHT The main colour accent, ultramarine, is used equally for the mast in sunlight and the building in shadow. For the plane in shadow it is applied over a layer of terre-verte. The word BAR thrusts itself forward onto the picture plane.

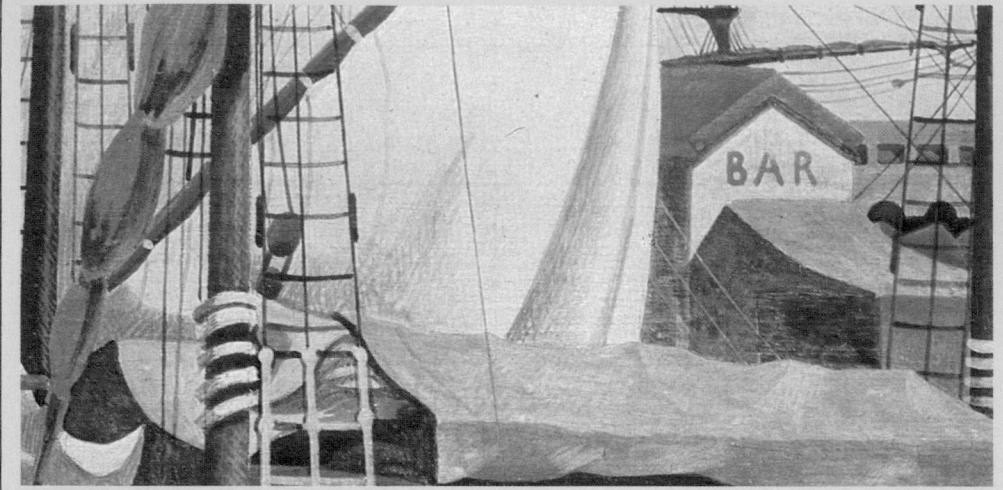

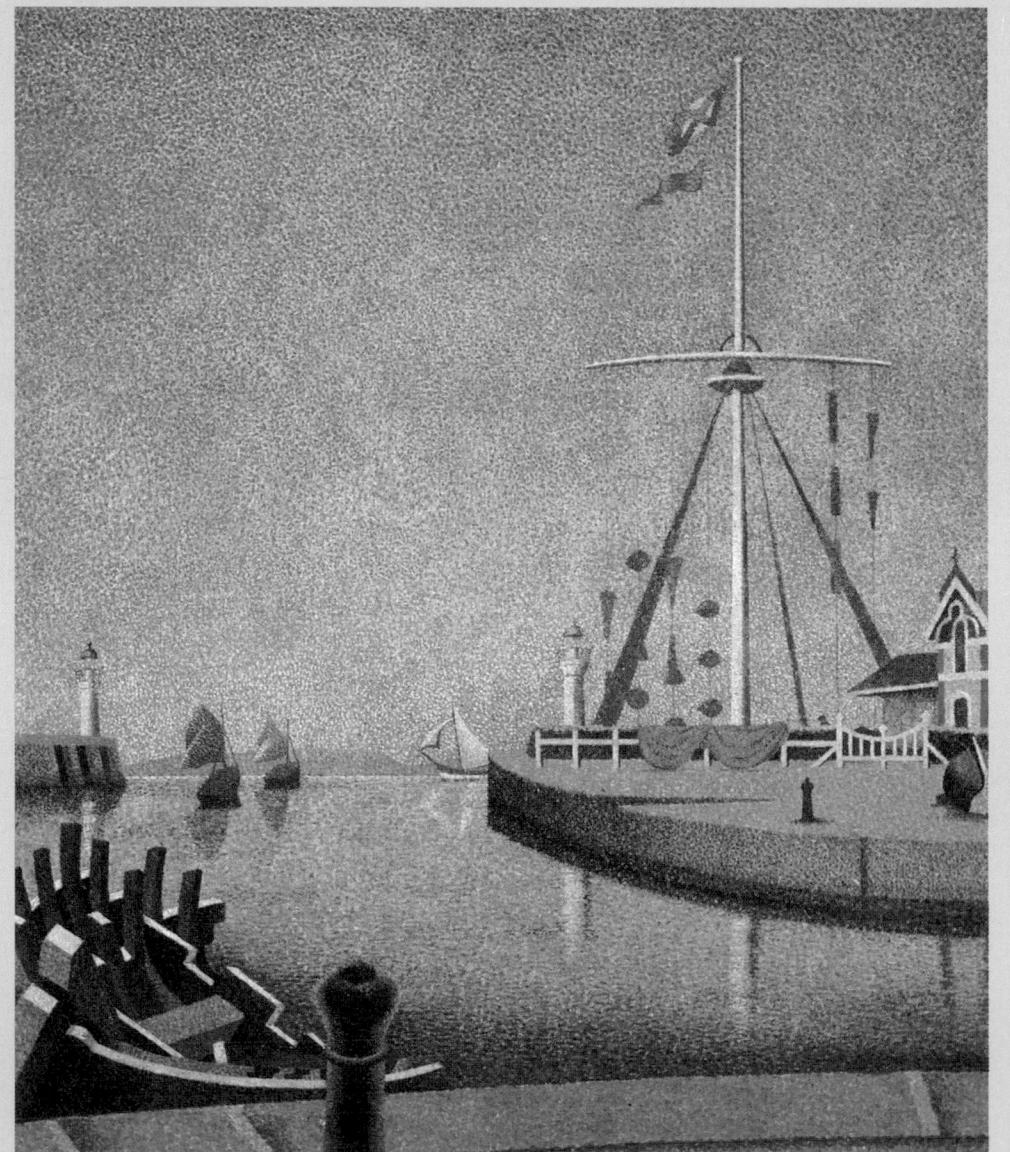

ACTUAL SIZE DETAIL The nails with which Wadsworth attached the plywood panel to its backing, a strong wooden frame, are visible at intervals along its edge. At the very edge some flaking of the gesso ground can be seen, and also air bubbles caused by the application of thick pigment. The light areas of the composition, the sails, the sunlit lighthouse and sea, are the most thickly painted and become opaque in quality, preventing the white gesso ground from showing through. In contrast, the areas of dark shadow, the water under the hulls, have more diluted paint and rely upon transparency. The original pencil drawing marking out the contours shows throughout, and Wadsworth has preserved those contours by carefully painting his colours up to their edges.

RIGHT: In Honfleur:
Entrance to Harbour
(1939) Wadsworth does
not rely upon the effect
of luminosity which a
white gesso ground can
provide. He has
covered the whole panel
with a thick weave of
Pointillist dots and
dashes, the largest
brushmarks being at the
bottom of the
composition. Stippling,
or Pointillism was not a
technique he employed
in L'avant port, and he
was only to pursue it
for a short period.

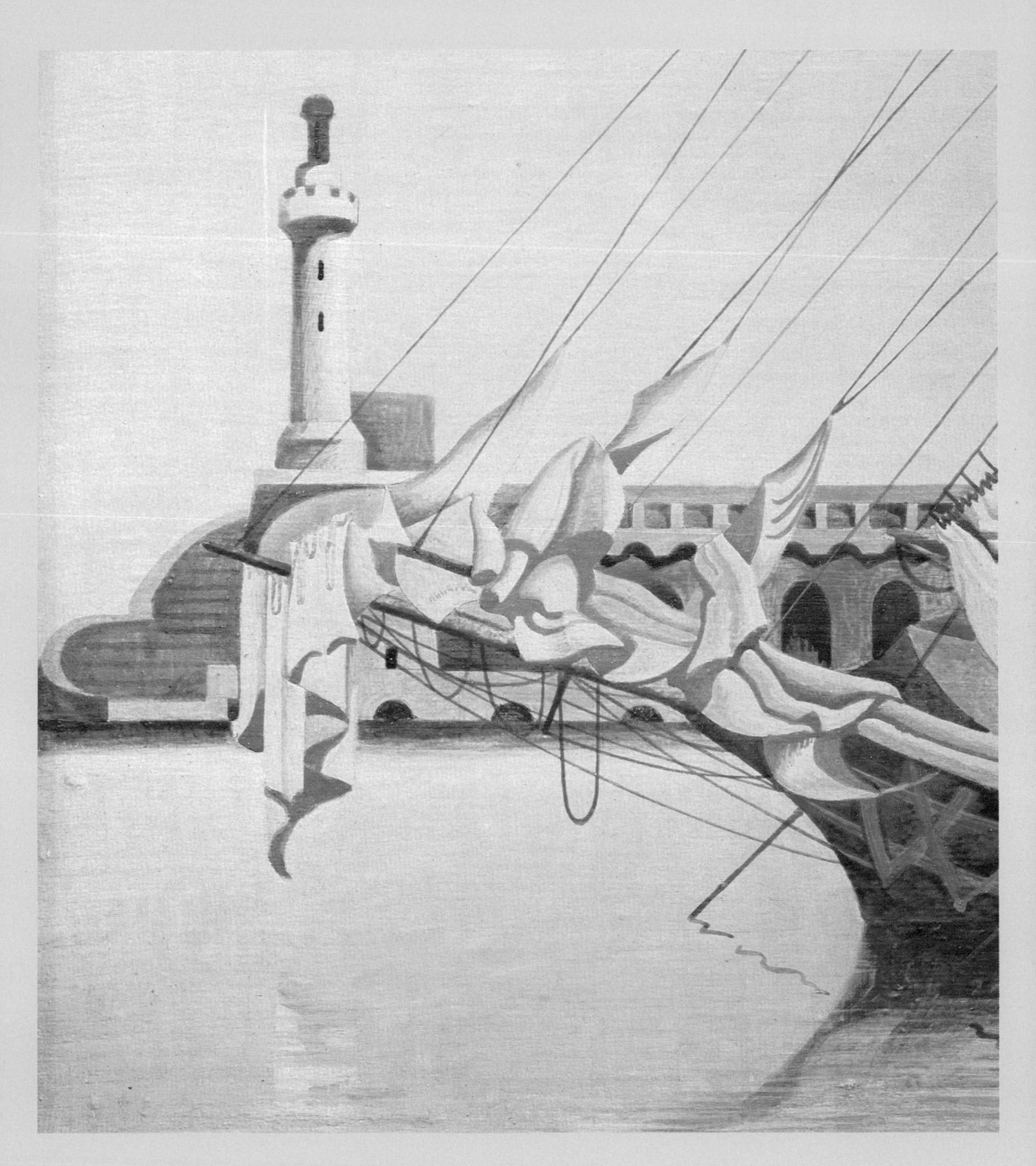

La fenêtre (1925) Oil on canvas 108.6cm x 88.6cm/42³/₄in x 34⁷/₈in

An acute observer of light values, though a rather conservative painter by twentieth-century standards, the Post-Impressionist Pierre Bonnard was born in 1867 in Fontenay-aux-Roses. As a young man he first studied law, and then painting at the Ecole des Beaux-Arts and Académie Julian. He joined a group of artists associated with Gauguin who were called Nabis (a Hebrew word meaning 'Prophets'). His first success was a poster France – Champagne (1891).

Bonnard's early career covered many aspects of design including furniture, poster and theatre commissions and many important book illustrations, in particular for the novel *Marie* by Peter Nansen, which was published in *La Revue Blanche* in 1898 (and which appears on the table in *La fenêtre*). These lithographs were singled out for praise by Renoir. From about 1905 Bonnard concentrated increasingly on painting in the Post-Impressionist tradition, uninvolved with the avant-garde.

In 1925 Bonnard moved to Le Cannet near Cannes. *La fenêtre* is a view from the window of his house Le Bosquet, where he died in 1947. Bonnard required the white priming in this canvas to act in two ways: firstly, left uncovered, it is used as a tone or shade of white in several parts of the picture, such as some house sides; secondly, it gives the colours additional radiance, if they are applied thinly enough, just as watercolours gain their brilliance from the whiteness of the paper.

Bonnard's technique was also linked to his instinctive discipline for colour which came from his experience of poster and printmaking, especially lithography: 'I have learned much about painting proper from making lithographs in colour, when one has to establish relations between tones by ringing the changes on only four or five colours, superimposed or juxtaposed, one makes a host of discoveries.'

Henri de Toulouse Lautrec (1864-1901) had been a strong influence on Bonnard's lithographic work. The two painters, like many others including Monet, were fascinated by Japanese prints with their powerful compositions and purity of colour. In *La fenêtre* this influence can be seen in the almost flat diamond pattern of the tablecloth, and the abstract rhythm of the green shutter slats which have a tendency to flatten out the perspective of the composition and make the distant colours jump forward with surprising strength.

Bonnard used a palette of about eight highquality colours which he applied, for the most part, very thinly. They were made to perform a great number of functions. A scarlet vermilion was applied pure, speckled beneath the green window bar. Bonnard often mixed it with a Venetian red which appears in the cover of the portfolio on the table. Mixed together they make a warm pink (with the addition of zinc white). An expensive cobalt violet produced a near rose pink when mixed with the vermilion and white in the writing box at left, and a cool brown when combined with the colours of the window frame at the top left of the picture. This same violet adds a coldness to the sky next to a cerulean blue, and is a powerful dark when touched into the hair of the woman.

Only two blues were used. The cerulean can be seen pure in the distant hills running in from the left and in dashes on the right of the window frame. There are only small amounts of the cobalt blue, often applied with a finger to add a particular depth, such as in the tiny area between the chin and arm of the figure.

Two yellows are discernible. A lemon cadmium appears with rare impasto over some foreground roofs and thinned with white for glazes in the foreground cloth. Yellow ochre complements the lemon to provide some drawing around the red book. Vermilion and lemon were put side by side to colour the rooftops 'orange'; a common Divisionist device.

Bonnard used viridian to great effect. He thinned it with zinc white to create the transparent acid green of the shutters and in the angled window bar. It was also used in the heavy green of the clumps of woodland.

White is one of the keys to an understanding of Bonnard's technique in *La fenêtre*. A flake white was used in the thickly applied pure white sheet offered to view, which then calls across to the pure whites and primed canvas of the houses, creating a set of optical stepping stones into the distance.

Bonnard also employed a black in a similar way. It was applied very pure, not to darken any of the colours artificially. This was a practice inherited from Monet. Ivory black can be found in the ink pot and in the dark areas of trees which draw the eye into and across the distance; like opening a Japanese fan.

Bonnard's planning of this painting is complex, and would have taken a long time in order to record colour and light precisely while, at the same time, sacrificing nothing of its transparency and depth. There is evidence of the meticulous brushwork which achieves such results in places such as the grid of the tablecloth, and in the house roofs and in the verticals at right. The only area which is truly opaque is the rectangle of sky. Much of the painting was applied with rags rather than brushes. This technique creates an unfocused appearance yet allows a strong sculptural quality in the 'architecture' of the painting.

Bonnard's slow, planned application of colour next to colour or superimposed one on the other, forces the viewer to actually do the colour mixing and see the world in skilfully contrived contrasts. The result is a sophisticated colour 'mechanism' which convinces with painterly deception, as Bonnard himself confessed: 'Il faut mentir' (one must lie).

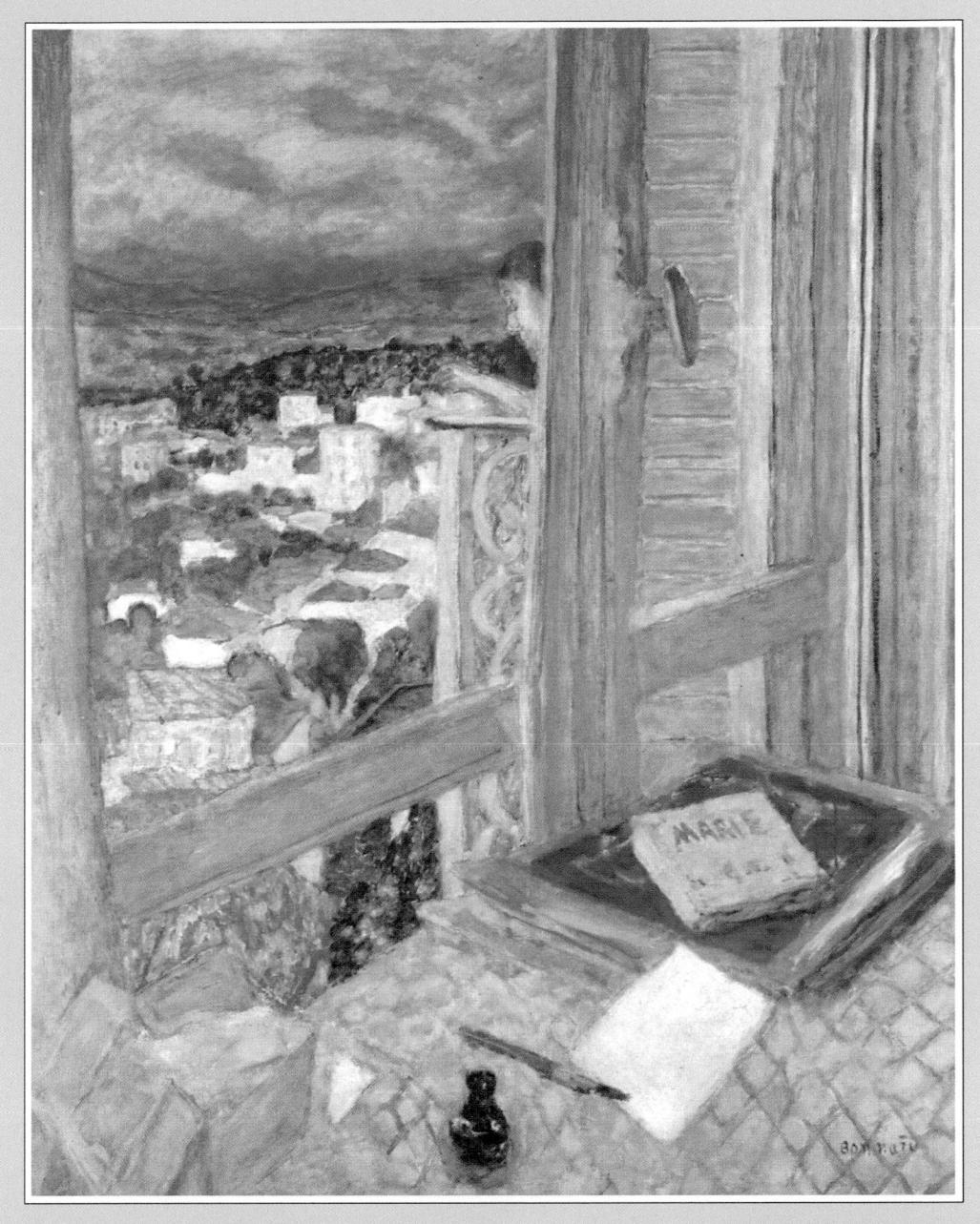

Bonnard is best known for his 'intimist' paintings. In La fenêtre he has made the randomly placed articles on a desk top echo the pattern of the village below. These mundane elements are elevated by Bonnard's slow and meticulous assembly of brushed and wiped colour and glazes to bring out a compelling mesh of abstract colour relationships.

The white primed canvas was allowed to break through in places, especially in the sides of the houses

Some touches of pure vermilion or cadmium red are put in to vibrate against the emerald green window frame

Areas of quite thick impasto create the texture and colour of some foreground roofs

A fine brush was used to mark in areas of drawing with greater emphasis, such as the tablecloth or verticals of the window frame

RIGHT In 1897, some 28 years earlier than La fenêtre Bonnard had made a set of lithographic illustrations for Peter Nansen's novel Marie which Renoir admired and was a triumph that is wittily referred to. Bonnard was noted for a great sense of humour. His interest in lapanese prints is evident in the flattening out of the foreground perspective to emphasize its patternlike qualities. The blank sheet, probably another piece of pictorial wit is brushed in with an impasto of flake white as is the pen handle. In contrast the tablecloth was built up slowly from a series of transparent glazes to create a translucent mosaic of pastel tones.

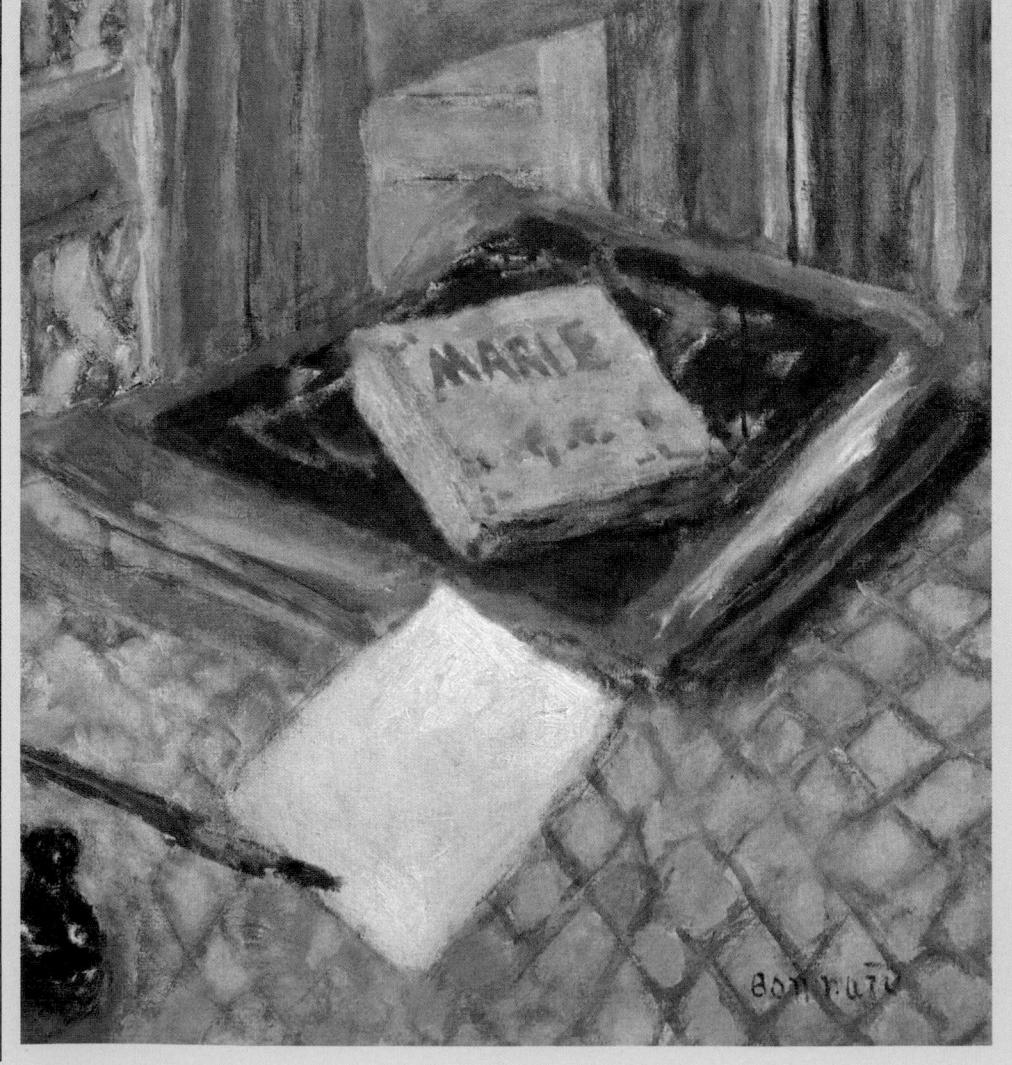

ABOVE Bonnard had worked with Monet for a while and inherited an Impressionist approach to landscape that did not prevent him rendering visual facts with a level of accuracy. The whites of the houses are a combination of flake white and the white canvas priming. These tones harmonize with the pure white sheet on the table, just as the pink and yellow ochre brushmarks in the roofs and windows find their equivalents in the tablecloth pattern.

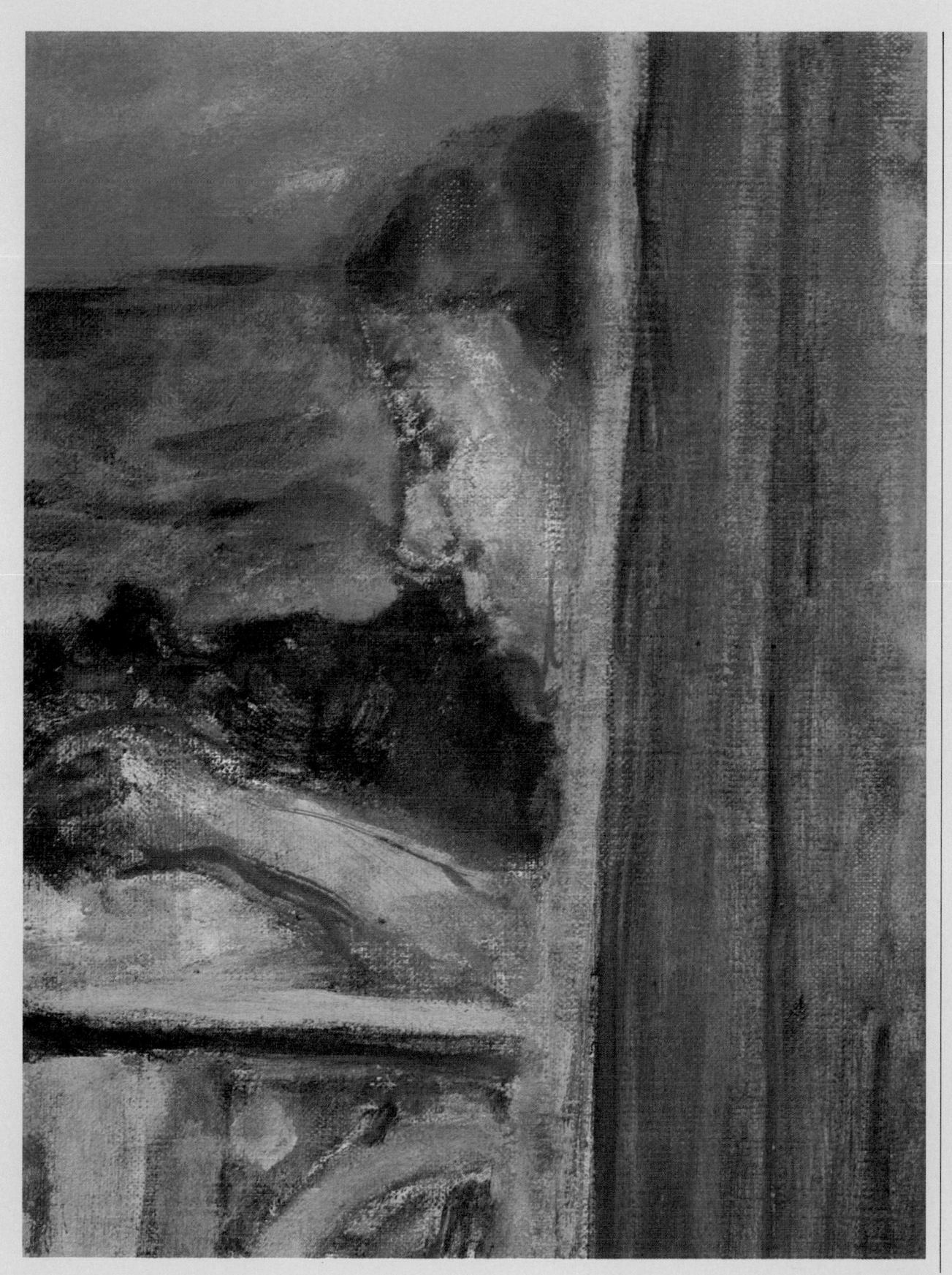

ACTUAL SIZE DETAIL In 1925 Bonnard moved to this small house called 'Le Bosquet' at Le Cannet, near Cannes after marrying Maria Boursin who preferred to be known as Marthe de Moligny. She had lived with him for about 30 years lived with him for about 30 years previously and had been a model in many interior and bath tub paintings. She is also included in still lifes and included in still lifes and interiors as if she had strayed into view. Bonnard rarely painted from life but made sketches and worked on his paintings over a long period in his studio. This method involved the application of thin veils of paint of thin veils of paint which would be left to dry before they could be reworked, using brushes, fingers and pieces of rag. His choice of colour is of colour is
Impressionistic and
emotional, rather than
realistic. He uses a
favourite cadmium
yellow deep and yellow
ochre for Marthe's face
with the with the complementary purple applied to the hair, mostly with a finger. He made full use of the colour and texture of the primed white the primed white canvas to give strength to the thinly applied colours. It breaks through in the cheek of the figure and in the balcony. The sky is the most opaque passage in the painting. This creates depth in contrast to the open handling of the foreground elements. foreground elements.

Refuge (1930)
Oil and watercolour on plaster-coated gauze, on paper-faced board $56.8 \text{cm} \times 38.1 \text{cm}/22\frac{3}{8} \text{in} \times 15 \text{in}$

The fact that *Refuge* has a packed sentence describing its medium indicates that Paul Klee enjoyed producing works with a complicated technical development. He liked art that grew and developed in just the same way that the natural world worked: a many-layered and rich process.

Klee was born in Switzerland in 1879, into a family of musicians. He was as gifted musically as he was artistically, but he chose painting as a career because of the two 'it seemed to be lagging behind'.

Klee was also an inspiring teacher, and was appointed by Kandinsky to the Bauhaus in 1920; he taught there for 10 years. From 1931 to 1933 he taught painting at the Düsseldorf State Academy, then gave up teaching and devoted himself entirely to his own creative progress. By 1933 the political situation in Germany appeared threatening and unconducive to artistic freedom, so he returned to his native Switzerland, where he died seven years later.

Alongside his codification of the various factors such as line, tone and colour which make up a work of art, Klee devoted much attention to the technical side of painting. His belief that technique should be the artist's servant, not master, led him to take great care in the use of his materials, and to consider the soundness and durability of his work. He was a great experimenter in the field of painting techniques and materials, and appears to have undertaken his technical experiments in a scientific guise. He recorded the stages involved in a work so that he could use them again for reference, or as an indication of what did not work well to his satisfaction.

Refuge is inscribed on the reverse, in Klee's hand, with the nine stages used in its execution. The inscription reads: '1, cardboard, 2, white oil-enamel pigment, 3, when 2 has become tacky gauze and plaster, 4, watercoloured red-brown as undertone, 5, tempera Neisch [a brand name?] zinc white with linseed mixture, 6, delicate drawing and brushstroked hatching with watercolour, 7, lightly anchored with oil-painting varnish [turpentine thinner], 8, partly illuminated with zinc white oil paint, 9, covered with oil grey-blue washed with oil madder lake.' The painting is basically a colour field made up from oil and watercolour, onto which, at stage six, the lines and the hatched shading which define the figure and the shape above were drawn.

Refuge is a fascinating combination of fragility and strength: the fragility is invoked by the tender frailty of line, and the strength by the effort and material involved in creating the base for it. The support is board which was given a layer of white pigment to prime it and to provide a sticky base, onto which Klee pressed a layer of thin gauze. The loose weave of this gauze shows through in patches all over the surface, and the warp and weft of the fabric

are cleverly echoed by the painted texture of the hatching. Most of the gauze, however, has been overlaid and impregnated by a thin layer of white plaster, applied with a flat implement – probably a palette knife. The scooped edge of several sweeps of wet plaster is clearly visible. Klee would not have wished to rub his plaster flat, since the visible evidence of the making of the work was important to him.

Klee usually thought up a title for a work after he had completed it: the experimental nature of its genesis totally occupied him and only when it was finished could he stand back, take stock and fully reflect on the nature of its content. Refuge was painted in 1930; the year before Klee left the Bauhaus and took up his post in Düsseldorf. It is tempting to speculate whether Refuge refers to Klee's own position, torn between holding influential social positions, and yet wanting to create poetic lyrical fantasy works in the quietude of his studio.

Stages one to five of *Refuge* laid in the texture and colour of the ground, the space or void, onto which the form was drawn. *Refuge* has a strong vertical axis; the straight line of the creature's nose, if continued upwards, would pass through all four apexes of the curtain-like structure at the top. Since the ground, with its texture and light tonal value, shows through the forms of creature and curtains, it imparts to them a great sense of transparency; and it is difficult to determine whether the formations at the top are to be read as four curtains held back from a central point which recede into space as they descend, or four mountain peaks which recede into depth as they ascend.

This ambiguity is continued in the subject matter. Does the creature wish to seek refuge in the structure at the top of the panel, or is it fleeing away from there, or even from the viewer who completes the picture? The only opaque area of the painting is the dark grey stain, the amorphous shape placed significantly between figure and structure. Reference to other works by Klee, especially Mixed Weather (1929), indicates that this opaque shape can be assumed to be a heavy and ominous thundercloud. Since it threatens to discharge matter, and is dense and brimming with material, Klee has wittily made it the only area of the canvas in which the gentle patina of the ground is overridden. Also, when he came to stage nine in his execution, he concentrated the grey-blue and madder lake pigments in their greatest density around this cloud.

Three further washes of various media lie on top of the figures and their hatched shadows. These final layers reinforce the idea of the plane, of the flatness of the painting which may have been in danger of disruption.

Refuge, although formally very simple, repays close study since its rich and complicated technical development contains the painting's main statement.

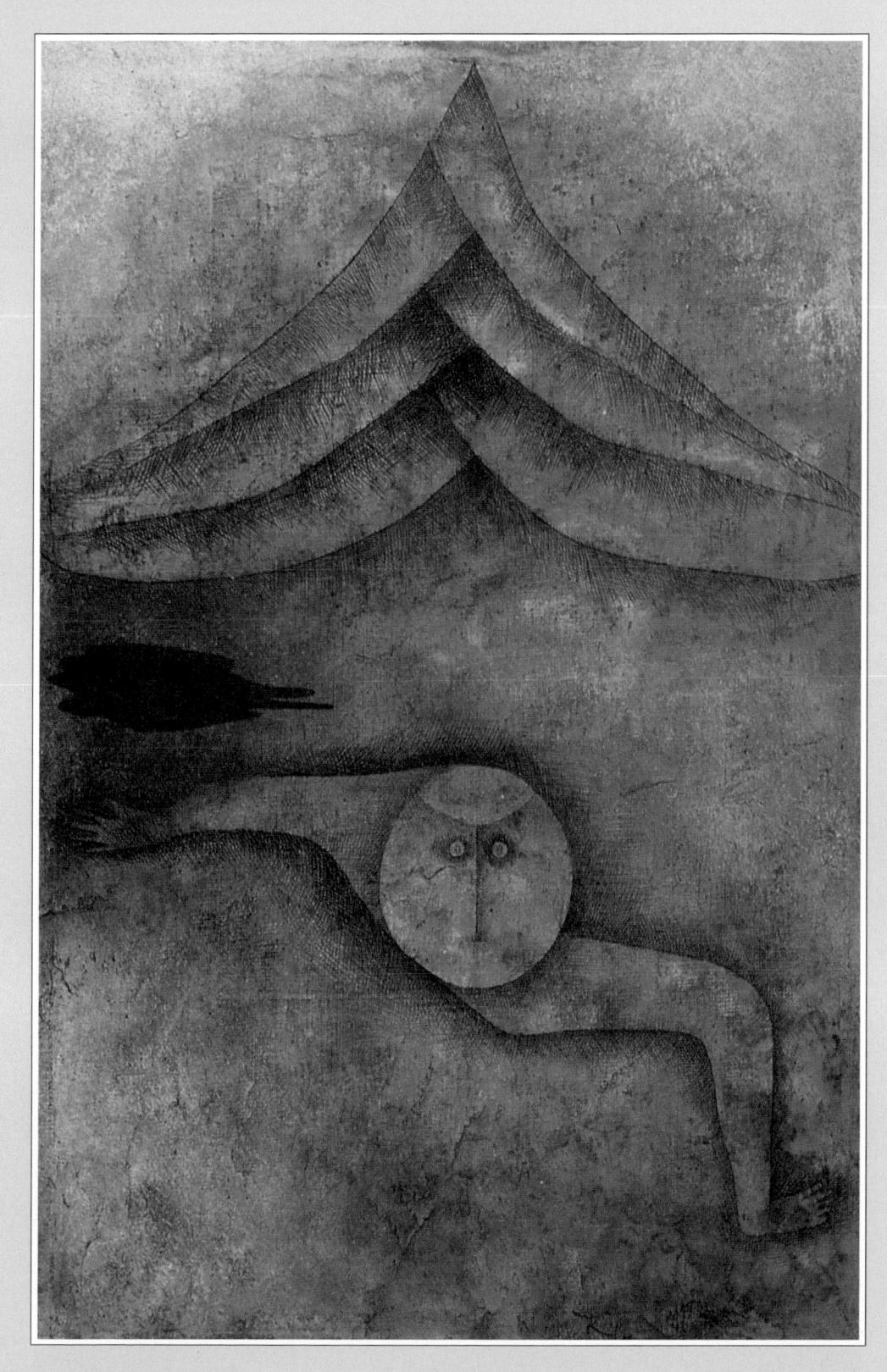

Paul Klee began his artistic career by cultivating his youthful dexterity as a draughtsman. His early works are drawings, engravings, and some watercolours. Colour gradually came to assume great importance for him, and he took up oil painting around 1919. This work combines an interest in line with an interest in the permeating qualities of colour. Klee was always experimenting with technique, and he liked to undertake work in the spirit of a scientific enquiry. The nine processes by which Refuge reached its final state are written on the back of the board in the spirit of a speculative theory.

Dominant staining hue of rose madder

Opaque areas of greyblue oil paint

Ground made up from oil, tempera and watercolour

Drawn lines executed with thin sable brush

Hatched strokes painted in watercolour

Evidence of laying down of plaster layer

ACTUAL SIZE DETAIL
The figurative element, this creature and its environment, only emerged at the sixth stage in the technical programme of Refuge. The regular weave of the gauze stuck on to the cardboard support shows through clearly in the area designated as the creature's hair. The gauze can be seen uncovered at the lower edge of the curve of its right cheek. The mottled ground serves as flesh tone, while the delicate hatched watercolour brushstrokes provide a sense of volume, and serve to distinguish the creature from its background.

ABOVE Klee liked to draw musical analogies with painting; if Refuge were to be likened to a Scarlatti harpsichord sonata, then Ad Parnassum, painted two years later, could compare with a Brahms symphony. Refuge is dominated by a single, central motif, while Ad Parnassum relies upon the repetition and orchestration of shapes, which are organized into warm-cool, and light-dark oppositions. It uses the traditional materials of oil paint and canvas to achieve this.

Max Ernst

The Petrified City: Le Puy, near Auch, Gers (1933) Oil on paper 50.3cm x 60.9cm/197/8in x 24in

Between the two wars Max Ernst established himself as a major figure in Surrealism and was one of the few artists who survived all the vicissitudes of the movement with his reputation enhanced. Prior to his arrival in Paris in 1922 he had almost single-handedly fired Dada in Cologne and he was one of the few painters who effected the transition from the anarchic effusions of Dada to the more programmatic concerns of Surrealism.

Born in 1891 at Bruehl, in Germany, Ernst always stressed the importance to his art and imagination of nearby Cologne and the formative influence of his childhood there. In this way he conformed to a typical Surrealist notion, that of the creation of a personal myth; but the 'myth' does draw attention to the importance of his provincial background in a city of Catholic legends, magic and relics, set, so he suggests, at no great distance from the primeval Germanic wald. The German tradition of painting, particularly the fantastic, unkempt forest world of Albrecht Altdorfer (1480-1538) and the calm but disturbing inner visions of Caspar David Friedrich (1774-1840), was important to Ernst's Surrealist work. He was also inspired by literature - both the romantic poetry of his own country and a select pantheon of French writers, particularly Alfred Jarry (1873-1907).

Ernst had a conventional academic education at the University of Bonn, where he acquired a thorough knowledge of psychiatry and psycho-analysis; knowledge that lay behind his apparently instinctive ability to summon up deep fears and desires in his work. It was at this stage, too, that he became involved with modern painting, meeting Macke in Bonn in 1909, attending the second Blaue Reiter and Sonderbund exhibitions in Cologne and gaining familiarity with a large range of avant-garde work.

Ernst had already achieved a certain cult status in Paris through his 1920 exhibition there before he actually settled in the city. Thus he was already a figure of authority to the young Surrealist group; his influence was enhanced by his nationality, which provided the Parisians with a genuine flavour of the fantastic German tradition they so admired.

Ernst's great importance at this point was as the pioneer and virtual inventor of Surrealist painting. His erudition and his friendship with the poet Paul Eluard (1895-1952) helped him to gain acceptance into what was still a firmly literary circle. Its leader, André Breton, still possessed doubts about the possibility of a visual equivalent of the written work that he hoped would express the character of Surrealism. Ernst's exploration of the Surrealist energy of de Chirico's work (who, like Ernst, was familiar with German poetry and philosophy) produced the celebrated work Celebes (1921), in which the use of factual, realistic elements, reassembled with the mysterious logic of the dream, created the technique used in most subsequent Surrealist paintings.

In this crucial respect, Ernst's work was enormously influential and his technique of drily applied oil paint, which he derived from de Chirico, became a medium favoured by the Surrealists, its studied conventionality acting as the perfect foil for the unnerving juxtaposition of images.

Ernst had used oils before the war but, like most Dadaists, rejected them in favour of alternatives less associated with a discredited, self-absorbed aestheticism. Thus in Cologne he had turned to collage, cannibalizing technical manuals, medical handbooks and mail order catalogues to create subversive anthropomorphic machinery and sinister, animated little organisms moving in pen, pencil and watercolour landscapes that were the precursors of the arid, hallucinatory plains of Surrealism. Actual machine parts were used in a rudimentary form of printing to leave their inked impression on the paper. Photomontage, too, gave the opportunity for manipulating familiar imagery until it lost the assurance

Ernst was a considerable technical innovator in his own right. Frottage - the process of producing rubbings through paper from the surface of wood, leaves, fabric or anything with textural pattern - produced the 1926 set of drawings Histoire Naturelle, an alternative handbook of Surrealist fauna inspired by the natural materials that lent themselves to the technique.

of its factual associations.

From frottage it was an easy step to grattage, which Ernst used in The Petrified City, painted in 1933. A painted canvas was pressed down on a surface, necessarily of a less fragile nature than those used in frottage; often metal grids were used, producing a harder, more linear form, and then the paint was scraped back to reveal a negative image of the texture beneath.

The Petrified City is a fine example of a subject that was to appear in many versions during Ernst's work of this decade. These lost citadels rise up from the tangled forest world that he had developed in his earlier work, and suggest the ruins of a lost civilization, now overcome by the dark, dense power of nature. Often he removed the central core of the 'moon' to create a mysterious 'ringed' planet which reveals more clearly the idea of parallel natural world upon another planet.

Besides the Surrealist concern for the creation of a new world, recognizable yet also disconcertingly apart from our own, the melancholy and menace of this work suggests too the prophetic quality that Ernst was often capable of creating. An image such as this can be seen as a vision of future desolation and a response to the darkening skies of Europe

before the war.

MAX ERNST

Heavily applied flat area of grey for sky produces impasto crinkles in the left side, possibly added later

Thin layer of pink vigorously brushed over existing work

Foliage allowed to 'invade' the first layer of grattage

Use of stronger reds nearer base to enhance effect of stonework

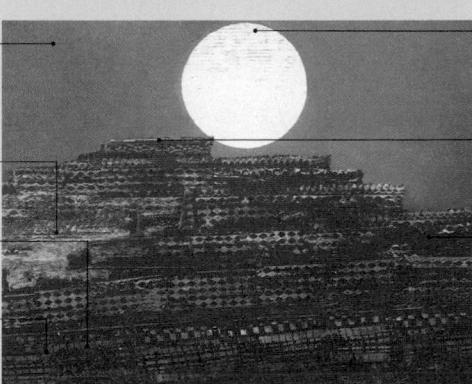

Blue tracks across front of sphere

Use of different patterned effects to differentiate 'crowning' layer

Leaving original areas of dark paint to blurr, grattage increases textural interest and suggests natural decay Typically with Ernst, while the entire look of Petrified City derives from the technique of grattage, he has used his original method for highly expressive ends. Eschewing traditional modes of paint application and representation he has created a hallucinatory, other-worldly image which is registered instantly, and which works itself out more through our powers of imaginative projection, than of close scrutiny.

MAX ERNST

RIGHT To the left, the blue background has been loosely overpainted wet onto dry, the brushmarks at the point flecking the surface of the moon. Pale blue points and ribs are visible across this moon, and the yellow paint has blistered into small bubbles and patches. Conversely, to the right, spots of yellow are visible through the blue. The crowning level of the 'city' overlaps the moon-disc a fraction, but there is a suggestion that this corner 'battlement' was added at a later stage. The dog-tooth and scroll-like patterns deriving from the spread of paint across a similarly designed surface are reddened with a sunset-like glow towards the bottom, smeared with a lighter blue in the top, and enlivened with touches of pink on the left. Black lozenges and blacked-out areas everywhere complement these brighter hues, while the whole grattaged surface has a kind of deep textural unity made possible only by Ernst's infinite technical finesse.

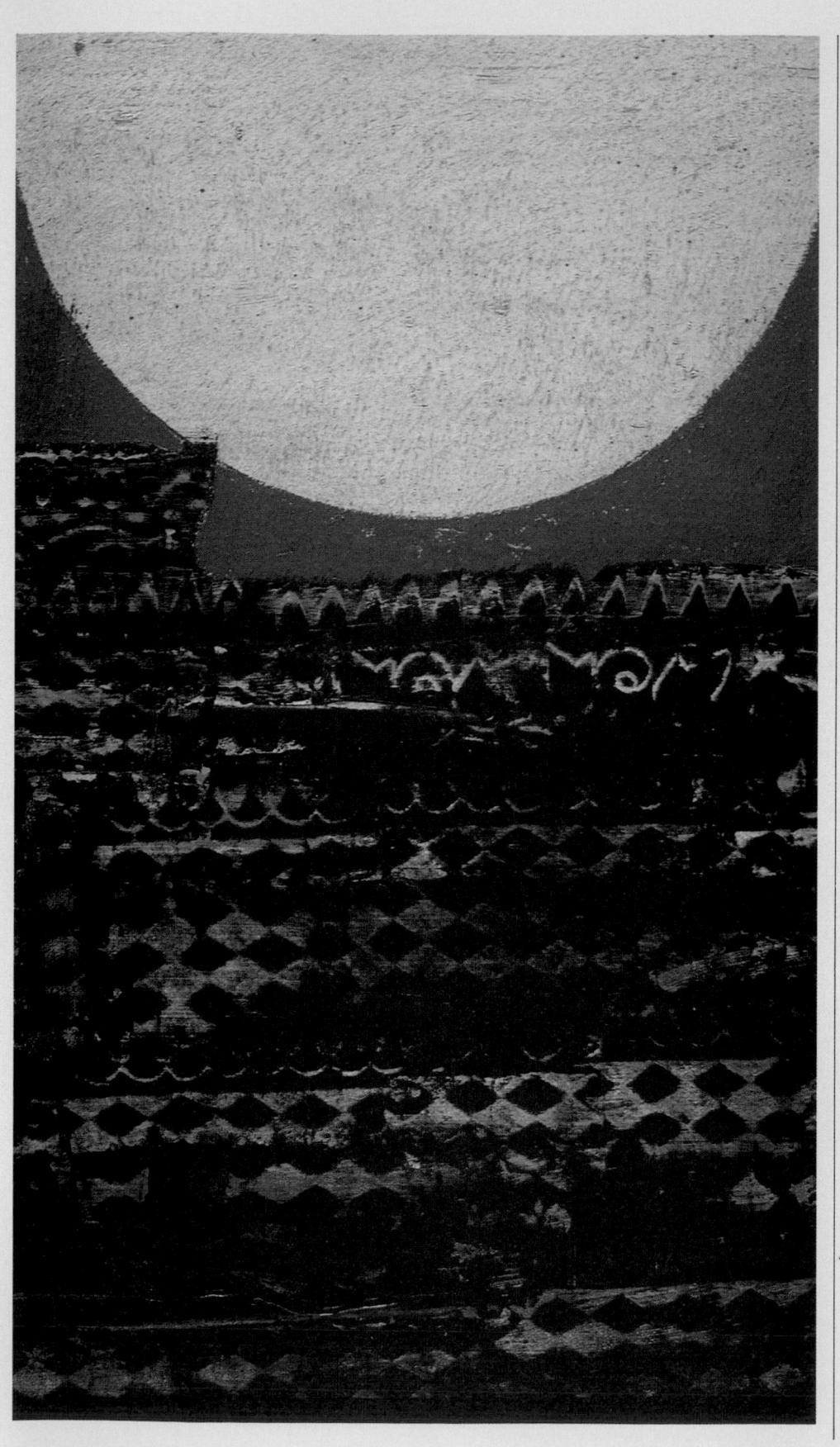

MAX ERNST

ACTUAL SIZE DETAIL
This section
through a grattaged
layer shows the main
alignment, rather like a
band of film with heavy
black checks and a
thinner, irregular grid
underneath. The grid is
interrupted by the
intermittent acanthuslike motifs below,
which appear ghostedthrough the thick black
paint, taking on
miscellaneous roseate
hues. The fineness of
lines in this pattern and
the coarseness of
application behind it, is
a subtle juxtaposition,
typical of the grattage
technique itself.

RIGHT Vox Angelica (1943) is made up of four canvases each 76 x 101.5 cm (30 x 40 in). The work includes reference to all the techniques for which Ernst was known. Paris and New York are juxtaposed in the Empire State Building and the Eiffel Tower. Images such as the geometrical instruments and the drill recur in the painting. The image of the drill is paralleled in the images of the snakes entwined around trees; possibly references to the serpent in the Garden of Eden.

Mountain Lake (1938)
Oil on canvas
75cm x 92cm/28³/₄in x 36¹/₄in

Dali's enormous appetite and talent for self-promotion and showmanship, his rhetorical and evasive writings, his gladiatorial capacity for debate and spectacle have so seduced the public imagination and the agencies of reproduction that he has some claim to being the most popular of twentieth-century painters. There has always been a wide gulf, however, between his popular, and his art historical reputations. Far from allowing his work to stand as paradigms of the Surrealist spirit, critics have been quick to label him as a 'charlatan', as non-avant-garde in his rejection of modernist techniques and styles, and as a vulgar herald of 'the triumph of publicity over art'.

Salvador Dali was born in May 1904 in Figueras in north-eastern Spain. He retained vivid and powerful recollections of the local landscape. Dali's first instruction and interests were thoroughly academic and largely nineteenth century. In 1921 he entered the school of Fine Arts in Madrid, where he met the poet Frederico Garcí Lorca (1899-1936) and the future film maker Luis Buñuel (b 1900). During the late 1920s Dali became progressively enthralled by some of the ideas and experiments of Surrealism; but there is a sense in which he was never a real convert. His allegiance was eccentric, and his paintings, like the work of most of the 'visual' Surrealists, did not toe the line of André Breton's manifesto orthodoxy.

As an artist Dali has employed a bewildering range of media apart from the photographic or 'magic' realism for which he is so well known. His defence of the conceptual priority of ideas above the materials and techniques used to express them is an indication that he would accept no hierarchic order of importance for his various activities, and that he often considered words and sentences to be as effective carriers of information as, for example, oil painting. He worked in film, advertising, set and costume design for theatre and ballet; he made jewellery, holographs, installations and a variety of Surrealist and other 'objects'. In more orthodox representational areas he used oil on board, panels, wood and canvas; mixed oil with collage and sand; drew on paper with ink, pencil and charcoal, and even put oil on embossed pewter. In 1958 he exhibited atomic 'anti-matter' paintings in New York. The list could go on.

Of all these techniques and styles, however, it was in oil on canvas and in the scrupulously detailed style of photographic realism which dominated his painting from about 1929 onwards that Dali found the suitable vehicle to express his alternative Surrealist theory of 'critical paranoia'. This self-induced state of delusion is evoked in a work such as *Mountain Lake* by the disparity of register between meticulous technical realism and the hallucinatory

interruption of objects which subvert the normality of the 'scene'.

With typical erudition Dali wrote in *La Conquete de l'irrational (Conquest of the Irrational)* (1935) that: 'My whole ambition in the pictorial domain is to materialize the images of concrete irrationality with the most imperialist fury of precision in order that the world of imagination and concrete irrationality may be as objectively evident, of the same consistency, of the same durability, of the same persuasive, cognoscitive and communicable thickness as that of the exterior world of phenomenal reality.'

Dali thus took an anti-modernist position on the nature of his technique and materials. Rather than celebrating the canvas surface as the site of visual autonomy and indulging in the play of shape and colour he communicated certain psychic effects as though his paint medium were transparent. It is, therefore, particularly difficult here to separate a technical analysis from other considerations.

The first impression of Mountain Lake is of the sombre bluey, grey-green crepuscular atmosphere which saturates the picture, only to be enlivened by points and flashes of light and reflection. This tonal ubiquity is one of the several devices by which Dali attempts to persuade the view of the seamlessness of his paint application. The modulation of the vast area of darkening sky in opposition to the calculated specificity of the rocks and pebbles on the shore of the lake is another encouragement. A photograph of the work in raking light reveals minutely moulded scumbling with careful tints of colour, particularly in the cliff face to the left of centre. All this technical virtuosity solicits an investment of belief in the image.

Practically, then, Dali did all he could to convince the viewer of the truth of the scene; a commercial white ground was applied to a standard-format closely woven canvas and then partially overlaid by a thin primary. The main contours were probably pencilled onto the surface before colour was applied with a variety of small sable brushes. In order to control the minutest of details Dali would rest his painting arm on a maulstick and scrutinize small areas with a jeweller's glass.

But these extravagant efforts at verisimilitude are merely the means for the communication of much broader ideas and paradoxes. In *Mountain Lake*, having registered the fairly blatant visual pun of the lake as a fish, one is left with the oblique and ironic allusion to the 1938 telephone conversations between Chamberlain and Hitler. The disconnected cable and the sedentary snails are eloquent testimonies to a series of non-sequiturs activated by the central opposition between dream and reality. This, in turn, is successful because of the technical seductiveness of the picture.

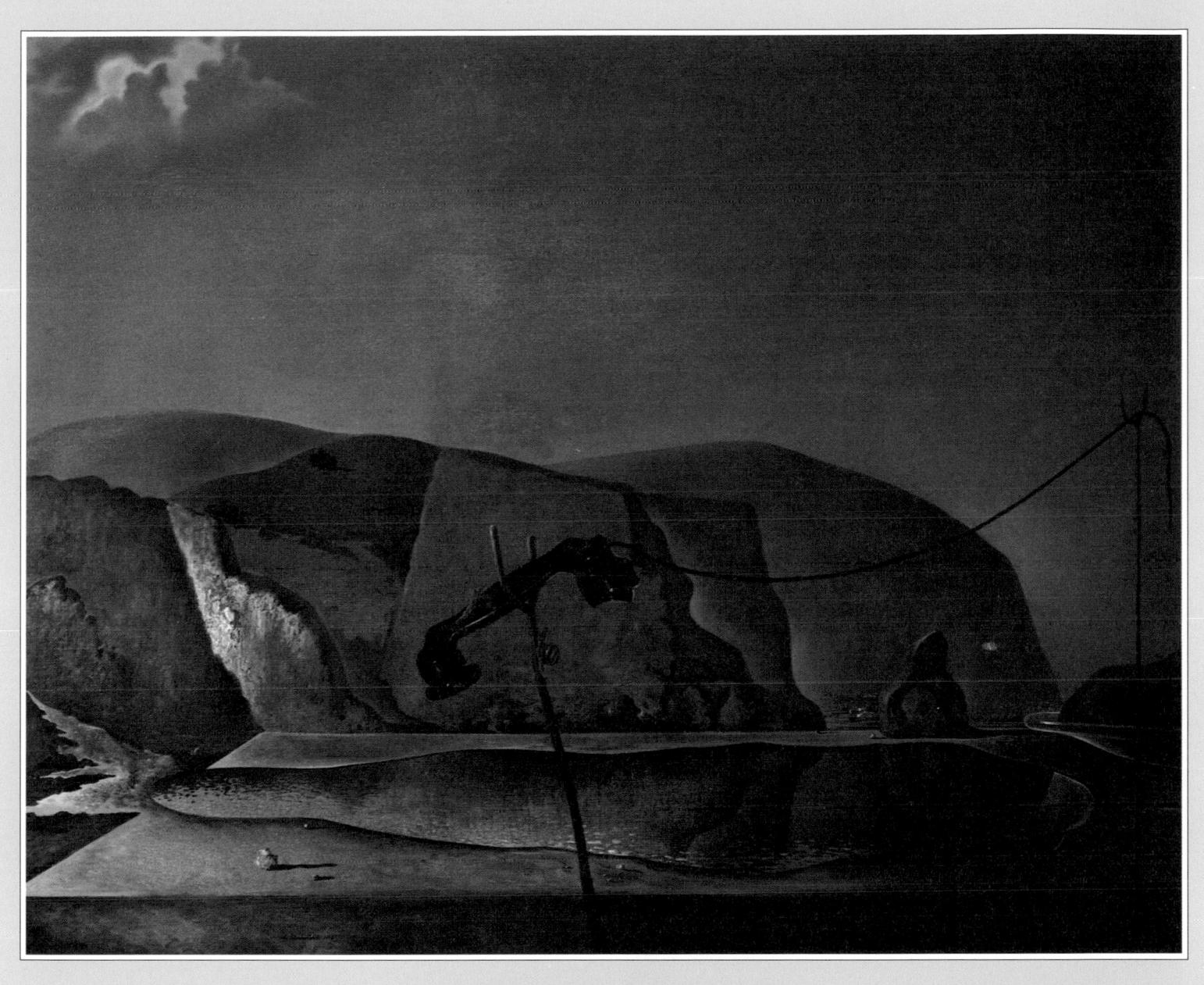

Blurring of yellow into blue for clouds

Abstract landscape markings in the middle distance

Extra-long shadows suggest raking angle of the sun

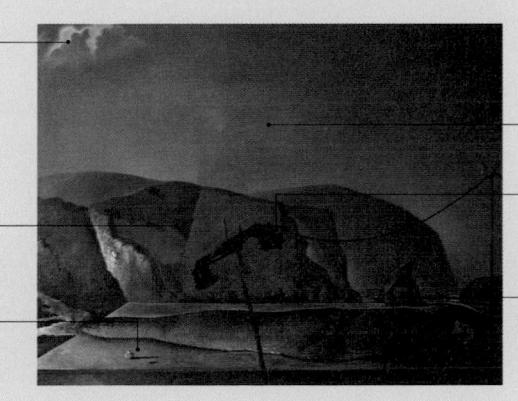

Paint blistering into white points (sky)

White reflecton stud

Red smear reflected more intensely in the lake than on the boulder above Attention to the technical devices of Dali's Mountain Lake is apparently minimized by the scrupulously realistic execution; but expectations of 'reading through' the image are frustrated by formal as well as iconographic interruptions. The fish-shape of the lake, and the parallelogram which encloses it provide the best examples.

RIGHT The telephone and its impotent connecting lead are painted in an intensely reflective black, highlighted by flashes and ribbons of white. The incongruousness of the telephone is emphasized by the naturalistically executed snails. These are set-off by the lightly brushed rock-scape directly behind where the canvas weave is clearly visible. In contrast, the abstract quality of the sinuous curve to the left is accentuated by smudgy yellow shading.

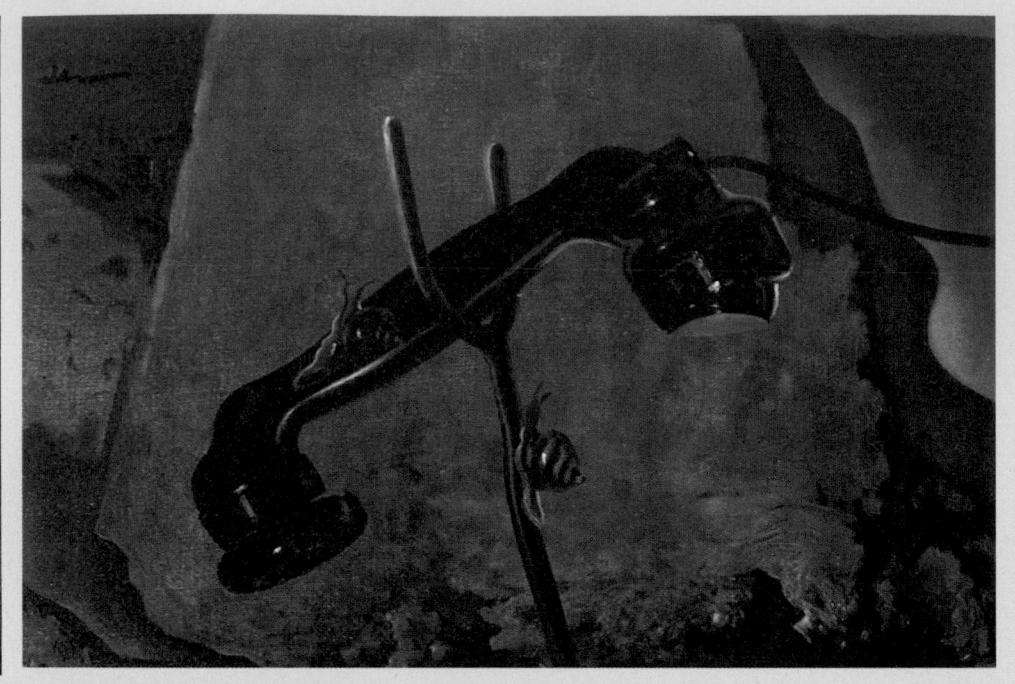

BELOW The black stem of the forked stick which supports the telephone cuts diagonally through five registers or layers. It has a skilfully managed transparency where the light hits the water and shore so that details behind the stick are glimpsed through it. Dali delights in effects of reflection. Water of mauve and light blue is merged into the creamy yellow-green shoreline. Multi-directioned flecks and dabs of paint are used to evoke the more fantastic rock forms of the lower mountains.

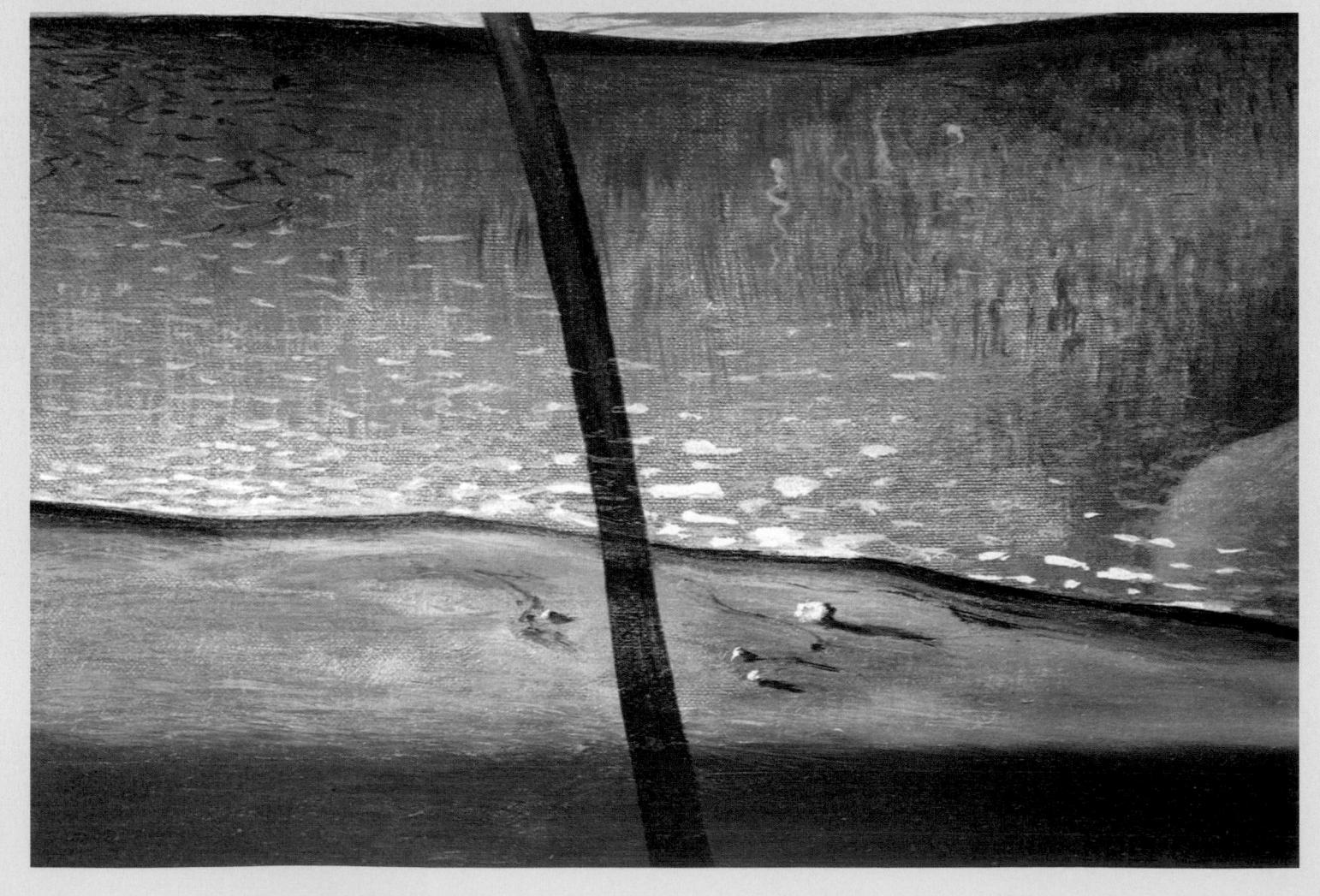

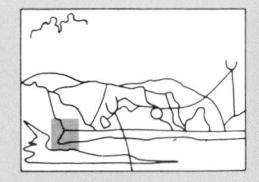

ACTUAL SIZE DETAIL In the centre of this detail Dali has almost 'sculpted a small field of impasto using both fine brushes and a blunt instrument (perhaps a palette knife or a fingernail). The layering of paint is graded out from a central focus of whites and creamy yellow, to the edges of the illuminated area where touches of greys and lavender diffuse the light intensity. The close-up reveals the artifice of Dali's 'naturalism', the lack of empirical logic which informs his choice of light-struck zones. It is not appropriate, then, for the straight line bounded area at the bottom right to be so entirely suffused with light while the dark rocks sloping up from right to left are uniformly unlit. Similarly, the mottling of the water at the bottom of the detail suggests that at this point it was more important to produce an impression of fish-scales than a convincing description of still water.

Introduction

<u>1941</u> 1960

The New American painting

During the 1940s important new artistic movements began to develop in America, where until then painters had tended to follow European models or assume a provincial stance. The events which led to the Second World War indirectly contributed to this change, insofar as many European artists and intellectuals had been forced by the rise of Fascism to emigrate to the United States, and they soon proved to be a powerful source of inspiration for a younger generation. In New York this included young artists such as Jackson Pollock, Franz Kline (1910-1962), Willem de Kooning, Mark Rothko (1903-1970) and others; they evolved pictorial styles which drew upon earlier movements, particularly Cubism and Surrealism, but eventually went beyond these precedents in terms of original techniques and vision. The New American painting stressed the manual aspect of art, as well as the intense emotional response which it sought to provoke in the onlooker. One of its central aims was to combine a high degree of abstraction with expressive qualities: it is also therefore described as Abstract Expressionism.

Although individual Abstract Expressionists established entirely personal manners, they shared the desire to create images with an elemental impact that would challenge the uncertain climate of the wartime period. Initially, there was an interest in the tragic myths and art of primitive or ancient cultures because these were thought to contain a core of universal truth. It did not take long, however, for visual priorities to supersede literary references: instead, what came to the fore were dynamic methods of handling paint; the use of simplified forms, and canvases of enormous dimensions far exceeding those of the ordinary European easel picture. The big formats meant that the scale of the composition required novel attitudes to the application of pigment.

Jackson Pollock took the lead on that issue in 1947 when he extended the Surrealist technique of automatism to surprising limits, by laying his unstretched canvas support on the ground. He could then move rapidly around the picture from all sides and to assist his spontaneous approach he dispensed with brushes. Instead, Pollock poured and dribbled his highly diluted paint directly from the can, or used a stick to fling it on in whiplash strokes.

By such methods Pollock built up a dense web of lines suggesting a visual record of his turbulent, innermost feelings and also a reflection of the violent gestures which had brought the painting into existence. Yet a measure of intuitive control was present beneath this seeming chaos, as he remarked: 'When I am *in* my painting, I'm not aware of what I'm doing. It is only after a sort of "get acquainted" period that I see what I have been about. I have no fears about making changes, destroying

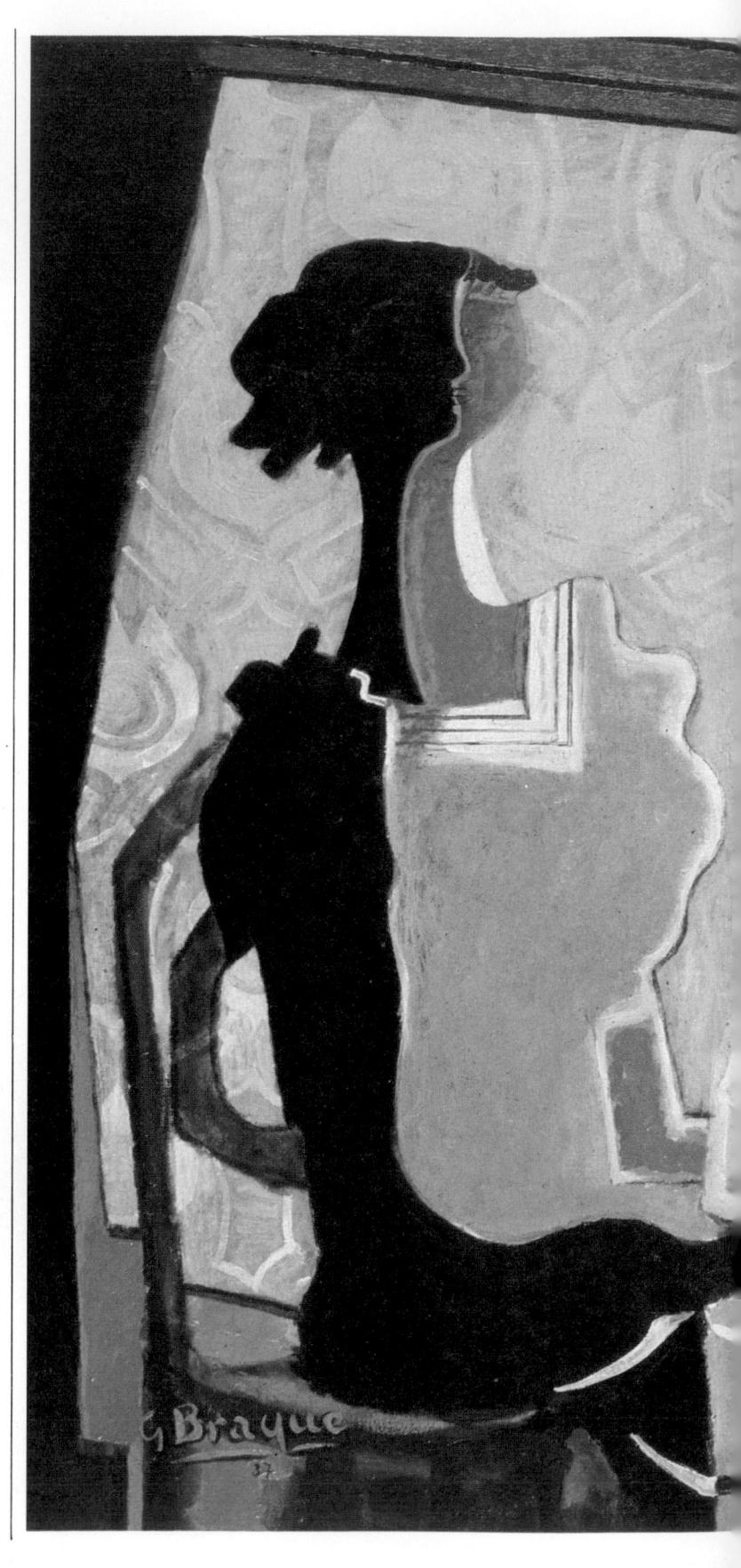

LEFT Duet was painted in 1937, at a time when Braque was developing his combination of elegance and formal simplification that culminated in a series of Oiseaux done in the 1950s. Braque's mature work remains within the terms of Cubist easel painting. He made the structure of his vibrant surfaces more flexible and fuller, so that the subjects did not endanger the painting's constructive framework.

the image, etc, because the painting has a life of its own. I try to let it come through. It is only when I lose contact with the painting that the result is a mess. Otherwise there is pure harmony, an easy give and take, and the painting comes out well.'

'I am nature', Pollock commented once, as if to say that his incorporation of physical movement into the act of painting signalled his own unity with the larger forces of the outside world. Indeed, he would occasionally introduce foreign elements – handprints, fragments of personal possessions and the like – into the surface of his compositions. These did

not echo the role of the recognizable ingredients of Cubist collages, but were integrated with the pigment as reminders, perhaps, of the organic oneness Pollock felt between himself, nature and his creations.

Not every American affected by Surrealist automatism, particularly its fascination with chance and the unconscious, followed Pollock's unconventional extreme. Most did agree, however, that the manual factor about picture-making was of fundamental value, since it was the artist's gestures that were the crucial link between his or her inward experiences and how they were externalized on can-

vas. On the West Coast, Mark Tobey (b 1890) produced networks of pale lines (often in the delicate tempera medium) on a smaller scale than Pollock's, yet they had a similar 'all-over' look: the entire work appeared to have been activated by the swift calligraphic touches of the brush. The results bear comparison with Pollock in their mysterious spatial aura too, because Tobey's Oriental mazes can be seen as both flat and infinitely deep. This impression was enhanced by Tobey's very soft colours, while Pollock sometimes chose the evanescence of silvery metallic paints.

The attitude underlying techniques such as those of Pollock and Tobey is usually termed 'gesturalism', denoting how the artist's dexterity, attack and physical movements in general contribute to the dynamism of his or her art. To New York painters, most notably de Kooning and Kline, gestural methods were ideal for expressing private tensions, the anxieties of modern urban life and the brutal immediacy of their materials. At moments their paintings appeared to have been left uncompleted, or else changes of mind and earlier stages were visible in the end product, which added to this unusually vigorous and aggressive feel.

In contrast to the ancient principle that artistic effort should be concealed, the gesturalists made it a tangible virtue. Hence their respect for *pentimenti* – the evidence that areas of a composition have been overpainted or reworked. During the early 1940s Pollock – who had yet to abandon brushes – deliberately

By the time Giorgio Morandi painted his Still Life (LEFT) in 1946, he had perfected his contemplative style of depicting objects within a formal framework. He blurred the edges of the things in his paintings and their form is heavy and full of the essential value of the objects. Morandi's carefully observed everyday objects have a poetic impulse, but despite this lyricism there is an underlying pessimistic quality about his work. In contrast to Morandi's sparse formal arrangement Cézanne cluttered Still Life with Plaster Cast (1895) (RIGHT) with objects which have a slightly eclectic relationship with each other, and they are used in a complex spatial way. The apple Cézanne has placed in the background is the same size as those in the foreground, and has the effect of flattening the surface and halting the recession. While Morandi confined himself to a sober palette, Cezanne used subtly modulated contrasting colours which he applied in interlocking planes.

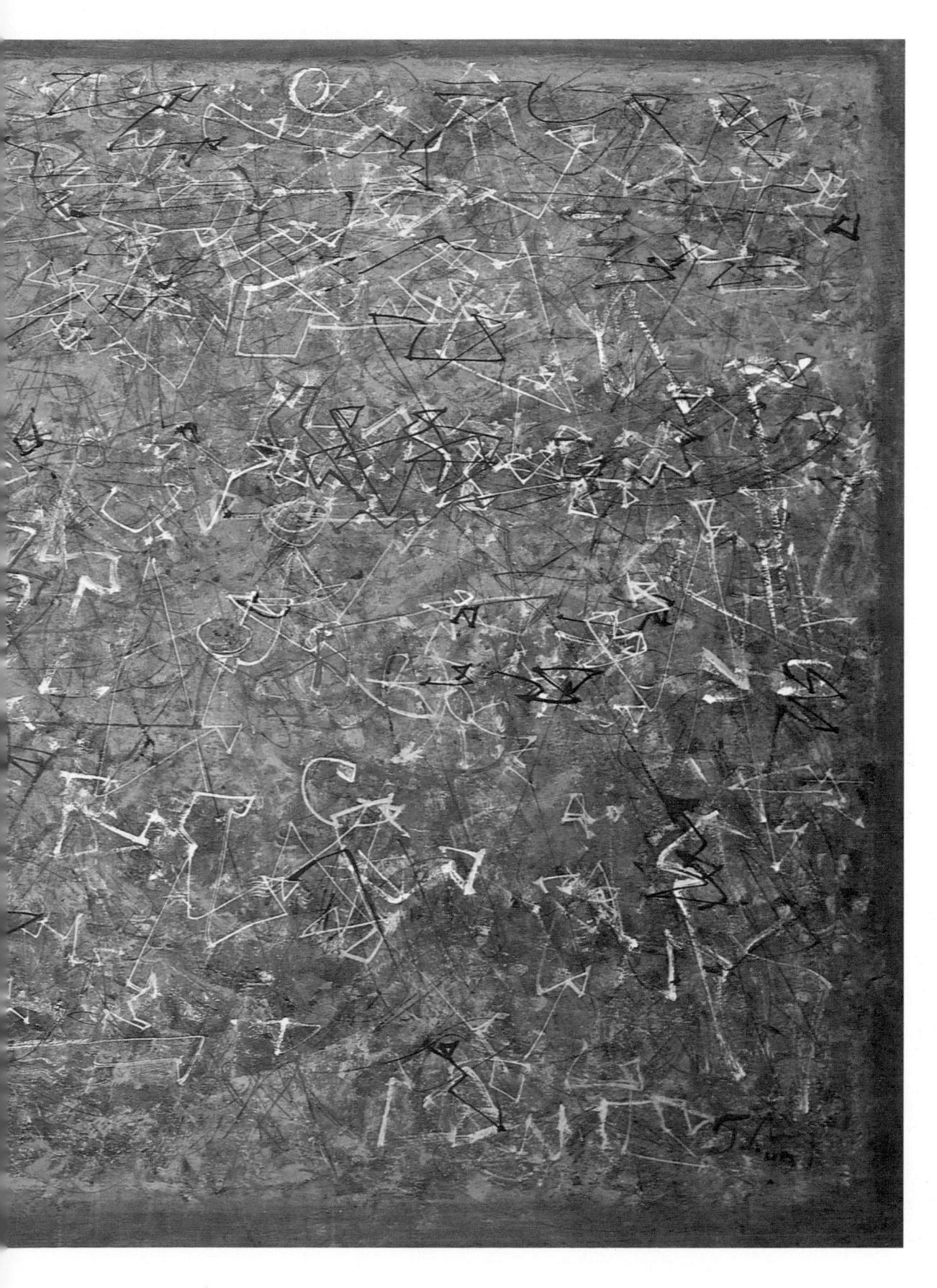

LEFT Mark Tobey's
Universal Field (1949) is
an example of his
remarkably powerful
way of painting which
concentrates on few
expressional means. His
style of 'gesturalism'
evolved in
complementary contrast
to the emotive action
paintings of Pollock
and others. Tobey
visited China and Japan
in 1934 and studied
Chinese calligraphy. By
the next year he had
developed his
characteristic 'white
writing' style. In
Tobey's very
individualistic kind of
brush-writing — the
calligraphic brushstroke is considered to
be a 'symbol of the
spirit' by Zen
philosophers —
bewildering movements
of white overlie dimly
discerned suggestions of
colour beneath.

overpainted the symbolic figures of works such as *Pasiphae* (1943) with successive layers of abstract markings. The resultant surface has a rich impasto permitting the viewer to discern Pollock, as it were, 'in action' as he progressed from figurative beginnings towards a near-abstract conclusion.

One influence on the rise of gesturalism, (or Action Painting, as it was called by the popular American critic Harold Rosenberg), was the art and teaching of the German-born emigré Hans Hofmann (1880-1966) who recommended fluent paint handling as an aid to spontaneity. Another starting point can be found in Arshile Gorky's later paintings where the colours are so thinned with medium that their almost liquid drips and washes form labyrinths associated with the mysterious depths of the artist's memory and unconscious. De Kooning and Kline, on the other hand, forged a more dramatic style that observers have linked to the violence and alienation of the contemporary American city.

In the 1940s both painters, like Pollock, dealt with the human figure and, through a study of Cubism, de Kooning fragmented it into planes and lines ranging over the entire composition. He simultaneously adopted enamel housepaints, mostly in black and white, because their easy flow enhanced rapid execution and added to the tough 'look' which he sought. These innovations in turn impressed Kline who in 1949 abstracted his figures into enormous strokes of black and white resembling magnified details from his previous imagery. employed housepainter's brushes Kline whose broad, flat edge produced marks which seemed to have been made with tremendous speed and forcefulness, particularly when some fail to stop within the edges of the composition and thus apparently hurtle beyond its boundaries altogether.

Despite the very different means of other Abstract Expressionists, such as Mark Rothko, Barnett Newman (1905-1970) and Clyfford Still (1904-1980), all of whom explored relatively static and sublime fields of colour, it remained the gesturalist side of the movement that was most widely admired throughout the 1950s. Improvisatory working methods, loaded brushes, big formats and tactile surfaces came to represent the breakthrough of the New American Painting. Its impact caught the mood of the times and was soon felt outside America, although in lesser hands the techniques easily became confused with the end result. Following the example of Pollock and his colleagues, painters such as Georges Mathieu (b 1921) in France and the Dane Asger Jorn (1914-1973) brought a fierce intensity and heavy impasto to their work. By stressing the vitality of the manual act of painting, Abstract Expressionism also fostered new tendencies that would culminate in happenings and other unconventional approaches of more recent years, where physical performance is an essential and, perhaps, total part of the work of art.

Figurative art in Europe

The aftermath of the Second World War caused a resurgence of figurative art in Europe, just as the Great War had played a part in the rise of Expressionism. Anguish and doubt concerning human existence again moved many artists to project their unrest through new images of the human which were distorted or threatened by hostile forces. In certain instances, abstraction alone did manage to convey something of this outlook. The Spaniard Antonio Tapies (b 1923) and the Italian Alberto Burri (b 1915) respectively fashioned dark, rock-like reliefs and configurations of torn and burnt cloth that had a deeply pessimistic quality. On the other hand, the still lifes of Giorgio Morandi (1890-1964), despite their apparent calm, depict objects whose edges tremble slightly under a light of otherwise unnerving stillness. But the most extreme statements came from those who continued to see the figure as a focus of meaning. Existentialist thought justified this since it stressed a person's isolation and helpless vulnerability in an absurd universe.

Even those painters who had reached maturity long before the war exhibited a reawakened gravity of style during the mid-1940s. Pablo Picasso, for example, executed his large and unfinished *Charnel House* (1944-1945), based on photographs of concentration camp victims, in solemn shades of grey that hark back to the tones of *Guernica* (1937).

Less overtly horrific, but still fraught with tension were the paintings, mostly portraits, of the Franco-Swiss sculptor Alberto Giacometti (1901-1966). His colours were also limited, possibly reflecting a world devoid of human warmth. Moreover, Giacometti was obsessed by the conflict between a person and the space or void that surrounds him or her. In his sculpture Giacometti had implied this emptiness by reducing the figure to very slender proportions, as if it were eroded by its surroundings and he carried over this practice into oils and graphics after the war.

In England Francis Bacon (b 1909) offered an especially trenchant version of post-war malaise reinforced by a technique that many others have used, although Bacon maintained a pronounced originality. The people in Bacon's works are captured in extreme situations like cornered animals. This may partly explain the importance of photography to his procedures since the camera can record a moment of crisis so abrupt that it could otherwise escape notice. Bacon's major problem has therefore been to translate such perceptions into the substance of oil on canvas. His solu-

RIGHT Although essentially a classical artist at a time of upheaval and change, Paul Delvaux painted works with an essential quality of modernity about them. This Sleeping Venus (1944) was one of several versions he painted, after becoming fascinated by two neighbouring exhibits, a sleeping Venus and a skeleton, at the Musée Spitzner. This idea of the proximity of love and death recurred in many of his works.

tion resembles that of the American gesturalists insofar as it involves quick brushwork and a grasp of how accidents may become positive features on account of their element of surprise. As Bacon noted in 1968: 'I think that you can make ... involuntary marks on the canvas which may suggest much deeper ways by which you can trap the facts you are obsessed by. If anything ever does work in my case it works from that moment when consciously I didn't know what I was doing.'

Bacon's imagery includes disturbing and unexpected juxtapositions, but it is the visual

beauty that he brings to details such as a gaping wound or carcasses of meat behind a sitter that affords the greater shock. In this respect his style belongs to the tradition of 'painterly' artists — Velazquez, Rembrandt, Courbet — who have exploited juicy impasto and prominent brushwork. Yet if Bacon too celebrates the opulence of his materials,he is nonetheless a painter of this century because of the distinctly modern neuroses which the materials serve.

The idea that our place in the universe could no longer be taken for granted similarly

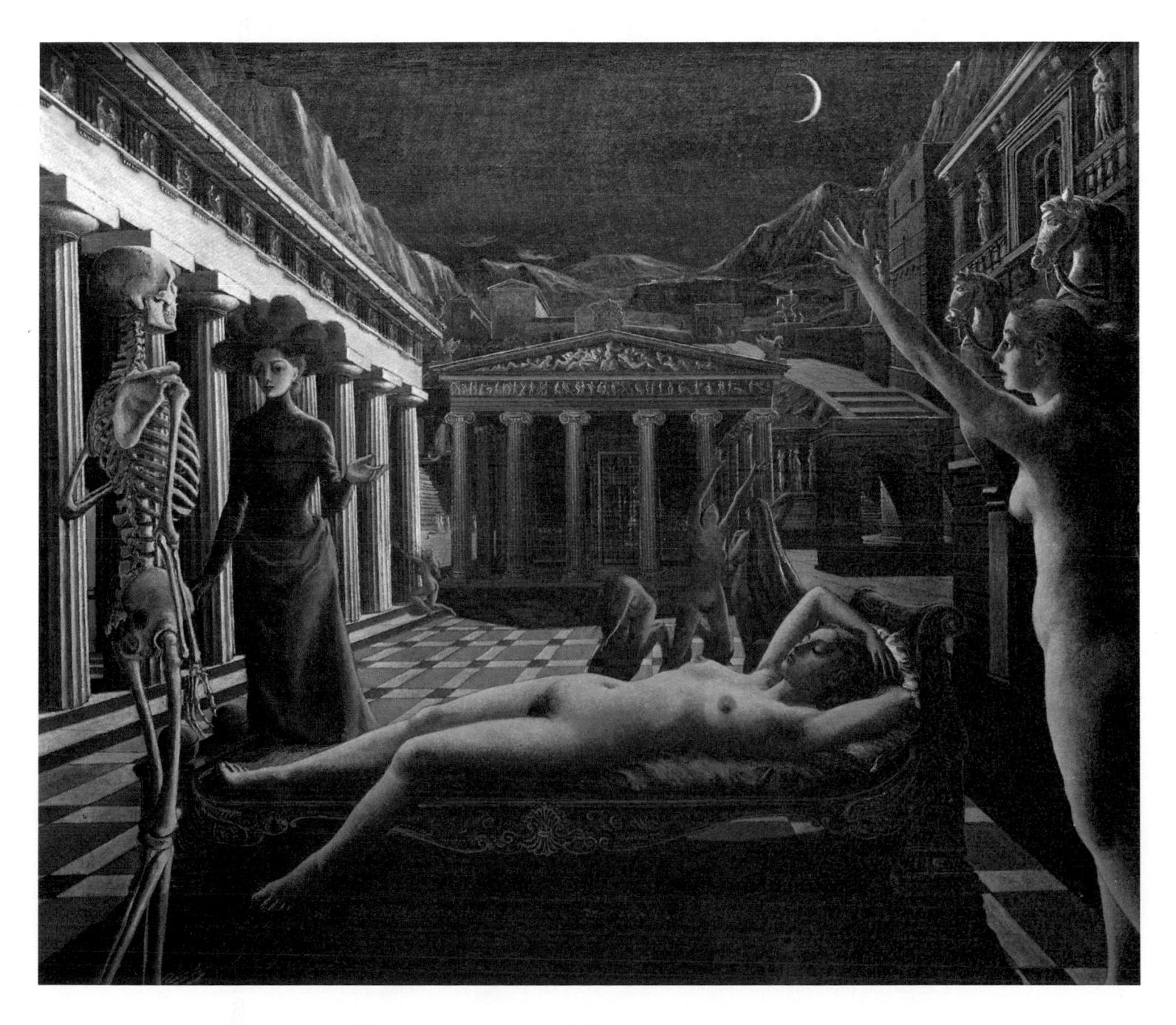

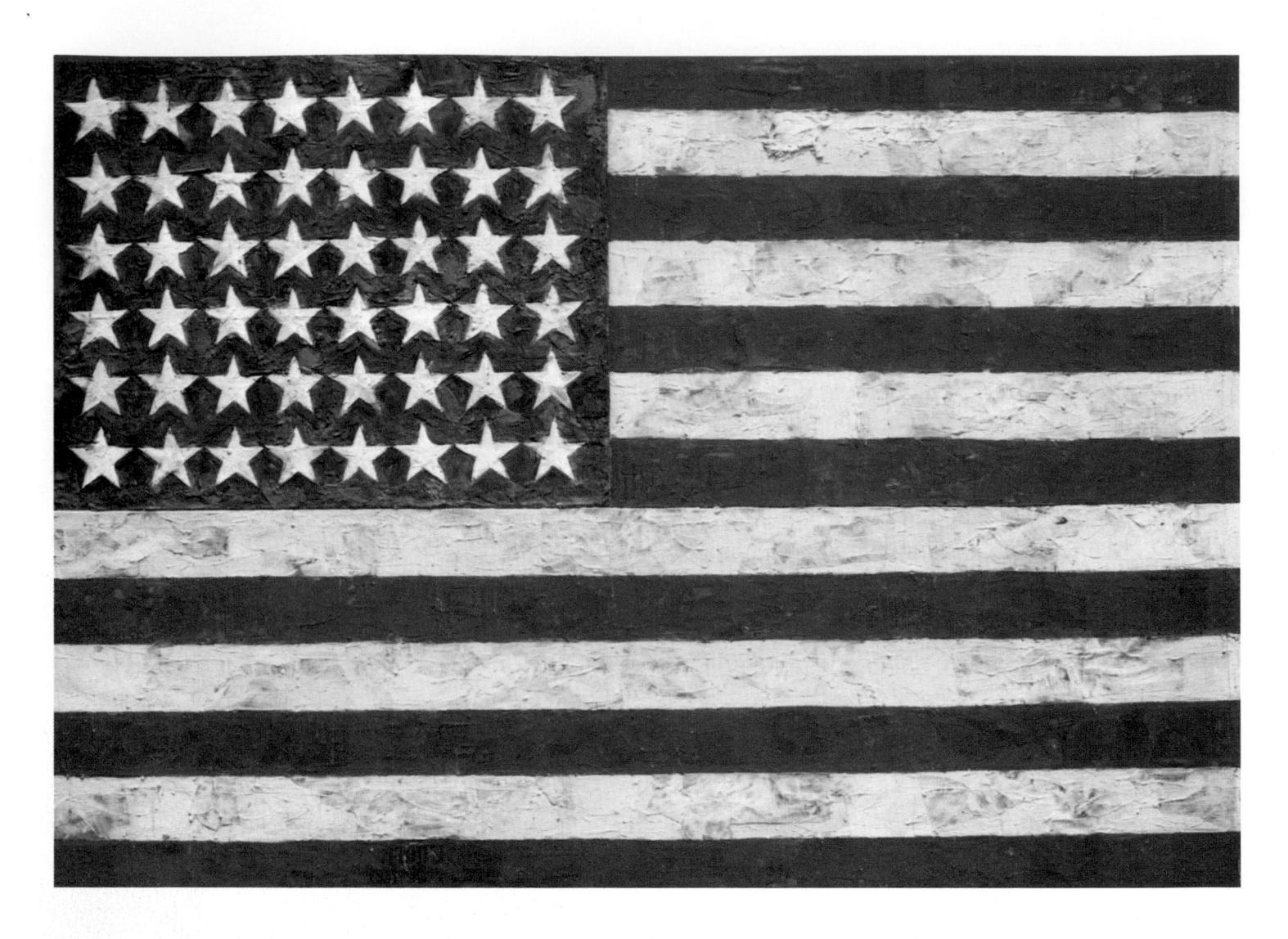

ABOVE Jasper Johns began Flag (1955) in enamel or oil paint. then changed to using an encaustic technique. I wanted to show what had gone before in a picture, and what was done after. But if you put on a heavy brushstroke in paint and then add another stroke, the second stroke smears the first unless the paint is dry.
And paint takes too long to dry ... someone suggested wax. It worked very well; as soon as the wax was cool I could put on another stroke and it would not alter the first.'Johns applied the paint with a brush or with material dipped into the hot medium.

affected the Frenchman Jean Dubuffet (b 1901) and his development of what he called *art brut*, meaning rough or raw, as opposed to 'fine' art. The prototypes for *art brut* were found in the work of primitives, children and psychotics who all view reality in a different light to that of the supposedly civilized artist. Dubuffet – and to some extent his contemporaries such as Jean Fautrier (1898-1964) and Wols (1913-1951) – admired this lack of sophistication allied to a crude vigour. According to Dubuffet, no distinctions can be drawn between humanity and art and the matter of which they are both, in the last analysis, composed.

Dubuffet consequently chose banal subjects to avoid any pretensions to intellectual refinement, but his real discovery was to see paint as no longer *depicting* light, colour or texture. Instead, its own material reality constituted the true purpose of the painting. To further this end Dubuffet added foreign substances, including leaves and earth, to his canvases and mixed the pigment with a filler such as plaster.

The resultant surfaces are virtually low reliefs into which primitive outlines are scratched. Although *art brut* proved fairly short-lived, it counteracted the dry academic manner still popular as a legacy of Veristic Surrealism.

It is significant that those Europeans who continued to explore the resources of colour were almost all from an earlier generation and so had either participated in Fauvism or were aware of its consequences. In France Raoul

Post-war developments in the use of colour

Dufy and Georges Rouault, for example, based their final works upon premises that had been current before the First World War. In Dufy's case this meant brilliant primaries and simplified design evolved from his Fauvist years, while Rouault maintained sombre glowing shades set within encrusted paint surfaces.

Above all it was Henri Matisse who took the colouristic freedom, established early on by Fauvism, to its most radical conclusions in the last decade of his career. He had always recog-

nized the inherent power of colour to transcend its roots in nature. This partly explains the extraordinary liberties Matisse took with his palette from the turn of the century onwards, experimenting with extreme saturation, pure primary tones as well as the most subtle combinations. He seemed to be able to generate light rather than transpose it realistically into gradual changes from shade to tint. When Matisse reached his seventies, however, illness increasingly prevented his activities in the orthodox medium of oil on canvas. His solution was to use large sheets of paper that had already been coloured to his own specifications. These were then cut as desired (hence the term papier découpé) and pasted on to a support. The cut-out paper allows me to draw in colour. It is a simplification ... I am drawing directly in colour; which will be the more measured as it will not be transposed. This simplification ensures an accuracy in the union of the two means.'

At face value papier découpé may resemble the Cubist collage technique but, in fact, the two have little in common. The Cubists were far less interested in colour and reduction than Matisse was, and regarded papier collé as a means of constructing a complex interplay of meaning and spatial organization. On the contrary, Matisse could now limit every element of his design to its barest essentials. Colour was the very substance of each shape. The breadth and directness of Matisse's methods

contributed to the return of colour as a primary factor in the art of the 1960s.

Yet perhaps an even more influential growth in the awareness of what colour can achieve took place after the war in America. Gesturalism did not actually account for the whole of the New American painting, since three of its pioneers - Clyfford Still, Mark Rothko and Barnett Newman - had created large abstractions where brushstrokes tended to be less pronounced than the overall grandeur of the colour fields. Still's technique was unique because he applied pigment with the palette knife in viscous layers, but Rothko and Newman kept their paint thin and fairly uniform so that texture did not interfere with the powerful hues. Newman, Still and Pollock in his later works also sometimes left parts of the canvas untouched to allow it to register as an individual colour. Rather as Matisse had united drawing and colour in his cut-outs, this approach permitted imagery to merge with the actual picture surface.

Such discoveries became especially relevant later when American artists reacted against what they considered the unnecessary sensationalism of action painting. They wanted to leave behind the loaded brush effects, turbulent composition and restricted palette. The formal beauty that abstract art can attain seemed a more urgent objective than any involvement with personal anguish or even the processes leading to the finished work.

BELOW Norman
Rockwell, probably the
most widely known
contemporary
American artist in the
1950s, has never
received critical acclaim
to equal his popularity.
His brand of Ruralism
displayed in The
Country Agricultural
Agent (1948) was
reproduced regularly on
the cover of the highcirculation weekly
magazine the Saturday
Evening Post.

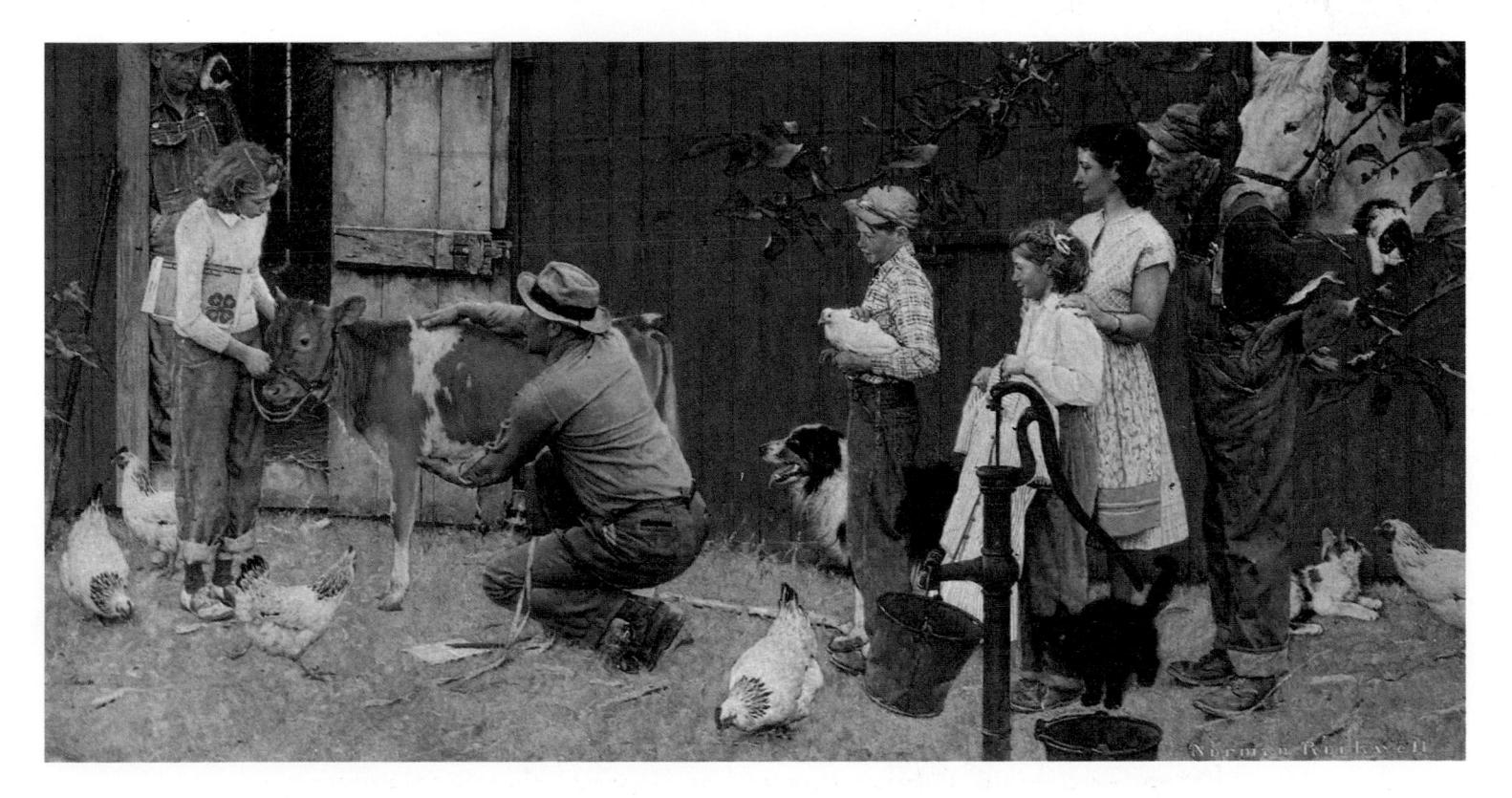

Assemblage and mixed media approaches

Perhaps the outstanding feature of the 1950s was the growth of the affluent society. Television, advertising and the media in general now reproduced images with a speed and insistence that brought visual information into the average person's routine as never before. Economic prosperity meant a surfeit of consumer goods and these helped to shape culture packed with an astonishing variety of products, both useful and disposable.

In this brash new climate, the high seriousness which motivated Abstract Expressionism looked increasingly out of place. Gesturalist art had been born of an era of social crisis and, although it was responsible for many technical innovations, it still upheld the basic assumption - largely unchanged since the Renaissance - that painting was a question of conveying emotion, illusion or ideas through marks on a flat surface. Yet one major alternative to this definition had arisen in the course of modern art. This was the Cubist notion that paper or other foreign materials could be used to construct rather than simply 'paint' a picture. From that realization grew not merely the three-dimensional Cubist construction but also the weird assemblages of found objects with which Dada and Surrealism blurred the boundaries of painting and sculpture. At a time when the British artist Peter Blake (b 1932) was introducing collage into his painting (which, however, was more akin to the Victorian scrapbook than to any Cubist work), the American Jasper Johns was revitalizing the notion of painting-sculpture, launching his ironic reply to the drama of action painting in the early 1950s.

Johns established his iconoclastic role on the New York art scene with pictures of deadpan motifs such as targets, numerals and flags. A possible key to these works is to interpret them as commentaries on the doctrine that paintings must have a meaning. By choosing signs that are always understood as part of a code – a target points to something, a number is only useful for what it measures - he deprived them of such meaning as the sole subject of a picture. Also, Johns depicted his designs with the agitated brushwork of a gesturalist, rather as if some monosyllable were repeated in a highly impassioned voice. To complete the contradictions he adopted the ancient technique of encaustic so that the normal flatness of a target, for instance, in fact become a low relief. Here was the start of an important modern tendency, continued by Larry Rivers (b 1923), Robert Rauschenberg (b 1925) and recent movements such as Conceptualism.

When Johns added plaster casts and similar artifacts to his compositions in the mid-1950s he anticipated a desire on the part of many artists to go beyond the conventions of the easel painting and its derivatives.

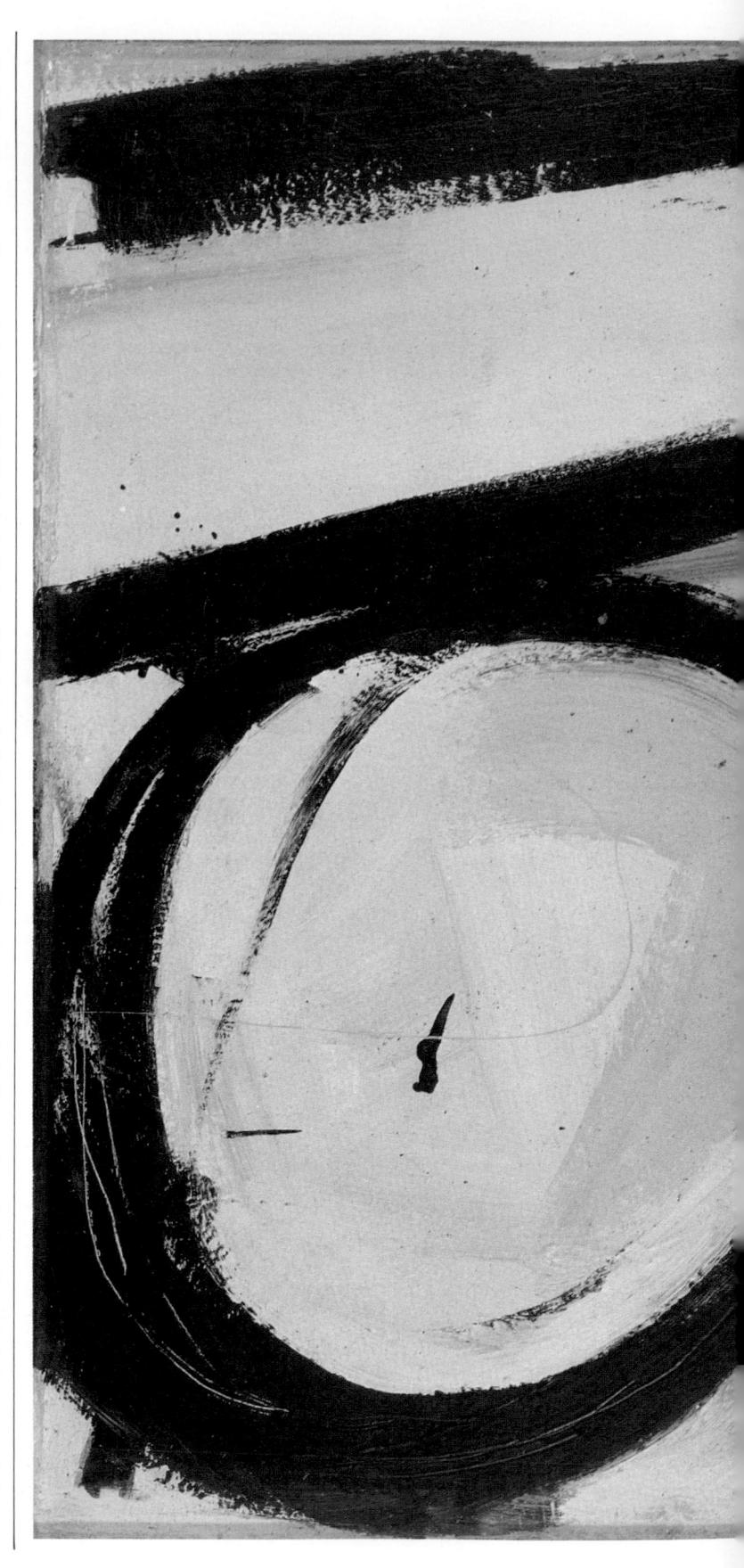

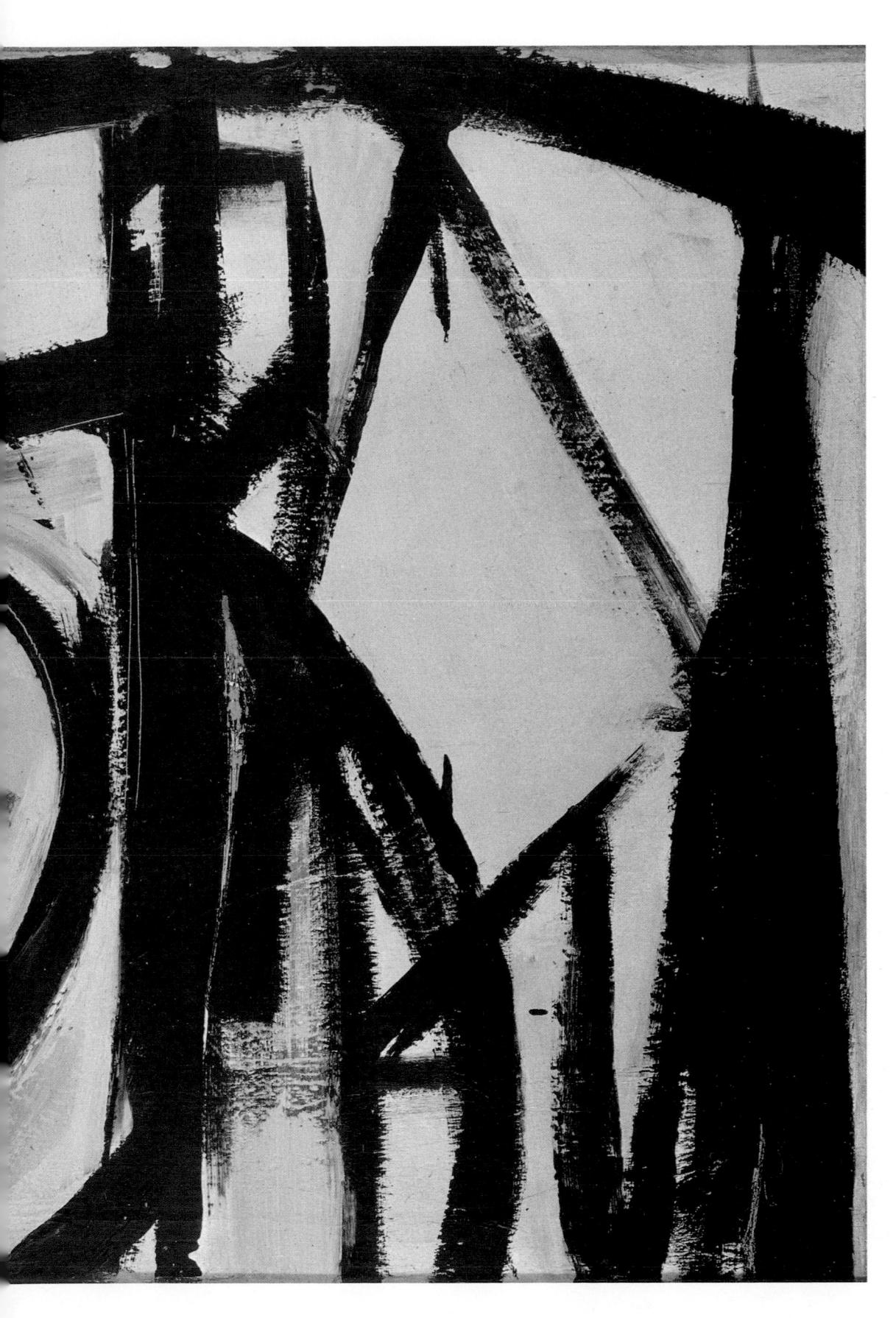

Kline was painting conservative canvases which developed into a bolder style based on traditional principles of abstract art. By the late 1940s and early 1950s, this abstraction evolved into a gesturalistic freedom of paint handling and brushstroke, as well as a certain eastern quality of calligraphy. Clock Face, which he painted in 1950, is a canvas of tremendous boldness with its strong black strokes against a white background. Kline reduced his palette to black and white, and this, combined with his dramatic and enormous brushstrokes, conveyed a sense of the alienation and violence characteristic of the contemporary American city.

Figure in a Landscape (1945)
Oil and pastel on canvas
144.7cm x 128.2cm/57in x 50½in

A peculiarly individual and isolated painter, Francis Bacon was born in Dublin in 1909. He moved with his parents to London when he was 16. He never received a formal art school training, but spent his twenties working as an interior designer making furniture and rugs. Throughout the 1930s he painted intermittently and in 1944 started to paint full-time.

A number of sources have recurred in his paintings. As prompts he employs X-ray photographs; Eadweard Muybridge's *The Human Figure in Motion* of 1887, showing the frozen movements of struggling or fighting pairs of men against a measured grid; film stills, as well as works by Rembrandt, Diego Velazquez (1590-1660) and Goya with particular reference to *chiaroscuro* areas of brilliant fluid brushwork emerging out of a dark field which provide drama and a sense of glimpsed movement.

Figure in a Landscape is an early example of Bacon's work, which had an enormous impact on post-war British painting. It is based on a photograph of his friend Eric Hall sitting astride a chair in Hyde Park, London.

Bacon frequently starts a painting with a controlled 'accident' of paint thrown at the canvas, which often evolves into a figure in violent movement in a disquieting domestic setting, or landscape. Figure in a Landscape was painted on a large white primed surface; probably some ivory black paint was 'accidently' splashed on the centre of the canvas in the area now occupied by the figure. The next task was to create what Bacon refers to as an 'armature'. This is a two-dimensional framework upon which he almost literally 'hung' the paint. The link with the sculptor's wire armature is quite clear, but so is Bacon's experience of technical drawing and furniture design. These first lines can be traced raking horizontally across the centre foreground in two parallel motions of thin black paint, also in an apparent railing curving in from the right, and later overpainted with two greens; and in the horizontal lines which slice across the centre of the painting at the top of the chair back.

The central dark space was painted at an early stage, possibly echoing the shape created by the first controlled accident. Here Bacon used his knowledge of Matisse who had revealed that strong resonant blacks are possible only if laid directly on to the primed canvas. Any lighter paint underneath would have prevented its tendency to recede. He used broader brushes to put down the fields of buff-coloured paint which dominate the entire upper half of the canvas but applied it more unevenly in the lower foreground where the primed canvas can be seen breaking through in many places.

The landscape behind the figure recalls a grid in movement, reminiscent of Eadweard Muybridge's experimental figure photo-

graphs. In the foreground it resembles a hot African grassland; Bacon has imaginatively transformed Hyde Park into a type of savannah. This is related to his interest in pictures of big game hunting, which have triggered off several other paintings.

Once this black/beige relationship had been laid down, the centres of focus could be established. The lapel, cuff and sleeve were put in as symbolic of a suit, Bacon's sense of commercial design enabling him to select the particular elements which would be universally recognizable. The wittiest piece of execution is at the lower knee where the cloying buff paint has been dragged over the now dry black underpaint so that the revealed canvas grain is 'read' as the assumed texture of the suit's cloth.

The area of greatest visual excitement occurs at the intersection of the four structures on the right, where Bacon creates a small explosion of scuffed paintwork using both his fingers and his brushes. This marks the introduction of alizarin crimson, which conveys a disturbing element of violence. Some of Bacon's most favoured reference tools are medical manuals; from them he has developed the technique which gives this otherwise relaxed seated figure a new kind of violence and vulnerability. The seated figure is welded to the chair and pinned by the structures on the right, one like a machine gun. Again the technique is adapted to this purpose and some of the black paint has been aggressively scraped away revealing the canvas surface like a wound in the area inside the curving 'railing'.

Eric Hall's body is shown headless, a rare occurrence in Bacon's work, with a cavernous torso like a wheel arch painted in lamp, ivory and blue blacks. The body's presence in space is enforced by the broken patch of shadow behind the leg, put in with very thick impasto in two blacks and a deep ultramarine.

Bacon unified the painting in terms of colour using alizarin crimson and cadmium red in a loose Divisionist speckling, in the red border at left and right of the figure and in the angled shadow at the lower right corner.

Cerulean blue was applied with a broad bristle brush in a broken strip across the top. This leads the eye to a flecked piece of raw sienna at top left. It functions as a colour 'key', as it is the pure component of the dominant beige colour of the landscape.

Figure in a Landscape is a brilliant example of the deliberate use of various methods and techniques, each shifting to accommodate Bacon's imaginative instincts in the different zones of the canvas. This activity entailed the visual destruction of a seated figure, yet was a highly organized disintegration which arose out of Bacon's stated 'desire for ordering and for returning fact on to the nervous system in a more violent way'.

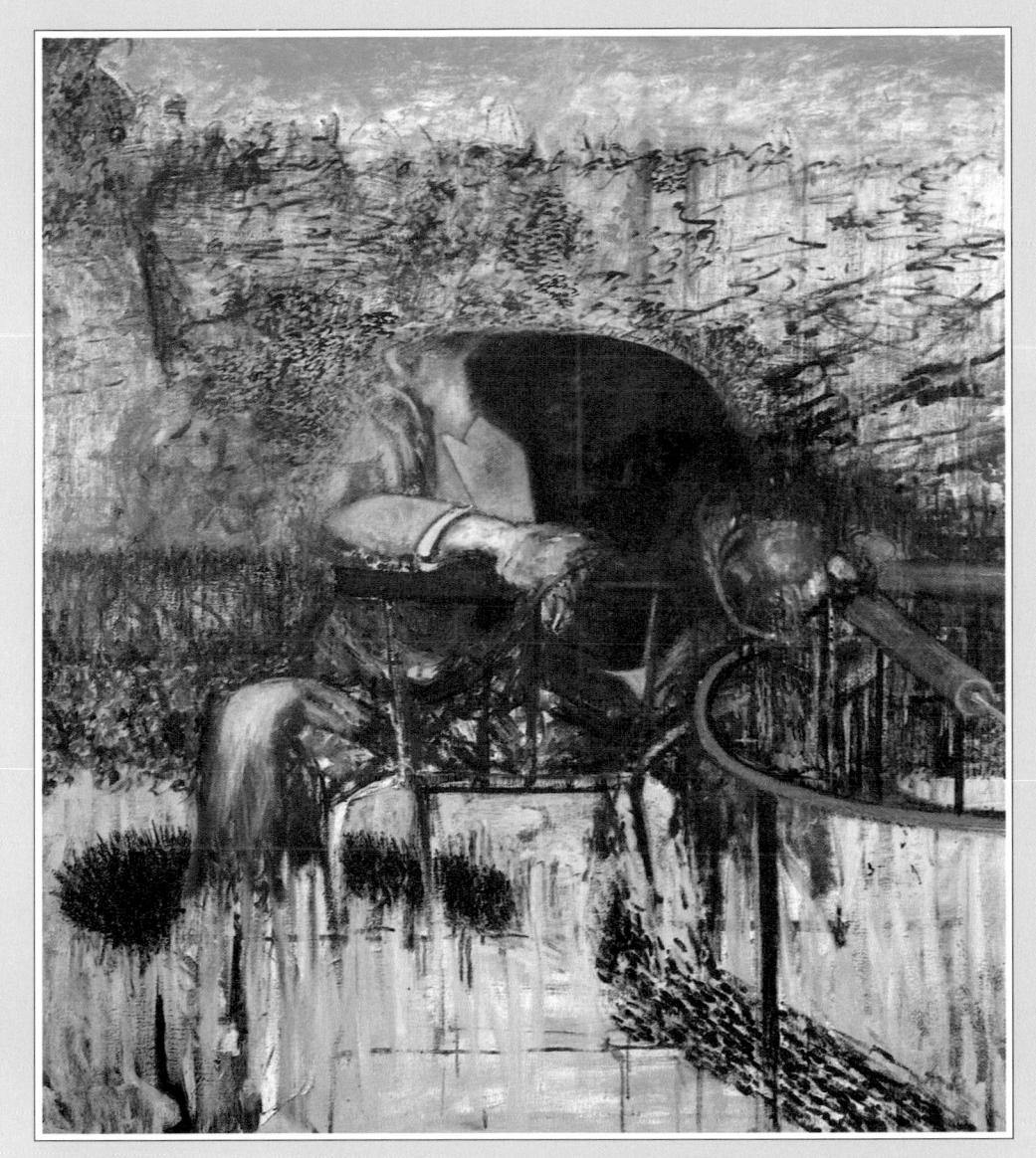

The Figure in a
Landscape is based on a
snapshot of Eric Hall
taken in Hyde Park.
The photograph was
used as a basis for a
range of treatments of
the surface of the
canvas. Bacon aimed to
give movement to the
traditionally static
seated figure, in order
to make the picture act
on 'the nervous system'
with greater intensity.
All technique was
conspiring to create a
cinematic view of the
figure. The starting
point for this work was
probably a controlled
accident (such as paint
thrown at the canvas)
— with most of Bacon's
paintings. This is then
brought under control
by an extensive painted
grid and successive
glazes and
overpainting.

A Chinese brush was used to create a rapid calligraphic brushstroke with thinned black paint

A 'sgraffito' effect was achieved by a bunch of brush ends raking into wet paint, creating a ploughed effect

One of several areas of divisionist brushwork; a speckled broken area of colour

White primed canvas breaks through in many areas of the painting to give air spaces to the composition

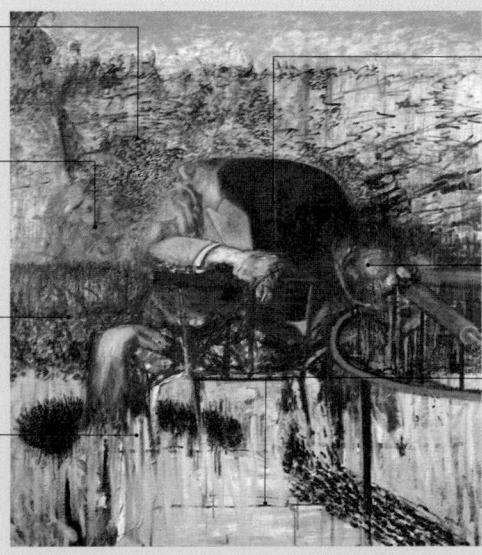

A lamp black, ivory black and pure ultramarine were used to give intensity to areas of deep shadow

Bacon used his fingers to blend the paint in several parts of the figure

Some traces of the initial black construction lines of the painting were left uncovered to give a sense of geometry controlling the composition

RIGHT The paint was applied with some heavy impasto in the green 'railing' which was toned down from a shrill cadmium green to a cooler khaki tone which harmonizes with the hue of the tubular structure on the right. The area enclosed by this structure had some paint scraped away with a blunt knife in downwards motions, emphasized by a light strip thickly studded with ultramarine.

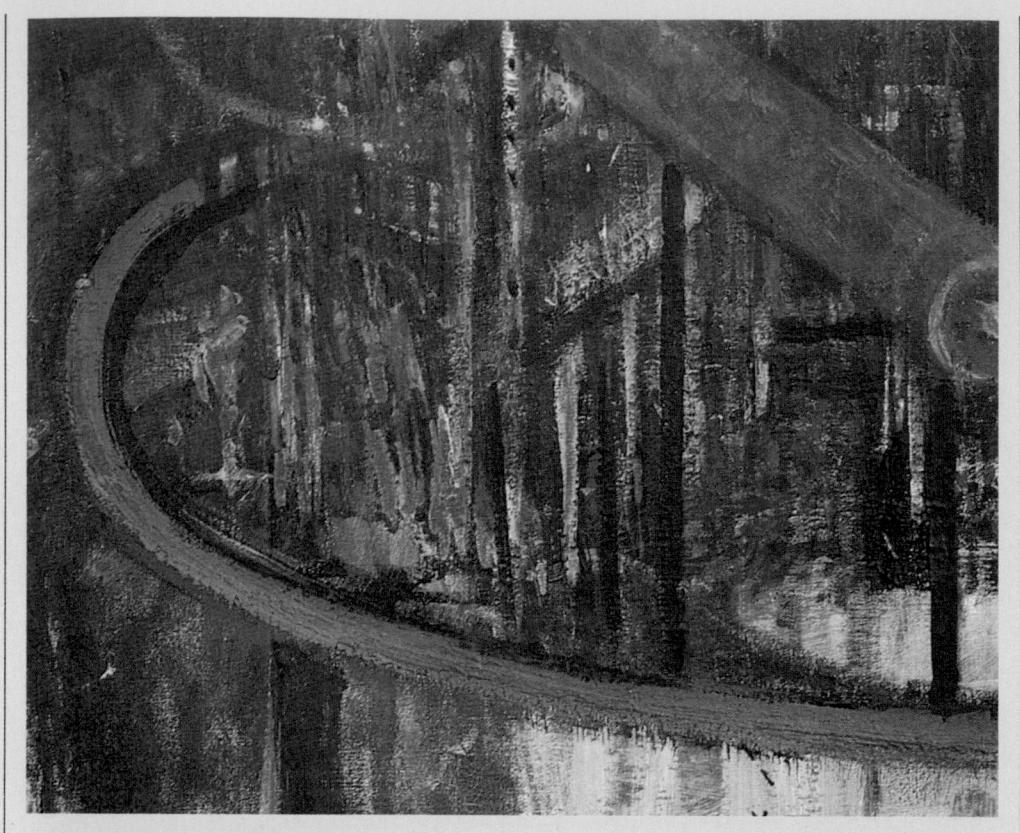

RIGHT The figure's right leg is made to disintegrate into the foreground with a vertical smudging of beige paint over partly dry, black underpaint. Some of the initial understructure is allowed to break through the oil-thinned glaze of beige which is brushed in where a foot might appear. Some primed canvas appears in this area creating a sense of space and volume. A pool of shadow behind the leg was built up out of many small vertical brushstrokes in two blacks and ultramarine. This also conveys the texture of dry grass.

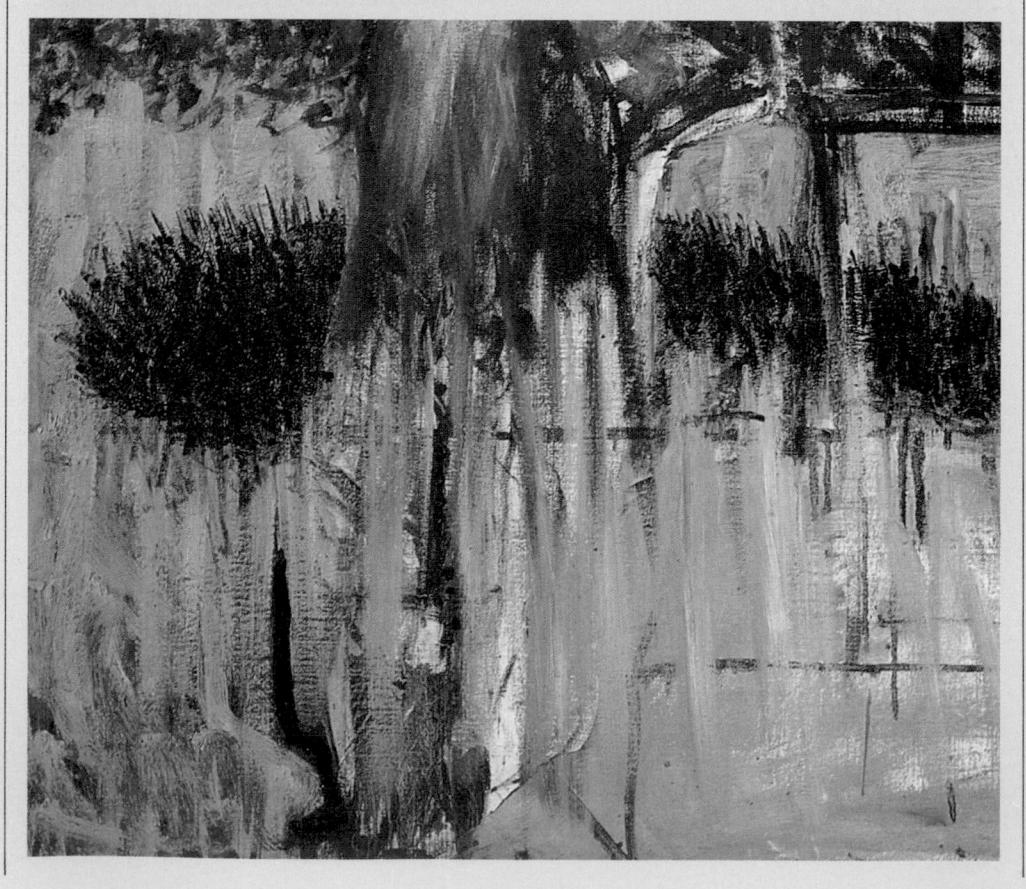

ACTUAL SIZE DETAIL The hands of the figure resting on the back of the chair indicate the precise centre point of the canvas. Bacon often uses a taut underlying geometry which is a result of his training as an interior designer. The upper hand has been painted and finger-smudged in a thinned flake white over raw sienna which had dried. The lower hand is The lower hand is merely drawn in with ivory black and is given some touches of thin white glazing on the knuckles to complement the light colour of the primed canvas. The chair back has been brushed in as a horizontal line of pure viridian across the viridian across the actual centre line of the actual centre line of the painting. The ivory and lamp blacks used in beneath this have been brushed in wet into wet. The flat side of the brush was dragged across the area depositing some random bristle prints to add movement and drama to the passage. some unpainted canvas is also allowed to remain to give the impression of depth behind the chair struts.

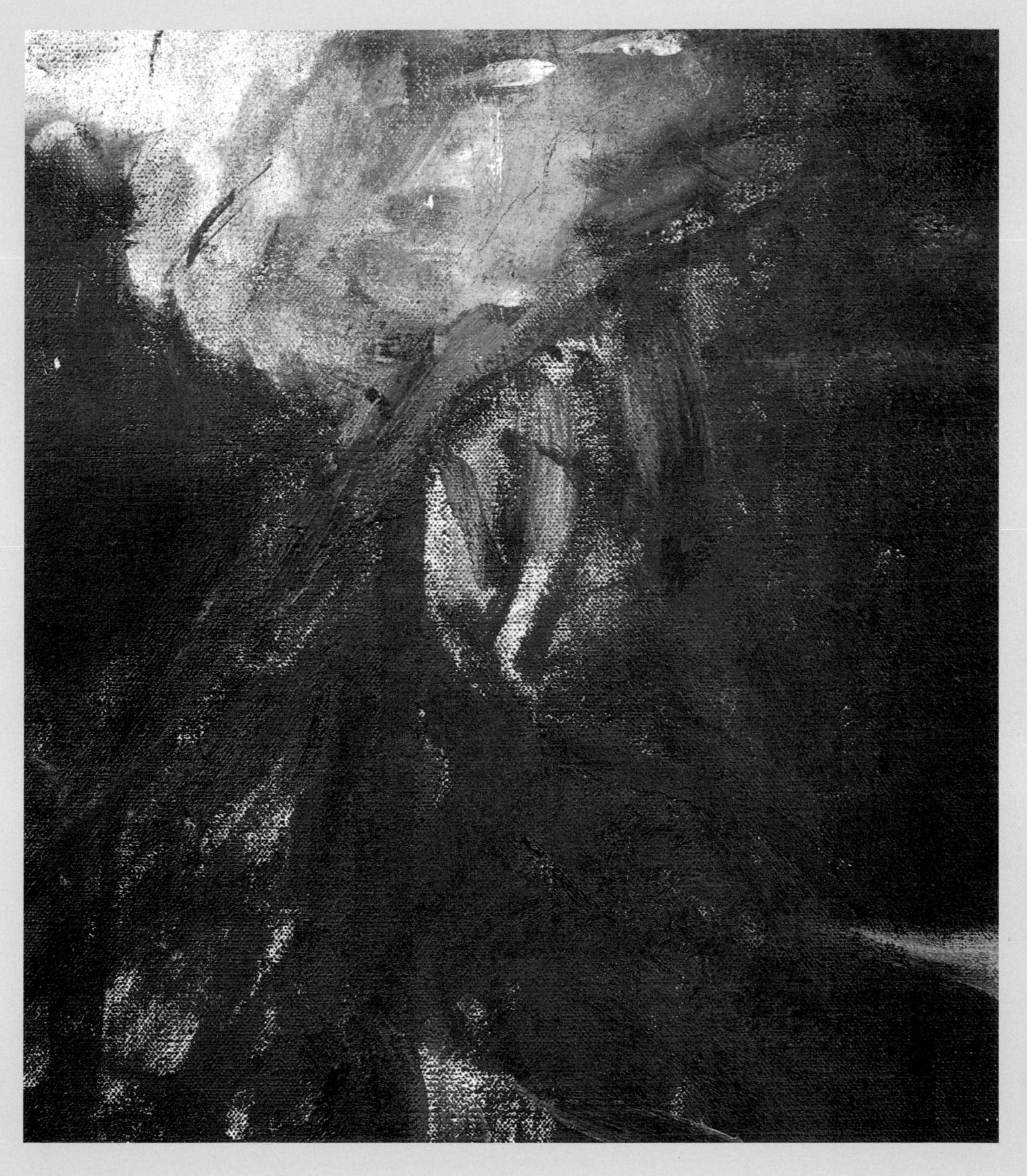

Dhotel nuancé d'abricot (1947) Oil on canvas 116cm x 89cm/45½in x 35in

Dubuffet was born in 1901 in Le Havre. In 1918 he went to Paris where he gave up his course in painting at the Académie Julian after six months and started working on his own. He knew the painters Dufy and Léger and both had some influence on his otherwise 'self-taught' approach to art. By 1924 he had given up painting entirely and instead concentrated on running a wine business. In 1933 he started painting again, producing mainly puppets and masks, but in 1937 this creativity ended once again. It was only in 1942 that he finally devoted himself to painting and to the direction that he has continued since.

Dubuffet's return to painting was accompanied by a passion for primitive and naive art forms, as well as for paintings made by the psychologically disturbed. By 1945 he had started to collect so-called 'ugly art' or Art Brut, and in 1948 he founded a society to promote this type of work. He also wrote some important statements, criticizing the cultural aims of post-Renaissance Western art, in the place of which he advocated the more spontaneous, non-verbal, and spiritually potent qualities of primitive cultural expression. This resulted in a totemic approach to image-making which soon revealed itself in his first exhibition, where city life and images of men and women were presented with an aggressively simple and childish vigour. These paintings looked more like graffiti-covered walls or tribal emblems than conventional oil paint.

The driving force behind these early works was Dubuffet's entirely novel and extraordinary painting technique. He combined almost any element with the paint surface, including cement, tar, gravel, leaves, silver foil, dust and even butterfly wings. In defence of this technique he stated that 'art should be born from the materials and, spiritually, should borrow its language from it. Each material has its own language so there is no need to make it serve a language.' Such an approach has drawn him into the field of sculpture, using materials gathered at first from beside Parisian railway lines; by the 1970s he was creating enormous architectural environments in concrete.

In 1945 Dubuffet painted one of his first portraits, a drawing of Jean Paulhan, who later introduced the artist to the group of writers and intellectuals that frequently met at the house of Florence Gould. She persuaded him to make another portrait, of the writer Paul L'Eautaud. This developed into a series and eventually into the third of Dubuffet's major exhibitions entitled *Plus beaux qu'ils croient (portraits)* (Better looking than they think). Dhotel nuancé d'abricot was one of this group. André Dhotel is its subject.

The portraits are named after the sitters, whose most curious features have been deliberately emphasized by the artist. They combine caricature, imagery and some factual ele-

ments. Dubuffet explained that for a portrait to go well: 'it must be scarcely a portrait at all. It is then that it starts to function at full strength.'

Dubuffet's technique in Dhotel nuancé d'abricot can be reconstructed from a studio log book kept by him at the time. Laying the stretched canvas on the floor, he covered its entire surface with a thick, sticky pâte of light-coloured oil paint applied with a spatula, like icing a cake. While it was still wet he took handfuls of ashes and sprinkled them over the whole area to darken the paint. Over this he dropped sand and then coal dust which would all, to a certain extent, sink into the surface. At this point some colour was put on in the form of a thin 'apricot' mixture of yellow ochre, white and crimson brushed over the surface broadly. Some pure crimson was also put on, and is still visible through parts of the black crust.

The surface was now prepared to be totally covered with thick black paint trowelled across with a palette knife, possibly with the addition of more ashes and dust. There was still no trace of the image at this stage – it would have looked instead like a plain smokeblackened wall. With a broad spatula Dubuffet then carefully rubbed the materials into the surface and put the canvas on an easel to let any excess fall off.

It was only at this stage that the head was painted in with a cream white on a palette knife. Then, using a blunt point, he incised the contours of the head through this rich sandwich of paint and material, so that sometimes the canvas texture was revealed, as, for instance, on the side of the face to the left of the chin. The lines of the hair and the rest of the features were also drawn in with this instrument, sometimes lightly, as on the chin and spectacles, or deeply, as in the neck and shoulders, breaking through to the first thick impasto. A very thin mixture of 'apricot' paint and turpentine was then brushed over the face so that it ran into the gutters made by the ploughed lines, and stained the face with a warm glaze. Some of the original light paint of the face which was outside these boundaries was then blacked over. Finally, using a fine lettering brush the lines were enhanced with the addition of crimson, yellow ochre, black and white, in particular drawn into the trenches of the teeth, hair, nose and bow tie. These colours were used in a broader way in the earlier preparation of the surface, and thus the head and background appear unified visually.

The title of the work is, as usual with Dubuffet, an important final contribution. The result, in the case of *Dhotel nuancé d'abricot*, creates a humorous tension between what the viewer anticipated by the rather poetic description and what is actually confronted in the finished work with its primitive, earthy textures and skull-like gaze.

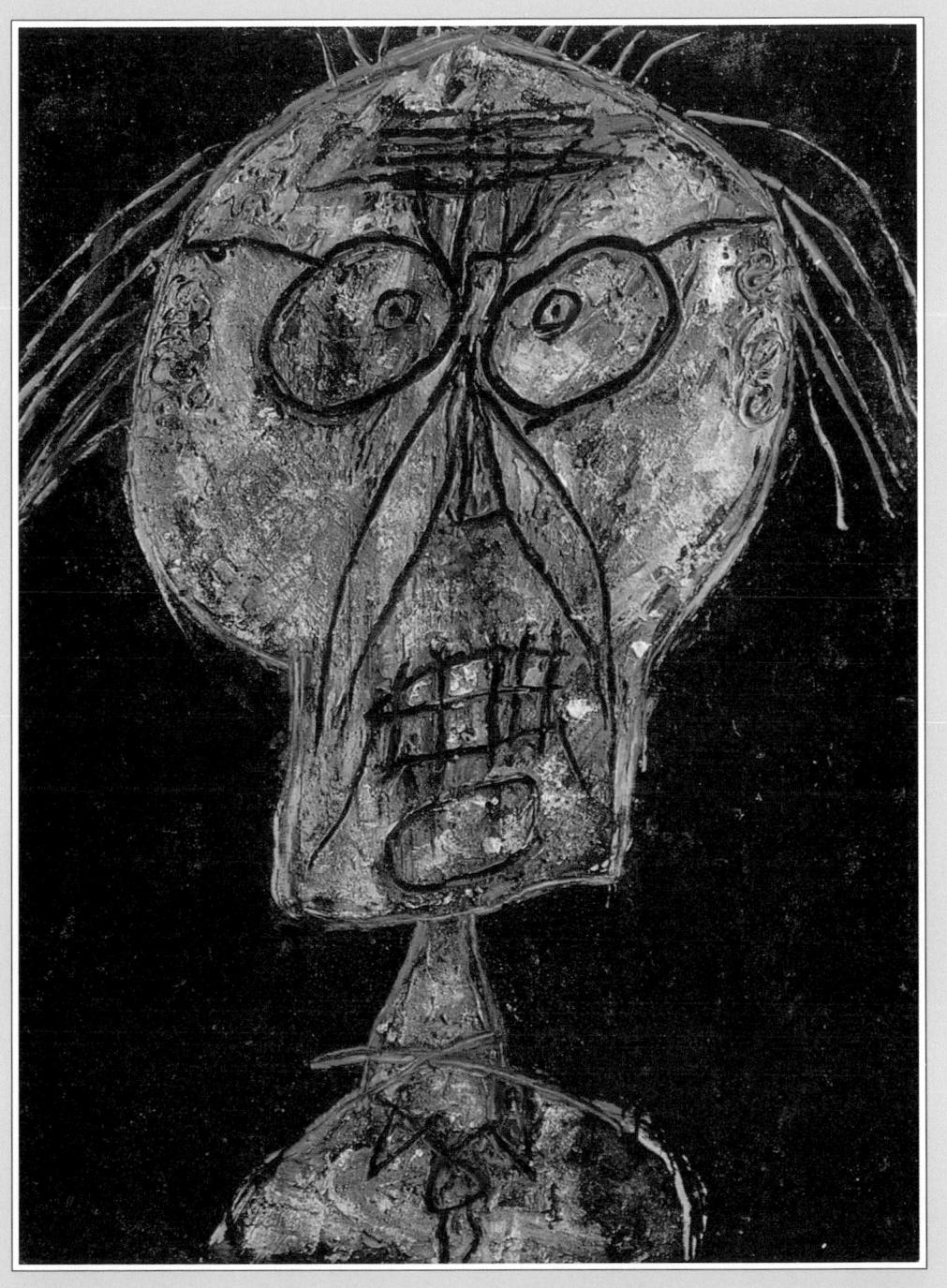

Dubuffet gave this series of portraits the title 'Better looking than they think'. Despite the apparently childish graphic qualities of line, there was no intention to create a caricature, but rather to emphasize the features that the painter thought were

worth remembering once in the studio. A sense of humour is also evident in the way the spectacle frames are echoed in the drawing of Dhotel's chin. Yet a slightly sinister skulllike quality is hinted at behind the frontal intensity of the gaze.

Crimson underpainting of the background breaking through the final layer of black paint and material

Thick cream paint mixture dragged by a broad spatula over the crumbly surface of the paint and material

The dense black background is the result of an elaborate sandwich of oil paint, ashes, sand and coaldust

Thinned black paint and turpentine is painted with a fine lettering brush into the troughs made by a palette knife

Touches of pure crimson red added to the blackened lines

The palette knife produced all of the 'drawing' and, in places, has exposed the light colour of the primed canvas

LEFT Dubuffet's portrait of Dhotel is a good example of his use of haute pâte which required a thick mixture of oil paint, turpentine colour washes and a limitless variety of granular raw material sprinkled over and mixed into the surface before any drawing was attempted. Here the head and shoulders required the final layer of cream colour before the contours and features were drawn in with a palette knife.

RIGHT Some of the successive processes in the assembly of haute pâte have been exposed by the furrows created by the palette knife. Here some of the texture of the primed canvas has been revealed. Dubuffet needed to paint this portrait with the canvas lying on the studio floor. When the portrait was put on the easel much excess material would fall off, then the main outlines and the finer hrushwork could be added. Dubuffet was concerned to draw attention to the humblest raw materials and to give the commonplace elements of dust, ashes and sand a sense of value and beauty when employed in a painting. This aim is particularly successful in the combination of coal-dust and black paint in the background.

ACTUAL SIZE DETAIL The surface of the painting is approached like the form of map-making, a fact often declared by Dubuffet in the titles of some later paintings. A palette knife or blunt instrument was used to score into the thick paste which had been built up while the canvas lay on the studio floor. The apparent coarseness of the handling and the invitation to accident was then counteracted by the use of a fine lettering brush which was used, like a pen to reinforce the troughs in black and touches of crimson. The picture was probably completed within a day because the deep gouging was only possible while the pâte was still moist.

Full Fathom Five (1947)
Oil on canvas with nails, tacks, buttons, coins, cigarettes etc
129cm x 76.5cm/50% in x 30% in

Jackson Pollock is held up as the tortured champion of American painting; the artist who, more certainly than any other, took the standard of the avant-garde from Paris to New York, a shift which is the most important single event in the history of post-war visual art. His technical and formal achievements, especially during the furiously innovative years 1947 to 1950, when he pioneered his famous drip technique, have been the most revolutionary since Cubism, and, some would claim, transcend even this. Most fertile of the Abstract Expressionists, Pollock took painting off the easel and finally cut the ties with imitation that are hidden in almost all modes of non-geometric abstraction prior to his.

He was born in January 1912 in Cody, Wyoming and spent his childhood largely in the west of the United States, in Arizona and California. He became interested in art through the influence of his eldest brother Charles, and he studied painting in Los Angeles at the same school as Philip Guston (b 1913), the future Abstract Impressionist.

The influences on Pollock's visual style and method have been the subject of much debate and controversy. Critic William Rubin presents the most extended and plausible argument, claiming that Pollock 'built simultaneously on such diverse and seemingly irreconcilable sources as Impressionism, Cubism and Surrealism', and arguing against the myth of instantaneousness started when critic Harold Rosenberg labelled Pollock's work as 'Action Painting'. Certainly, there is no doubt that Pollock was aware of the surface emphasis and scale of Monet, the stylistic and material experiments of Picasso and Braque, and the exploitation of 'automatic' procedures by Surrealist painters such as Joan Miró.

Possibly of relevance also, though notoriously difficult to detect precisely in the paintings themselves, is Pollock's known interests in mythology, religion and theosophy, and in particular the psychological writings of Carl Jung (1875-1961). From 1939 Pollock was in analysis and produced a variety of 'psychoanalytic drawings'. Ideas, then, of the untutored 'cowboy' from the West must be firmly resisted, as Pollock's attention to the art and writings of the past was extensive.

Such was the power and individuality of his achievement, however, that Pollock was more often reacted against than imitated in American and European art. Indeed he is difficult to imitate. Numerous attempts to fake his work appeared on the art market in the 1960s and they reveal the strength of the technical mastery Pollock developed over his own unique painting process. In fact the influence he did exert over subsequent generations was to provide artists with a final liberation from traditions of representation and from the controlled touch of the brush on canvas.

After a brief early flirtation with sculpture, Pollock became dedicated to painting, and his contribution technically was effected by experiment with the tools and means of application, mediating between the oil and canvas, or paper, rather than with the material constituents of these elements.

Full Fathom Five is one of the earliest masterpieces of Pollock's drip technique. The actual origins and initial development of this technique have never been fully explained, except by reading back from fuller photographic evidence produced about 1950, two or three years after this work was painted. Like other practical breakthroughs in twentieth-century painting, 'creative accident' seems likely to have played an important part, as Pollock probed and tested methods of paint application which promote the continuousness of line rather than the broken lines inevitable in the constant reloadings and readjustments of conventional brushwork. His solution was to pour from a can of domestic paint along a stick resting inside the container, so that a constant 'beam' of pigment came into contact with the canvas (which he left unstretched on the studio floor). The character of the line was determined by certain physical and material variables that could be combined in almost infinite permutations: the viscosity of the paint (controlled by thinning and dilution); the angle and hence speed of the pouring; and the dynamics of Pollock's bodily gestures, his sweep and rhythm, especially in the wrist, arm and shoulder. 'Like a seismograph', noted writer Werner Haftmann '[the painting] recorded the energies and states of the man who drew it.' In addition Pollock would flick, splatter and dab subsidiary colours on to the dominant linear configuration.

In Full Fathom Five the initial impression of a vibrant sea-green hue is relieved on inspection by the variety of shades and inflections which combine to produce an idea of water and of depth. A strenuous black calligraphy loops and curls round the volume of green; mottled and patchy areas of white interact with these, while the green is 'seasoned' with amounts of other colours.

Pollock has embedded nails, tacks, buttons, keys, coins, a torn cigarette, matches, and paint-tube tops into the surface – witnesses of the accidental nature of the 'painting' process and of the legitimacy of the trouser-pocket paraphernalia – as three-dimensional textural agents to amplify the signifying potential of the image. These alien materials, however, are subordinate to the overall design. They are, interestingly, almost invisible in normal reproductions of the painting; suffocated by the overwhelming presence of paint their function is analogous to the smears and touches of colour, providing resistance and difference in the optical pattern.

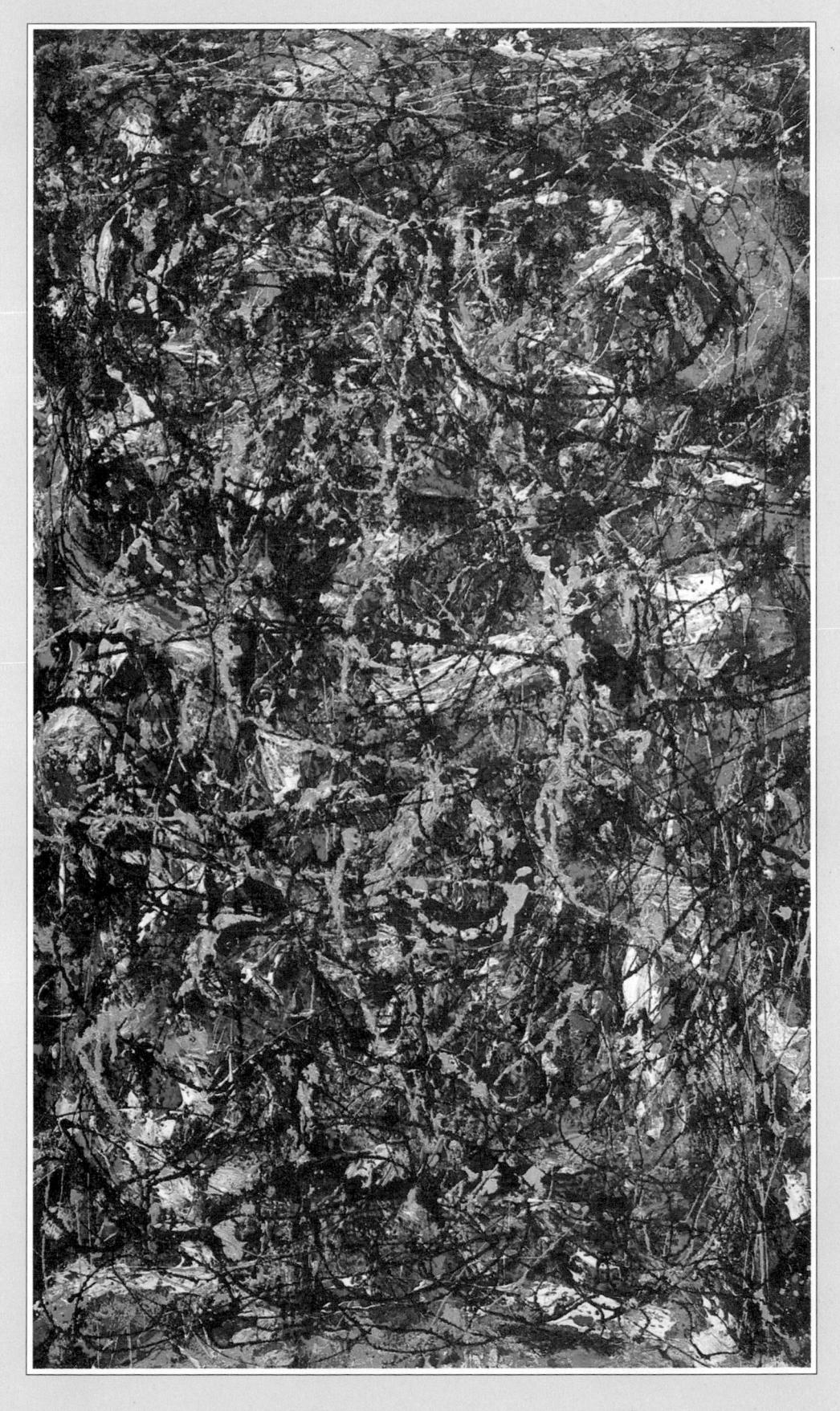

Full Fathom Five is a boldly experimental early drip piece. The whole work however, has not been executed by pouring. There seem to be considerable areas, particularly in the various greens, that have been applied nearer to the surface. Liberal use has been made of aluminium paint whose sheen is skilfully exploited to contrast with the sharp white and more matt colours. Other colours are applied according to their hue and viscosity, as Pollock worked from all sides of his unstretched canvas, laid out on the studio floor. Unlike some later drip pieces such as Autumn Rhythm (1950), Full-Fathom Five is densely worked and multicoloured and, even at the peripheries, often in Pollock the sites of slacker activity, there is scarcely a glimpse of the unprimed surface.

Smears of yellow and orange, possibly the last and most deliberately applied pigments

Button embedded in the surface with paint

Thin, black tracery on a thick clot of white paint

Thick almost circular band of black, probably dripped and worked

configuration in this detail is predominantly cursive and the colour patches less discreet, invaded by other hues and effaced by later overpainting. The black calligraphy and metallic grey areas appear typically to have been added in the later stages of working. Small, but quite evenly rounded, paint flicks are visible over the whole surface.

Edge of composition with no linear drippings

RIGHT In a less heavily textured area such as this, the extreme delicacy of touch of Pollock's technique is clearly apparent. Minute spots and dabs of blue, yellow, orange and white inflect the mauve colour patch, which is also traversed by all three of the main types of line used in the work, from the hairthin sliver of white to the two thicker dribbled black lines.

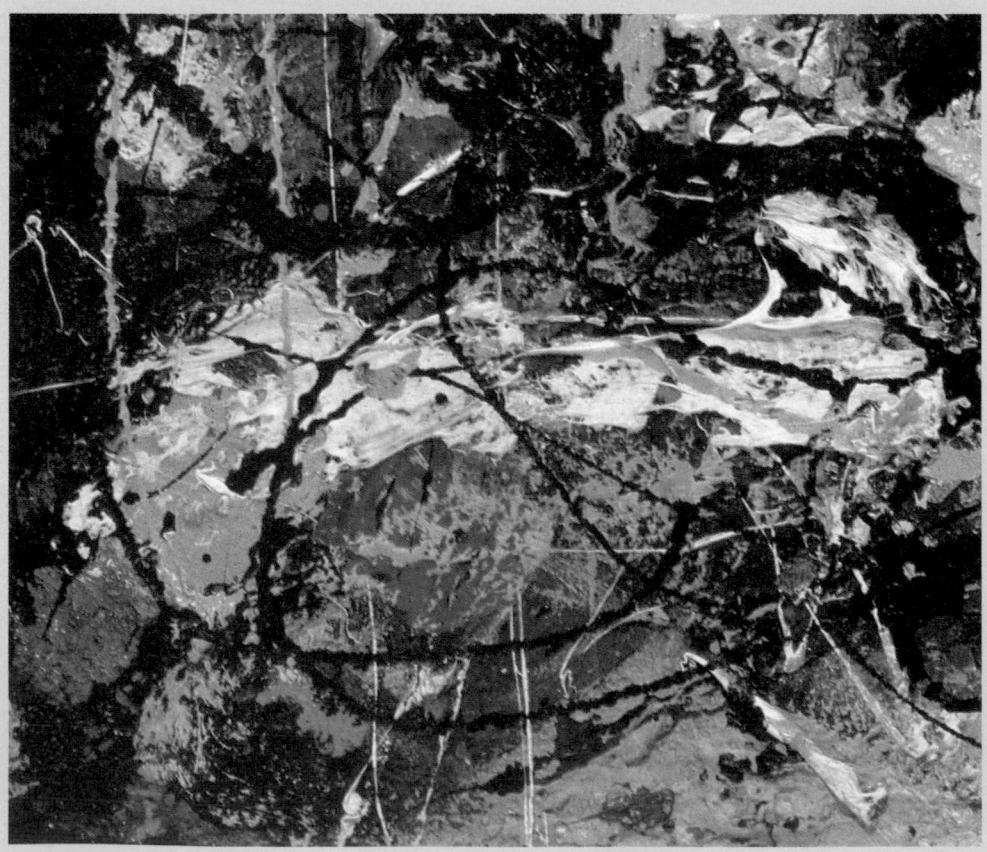

ACTUAL SIZE DETAIL A number of marks, particularly the yellow and orange slabs with purple edging, appear to have been directly applied onto the surface, obscuring some of the black tracery. There is considerable variety of texture between the different modes of application; the thick smears of white, smaller touches, dots of paint flicked or applied from a distance, and continuously dripped lines.

L'escargot (1953)
Gouache on cut and pasted paper on heavy white cartridge paper
286.4cm x 287cm/112³/₄in x 113in

Born in 1869, Matisse did not become established as a painter until the first decade of this century, when, after a period of sustained study of still life and figure painting, including copying paintings in the Louvre, his works were exhibited with other Fauve painters in Paris. This group, including Derain, Vlaminck and Georges Rouault (1871-1958), adopted a very high-keyed approach to colour which is evident in Matisse's early masterpiece, *Joie de Vivre* (1905-1906). This work features a group of strongly outlined nudes and a circle of dancers; motifs that were to concern him to the end of his life.

Matisse's studies of the nude led him to create, between 1904 and 1929, a series of four very large bronze sculptures Backs (of women) that became gradually more simplified and abstract. This process can also be traced in his studies for the Barnes Foundation murals of 1930-1932 where another group of gigantic nude dancers appear on an architecturally massive scale; he first used cut paper shapes in this project to help him plan out the mural. Matisse was given several other commissions in the decorative arts, such as tapestry, glass, interior decoration, a ballet set and the Chapelle du Rosaire at Vence. He also worked on a number of illustrated books; the most important is the 1947 Jazz which contains 20 brilliantly coloured screenprints directly derived from some earlier small gouache and pasted paper cut-outs. This experience was to have great importance for the series of large cut gouaches of his last years. Matisse died in Nice in 1954, aged 84.

L'escargot, made the year before his death, was part of this series. It cannot be simply defined as either a conventional painting or a collage in the manner of the Cubists (who applied commercial or hand-prepared papers to their compositions and then added drawn or painted elements to unite the picture visually).

Matisse was here 'making' a painting in a process which he likened to sculpture, by cutting or tearing sheets of fine watercolour paper that had been prepared with opaque or semi-transparent washes of high quality gouache, laid on with a broad brush in even strokes. He directed his assistants in the composition of these cut-out shapes which were pinned on to a temporary surface while he considered their arrangement. These pinholes are still visible in the corners of some pieces, as are several faint pencil lines and errant scissor cuts: all signs of the struggle of its making.

This technique had been used as early as 1930 in the Barnes murals where the cut-out dancers could be manoeuvred more effectively than unwanted charcoal drawing could be removed. However at that time, the paper was only a tool which was discarded once the desired outlines had been drawn in. It was only after the Jazz screenprints that Matisse de-

veloped this technique into a fully-fledged pictorial medium in its own right.

Two important processes had an influence on *L'escargot*. The first was printmaking, the second, architecture.

The cleanly cut edges of colour, against a pure white background give *L'escargot* the appearance of some enormous screenprint. For *Jazz* Matisse had cut stencils for the colour, thus blocking out areas of the white page which would have gleamed through as the whites do in this composition.

In 1947 Matisse was commissioned to do the entire decoration of a nuns' chapel, Chapelle du Rosaire, at Vence. He designed the building around stained glass windows which light the plain white-tiled interior. The subtle mathematical discipline of L'escargot derives from working with the proportions of the chapel space. In the painting a visual measurement is provided by the blue rectangle whose length equals the width of the large roll of paper that was being employed for the work. That same width is quietly apparent where the edges of the orange 'frame' meet on the left and right sides just above the centre, and it can be traced in the proportions of several other shapes in the composition.

Other interesting structural elements in *L'escargot* are the two pieces of emerald which came from a single sheet, torn across, creating the only rough edges in the work; the rest of the pieces were cut with scissors or against a straight edge. In other large cut-outs in this series Matisse employed both the cut shape and its template as a piece of visual wit, creat-

ing echoes across the surface.

Matisse's palette was made up of nine colours which are held in position by a cadmium orange 'frame'. Gouache, a dense type of watercolour, can produce an infinite range of colour, yet he chose simple primaries: a cobalt blue, a deep red and a warm cadmium yellow – and black and white – to which he linked five other complementary colours. Matisse controlled their strength with extraordinary precision. He said: 'simple colours can act upon the inner feelings with all the more force because they are simple. A blue, for instance, accompanied by the shimmer of its complementaries, acts upon the feelings like a gong.'

The musical simile is typical of Matisse. His reference to the function of blue is of special significance to *L'escargot* because it is the complementary colour to the dominant orange. This is echoed by other contrasts: black against white; magenta against yellow, and even two greens against red. 'It's not enough to place colours, however beautiful, one beside the other; colours must also react on one another. Otherwise, you have cacophony, noted Matisse. The result in *L'escargot* is a finely-tuned spiral of colour that gives the 'snail's' shell a spiritual significance.

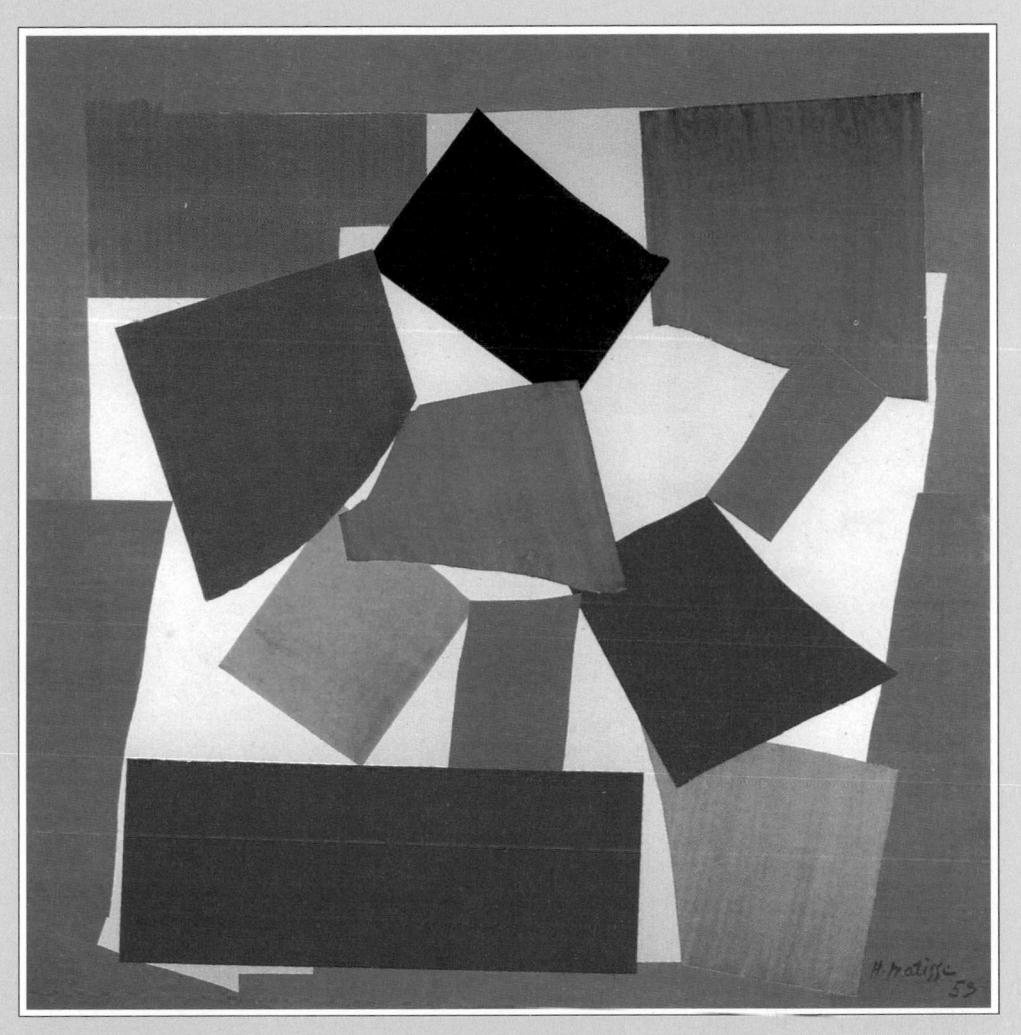

L'escargot was one of a series of enormous papiers coupés that occupied Matisse at the end of his life. Their conception occurred during a series of earlier mural projects which involved the moolved the manipulation and changing of large dancing figures, made easier by cutting them out of paper and tracing round them. A series of screenprints called Jazz also formed the starting also formed the starting point of these gigantic works which look like very large prints.

Matisse directed his helpers in the arrangement of the cut and painted papers which were temporarily vinned into position. pinned into position while the composition was considered. The colour choice was governed by Matisse's realization that the feelings are affected by simple colours. Here they are arranged with an architectural subtlety and precision that has often eluded his imitators.

The black was painted on to appear very opaque, so that the white is totally covered

The meeting of the green and the crimson create a curving area which is completed at the left edge of the cobalt blue element

The width of the roll of watercolour paper is used like an architectural module in the length of the blue element

The torn edges of the two pieces of emerald painted paper show they were once unified

Plain, white, unpainted paper over 274cm (9ft) high makes a continuous surface for the painted papers

The brushmarks create a rhythm of their own in several pieces of paper

RIGHT Matisse used scissors, knives, a straight-edge and random tears to provide a variety of profiles on each sheet. An error in the cutting of the cadmium orange border has been retained. The dimensions of the cadmium yellow sheet were sketched in pencil before it was cut.

BELOW The black gouache rectangle marks the summit of the 'snail's' back. It is always used as pure colour in Matisse's palette. It is positioned to vibrate against the complementary white and orange and also creates two more echoing white triangles.

ACTUAL SIZE DETAIL The struggle involved in the manipulation of the large sheets of paper has left its trace on L'escargot. Matisse's changes of mind are recorded in the large number of pin holes left in the torn corner of an emerald green sheet, as in the corresponding marks in the complementary crimson sheet which it overlaps. Other clues to its making can be found in pencil lines, folds and even thumbprints which were allowed to remain in the finished work.

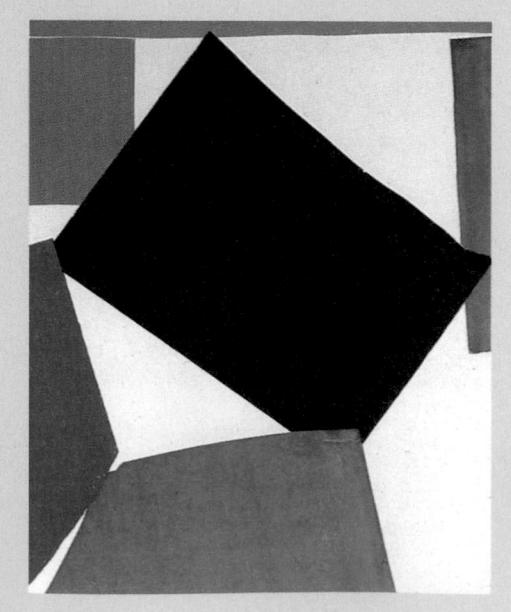

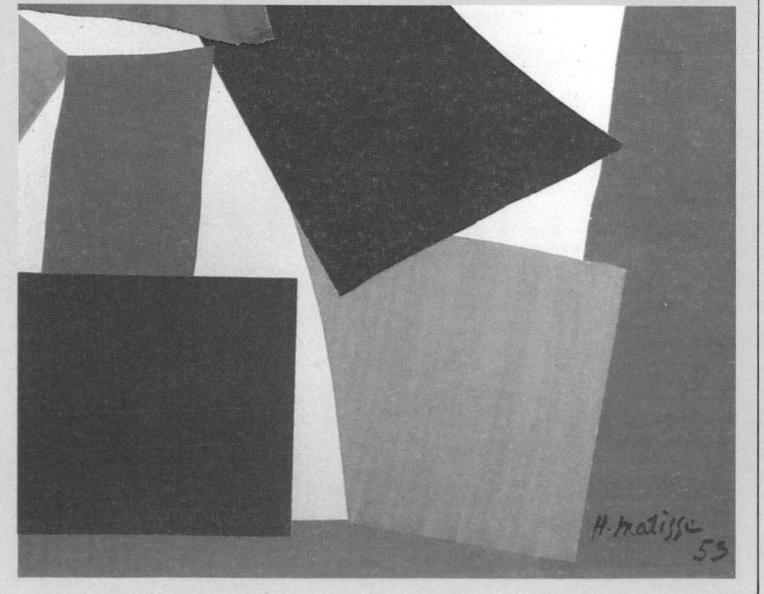

LEFT At the age of 83
Matisse created this
very large composition
with extraordinary
energy, using assistants
to position the papers.
His signature is always
an important element in
his paintings. It creates
a quiet point of focus
beside the architectural
bulk of the
complementary colours
rotating beside it.

Alberto Giacometti

Annette assise (1954)
Oil on canvas
91.5cm x 64.1cm/36in x 25in

Alberto Giacometti was born in 1901 into an artistic family. His father Giovanni Giacometti was a well-known Swiss painter who worked in the Impressionist style. By the time he was a teenager, Alberto Giacometti was proficient in both painting and sculpture, and he briefly studied sculpture at the School of Arts and Crafts at Geneva. In 1922 he went to Paris, where he was to spend most of his working life, and again studied sculpture for three years, this time under Antoine Bourdelle (1861-1929).

Although he began his artistic career using models or working from the natural world, Giacometti found this approach burdensome, and for about 10 years from 1925, he worked from memory and imagination.

Sculpture was always Giacometti's primary activity, but from about 1946 until the end of his life in 1966, painting came to play a large role in his creative output. He seemed to turn to painting in order to approach the overwhelming problems he had in rendering reality from another angle: in his sculpture, he attempted to reproduce matter which then would act on and also be acted upon by its surrounding space; in his paintings, he had to create a pictorial space in order to find a way for the figure to come into existence.

The subject matter of Giacometti's paintings is nearly always the human figure. The figures either sit or stand, but always adopt a frontal pose, looking out and engaging the attention of the spectator, so that a relationship is formed between the two.

Giacometti's sculpture and paintings do not look like the work of any other artist: they are unique, and they reveal the path of artistic enquiry which he followed. He tried to convert precisely what he saw when he set up a figure in front of him, when a model was a certain distance away from him he attempted to render the model either in clay or in oil paint at the size that they actually appeared to be. Normally the mind involuntarily tells the eye that the figure one sees in the distance is life-size, like oneself, and thus conceptually alters its scale and dimensions. Giacometti tried to, and succeeded in, bypassing this mental trick, but then found that he had difficulties in determining the exact scale of his subject material when he tried to record it: '... the exact limits, the dimensions of this being become indefinable. An arm is as vast as the Milky Way, and this phrase has nothing mystical about it', he noted in despair, and '... the distance between one wing of the nose and the other is like the Sahara, without end, nothing to fix one's gaze upon, everything escapes.'

In his oil paintings, Giacometti eschewed bright hues, and kept to a range of greys and earth colours. This was because he felt that bright, primary colours would block his path, would create shapes and set up relationships

outside of those he wished to entrap. He was aware that observers thought that his colour range was limited, and that this limitation could be potentially harmful. His reply was that by choosing grey he was not limiting himself, but allowing himself an infinite richness: 'Already as a boy I got to know the colours on my father's palette and in his paintings; he really understood the primary colours. And when I was young I painted with those colours, too. Isn't grey a colour, too? When I see everything in grey and in this grey all the colours I experience and thus want to reproduce, then why should I use any other colour? I've tried it, because I never intended to paint only with grey and white or with any one single colour at all. I have often put just as many colours on my palette as my colleagues when starting in to work; I've tried to paint like them. But as I was working I had to eliminate one colour after another, no - one colour after the other dropped out, and what remained? Grey! Grey! Grey!' For Giacometti the stuff of life and its representation in pigment was more than adequately served by this one colour with all its variations. It would have been an artificial act for him to force himself deliberately to use blue and green, for example, and he set his aim upon truth.

In Annette Assise browns and greys are spread all over the canvas, and they seem to both cloud and create the image. A tension arises from the fact that Annette is seen far back in the picture space, set in a corner of the studio and pushed back in this imaginary space by illusory painted borders like overlapping mounts. Yet she emerges as a dense central core of matter, the most thickly painted part of the canvas, which thus projects forward from the picture surface into the real space of the observer. At a certain distance, the painted head takes on an almost tangible reality and the dark eyes have a gaze which is both robust and aloof. Yet a detail showing the head in close-up reveals that the eyes are not defined; the model's left eyebrow arch is marked by three parallel black strokes, and the forehead, nose, cheeks and chin stand out because of the white brushstrokes which traverse them. But the eyes and their sockets are rendered in the same way and in the same pigment as the shoulders and neck. Amazingly, their presence is marked by an actual absence of marks; they are formed by the treatment of the surrounding areas.

The very sketchy quality of the painting, the many attempts at an outline, the quickly brushed opaque background around the model, and the runnyness of the pigment in the border all testify to Giacometti's approach to oil painting. He did not use it for its sensual or decorative qualities: instead he saw it as a vehicle, with sculpture, in which to investigate and record spatial associations.

ALBERTO GIACOMETTI

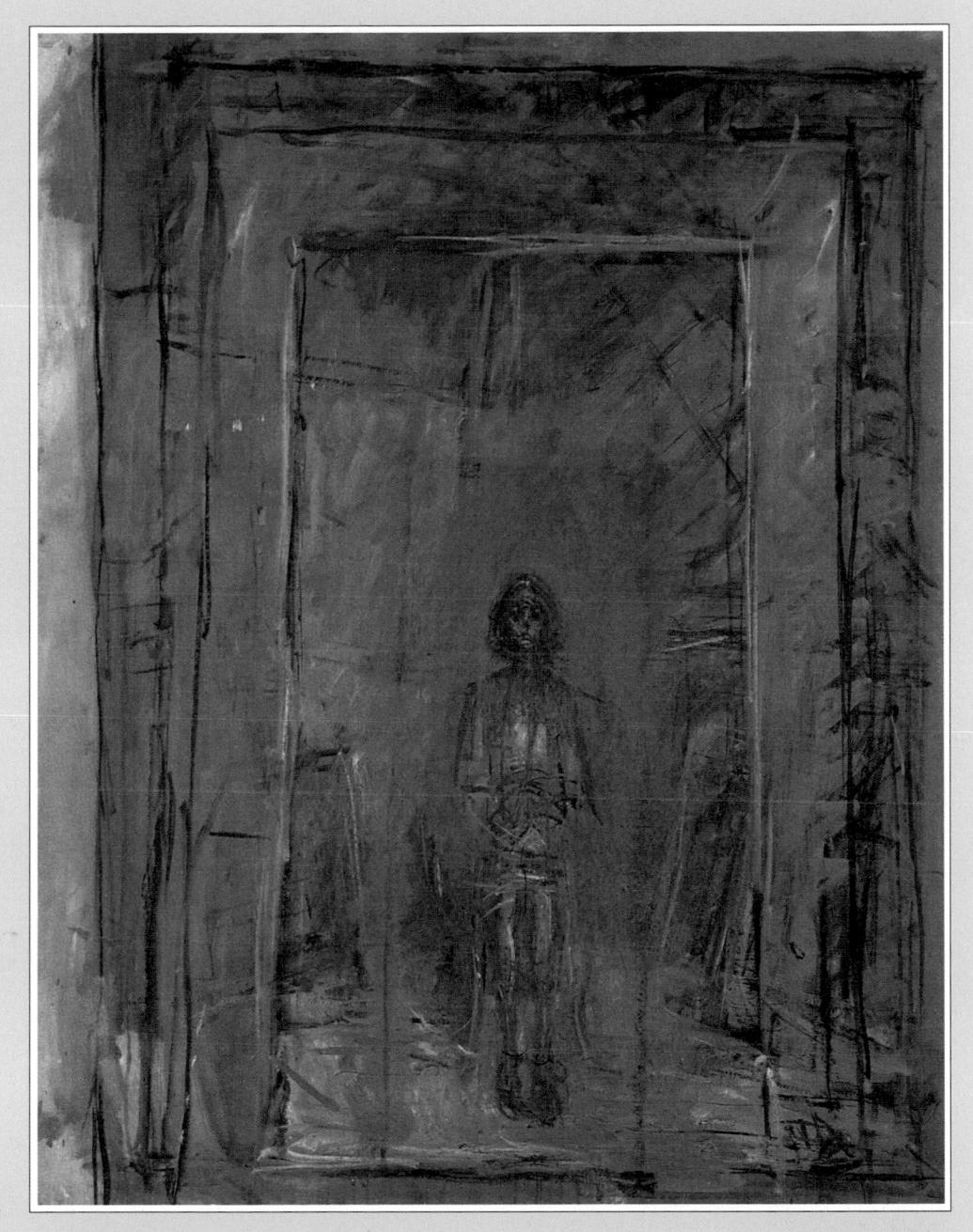

The brushmarks, the physical evidence of the activity of Giacometti's hand and eye, are left very apparent in this painting. The palette chosen is a low-keyed range of earth colours, and the composition is deliberately kept simple, based on a vertical axis.

ALBERTO GIACOMETTI

Odd touches of vermilion

Raw sienna mixed with black and white brushed around the figure

Swiftly brushed black lines define the environment

Impasted highlights

Primed layer of ochre mixed with white left visible

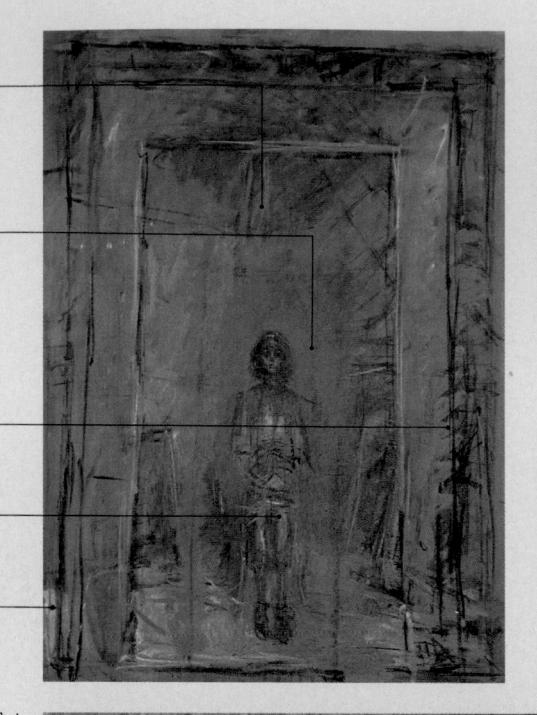

RIGHT Giacometti found that if he tried to use any colour other than grey he set up problems which he could not resolve. Bright colours seemed to stick to the surface of the canvas and prevent the creation of an image set in illusory space. Since he adds three touches of pure red, probably cadmium, which is not used anywhere else in the painting, he must have wished to emphasize the location of the brow and upper lip of the model.

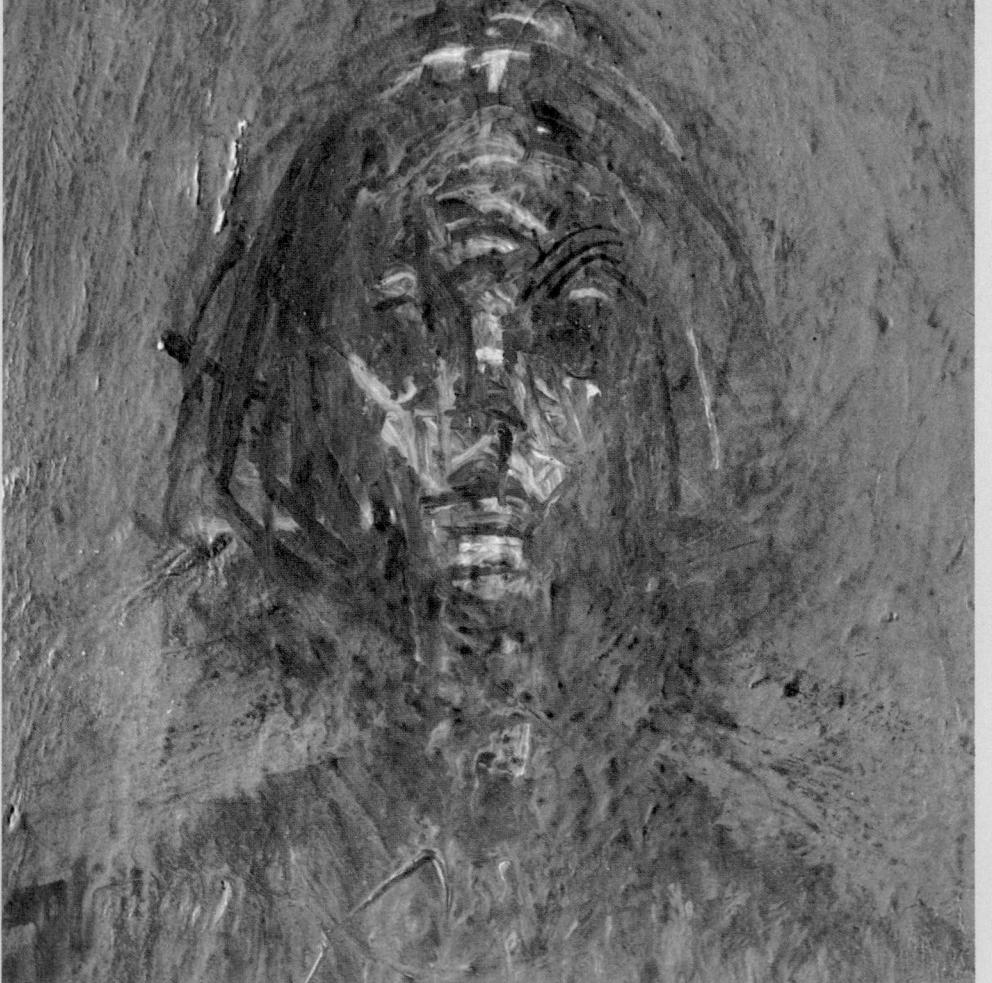

ABOVE The several successive layers show because of the very diluted nature of the oil paint. Giacometti keeps close to his chosen all-purpose hue — grey — but horizontal lines of raw umber and an aggressive sweep of vermilion add their richness. The strong black right angle marks the corner of one of the three or four concentric borders.

ALBERTO GIACOMETTI

ACTUAL SIZE DETAIL
This is not
descriptive brushwork,
and a great deal of it is
loosely brushed,
applied wet in wet.
Some of the horizontal
brushmarks carry more
than one colour, lifting
the paint in that state
straight from the
palette. Giacometti kept
his paintings loose since
he liked to work over
the complete canvus ul
one and the same time.
For him, a final and
finished painting was
not necessary, what
counted was the process
of laying in marks and
making them relate to
the chosen motif. The
short ochre dashes are
part of the web of
marks, which build up
relationships
throughout the canvas.
Different size brushes
have been used, the
vertical strokes were
painted with the widest
one.

Target with Four Faces (1955)
Encaustic and collage on canvas with plaster casts
75.5cm x 71cm x 9.7cm/29³/₄in x 26in x 3³/₄in

Jasper Johns's work, like that of Robert Rauschenberg (b 1925), played a crucial part in a watershed period of American painting, giving it a new, more objective approach than the then current Abstract Expressionist orthodoxy, which had reached its highpoint with Jackson Pollock's work.

Born on 15 May 1930, in Augusta, Georgia, Johns was brought up in Allendale, South Carolina, by a variety of relatives. His first limited training in art occurred while he was at the University of South Carolina. He settled in New York in 1952 when he began to paint seriously, and devoted himself full-time to art in 1958.

It was in New York that he formed life-long friendships that helped to foster both the appearance and the dominant concerns of his art. Chief among these was that with Robert Rauschenberg, through whom he met the composer John Cage and the dancer and choreographer Merce Cunningham. They introduced Johns to the idea of an opaque, impersonalized art, and, more particularly, through Rauschenberg's work, to a form of painting that used the bravura brushstrokes of the Abstract Expressionists, but drained them of dramatized self-exploration and emotional rhetoric. Rauschenberg was using common objects to enliven his work: 'junk art', was a technique that absorbed Johns increasingly.

Johns's work rapidly acquired its characteristic deadpan nature which overlaid a basic but sustaining creative tension between sardonic insolence and a more powerful seriousness. This arose from the issues suggested by his deceptively throwaway attitude: he was reported as suggesting that a painting of his should be accepted as an object, 'the same way you look at a radiator', leaving in the air both the distinction between a work of art and an everyday object, and the role of the observer in approaching a decision on the problem.

Johns began his career working in the encaustic medium but by 1959 was increasingly using oils, a step which corresponded to a more sustained use of pure colour. Previously, his consistent interest (in a busy, well-worked surface texture) had been in paintings of predominantly pure tonality, and it is significant that False Start (1959), his first canvas in bright colours, was matched by the accompanying Jubilee (1959), virtually a grisaille commentary on the former. Apparently abandoning textural development, he turned to lithography in 1960; a rare, almost anachronistic medium at the time, but one that, in fact, maintained the concern for surfaces, that of the 'skin' of the lithographic stone. He also turned to sculpture: his first sculptures of 1958 were executed in sculp-metal, an easily modelled medium intended for the amateur, which he subsequently replaced with pâpier-maché.

Johns's primary importance has been in

providing an alternative to the sterility of decaying Abstract Expressionism. Yet in many ways his work is too personal to supply a simple and sustained stylistic impetus to a new generation. However, his free use of materials and conventional consumer imagery, lettering and everyday objects, proved to be a significant ingredient in the iconography of Pop Art.

As Johns's career progressed, his additions to the flat picture plane became more complex. Objects and even furniture fragments were attached to the work and early letters and figures had become separate fixtures sometimes hinged on to the background setting. However, after an extended visit to Hawaii and Japan in 1964, Johns's work relaxed. He used many of his previous images, but in a much freer, more spontaneous way, and added more homely features, such as coffee cups and coat-hangers.

Target with Four Faces is from 1955, a highly productive year, and, as an earlier work, lacks the more sweeping brushwork and dramatically amplified addition of objects that Johns was to develop later. The subject of the target, an example of a favourite visual cliché, he has said, 'seemed to me to occupy a certain kind of relationship to seeing the way we see and to things in the world which we see... have clearly defined areas which could be measured and transferred to canvas.'

The use of encaustic here emphasizes the flatness and banality of the familiar subject while also, on closer examination, revealing (literally) hidden depths, visible layers which help to individualize this particular version. The encaustic technique involves mixing pigment with molten beeswax or resin; at which stage Johns added fragments of newspaper and fabric, applying the mixture and then drying it under a radiant heat, thus fusing the elements together. The immediate advantage was that of speed; the solution dried quickly and another layer could be added. There is, too, a degree of translucency which enables the viewer to see directly the various stages of work and the additional interest of collage elements embedded within the medium. As a glutinous medium encaustic is best applied with the palette knife and this gave Johns the opportunity to produce the heavy impastos which he so enjoys.

The use of plaster casts is an example of another favourite medium of the time: here they are taken from the same model, though carefully rearranged to avoid the impression of a sequence that had been inadvertently produced by the steady relaxation of the model's jaw throughout the casting, thus avoiding the impression of a mouth opening to speak. The wooden structure in which the casts are contained, despite its slightly sinister regimentation, provides another sort of the compartmentalization that Johns frequently employs.

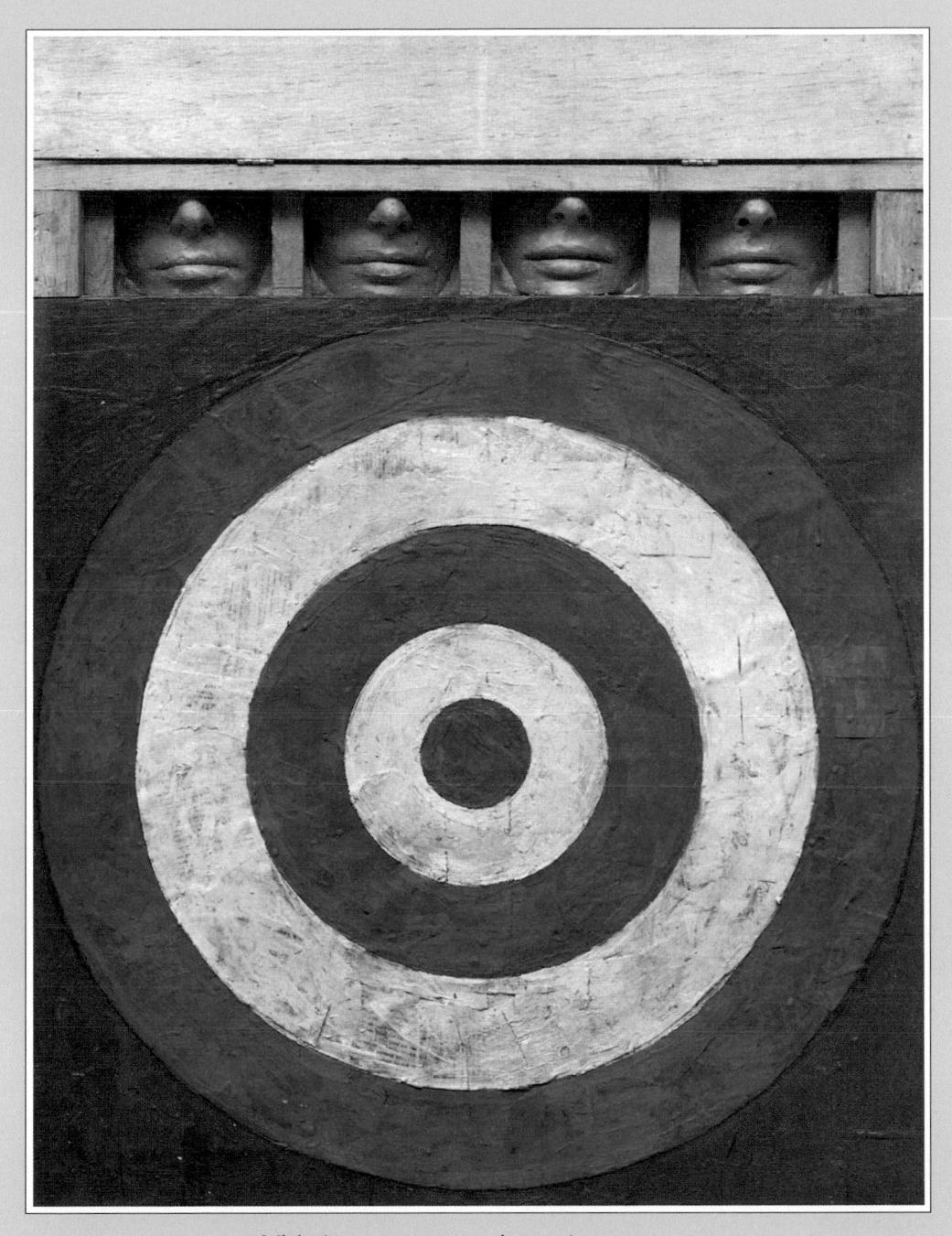

While there are iconographic and formal precedents especially within early American modernism, for Johns's series of targets, first shown in 1958, the artist has denied any direct influence. This originality is seconded by the incorporation into the work here of coloured plaster casts of

faces, calculated material additions which dispel 'some of their identity as mere paintings'. Target with Four Faces (1955) was bought by A.H. Barr for the Museum of Modern Art in New York, a swift recognition of the reaction against Abstract Expressionism.

Painted plaster cast of nose, cheeks and mouth

Hinge on wooden structure built into the work

Collage newsprint clearly visible through encaustic application

Red coloured encaustic is used for the periphery of the target, reversing the normal representation

Rough surface of collage and encaustic mix produces ridges and furrows

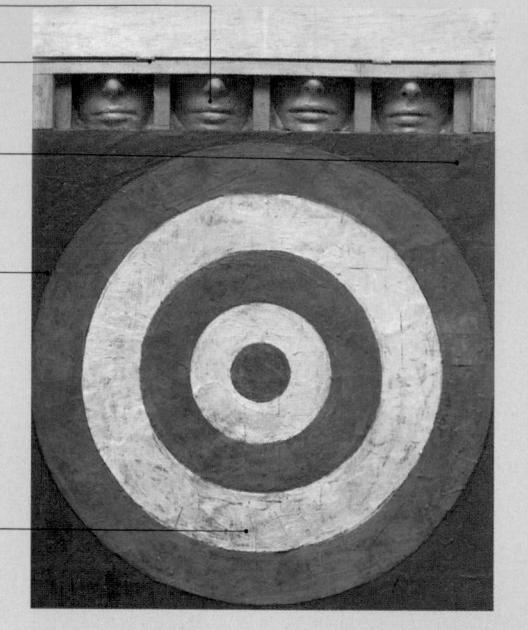

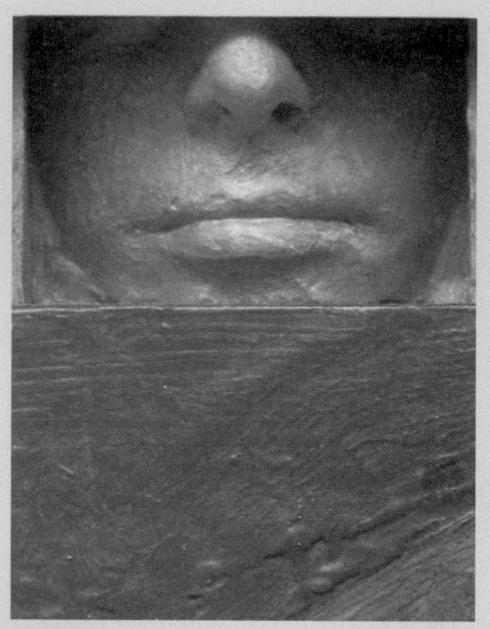

LEFT The plaster casts have all been taken from the same model but slight physiognomic variations have been encouraged, both to prevent mechanical repetition and to add a typical hint of discontinuity and menace. This is augmented by the surreal appearance of the casts as if balanced on their flared nostrils. The texture of the casts is not unlike parts of the painted target, but contrasts sharply with the finished surface of the wooden compartment.

LEFT The texture of Target with Four Faces is more densely worked than either Target with Plaster Casts or Flag, both of the same year. A further layer of collage and encaustic appears to have been added and worked in with a palette knife, producing scratches and inflections loosely aligned with the concentric circles of the target, but occasionally making straight lines. A patch of collaged material is clearly visible in the centre of this excerpt, standing slightly proud of the surface.

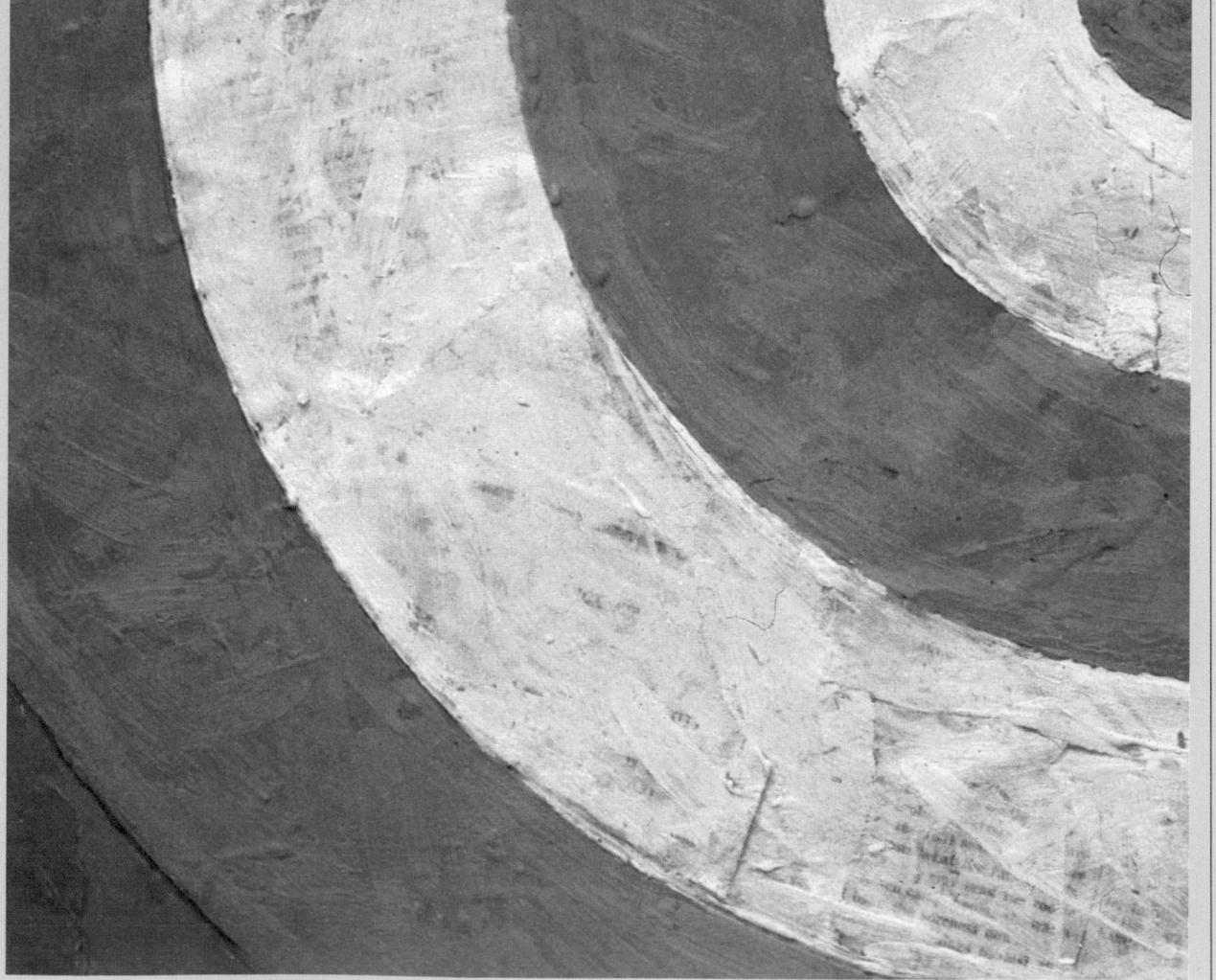

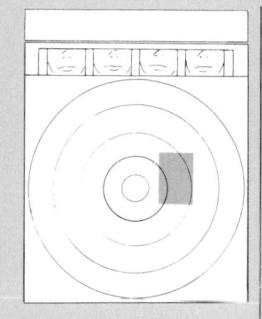

ACTUAL SIZE DETAIL
Printed material is
clearly visible through
the transparent
encaustic, but unlike
similar additions in
Cubist collage Johns has
exposed the nature of
his technique by
providing a kind of
'horizon' by crosssection down into the
upper layers of the
surface. Paint is
revealed as a skin over
a more solid structure,
and the whole surface is
more like a miniature
mountainscape than a
flat canvas. Above the
print is a crinkle or
'flaw' in the texture,
probably the torn edge
of a slightly corrugated
collaged element.

PETER BLAKE

On the Balcony (1955-1957)
Oil on canvas
123cm x 90.8cm/47³/₄in x 35³/₄in

Although closely associated with Pop Art, Peter Blake is concerned with neither consumer goods nor technology. He sees the role of his art as not 'to make social comment in a critical way. It's purely to record.' Blake's art is rooted firmly in nostalgia: his subjects come from his own childhood and youth. But he is also conscious of both past and contemporary art and makes constant references to it.

With his discriminating sense of fantasy, Blake has annexed or incorporated the image of popular culture into the realms of modern British art. Bric-à-brac, Victoriana, photographs of film stars, plastic give-aways and children's comic strips – trivial in themselves – gain status and significance when gathered together by Blake. The identities of these objects and images are preserved but they are often modified by his way of painting which includes a formidable talent for sharp focus or trompe l'oeil.

Peter Blake was born in 1932 in Dartford, Kent. He studied graphic art, then fine arts at the Gravesend Technical and School of Art from 1945 to 1951, and attended the Royal College of Art in London from 1953 to 1956. As a painter, Blake could be classified as a pre-Cézannite, and as a practitioner of collage and assemblage, the heir, not of Cubist collage, but of the Victorian scrapbook. He has been influenced by the popular Victorian realists, including the Pre-Raphaelites, and by American Symbolic Realists, such as Ben Shahn (1898-1969) and Honoré Sharrer (b 1920). In fact Sharrer's painting Workers and their Pictures, in which contemporary workers hold famous paintings that they could never possess was the starting point for On the Balcony.

In Blake's painting there are no less than 27 different references to the balcony subject, which was set for the Royal College of Art's diploma in 1955, and many of these are references to art. The most obvious is the reproduction of Manet's *The Balcony* (1869) held by the figure on the left sitting on the park bench. The trio of paintings in the centre bottom half of *On the Balcony* are Blake's idea of what three of his fellow students would have done with the same subject: behind the Royal Family is a 'Richard Smith', immediately below it is a small thin Robyn Denny, and at the bottom is a framed Leon Kossoff abstract.

At first glance parts of *On the Balcony* – the magazine covers and postcards, for example – appear to be collaged, a technique frequently employed by Blake. But every detail is painted: '... when I'm expected to paint it, I collage it, and when you might think I might collage it, I paint it – it's a kind of aesthetic game,' Blake commented. 'A picture like *On the Balcony* was purely a photo-realist, magic-realist picture where one was trying a *trompe l'oeil* technique – it wasn't about whether it should be collaged or not – it was just painting

a picture and those questions came up afterwards.'

In the painting Blake is playing on the differences between reality and illusion. Side by side with his use of 'painted collage', items such as the cornflake packet and the two tables are painted in the traditional illusionistic way. This ambiguity is further underlined by the green background which could as easily be a noticeboard as a patch of lawn.

Interestingly, while he was working on *On the Balcony*, Blake was also studying West European folk art, and this could have been an important influence in the composition of the work and in his execution of the figures.

There are five figures in *On the Balcony*. One stands on the painter's table at the top left, and is cut off from the waist by the edge of the canvas. The four young figures sitting on the park bench wear the paraphernalia of the post-war, American-influenced youth – the 'I Love Elvis' and cinema club badges, fancy ties, sunglasses and jeans. The most interesting figure is that on the right, which looks like a self-portrait: the figure wears a portrait of John Minton, an artist who taught Blake at the Royal College and who committed suicide, and the painting he is holding is a work by Blake's brother.

A constant theme of Blake's work – which is evident in much of the British Pop Art – is his patriotism. Two of the figures on the bench are wearing Union Jacks and the Royal Family are represented no less than three times.

Blake paints slowly, gradually gathering images to incorporate into his work. He spent two years working on *On the Balcony*. Each of the objects he has included in it is in scale, but there are vast inconsistencies in the scale relationships to other objects in the work, rather like there would be in a magazine or book from which mechanically produced images might have been cut.

The canvas is attached to a pine stretcher with iron tacks, and it was prepared for Blake (not by him) with white oil ground through which the texture of the canvas is visible. Blake's medium is oil and gum and he has employed a variety of techniques to produce the mimetic effects of collage. The Leon Kossoff, for example, is painted in a 3-mm (½-in) thick impasto, while Manet's *Balcony* is executed in a lively Impressionistic manner, in contrast to the detailed photo-realistic *Life* covers.

The canvas has been left unvarnished and the artist has written in pencil on the reverse of the canvas's foldover edge: 'Blake RCA On the Balcony Unfinished'. It is common for Blake to regard a work as uncompleted. 'One of the reasons he may leave a picture unfinished or hesitate to complete it', noted art historian Michael Compton, 'is, simply, that he enjoys the visible brushstrokes that will disappear or become almost completely integrated in the finished work.'
PETER BLAKE

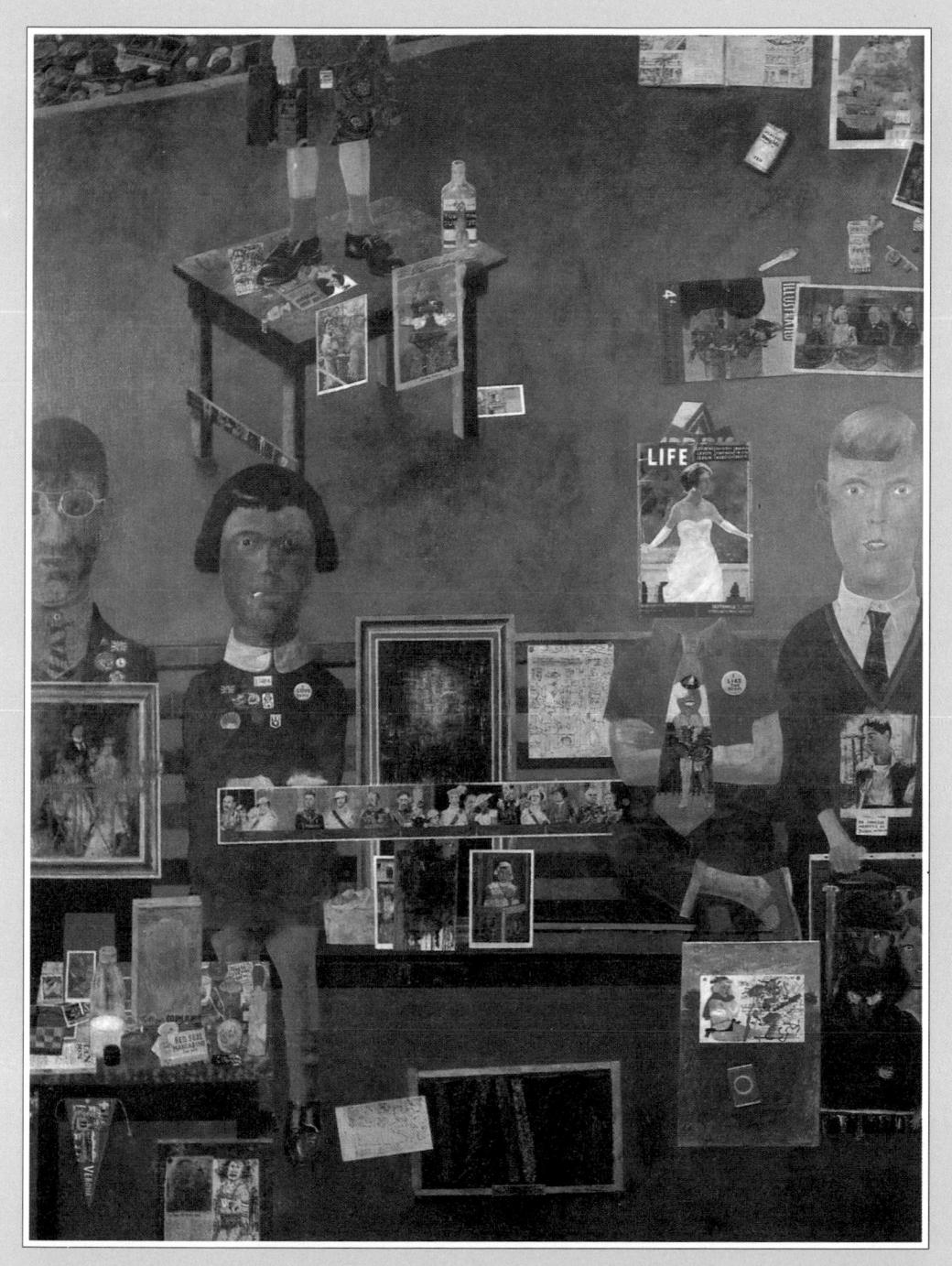

On the Balcony is a tour de force of what might be called heterogeneous photographic realism. The technical representation of the wide variety of people, cloths, artworks and miscellaneous popular artefacts, is scrupulously attuned to the demands of each

item so that the brush is motivated by a mass of particular contingencies, and imitates their own (supposed) modes of realism. The result is a remarkable interface between the visual art of the period and the habits, images and icons of its everyday life.

Introduction

Artists in these times have to face the weight and extension of art historical knowledge. To some this knowledge can be like the albatross was to the Ancient Mariner, while to others it is a stimulation and a challenge.

There was a period centred around 1970 when artists, feeling overwhelmed by information and images about earlier art, chose to reduce the amount, physical quality and content of their output. This phase has now been replaced by a kind of horror vacui: large canvases and complex painted sculptures appear - the canvases are filled to the point of saturation by pigment and heavyweight ideas, and the sculpture seems almost Baroque or Rococo in its largesse and decorative power. Today, mythological subject matter abounds it is related to ancient mythology because both emerge from a concern with the basic human issues of love, death, power and sexuality but it is too early to recognize the dominant themes; they remain too autobiographical and too expressive of the artists' particular stances.

We have experienced a full circle of development from 1950 to the present day. The Second World War was not a period conducive for work. Artists emerged from that time in a torpid state, their horizons diminished and their isolation increased. It was necessary to take stock - this resulted in an examination of art produced prior to the outbreak of war - and decisions had to be taken as to whether to continue as before or to start afresh.

The early 1950s found artists working in the Abstract Expressionist style; at the same time a new aesthetic was emerging, which played down personal expression and in its place proposed a dialogue with the techniques and materials of mass media. Pop Art, as this new style became known, was clearly recognizable and capable of speedy assimilation. A total rejection of anything expressionistic was the extreme of this evolution, and the concept of minimal art was explored. Eventually the pendulum has swung right back towards a new expressionism, with a re-examination and assessment of the art of the past. Artists now feel able to plunder the art of the past and take what they personally feel was successful.

Pop Art

This movement developed simultaneously in England and America. Each country produced its own style, but to a great extent themes and materials were shared. The themes were those referring to mass or popular culture, hence the name of the movement. The name Pop Art was coined by the English critic Lawrence Alloway who identified the movement as originating among his friends: a group of artists, architects and designers who began to meet regularly for discussions at the Institute of Contemporary Arts (ICA), London, in the early 1950s. The group included Richard Hamilton (b 1922) and Eduardo Paolozzi (b 1924) and concentrated its attention upon commercial culture, finding in it a breadth and inventiveness which was in opposition to the élitist stance of the art world, which was promoting abstract, non-referential art.

Likewise in America, Pop Art arose partly as a reaction against the hermetic imagery and impassioned brushwork of Abstract Expressionism. Artists wanted to reintroduce figural imagery and to experiment with the new technical processes offered by commercial and

industrial quarters.

A new alternative to oil paint began to be marketed in the 1950s. Originally developed for the household paint market, synthetically made acrylic paint emerged as a most useful medium for artists, just at the moment when they were looking for a way to produce colourful, hard-edged, somewhat impersonal works. Acrylic is soluble in water or a special thinner, and thus provides a great variety in the thickness of pigment available, as well as a finish which disguises the activity of the brush. It is quick drying and allows an artist to finish a work in a shorter time, since it is no longer necessary to wait while oil paint slowly dries.

As early as 1953, Morris Louis (1912-1962), a young painter from Baltimore, had begun using acrylics to explore a technique developed by Helen Frankenthaler (b 1928) of soaking washes of diluted paint into the canvas. Louis's first mature works consist of limpid colour washes whose iridescence recalls not only Rothko but also the late Waterlilies of Monet. Where Louis differs from his predecessors is in the exceptionally transparent effects that his new materials made possible. His next series was the so-called Unfurleds (1961) where diagonal rivulets of intensely saturated colour frame a central expanse of immaculate canvas which, by comparison, appears to radiate a pure white glow.

The hard-edged style which pioneered in acrylics had a 'cool' rigour about it: the new synthetic pigment could be treated in a less sensual way than oil. There was a move towards objectivity and the more formal aspects of painting. The loose, painterly, often ugly brushwork of the Abstract Expressionists, with its concomitant ideas about truth and sincerity of personal feelings immediately and powerfully expressed (not always comprehended), gave way to a more impersonal approach to the handling of paint and a more

anonymous subject matter.

Roy Lichtenstein (b 1923) and Andy Warhol (b 1930) were two of the artists who began to change the look of American painting by choosing a range of imagery from the most obvious visual aspects of American popular culture; imagery which did not belong to their private world but was already created by somebody else, for the public domain.

RIGHT This extremely complex composition, Calcium Light Night is the result of a series of screenprints. Eduardo Paolozzi (b 1924) began with a matt black printing, over which he laid a translucent white, giving shape to the main abstract forms in a resulting grey. Slowly, detail and definition were added with subsequent layers of white, red, blue and white again, so building up a three-dimensional impression of organized unreality. The final opaque cream printing provided a vibrancy, while a varnish completed the picture.

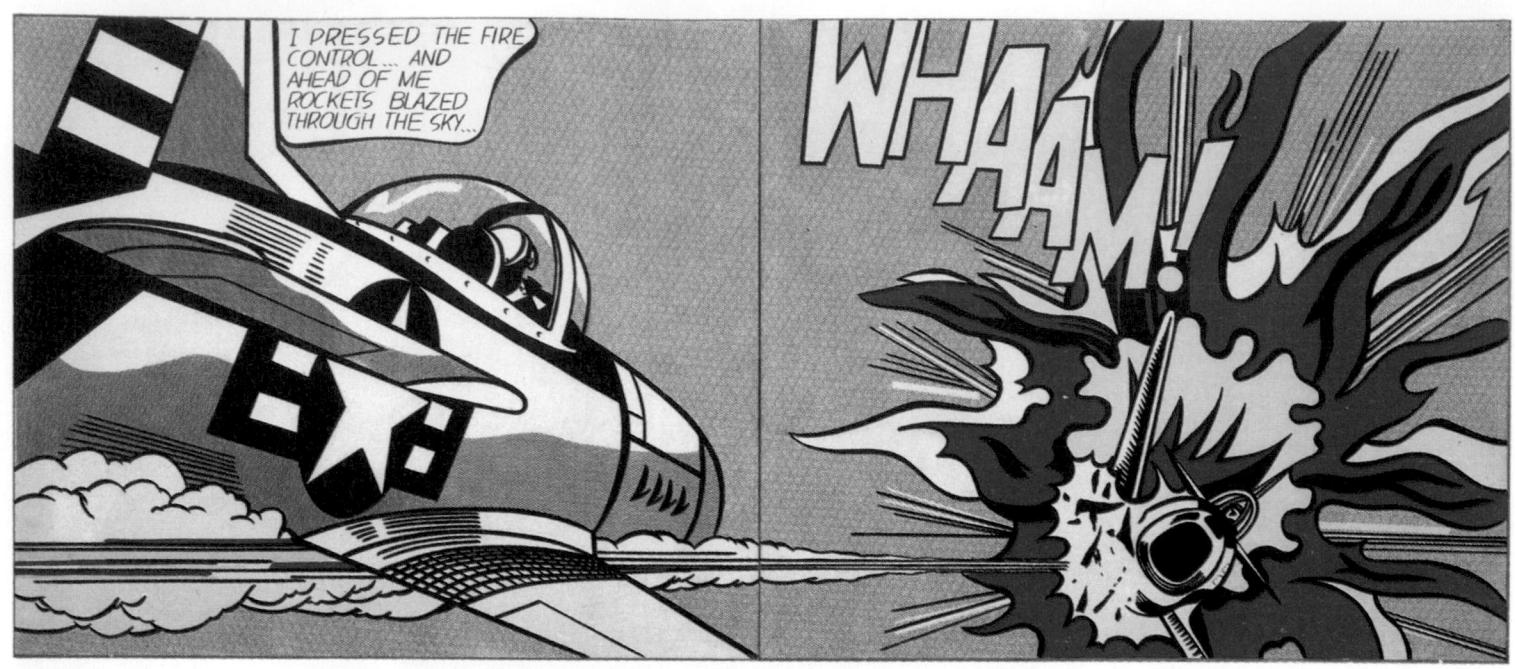

ABOVE Whaam! (1963) by Roy Lichtenstein began as an idea for two separate paintings - one with a fighter plane attacking, and the other with a fighter plane being shot down. Then Lichtenstein decided that they would make more impact if he combined them. Thus the work is made up of two canvases identical in size, with the composition continuous across both. Lichtenstein began to use comic strip imagery in 1960, and the subject of Whaam! probably comes from a magazine he often used as source material - 'Armed Forces at War'. The strong, controversial subject-matter is in stark contrast to the dispassionate techniques used, yet both are derived from advertising and comic strips. Indeed the central divide between the two canvases can be read as a kind of echo of the divisions between pages. When the Tate Gallery acquired this work in 1966, the idea of paintings with bubbles full of words and large painted words of exclamation was still

auite new.

Lichtenstein purloined the work of major European artists, such as Monet, Picasso and Mondrian, and parodied their styles as though attempting to make their work as easily available as a bill-board advertisement. Lichtenstein and Warhol introduced an anti-Expressionist regime, subordinating the handling of paint.

Pop Art drew upon certain Dada precepts, and much that had been introduced by Marcel Duchamp. Distinctions between good and bad taste were avoided, and much that was tawdry, trivial or over-familiar in the late 1950s was converted into the material of art. Because art and life drew so close, objects from daily life found their way into art, either presented emblematically or standing as themselves (an appropriated piece of the real world).

Multi-media spectaculars began to enter the art world; artists themselves began to adopt a theatrical frame of reference, and perform their works as well as paint them. As Lawrence Alloway noted: 'The city with its inhabitants was not only the subject of much of this art, it was also literally, the *substance*, providing the texture and bulk of the material itself.' Thus objects from the real world, the debris and throw-away commonplaces of everyday life were used as artistic materials.

This is a link back to Dada, Cubism and Duchamp: Dada because the artists of that movement used provocative behaviour as their mode of artistic creation; and Cubism and Duchamp because the Cubists introduced collage, and Duchamp was the inventor of the 'ready-mades' (objects selected at random from the oblivion of their existence in the everyday world, and accorded a new autonomy as artistic objects, yet which at the same

time challenged the rules of art and proposed an anti-art value). Cubism, with its investigation of the use of *papier collé* and collage as artistic procedures, was an important ancestor. *Papier collé* and collage drew attention to the scraps of the real world which had been chosen to stand as artistic materials and were thus to be given a new scrutiny in terms of their technical properties.

Lichtenstein and Warhol produced works which lay an aggressive stress upon the picture surface, although neither chose to make much use of collage. One of Frank Stella's first works was a small collage entitled *The First Post-Cubist Collage* (1959). The arrogant title of this little work, which implied that there had been a fallow period in the use of collage since about 1914, shows that Stella was thinking deeply about the problems of space, flatness, colour and texture.

Stella turned towards autonomous abstract art, a path critics of Cubism had always thought the movement would lead. He was working in America at the same time as Warhol, Lichtenstein, Jasper Johns (b 1930) and Robert Rauschenberg (b 1925), and contributed to the movement of anti-Expressionism, but he concentrated more on the interplay of geometry, structure and colour to the exclusion of subject matter. He used commercial household paint to accentuate the flatness and surface tension of his canvases.

Thus Stella's aims were close to those of Warhol. But for Warhol subject matter was a better vehicle and he made much use of photographic images; by the early 1960s the camera and all its procedures emerged as a powerful artistic tool. Photographs have been

used by artists as source material ever since photography was invented in the 1830s, but at first a photograph was used as a sketch, a way of noting reality and a jog for the memory. In the 1960s photographs began to be used as the basis of the image on the canvas: Warhol's Marilyn Diptych (1962) is made up from 50 silkscreened images printed from a publicity photograph, and Lichtenstein has recounted how he begins many paintings by projecting an image on to the canvas.

The British artists Richard Hamilton and David Hockney (b 1937) have enjoyed a fruitful involvement with photography. Hamilton plays upon the manipulative procedures involved in mass communication and advertising, and exaggerates many photographic techniques. His Swinging London series uses the same image which becomes modified with each new attempt, in much the same way that the images of Marilyn Monroe are in Warhol's Marilyn Diptych. Hamilton's small collage - Just What Is It That Makes Today's Homes So Different. So Appealing? (1956) – is a collection of images cut out from advertisements in magazines. In its subject matter and anti-traditional materials, it stands as a beacon to the British Pop Art movement.

Hamilton's move towards Pop Art actually predates anything produced across the Atlantic, but it was to America, and particularly American consumer goods and magazines, that British artists turned for their source material. Hockney turned to America for its glamorous subject matter, especially the hedonistic life of California, and then selected and painted things which interested him, just as Blake did. The paintings of Patrick Caulfield (b 1936), another British artist to whom the term Pop has been applied, shares more of the cool, impersonal American outlook. For a while like Hockney, Caulfield preferred to work in acrylic or commercial household paint. His work also has affinities with Lichtenstein, for Caulfield experiments with contrasting styles and methods of representation, and shows an interest in formalizing his composition into flat colours bounded by strong lines. He works from his own drawings done from real life and from photographs.

Conceptual Art

This blanket title has been used to cover art produced from the late 1960s until the late 1970s, which challenged the orthodoxy of the traditional media of painting and sculpture. Conceptual Art is not a totally satisfactory term, since it has to contain much that is contradictory, but its usefulness lies in the stress it places upon the conceptual rather than the practical, craftsmanship aspects of art practice.

In its breadth and voracity, the term has embraced other approaches such as idea art, process art, performance art, earth art, minimal

art and Arte Povera. Conceptual Art has been seen as taking a reductive path: 'The world is full of objects, more or less interesting. I do not wish to add any more,' commented Conceptualist Douglas Huebler (b 1924) in 1968. Huebler's attitude, and the remark of Ad Reinhardt (b 1913) - 'sculpture is something you fall over when you step back to look at a painting' – contribute to the idea that art had reached a kind of impasse, because if the production of art objects were to continue unabated as it had done for previous centuries, the world would become clogged up with these precious commodities. Since Cubism and Dada, increasing importance has been attached to the choice of materials which are non-precious and ephemeral. Now the art object was thought of as dispensable too.

Returning to the ideas proposed by Marcel Duchamp as early as about 1913, Conceptual artists devoted their energies to creating an art of the mind. Art which could be conceived and appreciated in the mind did not necessarily need to be executed. But if it were to be executed then the materials used were to be commonplace and dispensable. Sometimes the work could only be satisfactorily comprehended in the mind, because the scale of the work prevented the viewer from ever ex

periencing it whole, at first hand.

Many works consisted of holes dug in the ground and then filled in again: Claes Oldenburg (b 1929), the American sculptor, had grave-diggers dig a hole and then fill it in again in Central Park, New York, as his contribution to a 1967 exhibition Sculpture in Environment. In 1969 Jachareff Christo (b 1935), the Bulgarian-born sculptor, wrapped part of the coastline near Sydney, Australia, with about 300,000 sq metres (1,000,000 sq ft) of industrial fabric and 500 km (36 miles) of rope; the previous year he had caused the Kunsthalle at Berne in Switzerland to be similarly packaged.

Minimal Art is one of the subdivisions of Conceptual Art. As the name implies, Minimalism means making do with less rather than more, usually in terms of the artist's intervention. The Americans Dan Flavin (b 1933), Don Judd (b 1928) and Carl André (b 1935) usually chose their material from industry-for example, Judd has used rolled steel, Flavin neon tubes, and André firebricks — and presented these materials organized into logical and systemized units. The materials are presented absolutely as themselves, leaving no room for misrepresentation, and no impression of any feeling or emotion of the artist. The subject matter of these Minimal works lies in awareness of the material. The essential properties of the chosen materials are permitted to speak more strongly in an art context than in their original, or unchosen, state. Also, the strength of the Minimal work often lies in its use of

repetition of identical units.

One of the principles of Minimal Art was that the work need not be made by the artist: Don Judd's steel boxes were manufactured by others, and Sol LeWitt's serial wall drawings, which he initiated by producing one himself on the wall of the Paula Cooper Gallery, New York, in October 1968, are more usually drawn by draughtsmen who work from a set of in-

structions provided by the artist.

In 1971, LeWitt provided 35 sentences on Conceptual Art as his contribution to the magazine Flash Art. Sentence eight reads: When words such as painting and sculpture are used, they connote a whole tradition and imply a consequent acceptance of this tradition, thus placing limitations on the artist who would be reluctant to make art that goes beyond the limitations.' These limitations were evidently overthrown in the late 1960s.

The main result was the physical disintegration of the art object. Often this involved inflicting violence upon the art object. Either deliberately mean materials were used - felt, twigs, mud - implying that the materials mattered less than the ideas (this manifestation was called Arte Povera), or else artists discharged their feelings by rupturing the standard processes. This could be done formally, for example Francis Bacon's distortions of subject matter, or materially. Lucio Fontana (1899-1968) slashed cuts into his canvases with a razor as early as 1957, in order to introduce a new concept of space: Gustav Metzger (b 1926) chose acid instead of paint, and nylon instead of canvas, so that when he created a painting by applying the acid to the nylon support, the acid caused the nylon to rot away, thus initiating the destruction of the piece.

Reduction, or destruction, of techniques and materials led to an enlargement of the role of the artist and his or her creative motivations and actions. Artists began nakedly to propose themselves, especially their bodies, as matLEFT Helen Frankenthaler (b 1928) is a member of the generation who followed after the pioneer work of the Abstract Expressionists, and thus a change of direction can be clearly seen. There is a calm and lyrical auality about Mountains and Sea (1952) also reflected in its title; works of this nature by Frankenthaler and her colleagues have been dubbed 'lyrical abstractions'. This is a large early canvas which shows the new techniques pioneered by her and taken up by other American artists in the 50s and 60s. She painted on raw unsized canvas, with the canvas laid on the floor rather than on an easel or wall. Since the canvas is unsized the colours sink into and blend with the support.

BELOW Morris Louis was enabled to make such bold, colour stained canvases — as here in Golden Age (1959) by the dual influence of Frankenthaler's way of working and his own adoption of acrylic paint. Frankenthaler did not overlay her paints since oils would have caused opacity, but the water-soluble acrylic used by Louis allows veils of colour to mingle within the fabric of the canvas, while still retaining their identities and without becoming muddied.

BELOW Self-portrait with Badges (1961) by Peter Blake has attracted the epithet 'pop' because it contains popular imagery, shown in the veritable plethora of metal badges. It is a strongly autobiographical work which provides much material about the artist in terms of emblems and symbols, and in this it recalls early English portraiture. Blakes likes to work his paintings up to a high state of finish, but not all areas need to be at the same stage at the same time. The meticulous painting of the badges contrasts with the sketchy treatment of his left

erial for artistic manipulation. This earned the term Performance Art. Artists such as Dennis Oppenheim (b 1938) and Vito Acconci (b 1940) subjected themselves to feats of endurance, strength, boredom and fear. Art and the life of the artist thus became indistinguishable.

Since many of the performance pieces were done privately, or involved an activity spread over a certain determined period - for example, Acconi's Following Piece which involved following people chosen at random on the New York streets for a one-month span – some kind of record or documentation was deemed necessary in order to prove the existence of the piece. Documentation was also necessary for Earth Art works. In 1970 Robert Smithson (1938-1973) designed a Spiral Jetty for Great Salt Lake, Utah, which was made out of earth by a construction team, and measured 450 metres (1,500 ft) long and 4.5 metres (15 ft) wide. The work would have remained quite private if Smithson had not exhibited his working

drawings for it, and made a film revealing the context of the Jetty. Richard Long (b 1945) records his walks over unpopulated ground by providing the viewer with annotated maps, photographs and, more recently, a conjunction of place names and poetic incidents.

Joseph Beuys (b 1921) is an artist who believes in the value of teaching as an artistic commodity. Partly because of memories of experiences of the Russian front during the Second World War, he creates works which use animals; his performance work *How to Explain Pictures of a Dead Hare* (1965) consisted of Beuys cradling a dead hare in his arms, with his face covered by a layer of grease and goldleaf. He wants such works to express metaphysical and social matters.

New Expressionism

During the mid-1970s it became apparent that there was a movement, or change of direction in art, which existed contemporaneously with Conceptual Art. This new approach contrasted strikingly with the methods, practices and techniques of the Conceptualists, because it represented a return to the traditional values of painting. Lucian Freud, who had been using oils exclusively for some time, was applying the paint with unconcealed brushstrokes, to sculptural effect. Several artists who had never subscribed to art as concept and who had continued to execute orthodox paintings, turned from using acrylic to oil paint, feeling that oils, with their classical central position in the history of painting, provided the painter with inbuilt, expressive, and even emotional qualities. If oils had served Rembrandt, Titian and van Gogh, then their value could only be enhanced by a conscious acknowledgement of this allegiance. Malcolm Morley (b 1931), a painter who had produced super-realist works from the mid-1960s, was one who changed from using acrylic paint with its precise, cool finish, to oils. One of the first canvases he painted using oil was Piccadilly Circus (1973), in which there is an obvious reference back to the work of the Abstract Expressionists: their loose, almost improvisatory painting style implied freedom of expression and, equally, placed great store upon the quality and quantity of the material used. Paint was applied thickly, quickly, with great texture and flourish. Often the subject was obscured or dominated by the pigment.

Nowadays, the younger artists of the 1980s take up much that was proposed by the Abstract Expressionists, but also look further back – to the German Expressionists, to van Gogh, Chaim Soutine (1893-1943) and even to the later style of de Chirico. Ernst Kirchner, cofounder of the German Expressionist Die Brücke group, wrote in 1906: 'We claim as our own everyone who reproduced directly and without falsification whatever it is that drives

RIGHT Mountain Indian (1982) by Rainer Fetting is a large composition made up from two separately stretched pieces of canvas. Fetting chose to go to Berlin to pursue an artistic education, and in doing so he followed the path taken by the Dresden painters of Die Brücke, who moved to Berlin in 1911 in search of new creatine experiences The modern city, with its bars, shared flats, nightlife and aura of violence is usually the chosen subject matter, but in Mountain Indian a naked figure Fetting himself? – stands before a lowering neo-romantic landscape. The overt subjective, emotional, autobiographical content of this painting, and indeed all of his work, looks back to the same choices made by the Die Brücke artists. They, and Fetting, record their activities in canvases with a range of colour harmonies which is often lurid. The black, purple, green and yellow of Mountain Indian are just the choices that an artist like Kirchner would have made. Fetting has rejected both oil and acrylic paint as his medium. and works with powder paint — dry pigment which has to be mixed with a binder; traditionally this has been water, but a plastic medium is also possible. The rich purple and blue harmonies are reminiscent of those chosen by Symbolist painters, the young Picasso of the blue period included, and Fetting prefers works which are rich in psychological content. His paintings are not laboriously planned, but executed in a deft, hedonistic manner.

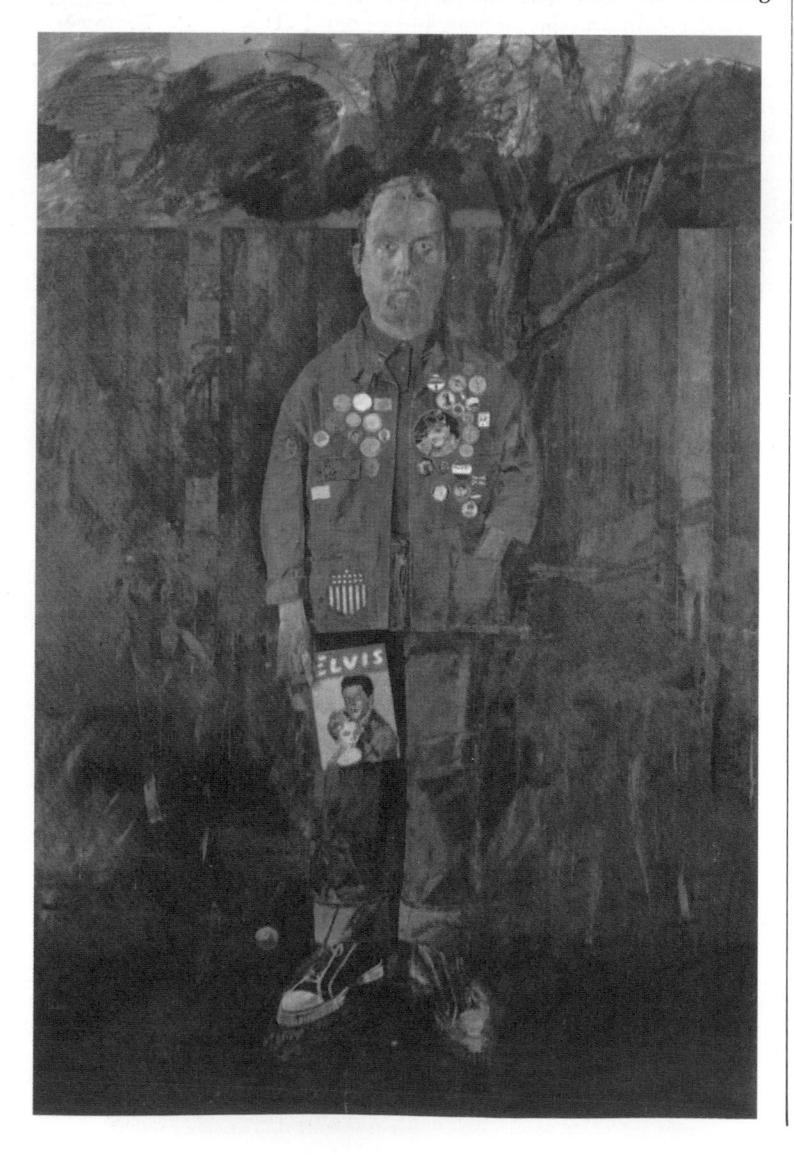

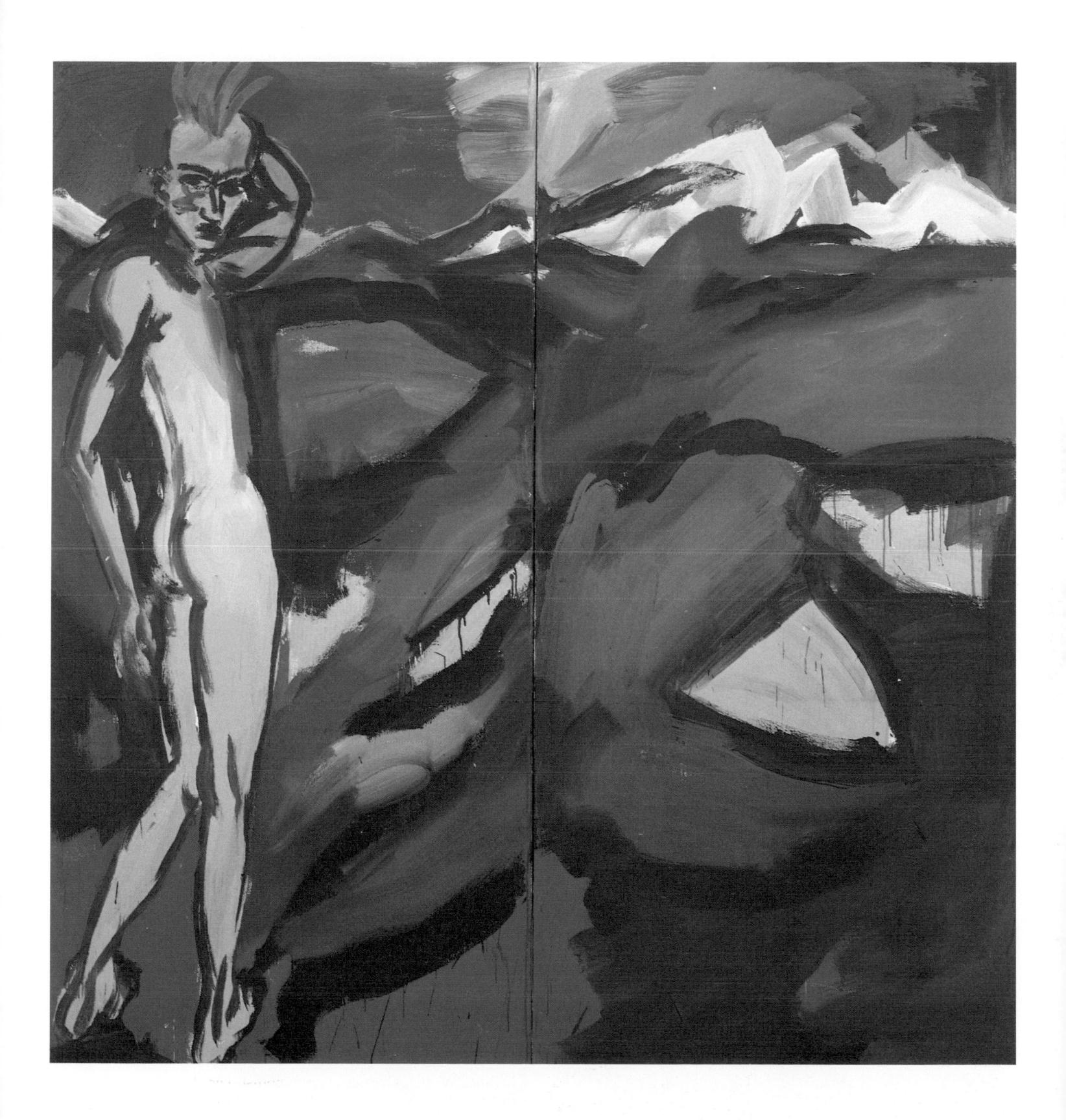

him to create.' The paintings of Karel Appel (b 1921), Asger Jorn (1914-1973), and the members of their Cobra group who worked towards the same aim from 1948 to 1951, also displayed spontaneity and emotion; they offered a more lyrical, witty kind of Expressionism which ran counter to the strength, violence and scale of the work of the American Abstract Expressionists.

Today, the international band of painters working in the New Expressionist idiom – they came from Germany, Italy, Britain and America – prefer the wild, violent approach. Canvases are large and their emotional content is high. Rainer Fetting (b 1949), for inst-

ance, has reworked the traditional theme of the crucifixion of Christ, and the choice of such subject matter is related to the sadomasochistic streak in his imagery. Identification with the suffering body is intensified by the way the paint is applied to the canvas and the image: maximum expressive *means* is wedded to maximum expressive *content*. Paintings can be triggered by an incident experienced or an image which fascinates; they express the claustrophobia and heady excitement of life in large cities, but they also give the idea of painter as observer, as anthropologist studying the wayward, sometimes incoherent activities of humans.

RIGHT The title gives a clue to the form and content of Entanglement Series: Perpetual Flux (1981-1982) by Peter Phillips. He began making painted reliefs in 1963 and the entanglement can refer to the interpenetration of the three-dimensional elements which ride in front of a canvascovered, painted backboard. The motifs are equally commixed: a fan, part of what looks like a cocktail dress, and the front half of subtly coloured skis all take their palce. Phillips' mature style is one that revels in trompe l'oeil effects, and the mixing of 2-D and 3-D elements in this piece puzzle and delight.

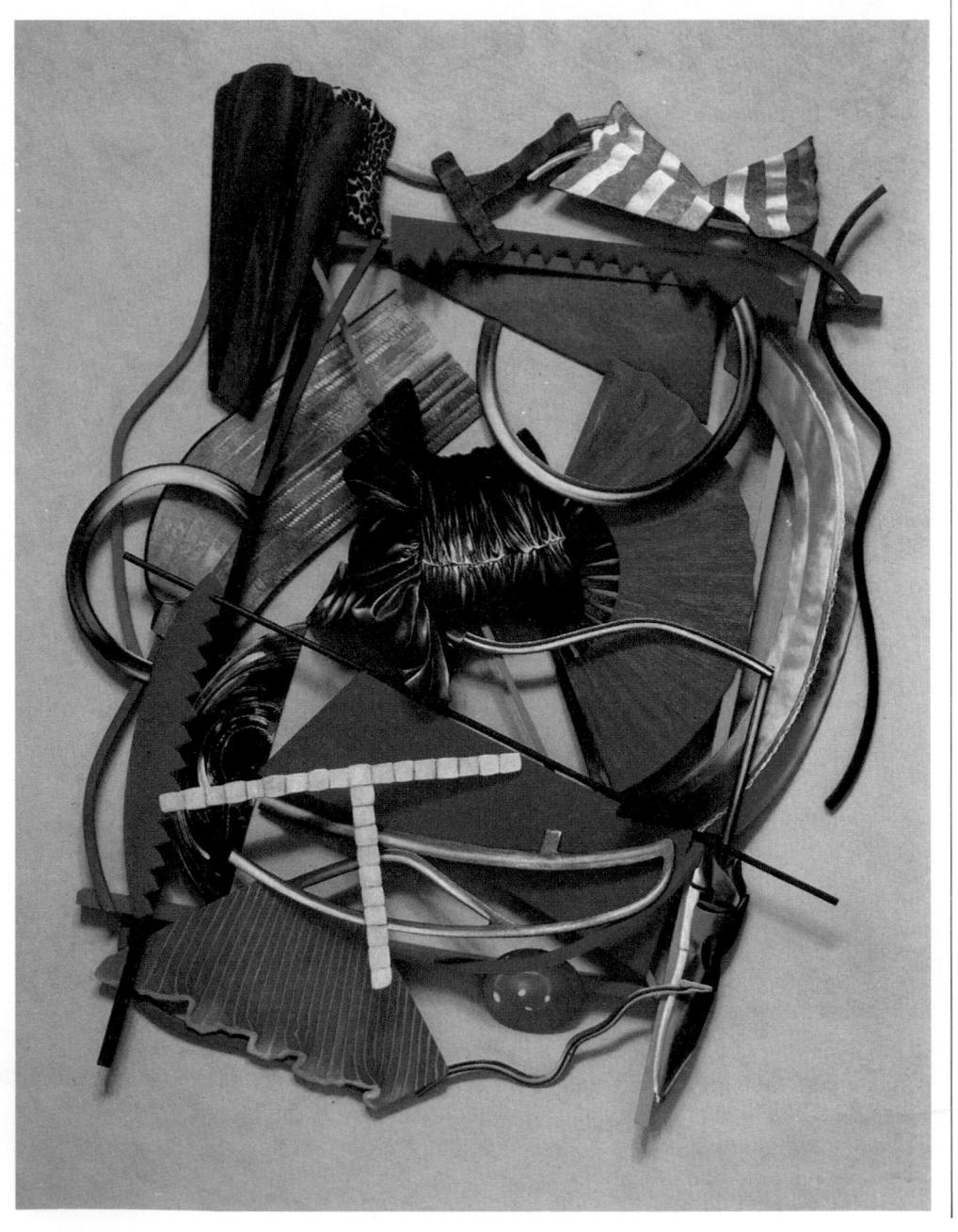

RIGHT The subject of a dancer or dancers has long held a fascination for Allen Jones, as has the idea of a hermaphrodite image. In Spanish Dancer (1982) three figures are visible — two men, one in a dark grey and one in a red suit, and a dancer in a long blue dress. But the title of the piece is in the singular, implying that all the figures are fused into one. Following on from his early shaped canvases, and sections of relief in his panel paintings, Jones started to make free-standing painted sculpture in 1969. Then, as now, the strong, hard-edge of the contour of the plywood contrasts with the loose, expressionistic brushwork painted upon it.

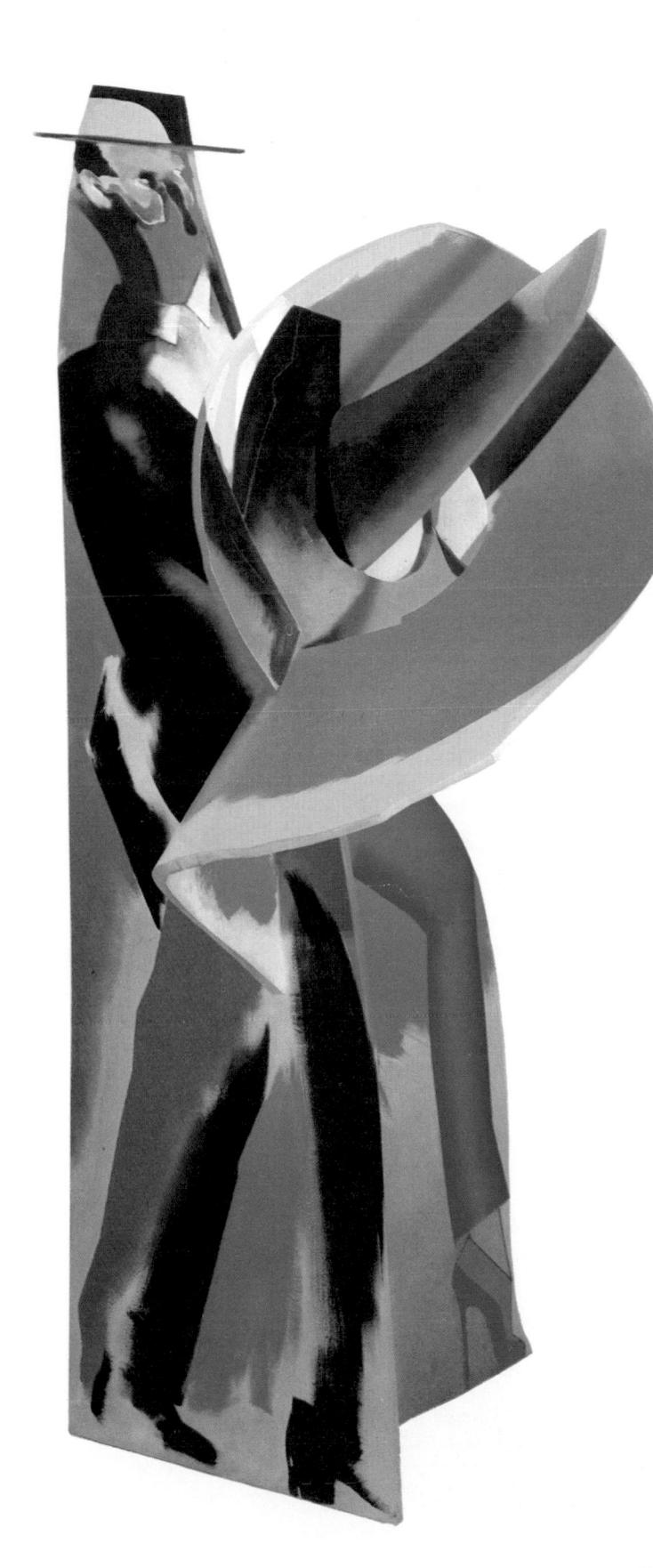

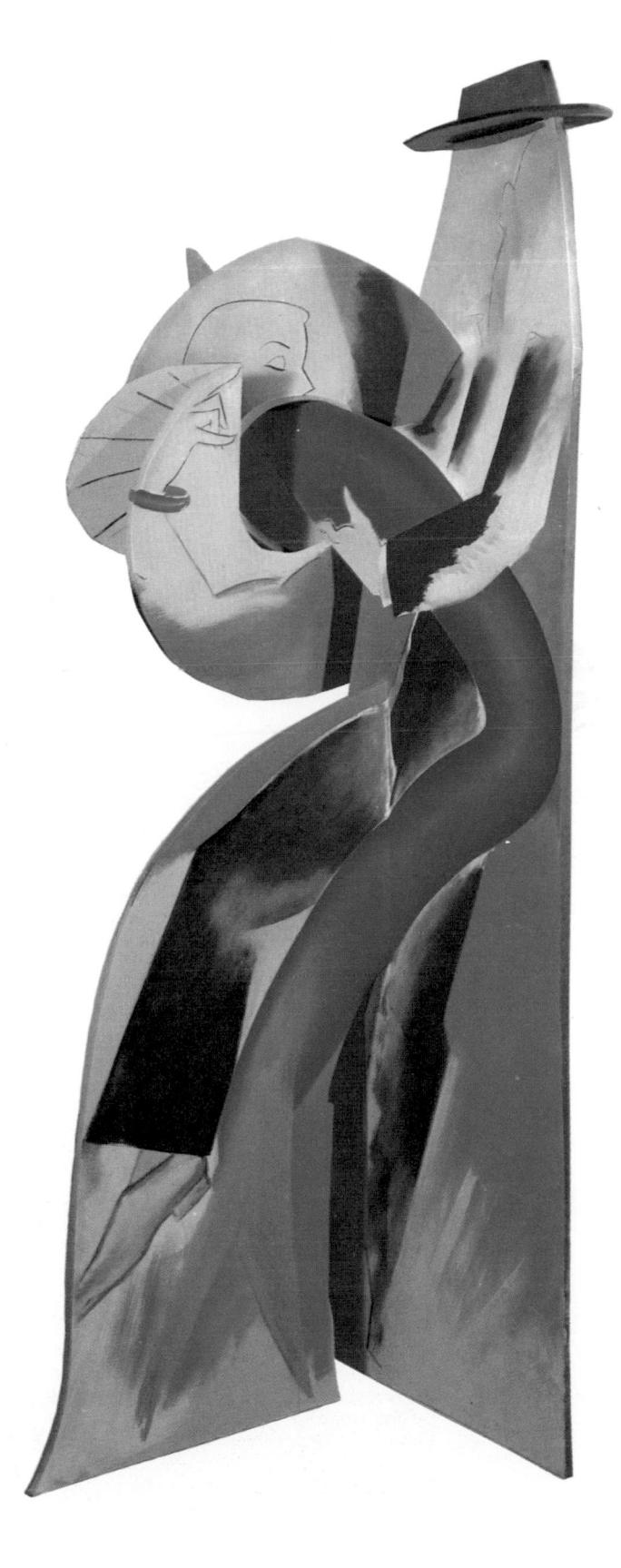

Morris Louis

Spawn (1959-1960) Acrylic on canvas 182.8cm x 243.8cm/72in x 96in

Morris Louis has been hailed as heir to Jackson Pollock's pictorial revolution, responsible for a real contribution to the liberating and abstracting tendencies of the art of the immediate post-war period, and as an artist who lived his life for painting with a dedication close at times to obsession. Under the championship of the critic Clement Greenberg, Louis took painting right into the fabric of the canvas and finally subverted decades of discussion about 'surface' and 'depth'. In the end he reacted against the 'gestural' practices of Action Painting and the seductive tactile qualities associated with it, in favour of the coolness, restraint and impersonality which became the mark of so much of the art of the 1960s.

Born in November 1912 in Baltimore, Maryland, Louis gained his knowledge of contemporary developments in painting, especially in the New York scene, mostly through a friendship with the artist Kenneth Noland, which began in the early 1950s. His style of painting up to about 1952 has been dismissed, perhaps over-hastily, as 'minor and provincial'. It reflects the influences of two close friends David Alfaro Siqueiros (1896-1974), the Mexican muralist, and of Arshile Gorky, the Abstract Surrealist, and finally of Pollock. But he was always experimenting during this 'preparatory' period with techniques such as Duco, and he first employed acrylic colours as early as 1948.

In 1953 Louis saw the Mountains and Sea (1952) of Helen Frankenthaler. This painting had been executed by pouring and staining, a colour process developed by Frankenthaler after Pollock's dominantly black stainings which he produced from about 1951 to 1952, and in combination with, his drip technique. Louis noted of Frankenthaler that 'she was the bridge between Pollock and what was possible'.

Frankenthaler's *Mountains and Sea* produced an almost visionary reaction in Louis and led him to annex and extend the technical possibilities of the staining method. By 1954 he had solved, to his own satisfaction, most of the practical problems of the technique.

The last eight years of his life were devoted to three general modes of staining canvas, differentiated both by the overall 'look' of the pictures and by definite shifts and nuances in the process of application. In 1954 and from 1958 to 1960 he painted *Veils* and *Florals*; in 1960 a concentrated series of *Unfurleds*, and from 1961 until his death from lung cancer in September 1962, a sequence called *Stripes*. These categories are not absolute and there are many 'marginal' works particularly from the years between 1955 to 1957 when Louis destroyed nearly all his work (because his methods allowed him to make no changes to the work).

Louis was a dedicated painter. Having used

acrylic paint since the late 1940s, he was not really tempted by any other medium, except for a few collages (tissue paper and acrylic on upsom board) in 1953. There are several eloquent accounts of his mature technique but none from the artist himself.

The Magna paint which Louis used, distinguishes it from conventional oil paints and from the different acrylics used, for example, by David Hockney (b 1937). Magna is the trade name for an acrylic-based paint manufactured by Bocour Artist's Colors Inc., and contains a resin, a thinner, an emulsifying agent and pigment. Unlike oil, it is quick drying, non-acidic and can be thinned to flow and bind. Unlike the Liquitex water-based acrylic used by Hockney it is oil compatible and soluble in white spirit.

Spawn (part of the Floral series) was painted between 1959 and 1960, a crucial moment in the development of Louis' working procedure, as he became unhappy with a new formula Magna paint which was too viscous to flow and stain as he would have liked and the evidence from Spawn suggests a struggle with a somewhat recalcitrant medium.

The unprimed and probably unsized canvas which is not stained with colour appears slightly scuffed and marked, possibly from the effort of manoeuvre; the support would have had to have been tilted right round the compass angles – a movement greater and more complex than that necessitated by the *Veils* and *Stripes* with their dominant north-south or diagonal orientations.

The 'floral' effect of *Spawn* is achieved by the centrifugal movement of paint from a central depot (a stigma as it were), which is the point of focus for the composition. These colours were separated towards the peripheries where they were stopped and blunted or pointed, according to the volume and thickness of the acrylic (the 'petals'). A third, roughly concentric, band can be identified between the central nub and the one-colour petals, where two or more hues merge and interact, producing a darker layered effect (the 'sepals').

The paint accumulated in the centre of the work, an unusually dense area of impasto, has cracked on drying and stretching. To the left of centre there are *frottage*-like tracks, created by the sweep of a swab or other implement across the surface as an aid to spreading. Slightly above the centre there is a definite brushed radius, more consciously articulated. Elsewhere characteristic 'capillary scars' are visible round the boundaries of the colour shapes, where the resin has become separated from the paint.

These various surface incidents, however, are only the technical constituents of a powerful colouristic sensibility, as significant in its own way as Robert Delaunay's early modern chromatic discs.

MORRIS LOUIS

The abstract but 'floral' appearance of Spawn belies a considerable number of technical incidents and decisions across the canvas surface. The work is not merely decorative, but is 'set-up' for the eye. It

proposes not just the pleasurable experience of colour combinations, but an experience which includes an apprehension of the very procedures which brought the painting into being.

Trail of primary layer visible through subsequent pourings

Circular edge achieved by rubbing possibly with a cloth

Central 'depot' of paint, dark where colour layers accumulate

Capillary zone dilutes the colour of the adjoining veil

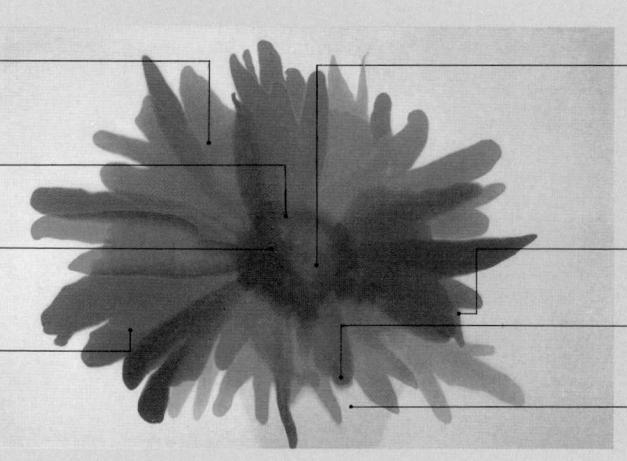

Off-centre core, wiped and brushed, produces a dull sheen

'Straight' edge produced by sharp change of tilt direction

Fuzzy prong-endings as paint seeps into the weave

Funnel of resin draining downwards

MORRIS LOUIS

ACTUAL SIZE DETAIL The relatively coarse weave is everywhere visible, with occasional tufts and irregularites in the fabric. There are no brushmarks, just boundaries and gradients between successive veils and pourings. The transition from the blunt finger of red-orange to the yellow paint in the bottom left corner of this detail shows how the eye reads the boundary as a continuous curve; in fact, close inspection reveals the zig-zag incursions that each colour makes into the other's zone. Where colour veils overlap there is a distinct there is a distinct tendency for individual knots of canvas to be colonized by a discrete hue, so that there is a kind of two-colour Pointillist effect. This is particularly clear in the top right where the redorange and darker green colours merge. The close-up masks, however, some of the tentacular extensions which stain downwards in vertical alignments. On the lefthand side there are two paint blisters clearly visible as deals in the state of th dark circles enclosing lighter interiors.

RIGHT The 'top' section of Spawn has been stained carefully to produce a range of grouped pinnacles of paint. The poured prongs are more variously terminated than elsewhere in the work; the yellow finger to the left for example, is spectacularly attentuated in comparison to the normally blunted termini. On the left, a termini. On the left, a black stain ends with a strong dark zone the result of either the addition of a small dose of colour, or the removal of paint by rubbing down from it. In the centre, the 'pigeon-head' configuration of the brown stain was achieved by altering the angle of canvas tilt at the last moment. The capillary scars around the triple red prongs are particulary pronounced and evenly disposed.

MORRIS LOUIS

First Landing Jump (1961)

Combine painting: oil, fabric, metal, mirror, wood on fabric and composition board, plus rubber tyre, licence plate, button, etc 225.6cm x 182.8cm x 16cm/891/8in x 72in x 65/8in

Rauschenberg was the spearhead of a trio of American artists (with Larry Rivers and Jasper Johns) who challenged the high seriousness of Abstract Expressionism. His work, however, is notoricusly difficult to classify, and only partially fits labels such as Neo-Dada or Proto-Pop. All three artists, and Rauschenberg in particular, added rare accents of wit, irony and satire to the production of visual art; all were acutely conscious of the traditions, values and techniques existing in painting; and all, in their desire for original statement, often found many of these traditions over-celebrated, precious or merely 'arty'.

Robert Rauschenberg was born in October 1925 and grew up in Port Arthur, Texas. After an indifferent high school career, he spent a short period at the University of Texas studying pharmacy. He registered at Kansas City Art Institute in 1947 and visited Paris in 1948 and studied with Josef Albers (1888-1976) at the Black Mountain School in 1949.

Rauschenberg has exploited a large, heterogeneous and unusual range of techniques and materials. Among his first works was a series of monochromatic 'white paintings' made in 1951, using ordinary household paint, and applied with a roller. In the 'black paintings' of 1951 to 1952, Rauschenberg built up irregular surfaces on the canvas with torn and crumpled newspaper pasted down and then coated with a layer of black enamel.

From about 1953 Rauschenberg produced a grand series of what he termed 'combine paintings', in which common objects from the artist's local environment, and occasionally more exotic creations, were appended to, or 'combined' with, the canvas surface. In addition he made free-standing objects, illustrated Dante's Inferno in a technique allied to frottage which has been called 'transferdrawing' and experimented with silkscreen stencil ing. Since 1955 he has collaborated frequently with Merce Cunningham and his dance company on costumes, stage sets, lighting and choreography.

In 1966 Rauschenberg co-founded EAT (Experiments in Art and Technology) which determined to examine 'the possibility of a work which is not the preoccupation of either the engineer, the artist or industry, but a result of the human interaction between these three areas."

Within all this variety, Rauschenberg's aim has always been to 'act in the gap between' art and life; the 'combine paintings', above all, are the earliest and most consistently developed of his new 'aesthetic of heterogeneity'. First Landing Jump is one of the last of Rauschenberg's combine paintings. It was produced in the same year as the Museum of Modern Art's influential exhibition The Art of Assemblage, in which Rauschenberg featured significantly and was saluted in the catalogue that accompanied the exhibition.

Rauschenberg's role, then, is one of organization and arrangement; he spoke himself of the artist as 'just another kind of material in the picture, working in collaboration with all the other materials'. Particularly in the early combine paintings, coherence was achieved between the variety of objects and surfaces with enveloping oil paint, and the disposition of the whole on either canvas or (as in First Landing Jump) on fabric and composition board. Rauschenberg refused to give the traditional priority to fine art materials as the sole agent of pictorial production: 'A pair of socks is no less suitable to make a painting with than wood, nails, turpentine, oil and fabric,' he said. But this calculated outrageousness has not prevented Rauschenberg from being assimilated and normalized by later writers as a classical artist.

In the later combine paintings, foreign objects are given more prominence and often hang out of the dominant quadrilateral that still provides a focus for the viewer. All Rauschenberg's studios and places of work have been rather like junk shops, containing a vast miscellany of bits and pieces culled from the streets, from friends or from printed material. From this store house paraphernalia a rubber tyre, licence plate, cloth bag, light fixture, electric cable and other objects have been selected and organized into a 'pictorial' unit. The tyre has been favoured by Rauschenberg previously; one is found around the goat's middle in Monogram (1955-1959) and it leaves imprints as tread elsewhere in his work. Rauschenberg is probably attracted to the geometric shape, rubbery texture and automobile associations of the tyre.

In terms of colour alone, in First Landing Jump the artist has been very careful in his articulation of individual elements. The square support is predominantly black in the upper section, interrupted by the battered white reflector, and a finger of black extends into the lighter coloured bottom area roughly parallel to the diagonally striped wooden slat which penetrates the black tyre out of frame. The strongest subsidiary colour is the blue of the light bulb inside a tin can, and the colour is echoed strongly in a crease of blue paint next

The whole work resembles a studio mockup of an aircraft's landing gear, with a light from the undercarriage focusing on the extended 'wheel', which rests on the ground. But this governing idea has been transposed and augumented by further references, particularly formal ones, and the piece exhibits a bizarre tension between its own internal system of references - the outside world from which the objects have been pulled - and its overall configuration.

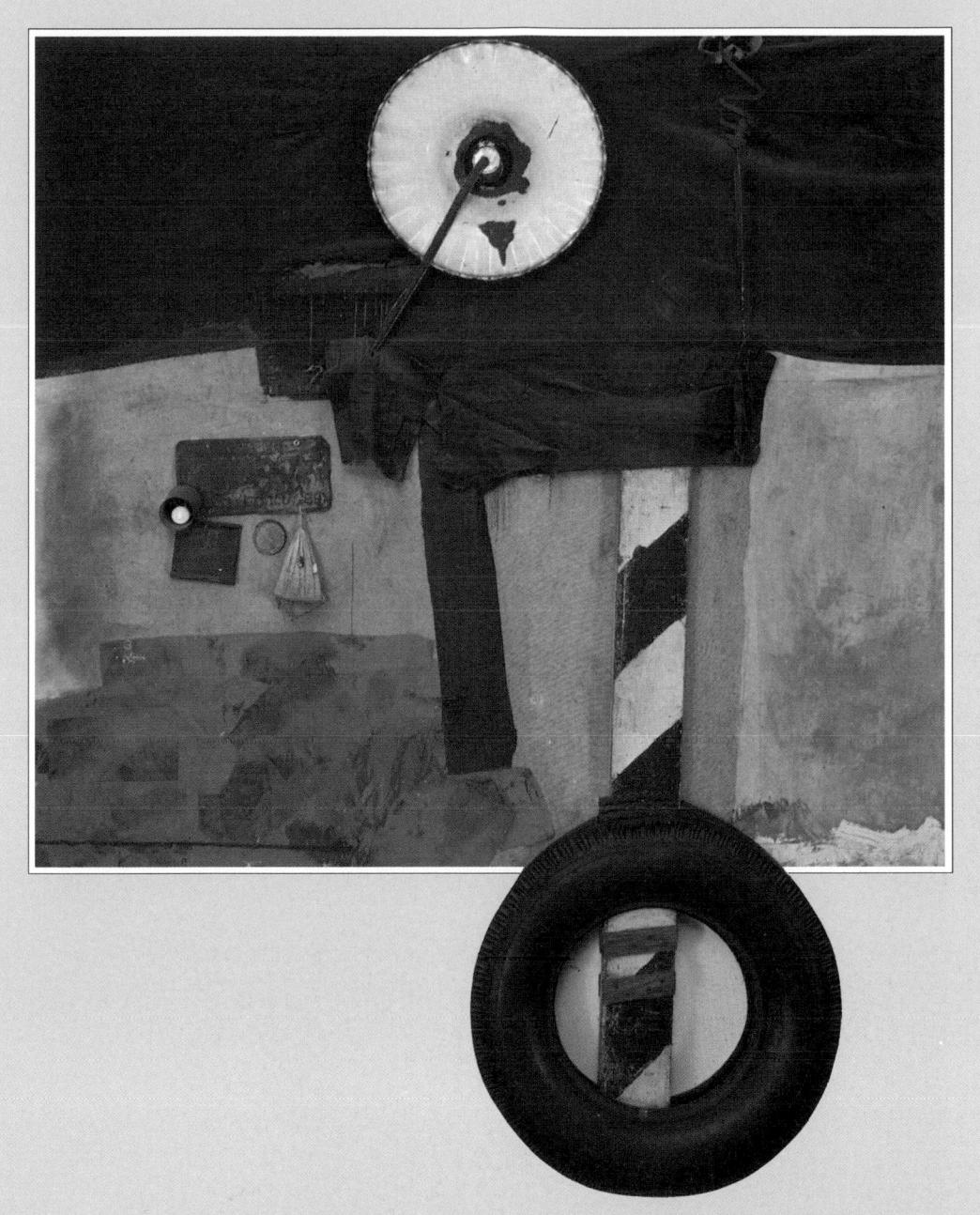

First Landing Jump is constructed in four zones. From the top of the work these are as follows: beige tarpaulin painted black which covers the top third of the base; the middle zone is lightly touched or untouched composition board, and white canvas drop cloth; a torn, tan khaki army shirt occupies the bottom left sector; while the tyre and wooden slat constitute a fourth zone, resting the work on the exhibition floor, and creating the playful illusion that it is a machine capable of some sort of motion. Despite the use of diverse elements and the strong formal arrangement it should not be forgotten that this large-scale work was intended to be viewed from a distance, and that a touch of absurdity is never far from other, more technical intentions.

Metal spiral issuing from 'rupture' in fabric

Shreds of cloth 'dripping' into the brown zone

Electric light bulb with mains lead (switched on)

Cloth bag suspended from licence plate

Automobile tyre pierced by wooden slat

Loose, thick white brushstrokes

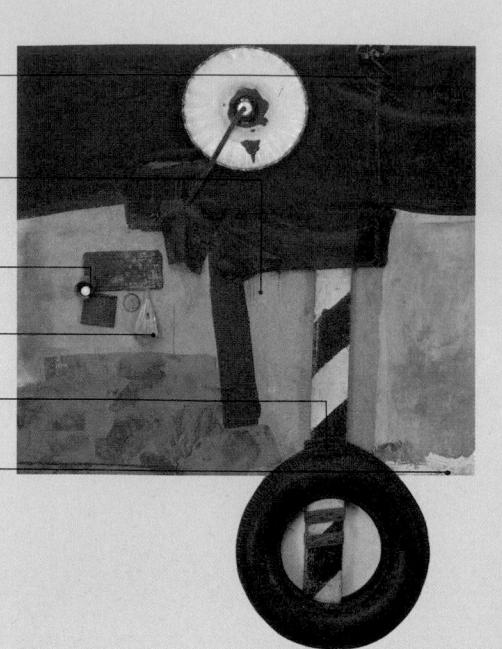

RICHT The commercial tyre projects inches' from the composition board, while along the bottom to the right is the most richly painted section of the entire picture, a flourish of white and brown brushstrokes. Most of the detail, however, shows the disposition of lightly brushed marks creating an apparently random field, in which the play of activity somehow parallels the incorporation of more three-dimensional material elsewhere. But these highly non-referential painterly signs deliberately disavow the charged symbolic interpretations which have attended the similarly abstract-looking marks of the Abstract Expressionists; and also evade the structural suggestions which marks in this colour elicited in Cubist compositions.

ABOVE Rauschenberg used an extremely heterogeneous collection of materials: in this detail a reflector, a leather cable and a thick black cloth patch edged with a luminous stripe.

ACTUAL SIZE DETAIL
Something of
Rauschenberg's
intricacy and anarchy is
evident here. Folds,
patches and creases of
woven material are
blended together and
highlighted with dabs of
white, black and red.

Marilyn Diptych (1962) Acrylic and silkscreen on canvas 208cm x 145cm/82in x 57in

Andy Warhol was born in 1930 in Pittsburgh of immigrant Czech parents. He studied pictorial design at the Carnegie Institute of Technology, Pittsburgh, from 1945 to 1949, and then moved to New York, where he still lives and works. During his first 10 years in New York he worked as a commercial artist. 'The process of doing work in commercial art was machine-like, 'but the attitude had feeling to it.' Warhol found that, in working as a commercial artist, he had to be creative and original, and also had to satisfy those who were paying him.

Concurrently with his commercial work, Warhol held shows of his drawings in New York galleries and published six books of reproductions of thematic drawings. Although the books were printed in limited editions, the idea aped that of commercial art, and made his own art less exclusive, less unique and more accessible.

From 1960 to 1961 he took his subject matter from the category of mass communication – newspapers, comic strips and advertisements – and produced paintings which look bland and dispassionate. In his quest for an art that could be machine-like, that would look as though no human had produced it, he also wanted to encourage the idea that anybody and everybody could and should be able to produce art – 'I think everybody should be a machine.' In 1962 he executed some 'do-it-yourself' canvases; a seascape for example, in which the canvas is peppered with numbers placed in various areas, mimicking the popular pastime of painting-by-numbers.

In the same year he began using silkscreens to transfer readily available images on to his canvases. He spoke of this process with pleasure '... I'm using silkscreens now. I think somebody should be able to do all my painting for me . . . I think it would be so great if more people took up silkscreens so that no one would know whether my picture was mine or somebody else's.'

Warhol's image of Marilyn Monroe is taken from a publicity photograph by Gene Korman, used for the 1953 film Niagara. It was therefore a well-known public image and was already removed from her real life persona. By 1962 Marilyn Monroe was famous, not only through her films, but also through the manipulation and dissemination of printed images. These are the two approaches which Warhol has chosen as the basis for this work. Newspaper pictures are in black and white, and magazines in colour; television sets and films also transmit images in both black and white and colour. Marilyn Diptych could well be making a subtle comment about such differences. And for him more seems to be better than less; 50 images of Marilyn Monroe have a more powerful impact than two, because they emphasize Warhol's mechanical techniques.

Warhol probably worked on Marilyn Diptych on a horizontal surface and it would have been screenprinted and handpainted before being stretched. Whether or not the canvases were fixed to stretchers before or after the screenprinting process, Warhol has decided to give it an unplanned air by leaving the bottom few inches bare.

After the two canvases for Marilyn Diptych were prepared with a thin coat of off-white commercial paint, the multiple image of Marilyn was added by forcing paint through the prepared silkscreen. This is usually done with a squeegee, a fin of rubber rather like a windscreen wiper, which is pulled along the length of the screen. The trace it leaves depends on the amount of pigment which is squeezed on to the upper surface of the screen and on how the operator moves the squeegee. In the second vertical row of the righthand canvas, particularly the second image down, the silkscreen has been charged with far too much paint, and it has been forced through the mesh to finish up as a thick mess which almost blots out the image of Marilyn Monroe's face; it is also apparent that the edge of the squeegee was marred by something and thus prevented from making an even sweep. Where the screen has been overloaded with paint, the weave of the fabric is very apparent.

Both canvases of *Marilyn Diptych* would have had the same preliminary silkscreen printing. The righthand one was left at this stage, while further processes were applied to the lefthand canvas. Pencil lines drawn over the screenprint are visible on the righthand canvas, drawn as if to mark the limit of the dimensions of the screen. They serve little purpose on the righthand canvas, but it can be assumed that similar lines helped in guiding the application of colour on the left and are now overpainted.

Six separate colours have been applied pink for the face, yellow for the hair, turquoise for the eyeshadow and collar, red for the lips, white for the teeth, and orange for the background. The exact order of their application is difficult to determine since they do not overlay, but instead abut each other. In some images, however, the yellow overlaps the pink, and the orange overlaps the yellow. The application of each separate colour must have been aided by some form of stencil which masked off the other areas. When all six colours had been painted on, again either by Warhol or assistants, a further layer of screenprinting was undertaken, since much of the detail and coherence of the image would have been lost under the colour.

The cosmetic glamour of the lefthand painted canvas works as a necessary foil for the sombre *grisaille* of the righthand one, which unrelieved might have been too raw a statement about a beautiful yet tragic victim.

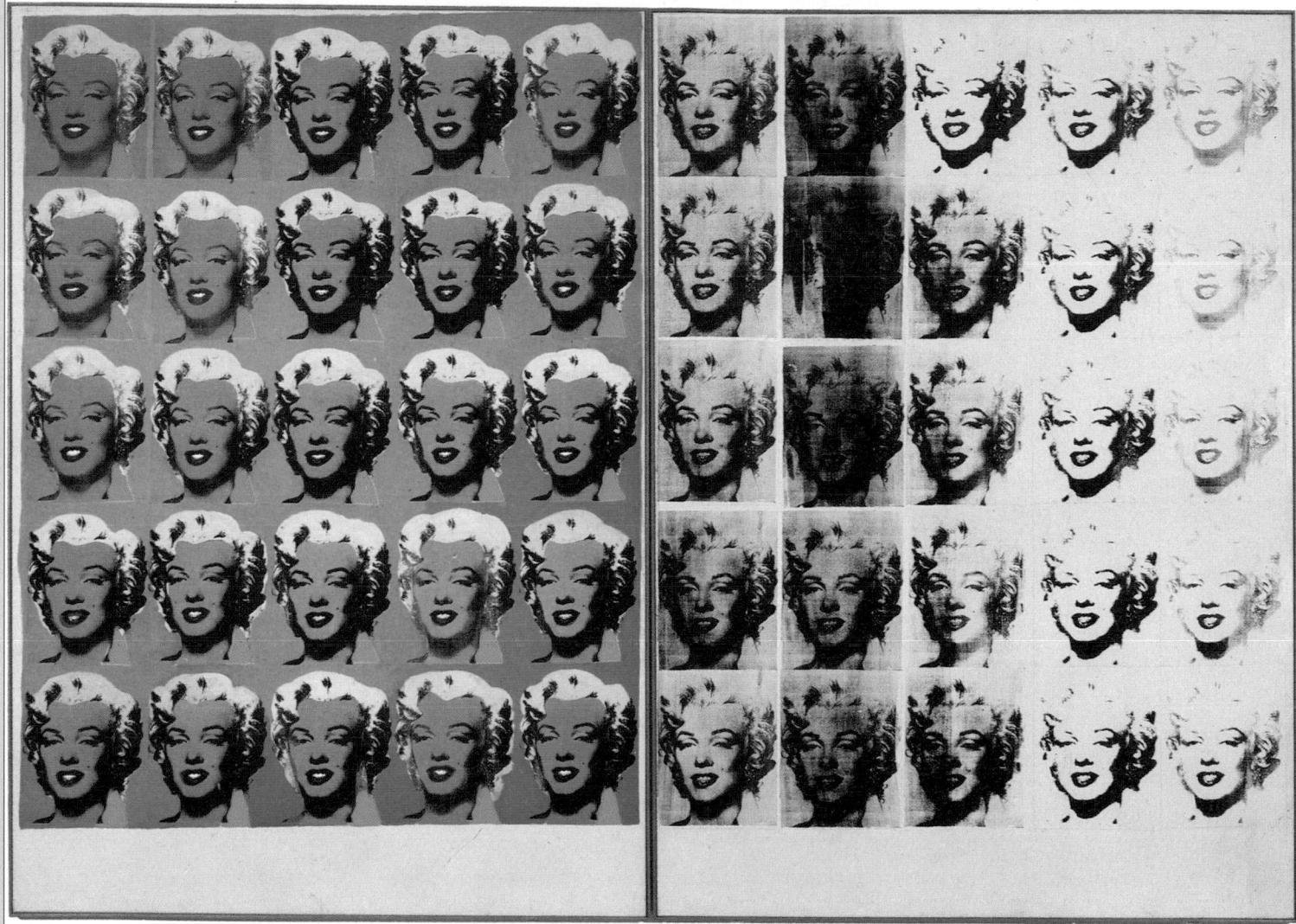

Warhol introduced a new era of portraiture with this work. Not only did he successfully infuse a traditional genre, the portrait, with immediacy and power, he also brought to it new materials and techniques, acrylic paint and silkscreen printing.

Final printing of black silkscreen image overlays coloured acrylic paint

Acrylic paint applied with the aid of a stencil

Parody of misalignment of contours found in cheap printing processes

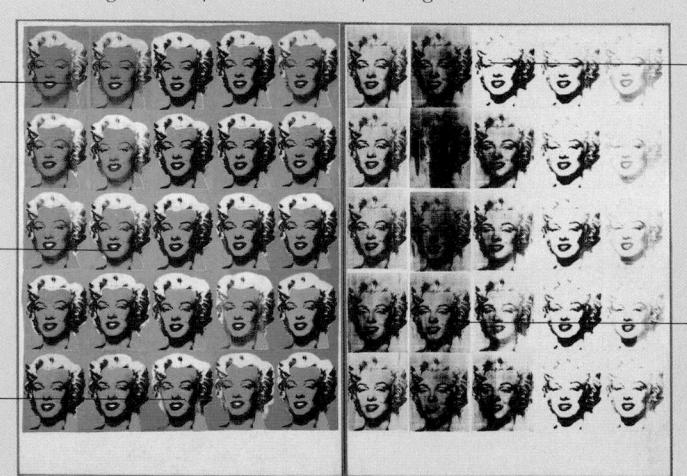

Repetition of identical motifs, altered by quantity of pigment added to silkscreen

Weave of silkscreen

00000	0,000
	0,000
00000	0,7000
	000000
00000	017000

RIGHT The differences caused by the application of acrylic paint by hand are noticeable here; the individual ways in which the yellow designates the hair, and the turquoise the standup collar, are the most obvious. The black pigment which was laid down by the silkscreen process shows no sign of manual application, but the strokes of a wide brush are visible in the yellow and orange.

00000 00000 00000	0,,000
00000	

BELOW These two images point up the different quantity of pigment with which the silkscreen was charged prior to printing. In the righthand image, the weave of the screen is apparent, and this is usually avoided in commercial printing.

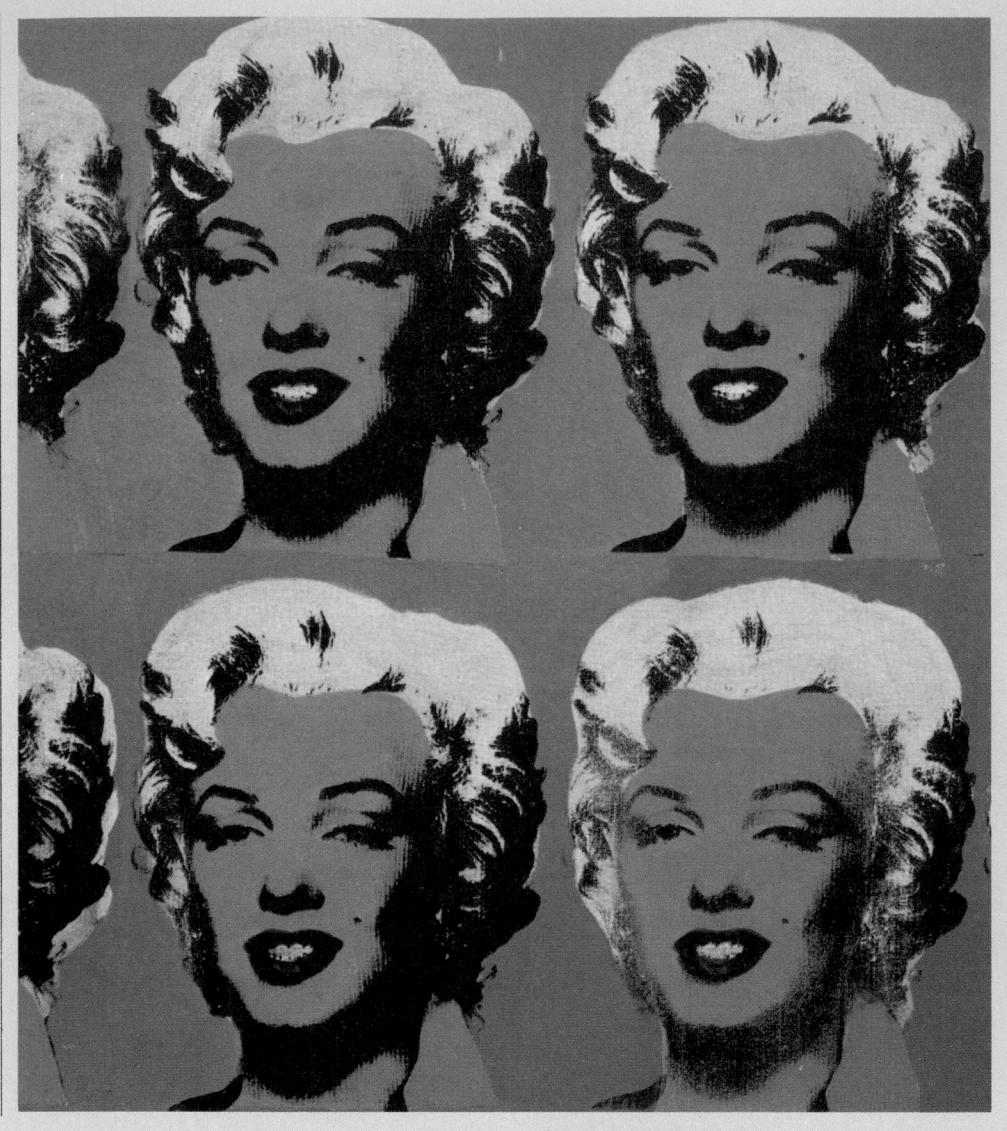

0,000
0,,000
00000
017000

ACTUAL SIZE DETAIL
The six separate
colours, pink, yellow,
turquoise, red, white
and orange, can be
clearly seen. The
colours are those of the
advertising world, and
do not conform to the
standard range
traditionally available
to artists. The lefthand
side of Marilyn Diptych
was first printed with
the silkscreen, painted
with acrylic colours,
and finally given a
second layer of
screenprint. The
original silkscreen layer
can be seen at the
lefthand edge of the
hair, where the
overpainting with
yellow and orange do
not quite meet,
revealing the earlier
process. The order of
laying on the paint can
be gleaned by the way
the yellow overlaps the
pink at various points,
and the orange the
yellow.

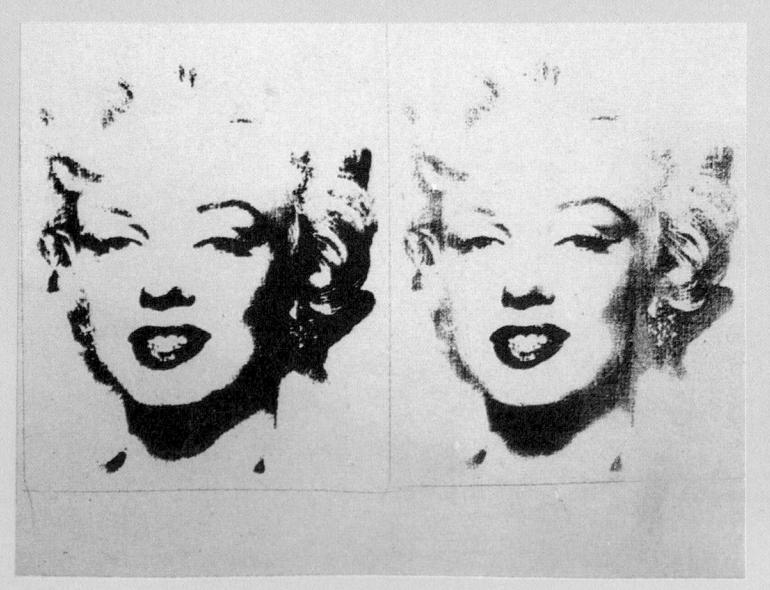

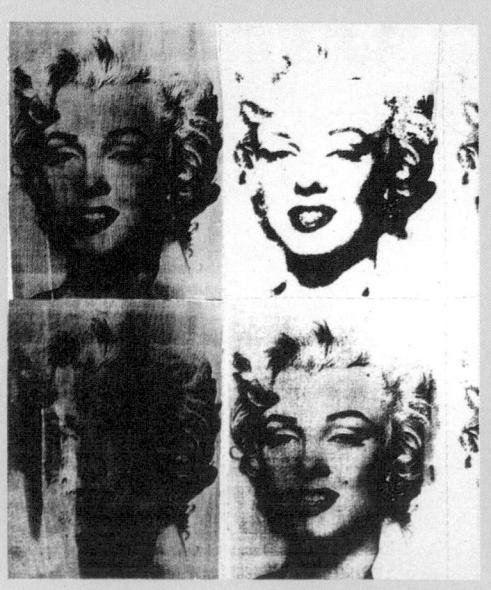

00000	0 1000
00000	0,,000
00000	0,7000
00000	
00000	011000

LEFT The canvas, primed with a commercial off-white paint, shows through as a light ground between the dots of pigment laid down by the silkscreen. The result of adding far too much paint to the screen is seen in the bottom lefthand image, where it has forced its way through the mesh and almost obliterates the design.

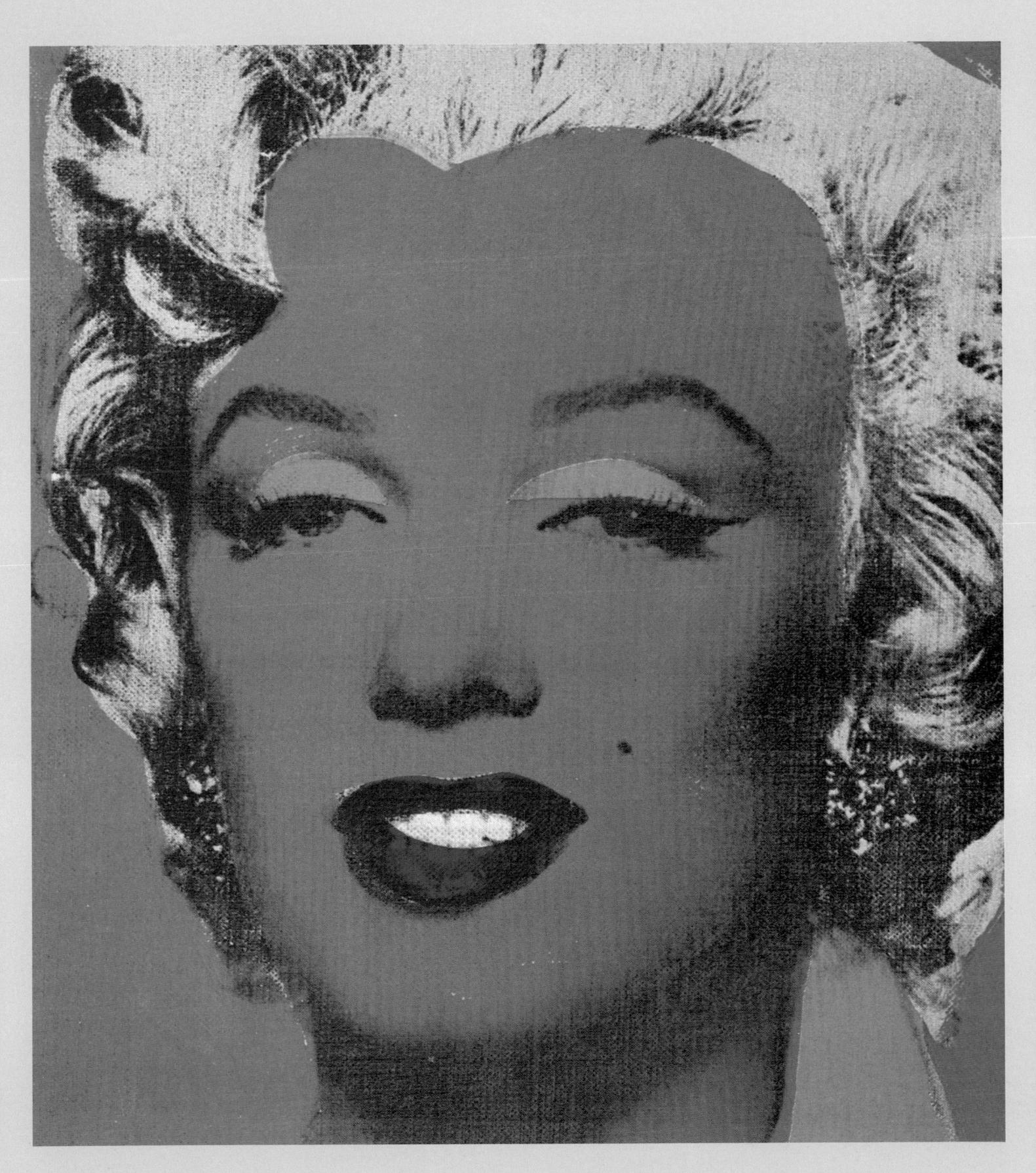

Hyena Stomp (1962) Acrylic on canvas 195.6cm x 195.6cm/77in x 77in

Born in 1936, Frank Stella grew up with a generation that witnessed the emergence of the New York 'school' of painting which drew world attention away from Paris, where most of the significant art revolutions had centred since the 1860s.

Stella was in close contact with the achievements of this group of American painters which included Pollock, Mark Rothko (1903-1970) and Louis; at art school in Princeton he became immersed in many of the technical and practical procedures that allowed this 'revolution' to take place, such as the use of acrylic and commercial paints which had, by 1960, eclipsed traditional oil painting in American art schools. While still a student Stella made some of his own paintings in the 'manner' of these recent masters; later he confessed that they 'tired' him both to make and to look at. His solution to this crisis was deceptively simple: to make the composition 'the same all over', like a type of enormous, yet simple, pattern. Stella's choice of materials for this was conditioned by his vacation jobs as a house painter; he used commercial brushes and equipment and enamel, motor vehicle paint and other industrial paints, as well as the usual acrylic and oil paints.

He first made his impact in 1959 when four of his plain black enamel striped paintings, some 3 metres (10 ft) high, were shown at the Museum of Modern Art, New York. These works contained variations on a repeating theme of brushed stripes within pencil-ruled margins, with a fine line of unprimed canvas between. In *Hyena Stomp*, painted in 1962, these bands are made crisp by the use of masking tape; in 1959 the edges were rough.

Stella needed to work through a series of at least 17 black paintings in order to explore all of the possible evolutions of his simple geometrical concept. *Hyena Stomp* forms part of a series painted between 1961 and 1964, for which Stella used the basis of a square, very often of 195.6cm (77 in) and it is a central work in this evolving series.

In an earlier square painting called *Sharpeville*, a decreasingly smaller set of striped squares shrinks towards a small central square; a rather predictable solution. Stella created a clockwise 'spiral' of stripes in *Hyena Stomp*. It enters from the top righthand corner in the form of the deep crimson stripe, taking the eye in decreasing lengths to a centre that hooks up into itself, yet is made to look very complicated because it is cut into by the intersection of three diagonals, created and emphasized by the L-turns of the stripes.

Later paintings in this series were to play with only one diagonal or turn the stripes sideways to enter from the edge of the canvas in alternating colours. Another work, *Jasper's Dilemma* (1962 to 1963) repeats the structure and scale of *Hyena Stomp*, and then parodies it

with a monochrome version which is painted directly to the left of it; the effect is like two large square eyes, one colourblind, the other garishly striped.

The structure of *Hyena Stomp* can be analyzed by visually isolating the triangle of stripes on the right, whose outer edge is composed of a deep crimson red, a pure lemon yellow and a cold mid-blue. This trio can be traced in ever-decreasing lengths spiralling in an anti-clockwise fashion into the centre. Stella starts each new crimson stripe at the far right corner of the last blue stripe (facing towards the centre).

There are eight more stripes, each of a different hue, before the red-yellow-blue combination occurs again, making a 'palette' of eleven shades in all. The more subtle tones of grey, orange-red, mid-red and the cadmium green could have been mixed from the stronger tones of blue, deep viridian, yellow and crimson in varying parts.

This structural analysis reveals that once Stella had decided upon the lefthand sequence of colours, for instance, the remaining three-quarters of the canvas was pre-determined with an almost automatic logic of its own. Once the paint had dried on one stripe the old masking tape could be pulled off and a new stripe masked off, leaving a constant gap between each.

The work was probably planned on graph paper, but the sheer scale of the canvas would have transformed its appearance. The impact can be contrasted with Matisse's *L'escargot* with its 'spiral' of saturated colour, strangely both

creating and destroying space.
Stella's paintings of the period of *Hyena* Stomp were exhibited with some Op art works in 1965, on the assumption that it attempted to dazzle with optical illusion. Certainly Hyena Stomp seems at one moment like a square tunnel, the next like an aerial view of an ancient Mesopotamian ziggurat, or stepped pyramid. But Stella's colours do not seem to have been selected simply because they occur in bands of vibrating complementaries, such as a blue against a yellow (its opposite), or a red against a green, but rather they also have a strange pre-selected appearance, comparable with a colour manufacturer's chart and are not simply Op art shades. Hyena Stomp was painted in the same year as Andy Warhol's Marilyn and other works of Pop Art and Stella's colours recall those of a flag or a piece of commercial packaging. The title, which in every case was carefully chosen by the artist, reveals Stella's own attitude towards the work, and refers to his love of jazz. Hyena Stomp, as the name suggests, strikes the eye like an African-inspired jazz rhythm, attempting a fusion of two contradictory elements; rich, untamed colour, caged in by a highlydisciplined and sophisticated structure.

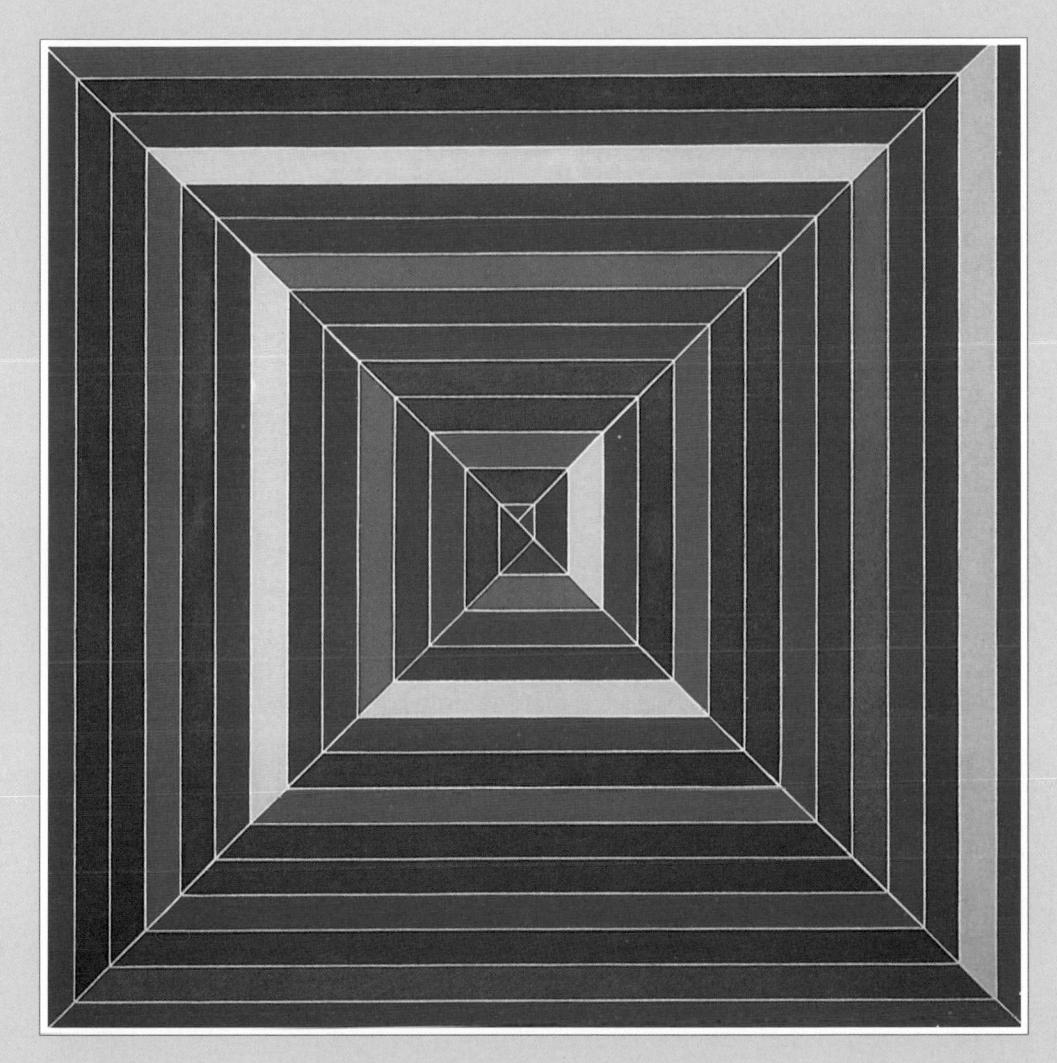

A precise geometry is achieved by the use of measurement and masking tape combined with unvarying coloured stripes which repeat themselves in sequences of groups of three. Hyena Stomp and similar works in the series have been likened to the appearance of a commercial colourmaker's chart. Stella said that he tried to keep the paint 'as good as it was in the can'. Nevertheless, the diagonals seem to create an illusion of space which creates an illusionistic receding or emerging architecture, and denies any sense of flatness. The lightholding potential of the colours is also exploited to create a spiral towards the centre which sets up another type of movement.

A constant gap of about 5mm (1/5in) of unprimed canvas is revealed between the lines

The spiral of stripes disrupts the placing of the third diagonal

The acrylic colours are mixed without white or black and brushed on without any modulation of tone within each stripe

A red-green complementary pair of stripes is arranged so they meet a similar pair of different hue and thus create a continuation rather than abrupt change

The cadmium yellow strip is the brightest colour used and acts as a light source as it resonates against the red and blue primary colours next to it

RIGHT The upper right corner of the painting is unique as the deep red stripe is squared off by the frame, revealing the presence of a spiral and preventing the diagonal from meeting the corner. Stella uses a combination of primary colours on the right edge which reappear to the left and continue into the centre. These groupings are often visually disrupted by their colour affinities with neighbouring stripes.

ACTUAL SIZE DETAIL The intersection of the three diagonals at the centre has created a set of four triangles which echo on a miniature scale the four large triangles of the composition of Hyena Stomp. The spiral system has been carefully calculated to preserve the widths of the line so that the centre also appears to interlock into itself. The colour combinations have been calculated so that a triangle of red appears to jump out of the very centre. This is composed of two different hues of red, surrounded by a mesh of hues of blue, blue green, and shades of cadmium green. The acrylic colour was brushed into areas that had been individually isolated with strips of masking tape which created the 'hard edge' style which was very popular in the painting of the 1960s.

RIGHT In 1959 Stella had produced a large rectangular painting of black enamel stripes called Tomlinson Court Park which anticipated the structure of this and Hyena Stomp by three years. This painting, Untitled 1962, like the larger Sharpeville (1962), broke away from the use of single colour stripes in order to experiment with the optical force of stripes of different colours radiating from a central square, but here avoiding the use of diagonal lines. The result is both minimal and architectural and permits colour to function as both light and space. It produced an image that has a neon quality suited to an urban setting and New York corporation architecture.

In the Car (1963)
Magna on canvas
172cm x 203.5cm/675/8in x 801/8in

If Roy Lichtenstein's own definition of Pop Art is accepted – 'the use of commercial art as the subject matter in painting' – he must be counted, together with Andy Warhol, who was raiding graphic and mass-media sources at about the same time and more or less independently, as one of its leading protagonists. Lichtenstein is certainly the most technically consistent. Through this almost dispassionate consistency, his greatest achievement is to conjure the unexpected from a scrutiny of the commonplace; to 'make strange' the vulgar and the clichéd, to add uncertainty, paradox and elusiveness to our view of the world.

Born in New York City in 1923, Roy Lichtenstein first studied painting at the Art Students' League during his summer vacations. From 1940 he was enrolled in the School of Fine Arts. Ohio State University, where he came under the influence of H. L. Sherman's theories of the psychology of vision and illusionism. During the 1950s he worked as a commercial artist and freelance draughtsman, while from 1957 to 1963 he taught, first at the New York State College of Education, Oswego, and then at Rutgers University, where he was a colleague of Allan Kaprow (b 1922), the creator of the environmental work Happenings in 6 Parts (1959). Lichtenstein resigned from Rutgers in 1964 to paint full-time. He soon became prominent in the New York Pop Art scene, loosely centred around the Leo Castelli Gallery.

Lichtenstein's early work was almost entirely in oil on canvas with occasional use of pastel. It betrayed a schooling in the vernacular of American Regionalism, unpretentious realists proud to celebrate aspects of American life. Gradually this early style gave way to a more expressive style and looser brushwork, which admitted influences from the Cubist and abstract idioms. In 1951 Lichtenstein exhibited a number of 'imagistic assemblages' at his first one-man show in New York. They were made up of a variety of materials, mainly discarded wood and metal objects clasped together. In the mid-1950s he experimented with painted wood constructions. His early comic-strip works were painted in oil on canvas without preliminary sketches. 1961 was the year when he first borrowed not merely the images of commercial art, but also the techniques of mechanical production, making use of Benday dots, lettering and balloons.

Since 1963 Lichtenstein's work has changed more in its subject matter and local style and scale, than in actual technique. The principal categories of his imagery derive from advertising, commonplace objects including foodstuffs, comic strip images, overt adaptions of works by other artists, classical ruins, land, sea, sky and moonscapes, paintings of brushstrokes and explosions. Lichtenstein has, however, produced a modest amount of glazed ceramic and other sculpture, and in

1977 exhibited a group of open-work silhouettes, cast in bronze and part painted.

By 1963, the year he painted In the Car, Lichtenstein had developed a sophisticated technique of projection which he has described to writer John Coplans: 'If I am working from a cartoon, photograph, or whatever, I draw a small picture - the size that will fit into my opaque projector - and project it on to the canvas. I don't draw a picture in order to reproduce it - I do it in order to recompose ... I try to make the minimum amount of change... I project the drawing onto the canvas and pencil it in and then I play around with the drawing until it satisfies me. For technical reasons I stencil in the dots first... Then I start with the lightest colours and work my way down to the black line... I always end up erasing half the painting, redoing it and redotting it. I work in Magna colour because it's soluble in turpentine... so that there is no record of the changes I have made. Then, using paint which is the same colour as the canvas, I repaint areas to remove any stain marks from the erasures. I want my painting to look as if it had been programmed. I want to hide the record of my hand.

In the Car, typically, is thinly painted with synthetic resin and oil so that the canvas pattern is strongly visible through a relatively rough surface. Dots were applied with a toothbrush through a perforated metal screen placed on the canvas, after areas which were not to receive them had been masked off. Areas of solid colour were then blocked-in before the black bounding lines were added.

The work derives thematically from Lichtenstein's comic-strip paintings, and from his avowed interest in the representation of 'highly confectioned' women. But here the situation is untexted, and the viewer seems to be invited to write in a dialogue from the disposition of the couple's eyes, their hair and the angle of their heads.

Lichtenstein's technique calls attention to the basic units of his design: blank areas, regularly dotted areas, blocked-in areas and lines. Particularizing details have been resisted, and each feature or configuration is registered by a simplified mode of working. Cutting into the composition, apparently both behind and in front of the couple, is the dynamic intrusion of speed-lines and reflection creases. The actual colour areas set up a fugal relation between the three primaries, red, blue and yellow, and interact with the 'non-colours', black and white, in ways that are superficially reminiscent of Mondrian (whose work Lichtenstein 'subjected to his technique' a little later). Just as Lichtenstein separates out the elements of his own painting process, so the visibility of his surface, its magnification and its very friction on the viewer's eyes, records the disruptive and disquieting aims of his art.

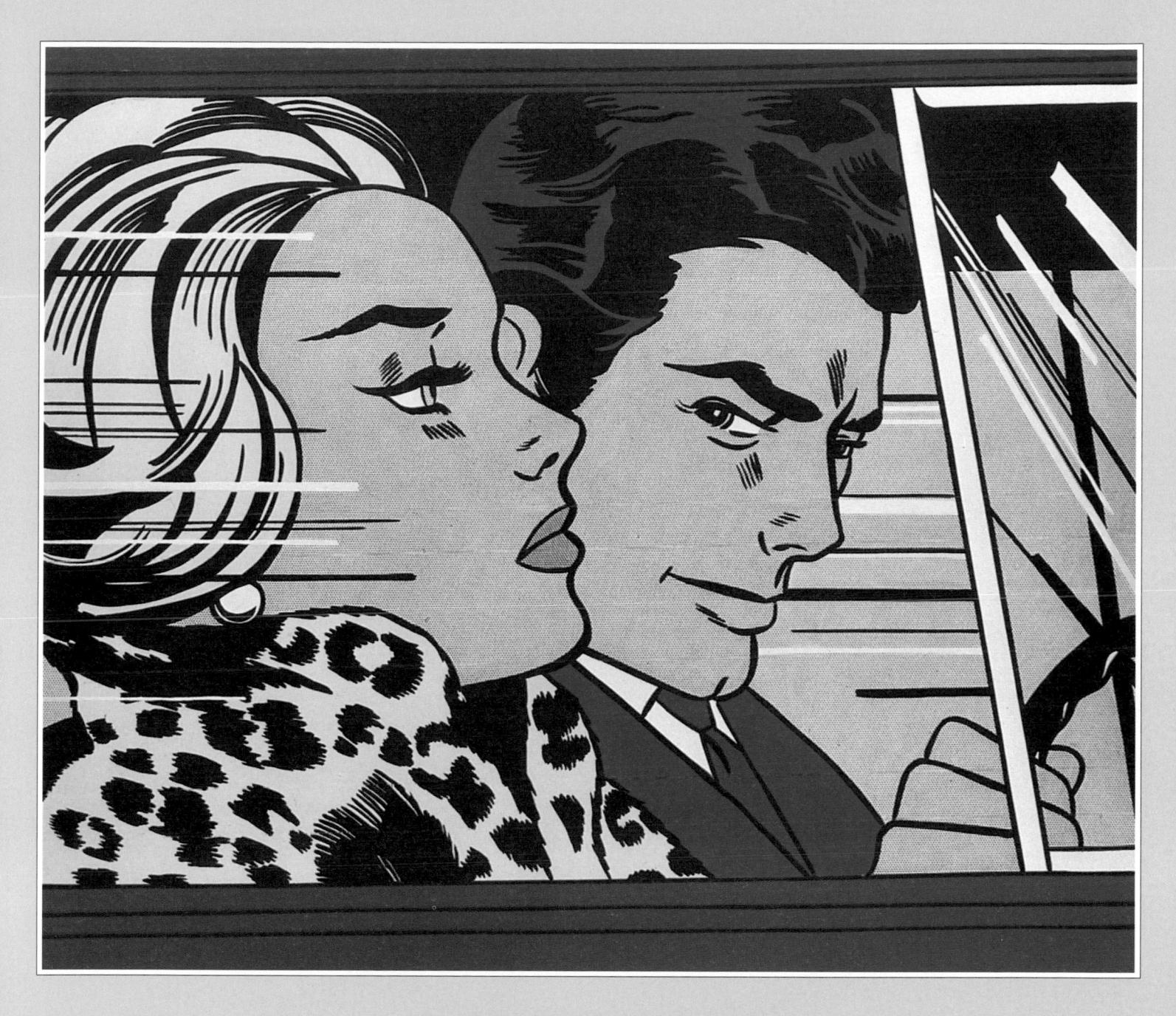

Lichtenstein was constantly aware of the formal and structural significations of his work which accompany the manifest event or situation. For example, the colour black functioning as infill, boundary pattern and shadow is counterpointed by the strong primary colours

and by the 'negative' areas of white. Unlike a work such as Whaam! (1963) where their use is more diverse, dots are restricted here to three main areas — the flesh tints of the couple, the stronger red of the woman's lips, and the blue sky zone 'outside' the vehicle, which is echoed in her eye.

Slight gap between yellow of hair and black background shows ground

Man's ear 'behind' woman's face creates a zone of spatial ambiguity

Diagonal reflection lines evoke the change of angle from side window to windscreen

Dots of the same hue are bunched together to produce a stronger red effect

Irregular fringes of black suggest leopard spots, and echo the shadow marks on the faces of the couple

Slight diagonal brush sweeps visible

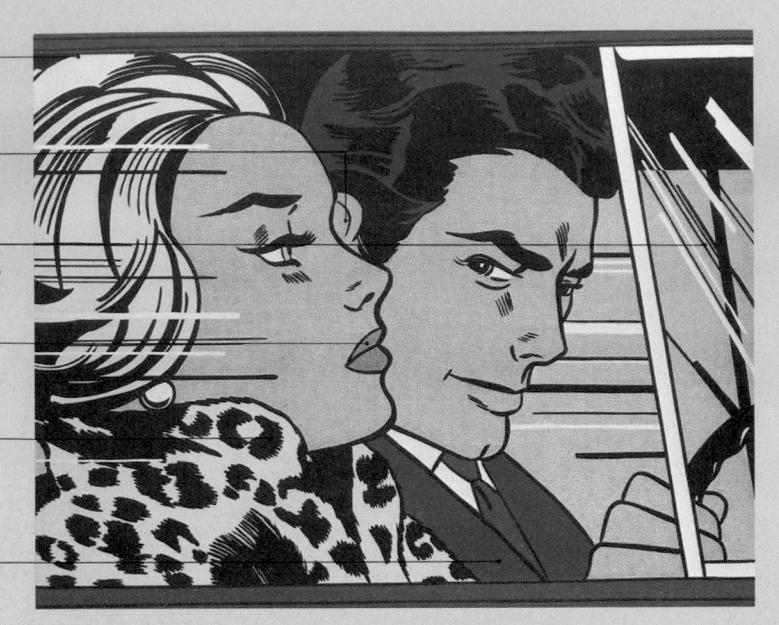

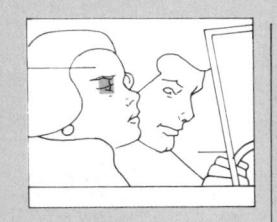

Quite loose pencil lines are visible as guiding marks throughout this extract, but the black paint does not completely infill them. The red and blue dots are evenly disposed in rows and diagonals, through the perforated metal screen, but are somewhat incomplete in places, particularly to the immediate right of the eye itself. This may have been the result of retouching after the removal of acrylic paint from the pupil or eyelash. Virtually all traces of the hand, magnified here, would be invisible at a normal viewing distance. The opacity of the black Magna paint, and the strong optical effect of the regular tessellation of dots are calculated technical strategies to promote this register of the gaze.

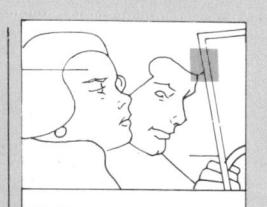

ABOVE The strongly abstract nature of the element with which Lichtenstein worked is apparent here, as the signs for hair, eyebrow and reflections in eye glass are abbreviated and minimized. Traces of the original pencilled design are visible along the fringes of the hair.

RIGHT The black patches with ribboned edges which connote the texture of a leopardskin coat are the most irregular paint marks in the picture. The blank space of the pearl and triangle of 'flesh' behind it echo and invert the form of the woman's eye.

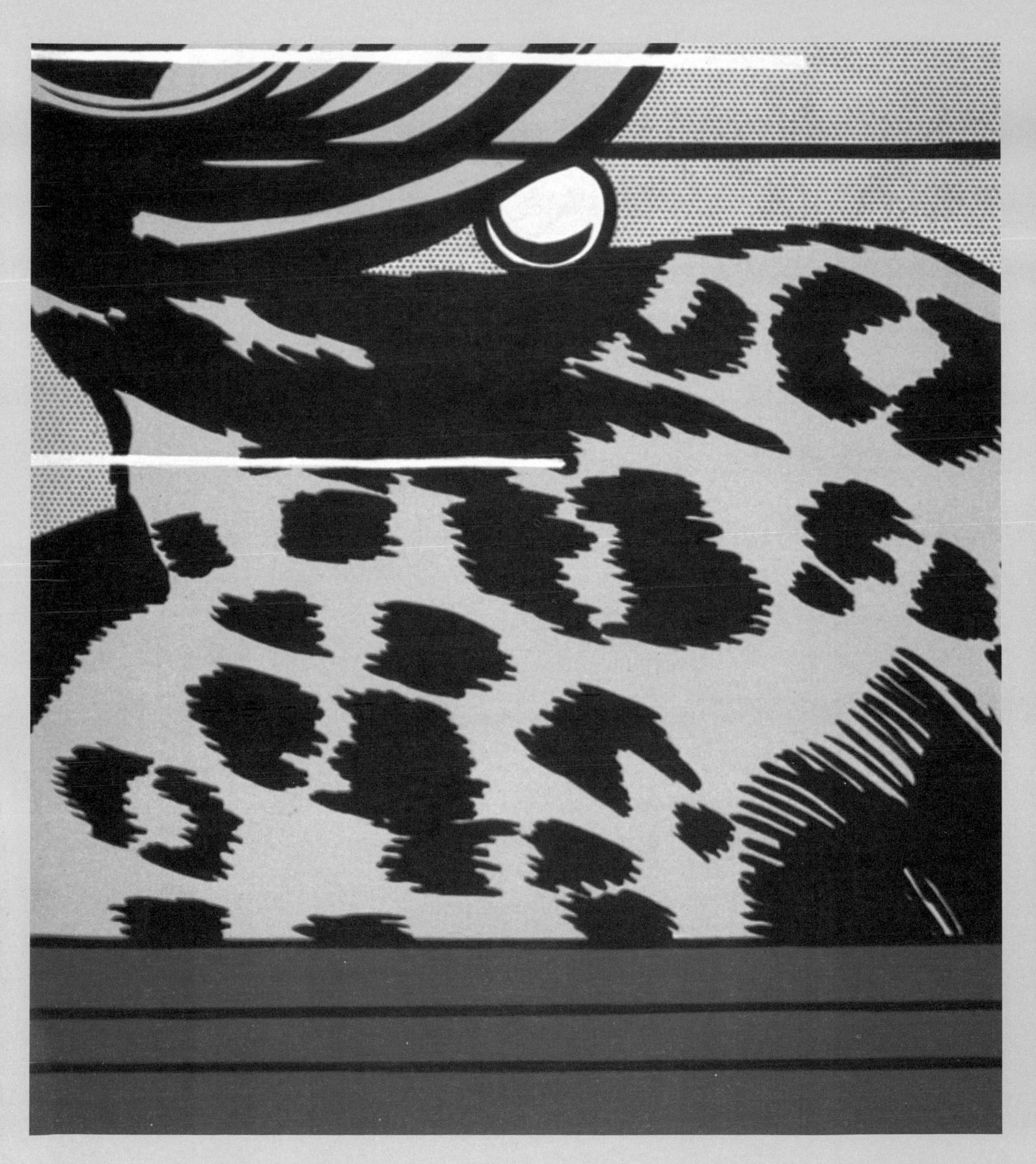

DAVID HOCKNEY

RIGHT The burr caused by the paint piling up against the edge of the masking tape is visible along the top edge of the pink pavement. The masking tape technique allowed Hockney to paint coloured areas edge to edge, but he chose to paint the small details, such as the chair, on top. The edges of the window jamb of the previous layer show through the chair back, and indicate that sequence. The paint which makes up the shadows on the glass is more diluted, and the light primed ground of the canvas shows through.

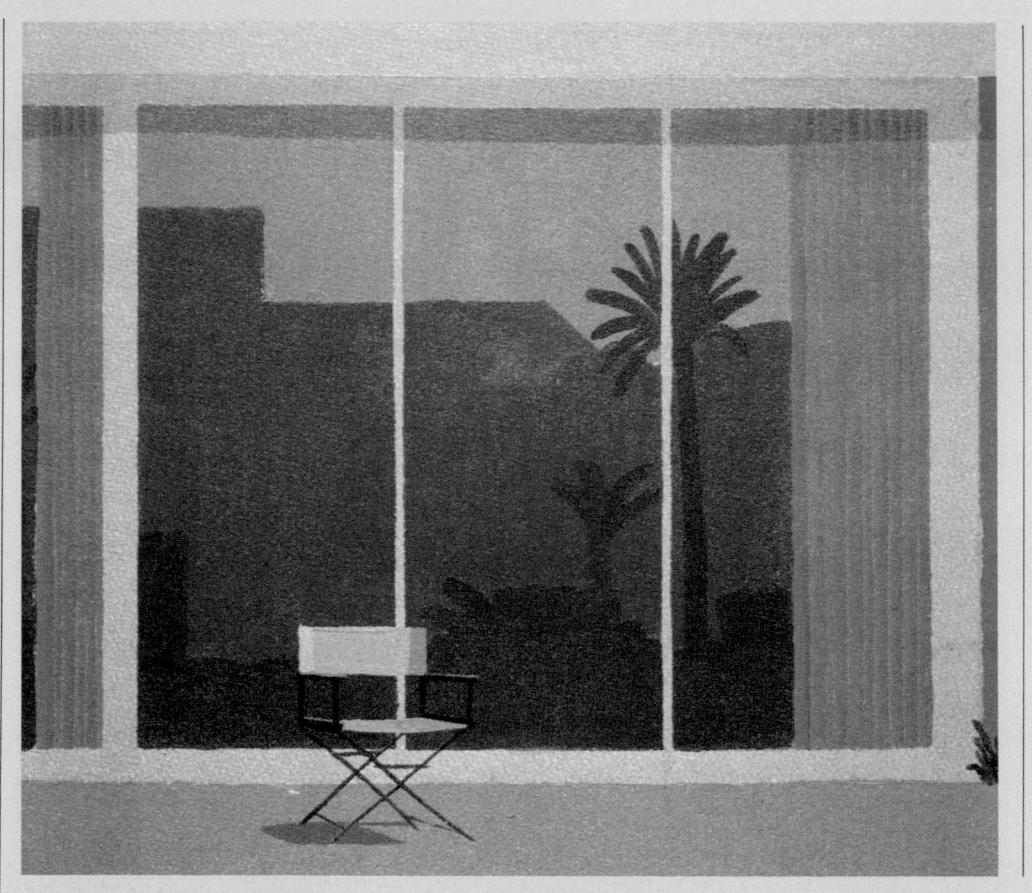

RIGHT The Naples
yellow paint used for
the upper surface of the
diving board was
painted within an area
masked off by selfadhesive masking tape.
Because the tape was
not pressed down so
firmly along the top
edge of the diving
board, pigment seeped
underneath and marred
the otherwise crisp line.
The most thickly
painted area of the
whole painting is that of
the splash seen
immediately behind the
diving board, where at
least four different
colours have been used
in succession.

DAVID HOCKNEY

Hockney recalls in his autobiography how the painting of the splash itself took him about two weeks; judging from the distribution of minute spots of different coloured hues in this detail, the statement is eminently believable. This section of the canvas is divided into horizontal bands of pink, ultramarine and a cerulean-type blue all applied with a paint roller. The light tonal strip of the pool edge is actually the white primer layer left uncovered. The tiny spots of paint which go to make up the splash have a random air, almost as though this could be a detail of a drip painting by Jackson Pollock, but Hockney, with a photograph of a splash as a guide, will have planned their placement with care. The smallest of all spots in this detail, those in blue on top of the pink pavement, must have been executed with the point of a loaded brush.

SOL LEWITT

Detail of: Fifteen Part Drawing using four colours and all variations (straight parallel lines, each colour in a different direction) (1970)

Graphite on wall surface

Dimensions variable

Sol LeWitt is one of the foremost exponents of the Minimalist Art of the 1960s, which deliberately reduced expressiveness and illusion, as well as an extremely important precursor of Conceptualism, which relegates the material means of communication to promote content at the expense of form. LeWitt represents one of the few key figures who have bridged the avant-garde movements of the 1960s and 1970s successfully. Like many artists of his generation, LeWitt's work is accompanied by a formidable body of explanation, amplification and rhetoric, from critics, allies and himself.

LeWitt was born in 1928 in Hartford, Connecticut, and studied at Syracuse University, New York, from 1945 to 1949. By 1962 he had completely abandoned painting which had been more derivative than experimental. During the mid-1960s he worked in three dimensions, first making black and white reliefs and then various types of constructions. The best-known and most repeated of these forms is the serial variations on a cubic structure; openframe, multicompartmental structures made of baked enamel on aluminium girders.

LeWitt had his first one-man show at the Daniels Gallery, New York, in 1965, wrote important texts on Conceptual Art, and taught at various institutions in New York. From 1968 he began an extended series of 'wall drawings', which included Fifteen Part Drawing using four colours and all variations (straight parallel lines, each colour in a different direction).

LeWitt himself spoke of 'subconscious' reference material being his starting points; others have identified the forerunners of his 'grid' system in Cubism, in the work of Jackson Pollock and in that of the early Rationalist Agnes Martin (b 1912). The theory and practice of Constructivism and Jasper John's interrogation of Illusionism were also of some importance.

Such diverse influences and his friendship with contemporary sculptors Donald Judd (b 1928) and Robert Morris, who were engaged in exploring spatial and environmental relationships, gives LeWitt a pivotal position in recent art.

Sol LeWitt's first wall drawing was exhi-

bited at the Paula Cooper Gallery, New York, in 1968. Some critics felt the long wall drawing series was as important for contemporary drawing as Jackson Pollock's use of the drip technique had been for painting in the 1950s.

LeWitt wrote that his overall motivating intention in the wall drawings was to be'as twodimensional as possible'. This demands a rejection of the conventional canvas and stretcher as unnecessary intermediaries between the viewer and the wall surface on which they are normally hung. Having, therefore, resolved to 'work directly on walls', LeWitt observes that 'the physical properties of the wall, height, length, colour, material, architectural conditions and intrusions are a necessary part of the wall drawing', and that the differences and 'eccentricities' of various wall surfaces should not be reduced or equalized. The drawing is to be executed by one or more recognized draughtsmen nominated by the owner of the 'certification' (a document providing diagram and instructions, written and signed by LeWitt, to be exhibited with the finished piece, although not an integral part of it).

LeWitt stipulates that 'the drawing is done rather lightly, using hard graphite so that the lines become, as much as possible, a part of the wall surface visually'. He allows that 'either the entire wall or a portion is used'. The actual kinds of line employed are straight and of four types; vertical, horizontal, 45 degrees diagonal left to right and 45 degrees diagonal right to left. The graphite colours used for coloured drawings (restricted to what is commercially available) are yellow, red, blue and black (the colours used in printing); and 'a flat, white wall is preferable'.

Fifteen Part Drawing is number 52 in the chronological list of wall drawings; it was first executed at the Jewish Museum in May 1970 and exists in five other versions. Further, as one of the first wall drawings aimed at 'the entire wall from floor to ceiling' and one which makes calculated use of all the basic colours and their permutations, and all the four line directions, it has been considered by the artist himself as perhaps the most important wall drawing of its kind.

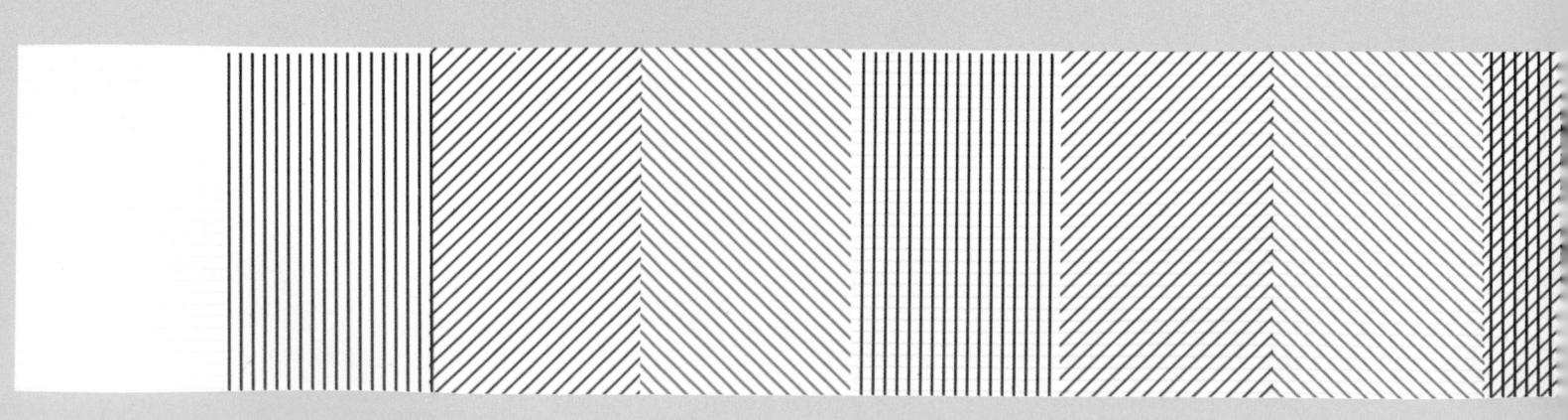

SOL LEWITT

WALL DRAWING / FOUR BASIC COLORS (BLACK, YELLOW, RED & BLUE) & ALL COMBINATIONS

Yeww	BLACK	Red	BLUE	Bryck	YELLOW RED	YELLOW BLUE	BLACK	BLACK	RED	YELLOW BLACK RED	YELOW BLACK BLUE	YELOW RED BLUE	BLYCK RED BLUE	YELLOW BLACK RED BLUE
------	-------	-----	------	-------	---------------	----------------	-------	-------	-----	------------------------	------------------------	----------------------	----------------------	--------------------------------

TO BE DRAWN USING COLORED GRAPHITE IN LINES ABOUT 1/16" TO 1/8" APART CONSISTENTLY THROUGHOUT; ON A WHITE WALL, REOVDERED BY COMPETENT DRAFTSMEN, PLACED IN AN ADEQUATE SPACE, PERIODICALLY PAINTED OUT AND REDRAWN TO SPECIFICATION. THE ENTIRE WALL FROM FLOOR TO CEILING SHOULD BE USED

YELLOW/HONIZOWAL

BLACK/VETCTICAL

RED/DIAGONAL RIGHT

BLUE/PIACONAL LEPT

THIS IS A CERTIFICATION
SH LOWAT
LONDON, JULY 6, A73

Any draftsman's true interpretation of Sol LeWitt's 'certification' (ABOVE) for Fifteen Part Drawing must necessarily be very precise; its success depends on fulfilling the artist's instructions. The composition graduates in complexity from left to right and is meant to fill the entire ceiling-to-floor wall space of a white-walled room.

Lucian Freud

Large Interior, W.9 (1973)
Oil on canvas
91.5cm x 91.5cm/36in x 36in

'The fascinated unblinking stare with which Lucian Freud fixed his subjects enabled him to represent them in a manner that makes it impossible for the spectator... ever to look at them casually: the eye is compelled to see them, down to the smallest detail, with something of the intensity with which he saw them himself,' art historian John Rothenstein commented. Much has been made of the fact that Lucian Freud is the grandson of Sigmund Freud, the inventor of psychoanalysis; and the grandson does seem to have inherited a passionate interest in the codification and seizure of states of mind from his grandfather.

Lucian Freud was born in Berlin in 1922 and was brought to England by his parents 10 years later. Lucian Freud drew and painted from an early age, and always wanted to become an artist. After a spell of making sculpture at school, he had a sporadic and varied period from 1939 to 1942 drawing and painting. By the middle of the 1940s his early style had been formed – it was at the same time sophisticated and naive, and reliant upon detailed draughtsmanship.

A friendship with Francis Bacon and deep admiration for Bacon's work lead to Freud's discovery of how oil paint can be a magic equivalent for living flesh, and how the medium can actually mould and render its subject matter. He stopped drawing for a while in order to learn more about paint as a substance and as a vehicle. His style became broader in treatment and more concerned with volume and with flesh in its contrasts of lumpiness, density and pellucidity.

With the broadening of style came an equal change in the tools: 'I had stopped drawing and worked with bigger brushes, hog's hair instead of sable.' The bigger brushes, he discovered, enabled him to handle paint in a more generous manner, and the new power and strength of his brushes (hog's hair is much harder than sable) brought a different kind of technical virtuosity, allied to a more energetic vigilance in the depiction of his models.

Like so many of his canvases, *Large Interior*, *W.9* is square in its dimensions. Freud usually chooses canvases 60 or 90 cm (2 or 3 ft) square, but on occasion has also worked on a larger scale. It is painted in oil on canvas, oil being the *only* paint medium for Freud. He has not been tempted to try any of the newer synthetic media, but has in the past varied his supports – in the 1950s he painted in oil on both wood and copper bases. These hard, unyielding grounds were abandoned at about the time Freud's incisive, linear approach gave way to a broader, more painterly one.

'For him painting has to be, among other things, the collection of objects that he likes, the realizing of data that he values, an accumulation of what he enjoys or desires – it amounts to the same,' noted Lawrence

Gowing, in Lucian Freud (1982), and went on to emphasize that the masterly technique and the content are inextricably allied. He has to have a relationship with the people he paints: 'If you don't know them it can only be like a travel book.' The seated figure is Lucie, Freud's mother, a status that puts her value beyond question. He first began to paint his mother in 1972, and this, one of 10 canvases of her, is the only one in which she does not appear alone. The half-naked model on the bed behind has also been painted several times by Freud. In this painting her admission into the mother-son intimacy subtly enriches the psychological situation, and at the same time enhances the formal values of the composition. The venue for their meeting, besides being the magic melding of oil paint upon canvas, is a corner of Freud's studio in Paddington, London.

Both figures would have been painted from life, both would have been required to pose for countless hours, but the fact that there is an odd relationship between the scale of the two figures (the head of the semi-naked model is as large as that of the mother and thus she does not take her place in the perspectival recession as she should) suggests that each model posed on their own.

From his earliest works, Freud has varied the scale of an object, usually a human figure, depending on how it works within the confines of the canvas and the setting, and within his sphere of interest.

The only other object in the corner of the studio, apart from the chair and bed which support the women, is a large pestle and mortar, containing a quantity of what seems to be freshly ground grey paint. Because Freud has held fast to the principle that'... the paint is the person. I want it to work for me just as flesh does', and because the mortar is positioned below his mother, with the grey paint being applied as the undercoat for her clothing, the pestle, mortar and paint could be read as a symbol for his mother. She is the paint and has endured what it has endured.

The clarity of Freud's perception, the 'realizing of data that he values', only works as well as it does because of his mastery of the technique of oil painting. In *Large Interior*, *W.9* different painterly approaches are used for different textures. The walls are thinly washed with colour, allowing the light ground to shine through. With the wooden floor, the brushstrokes make and follow the grain, and with the figures thicker paint and larger brushstrokes model the forms.

'Freud has spoken about the images of the past', said Lawrence Gowing; 'which "are so powerful that one cannot imagine how anyone could have made them or how they could ever not have existed". That is how one feels about *Large Interior*, W.9.'

LUCIAN FREUD

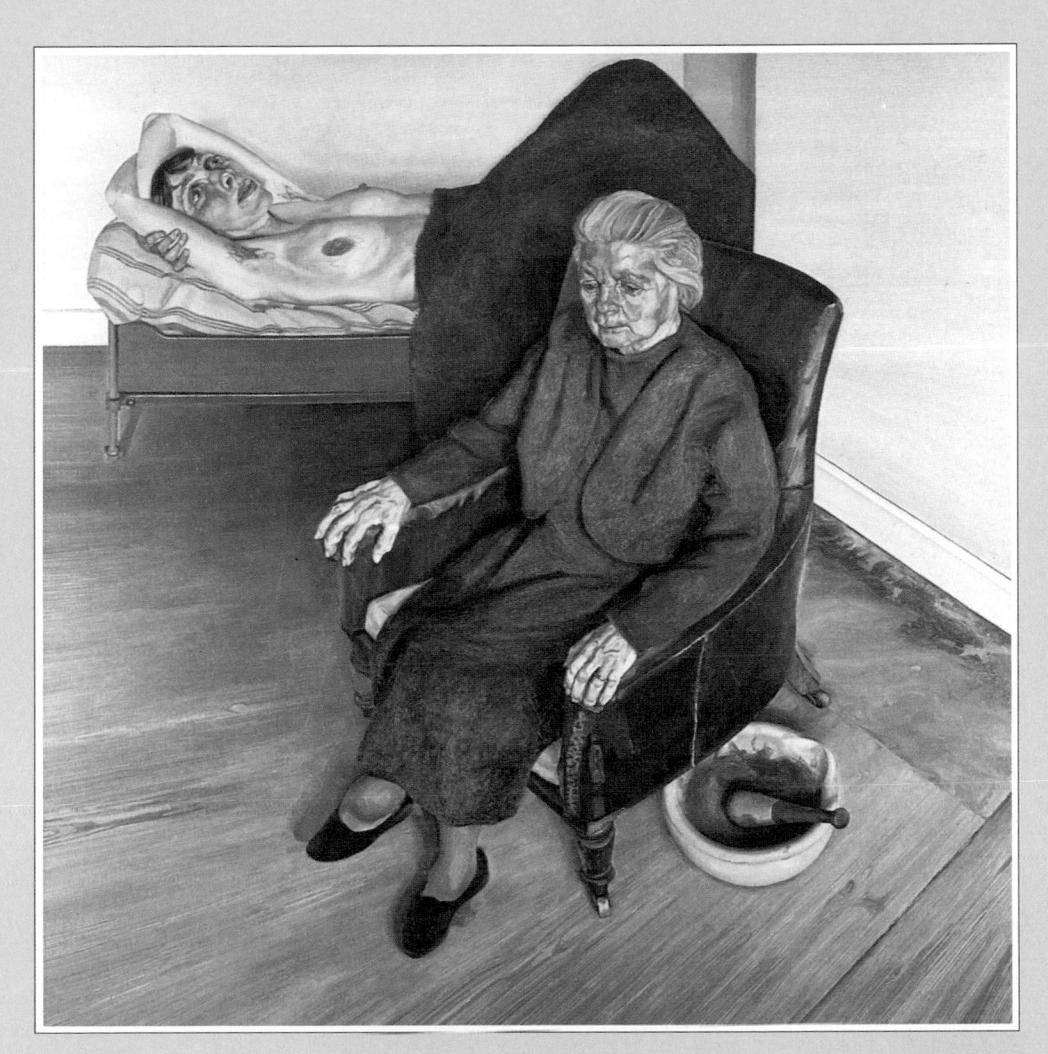

Freud chooses to concentrate on the human figure as subject matter for his work. He brings such a close intensity and keenness to his work that even the spectator finds himself persuasively drawn into a relationship with the sitter. Large interior, W.9 is the culmination of a series of portraits by Freud of his mother, and is the only one to contain another figure. It is actually a juxtaposition of a younger and an older woman, both there to point up ideas about innocence, maturity and experience. The blanket thrown over the nude model acts as a shield and an extended wing of the chair to hide her from the mother, and as the shape of the blanket rises to an apex directly behind the mother's head it serves as a kind of halo or hackcloth so that more attention is paid to the head.

Large long straight brushstrokes of Naples yellow and white follow the direction of the walls

Colour harmonies are built around the earth colours, siennas and umbers

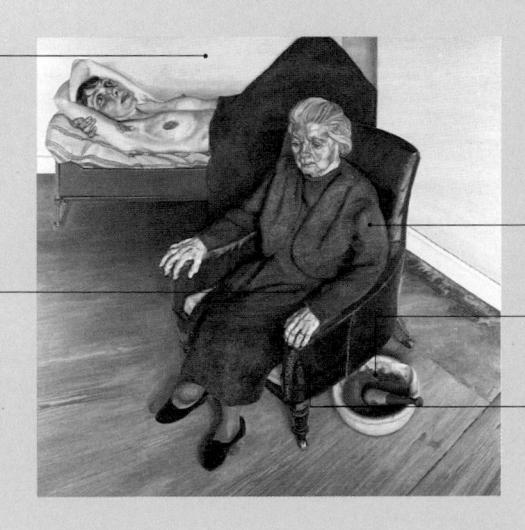

Mid-grey is thinly painted over a burnt umber layer

The grey pigment in the pestle is used for the side of the bed

A concentrated darktoned central area is offset by a paler surround

LUCIAN FREUD

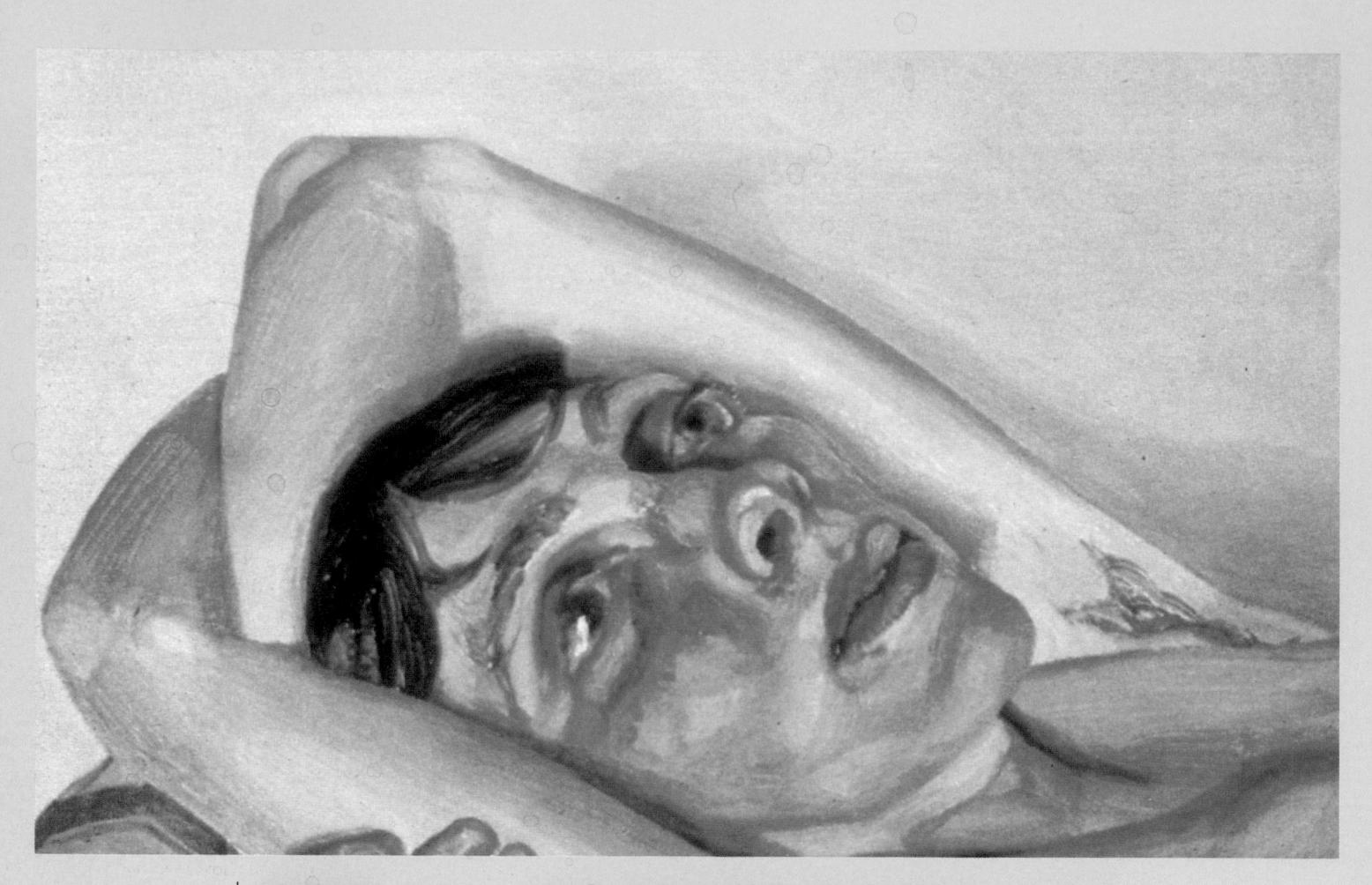

ACTUAL SIZE DETAIL
Freud has painted this
model before, and has
also used this
vulnerable pose which
draws attention to the
bare breasts. The
blanket which covers
the nude contains a high
proportion of burnt
sienna and the hot value
of this colour seems to
be reflected throughout
her flesh. The long
streak of white in her
eye is perhaps the
reflection of a lit neon
tube.

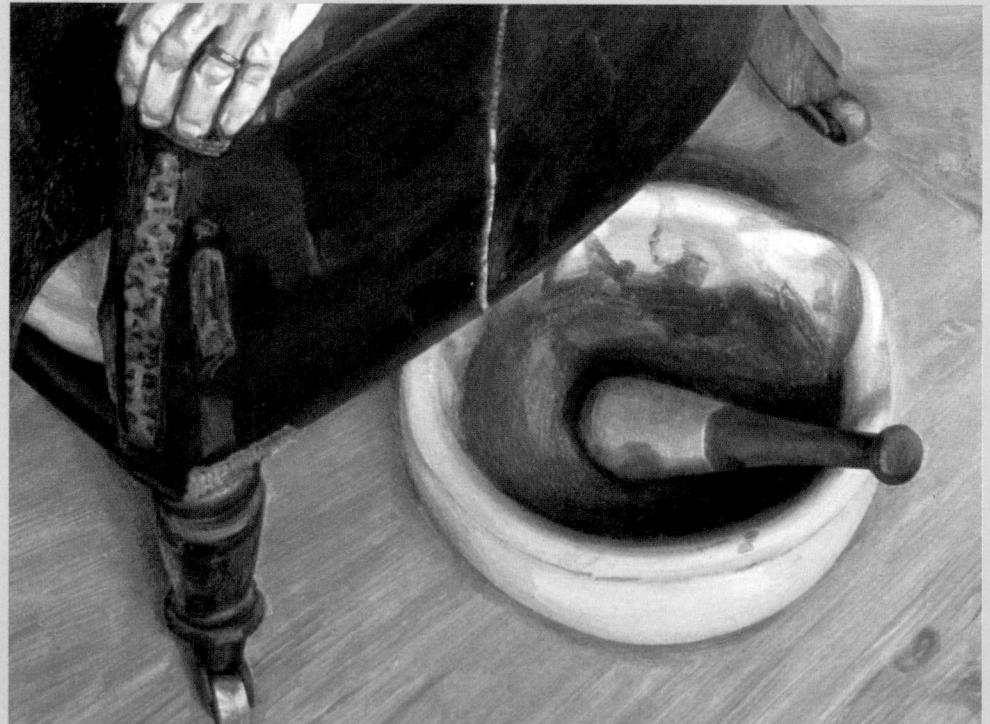

LEFT This pestle and mortar must be one of Freud's possessions, kept in his studio. They stand as a reminder of one of the traditional tools of the artist's trade, a necessary piece of equipment when the artist had to grind his own pigment, in the days before it could be purchased ready prepared in tubes. The pigment it contains appears to have been mixed with a binder and is ready for use.

LUCIAN FREUD

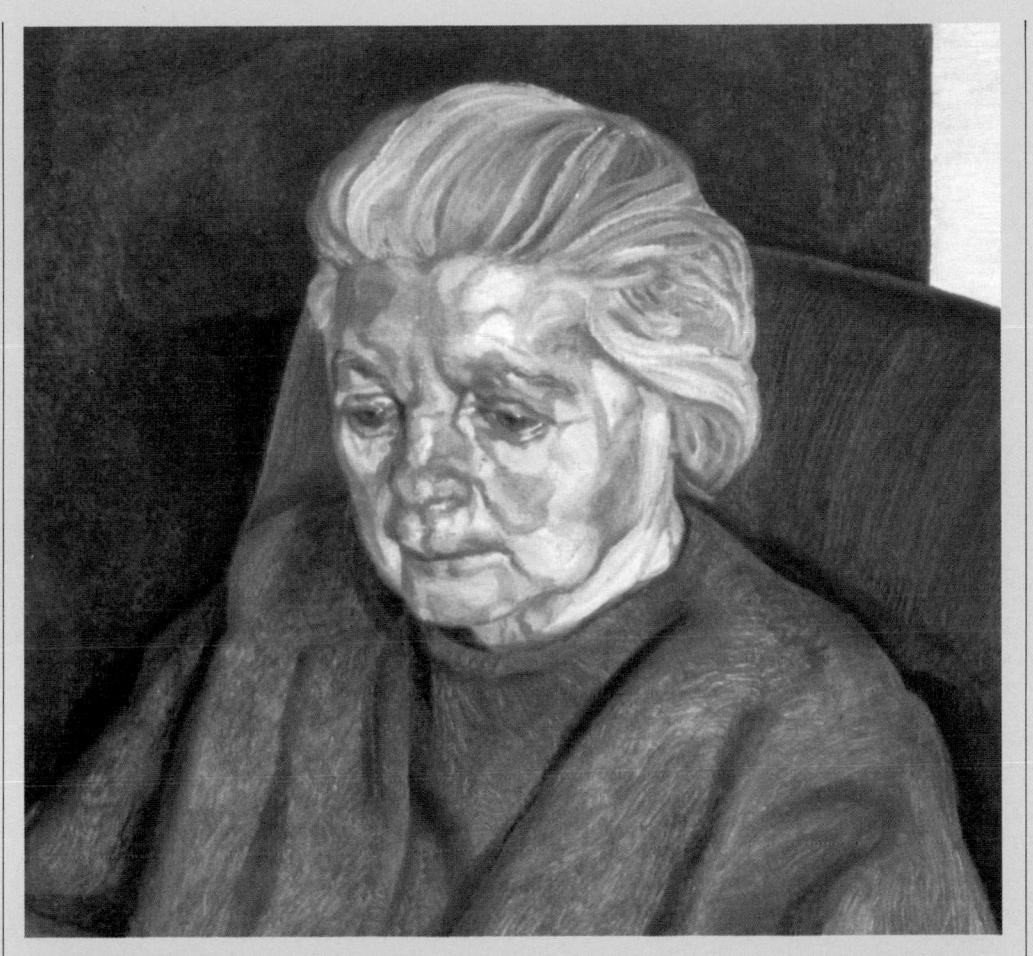

mother in one of this favourite studio props, a worn brown armchair with a hard reflective surface. As the model takes her colour values from the blanket which clothes her, so Freud's mother wears a dress which shares the burnt umber hue used for the armchair. Possibly he asked her to sit to him wearing it so that this colour relationship could be established, and it is echoed in hues chosen by Freud to capture the volumes of her face. The mother is lit from a strong light directly above; since he can work by both natural and electric light, and since the source of this light appears to be the ceiling, it is reasonable to assume that Freud painted this work under artificial lighting.

RIGHT The mother's right hand with the fingers spread apart, constrasts with the left which is seen as a closed unit. The pose is strong and it is reinforced by deft, swift handling. Three long continuous brushstrokes in dark brown delineate the divisions of the back of the hand.

GLOSSARY

Abstract Art A style of art that sees form and colour as holding the aesthetic values of art and not the naturalistic portrayal of subject matter. It is sometimes called *Concrete Art*.

Abstract Expressionsim A form of Abstract Art and Expressionsim which allows the subconscious to express itself. It is freed from the portrayal of everyday subject matter.

Action Painting (Gesturalism) A spontaneous action by the painter to express the subconscious in order to contribute to the personal dynamism of his or her work.

Alla prima An Italian term meaning 'at first'. A technique of painting straight onto the surface without any *underpainting* or *underdrawing*.

Analytical Cubism A phase of *Cubism* which sought to analyse nature by breaking down its subject matter, then reconstructing it again. It concentrated on the architecture of interlocking planes rather than on colour.

Automatism A method of drawing where the pen is allowed to rove without any conscious planning.

Baroque A style of art and architecture, originating in the sixteenth century, that was concerned with its effect on the emotions of the spectator. The use of curves, colours and unidealized naturalism were its stylistic features.

Bauhaus This was a German school of architecture, design and craftsmanship founded in 1919 and closed in 1933 by the Nazis. It was interested in fusing art with craft and the practicalities of daily life.

Biomorphism A form of *Abstract Art* which takes living organisms as its subject matter and not geometric shapes.

Blaue Reiter The name given to an influential group of Munich artists, formed in 1911 by Kandinsky, Klee, Macke and Marc.

Die Brücke An association of Expressioniststyle artists established in Dresden in 1905. They were linked by their desire to discover new creative experiences.

Chiaroscuro The balance of light and shade in a painting to produce an effect of modelling.

Chronophotography The process of recording figures, animals and objects photographically in motion.

Collage A term taken from the French word

coller (to stick). It refers to the practice of pasting various materials onto a surface. It originated with the *Cubist* artists.

Conceptual Art A term for art in the late 1960s to late 1970s where the idea for a piece of work is more important than the execution and completion of the work.

Concrete Art see Abstract Art.

Constructivism A Russian movement developed from *Cubist collage* and founded by Vladimir Tatlin. It laid emphasis on the importance of movement in space rather than spatial volume. The movement died out in 1922.

Cross-hatching The technique of shading by drawing in parallel lines that cross each other at an angle.

Cubism A radical movement that first introduced the abstract art forms. It started in Paris in 1907 under Picasso and Braque as a reaction against naturalistic art, towards a concentration on form and colour.

Dada The French word for 'rocking horse'. A nihilistic movement which arose in 1915 in disillusionment at the First World War and lasted until 1922. It was anti-art and tended towards the absurd in its desire to shock and scandalize.

De Stijl Originally a Dutch magazine (1917-1928) concerned with *Neo-Plasticism*, but also the name for the geometrical abstract ideas that the magazine advocated.

Divisionism A technique of applying small area of unmixed pigment onto the canvas, which optically combine for the spectator. It is also called *Pointillism*.

Ebauche A French term meaning 'lay in'. It refers to the *underpainting* of a canvas or support.

Encaustic The technique of applying melted wax mixed with coloured pigment onto a surface. It was originally used in the first century AD.

Expressionism A movement which opposed *Impressionism* and naturalistic art. It stressed emotion through exaggeration of line and colour.

Fauve A French word meaning 'wild beast'. The term 'fauves' referred to an association of painters formed between 1905 to 1908 with Matisse as one of its leading figures. Their main stylistic features were their excessive use

of colour and frenzied brushstrokes as a means of expression.

Figurative Art The straightforward representation of life and individual objects as seen purely by the eye and with no artistic interpretation.

Fresco A method of painting onto a plaster surface, which was popular in Italy in the thirteenth to sixteenth centuries.

Frottage A word taken from the French, frotter, meaning 'to rub'. It is the process of producing rubbings through paper from the surface of anything that has a textural pattern, such as wood.

Futurism An explosive movement which started in 1909 as an attack on the stagnancy of Italian art. It praised speed, the machine and violence and scorned traditional values. A recurrent stylistic feature was the use of repetition of an image in a painting, in order to imply movement. The phase died out with the advent of the First World War.

Gesso The absorbent, white *ground* used in oil and *tempera* painting.

Gesturalism see Action Painting.

Gouache An opaque, water-based paint.

Grattage A technique derived from *frottage*, where a painted canvas is pressed down onto an uneven surface, such as a grid, and then the paint is scraped away to reveal a negative image of the texture beneath.

Grisaille A *monochrome* painting executed in greyish colours.

Ground The surface applied to the support onto which a work is painted.

Hatching An effect of shading by drawing parallel lines side by side.

Illusionism A technique which deceives the eye into believing it is seeing a real object rather than its representation by the artist.

Impasto A term referring to thick layers of paint applied to the surface of a work. The thicker the layers and lumps on a canvas, the more impasted the painting is said to be.

Impressionism A movement founded by an association of artists formed in Paris in 1874. They aimed at portraying naturalism through the spontaneous, atmospheric effect of light and colour on the surface of objects and would complement these colours in the

GLOSSARY

shadows. They often used broken colours to achieve their effects.

Lithography A method of printing from the surface of a slab of limestone called a lithographic stone. Greasy ink is applied to the stone and made permanent by the addition of chemicals. Water is applied, which is soaked up by the porous, non-greasy area of the limestone. This means that when the limestone is covered in greasy ink, only the drawn area is transferred in replica.

Mastic The resin applied from the pistachio tree and used in varnishes.

Medium (1) The liquid used to bind pigment together. (2) The type of paint used eg oil, watercolour and so on.

MERZ A variety of *Dada* invented by Schwitters in 1920. Like *collage*, it consisted of an arrangement of various materials merged into a work of art. Schwitters, however, used more diverse materials than those adopted in straightforward collage, and would take anything from iron bars to plastic, waste-disposal sacks.

Metaphysical Painting A movement that arose in Italy in 1915 with de Chirico. It was partly a reaction against the functionalist tendency of *Futurism*. The inner aspect of objects was sought by placing them in unusual and unexpected settings and creating a magical atmosphere of mystery and hallucination.

Minimal Art A style of art concerned with an awareness of the object itself as it is. It is an impersonal and neutral portrayal of an object.

Monochrome A picture executed in just one colour.

Neo-Classicism A movement that arose in Rome in the mid-eighteenth century as a reaction against the fussiness of the *Baroque* and *Rococo* styles. It aimed to recreate the artistic mode and splendour of antiquity.

Neo-Impressionism A late eighteenth-century style based on *Divisionism*, but concentrating on a more scientific and studied composition.

Neo-Plasticism A term coined by Mondrian in 1920 for his purely geometric style of art. He used only horizontal and vertical lines and the primary colours with black, white and grey. This was a movement closely connected with *De Stijl* magazine.

Oceanic Art The art produced by the islands of the South Pacific.

Orphism A style that arose from *Cubism* in 1913 and aimed to produce a more lyrical quality in its work than the severe intellectualism of Cubism.

Palette (1) The surface used by the artist to lay out and mix paints. (2) The colours used by the artist.

Papier collé A French term meaning 'stuck paper'. It is a type of *collage* which involves sticking layers of paper onto a support.

Papier decoupé A French term meaning 'cut paper, and used as a type of *collage*.

Pentimento The evidence of a previous drawing showing through the top layer of a painting. It is generally an object the artist painted in and then corrected.

Performance Art The art of the artist posing and proposing himself or herself for artistic manipulation.

Photomontage The technique of arranging and gluing photographic images onto a surface as a type of *collage*.

Pointillism see Divisionism.

Polychromatic A picture executed in many colours.

Pop Art A dominant style in America and England in the mid-1950s to 1960s that employed the mass media, commercial and industrial products and popular images as its material in order to bring art closer to urban life.

Post-Impressionism A style that reacted against *Impressionism* and *Neo-Impressionism* and desired a return to the more Classical concepts of art and subject matter.

Pre-Raphaelite An English movement of the nineteenth century that looked back to fourteenth- and fifteenth-century Italian art. The artists aimed at portraying serious subjects with much use of symbolism.

Rayonnism A Russian style of art that believed in painting in a fourth dimension outside space and time. It used intersecting rays and lines of colour to achieve its ideal.

Realism A nineteenth century movement that used everyday life as its subject matter. It usually tended towards low-life or ugly and depressing situations, which were portrayed in a simple and straightforward manner.

Rococo A movement that arose in France in

the first half of seventeenth century as a reaction against the grandeur and finery of *Baroque* art. It concentrated on pretty, ornamental curves and designs.

Romanticism A style of art that occurred in the mid-eighteenth century and aimed at stressing passionate emotion and idealized pictures through the expressive use of colour.

Scumbling The process of applying an opaque colour over another layer so that the first layer is not completely covered and leaves areas of broken colour.

Sfumato A subtle blending of colours in order to create a misty effect.

Sgraffito An Italian word meaning 'scratched'. It involves scratching away the top layer of plaster or paint to reveal a different coloured layer below.

Size A mixture of glue and pigment used on the surface of a porous support to seal it for painting on successive layers.

Socialist Realism The official art of the Communist Party, which extolled the virtues of the party and work.

Spatialism A style that rejects traditional easel-painting for the development of colour and form in space.

Suprematism A form of *Cubism* constructed from pure, geometric elements.

Surrealism An influential, twentieth century movement that encouraged the miraculous and bizarre and rejected any form of reason.

Symbolism (Syntheticism) A style of art arising in the late nineteenth century. It sought to render mystical ideas and moods rather than imitate objects precisely.

Syntheticism see Symbolism.

Tempera (1) A type of binder used on powdered pigment. (2) A type of paint made from egg-tempera.

Underpainting, underdrawing The preliminary technique of laying in the basic structure of a composition and its tonal values.

Veristic Surrealism A tendency in *Surrealist* painting to depict the images of dreams.

Vorticism A type of *Cubism* where the diagonal was stressed like an imaginary vortex.

INDEX

The Red Studio. 10 Maurer, Alfred, 27 Merssonier, Ernest, 74 MERZ, 13 Metaphysical Painting, 35, 74 Metzger, Gustav, 151 Michelangelo, 17 Middle Ages, 17 Minimal Art, 8, 149-51, 180-1 Minton, John, 142 Miró, Joan, 72, 76, 78-81, 126 Personage Throwing a Stone at a Bird, 78; 79-81 Still Life with an Old Shoe, 78 mixed media, 116 Mixed Weather (Klee), 94 Modernism, 14 Moligny, Marthe de, 93 Mona Lisa (Leonardo da Vinci), 68 Mondrian, Piet, 8, 14, 22, 35, 76, 82-5, 172 Composition with Red, Yellow and Blue, 82; 83-5 Dusk. 82 Jazz and Neo-Plasticism, 82 The Red Tree, 76 Monet, Claude, 25, 90, 126 The Houses of Parliament, 42 Waterlilies, 146 Monogram (Rauschenberg), 160 Monroe, Marilyn, 164-7 Montroig, 78 Morandi, Giorgio, 112 Still Life, 108-9 Moreau, Gustave, 26, 71 Morley, Malcolm, 152 Piccadilly Circus, 152 Morris, Robert, 180 Morris, William, 18-20, 22 Mountain Indian (Fetting), 152-3 Mountain Lake (Dali), 102; 103-5 Mountains and Sea (Frankenthaler), 156; 150-1 Munch, Edvard, 34; 74 Munich, 56 Münter, Gabrielle, 34 The Muse Inspiring the Poet (Rousseau), 44 Muybridge, Eadweard, 32: 32, 33 The Hundred

Figures in Motion, 118 Man Walking Down an Inclined Plane, 33

Nabis, 90

Nansen, Peter, Marie, 90. 92 National Academy of Art, Amsterdam, 82 Nazism, 22 Neo-Classicism, 18, 24-5. 52: 24 Neo-Dada, 160 Neo-Impressionism, 25, 26, 32, 40, 60 Neo-Plasticism, 35, 82 Nessus and Dejanira (Picasso), 72 New American Painting, 106, 112 New Expressionism, 152-4 Newman, Barnett, 112, 115

Nicgara, 164 Noland, Kenneth, 156 Nolde, Emil, 34 North, S. Kennedy, 86 Notes on the Technique of Painting (Hiler), 18

Nude (Braque), 28 Nude Descending a Staircase (Duchamp), 8, 64; 32

Nude Descending a Staircase No. 2 (Duchamp), 18-19

Oceanic art, 68: 74 Oiseaux (Braque), 48; Oldenburg, Claes, 149 Olympia (Manet), 44 On the Balcony (Blake), 142; 143-5 On the Spiritual in Art (Kandinsky), 56 Oppenheim, Dennis, 152 Orphism, 32, 34, 60

The Painter and his Model (Matisse), Paolozzi, Eduardo, 23, 146 Calcium Light

Night, 146-7

papier collé, 30-1, 48, 52, 60, 78, 148 papier découpé, 115 Parts of the Face (Rivers), 8-9 patronage, 10 Pasiphae (Pollock), 112 Paula Cooper Gallery, 151, 180 Paulhan, Jean, 122 Performance Art, 149, 152 The Persistence of Memory (Dali), 76-7 Personage Throwing a Stone at a Bird (Miró), 78; 79-81 The Petrified City (Ernst), 98; 99-101 Pevsner, Antoine, 34 Phalanx, 56 Phillips, Peter, Entanglement Series: Permanent Flux, 154 photomontage, 68, 98; Physiologie artistique l'homme en mouvement (Richer), 32 Picabia, Francis, 32, 68 Picasso, Pablo, 8, 20, 22, 28-31, 36, 44, 48,

52-5, 60, 72, 78; 10 Charnel House, 112 Les demoiselles d'Avignon, 10, 28, 48, 71 Guernica, 112 Guitar, 52; 53-5 Man with a Hat, 52 Nessus and Dejanira, 72 Still Life with Chair Caning, 52

The Three Dancers, 22, 72 Violin, 52 Violin and Guitar. 54 Piccadilly Circus

(Morley), 152 Piero della Francesca, 14, 17 Piranesi, Giovanni, 71 Pissarro, Camille, 36 Pittura Metafisica, 35 Plato, 17, 22

The Republic, 17, 22 Pointillism, 86 Pollaiuolo, Antonio, 17 Pollock, Charles, 126 Pollock, Jackson, 10, 14, 76, 106-12, 115, 126-9, 138, 156, 168, 180; 8 Autumn Rhythm,

127 Full Fathom Five, 126; 127-9 Pasiphae, 112

Pompeii 18 Pontoise 36 The Pool of London (Derain), 40; 41-3 Pop Art, 23, 138, 142, 146-9, 172; 8, 14 Port Arthur, 160 Post Impressionism, 25, 27, 40, 52, 86, 90; 10 Poussin, Nicolas, 14, 25 Pre-Raphaelites, 20, 71, 74. 142 Princeton, 168 Process Art, 149 Proto-Pop, 160 Puvis de Chavannes, Pierre, 26 Puy, Jean, 26

Rauschenberg, Robert, 116, 138, 160-3 First Landing Jump, 160; 161-3 Monogram, 160 Ray, Man, 68, 78 Rayonnism, 34 Realism, 24 The Red Studio (Matisse), 10 The Red Tree (Mondrian), 76 Redon, Odilon, 26 Refuge (Klee), 94; 95-7 Regent Street (Derain), 40 Reinhardt, Ad, 149 Rembrandt, 18, 82, 118 Renaissance, 10, 18 La Rencontre (Courbet), Renoir, Pierre Auguste, 14, 90 The Republic (Plato), 17, 22 Richer, Paul, 32 Physiologie artistique l'homme en mouvement, 32 Rivers, Clarice, 8 Rivers, Larry, 116, 160; Parts of the Face, 8-9 Roberts, William, 34 Rockwell, Norman, The Country Agricultural Agent, 115 Rocky Mountains and Tired Indians

(Hockney), 176

Romanticism, 24, 25

112, 126

Rossetti, Dante

Gabriel, 20

Rosenberg, Harold, 10,

Rosenberg, Léonce, 82

Rococo, 18

Rothko, Mark, 106, 112, 115, 146, 168 Rotterdam, 26 Rouault, Georges, 26, 114, 130 The Round Table (Braque), 71 Rousseau, Henri, 25, 44-7, 71; 26 The Dream, 44; 45-7 The Muse Inspiring the Poet, 44 The Snake Charmer, 46 Storm in the Jungle, 45 Royal Academy of Art, 18 Royal College of Art, 142, 176 Rubin, William, 78, 126 Ruiz, Don José, 52

Rot, Dieter, 23

Rothenstein, John, 182

Russolo, Luigi, 31 Sailing Ships and Barges of the Western Mediterranean and the Adriatic Sea, 86 Saint Tropez, the Customs House Pathway (Signac), 28 Salmon, André, 44 Salon d'Automne, 26, 28 40 Salon des Indépendents, 8, 40, 82 Sant'Elia, Antonio, 32 Sartre, Jean-Paul, L'imaginaire, 14 Satie, Erik, Piége de Mèduse, 48 Schmidt-Rottlof, Karl, 34 School of Arts and

Shoenmaekers, Bart van der Leck, 82 Crafts, Geneva, 134

School of Chatou, 40 Schwitters, Kurt, 68; 13 Fernspr, 13 Sculpture in

Environment, 149 Sea = Dancer and a Vase of Flowers (Severini), 60 Seated Boy with Straw Hat (Seurat), 30-1 Section d'Or, 32 Self-Portrait with Badges (Blake), 152 Seuphor, Michel, 82

Seurat, Georges, 26, 27,

32, 40; 28 Entrée du port à Honfleur, 86 Seated Boy with Straw Hat, 30-1 Severini, Gino, 32, 60-3 Centrifugal Expansion of Light, 60; 61-3 Dance of the Pan-Pan and the

Monico, 60 Dynamic Hieroglyphs of Bal Tabarin, 62 Sea = Dancer and a Vase of Flowers, 60

Shahn, Ben, 142 Sharpeville (Stella), 168; 162 Sharrer, Honoré, 142 Workers and their Pictures, 142

Sherman, H.C, 172 Signac, Paul, 26, 40; 28

Saint-Tropez, the Customs House Pathway, 28 Siqueiros, David Alfaro, 156

Sitwell family, 60 Slade, 86 Sleeping Venus (Delvaux), 112-13 Small Pleasures (Kandinsky), 56;

57-9 Smith, Matthew, 27 Smith, Richard, 10, 142 Smithson, Robert,

Spiral Jetty, 152 The Snake Charmer (Rousseau), 46 Socialist Realism, 22 Soffici, Ardengo, 44 Soutine, Chaim, 152

Spanish Dancer (Jones), 154-5 Spatial Concept 'Waiting' (Fontana), 20-1

Spawn (Louis), 156; 157-9 Spazialismo, 20 Spiral Jetty (Smithson), 152

The Splash (Hockney), 176 Stalinists, 22 Standing Nude

(Braque), 48 Stella, Frank, 10, 14, 148, 168-71 The First Post-Cubist Collage, 148 Hyena Stomp, 168; 169-71

Jasper's Dilemma, 168

Sharpeville, 168; 162

BIBLIOGRAPHY

Tomlinson Court Park, 170 Untitled 1962, 170 Still, Clyfford, 112, 115 Still Life (The Violin) (Gris), 10-11 Still Life with a Beer Mug (Léger), 70 Still Life with an Old Shoe (Miró), 78 Still Life with Chair Caning (Picasso), 52 Still Life with Plaster Cast (Cézanne), 109 Storm in the Jungle (Rousseau), 45 Stripes (Louis), 156 Stuck, Franz von, 56 Suprematism, 34, 35, Surrealism, 17, 25-6, 35, 52, 68-76, 78, 98, 102, 106, 108 Sweeney, J.J., 82 Swinging London (Hamilton), 149 Symbolic Realists, 142 Symbolists, 25, 26, 40, 71; 152 Synthetic Cubism, 30-1, 32, 52

T

Tanguy, Yves, 25, 76 Tapies, Antonio, 112 Target with Four Faces (Johns), 138; 139-41 Target with Plaster Casts (Johns), 140 Tatlin, Vladimir, 34 Technical Manifesto of Futurist Painting, 31 2 techniques, 12-14 tempera, 86 Three Bathers (Cézanne), 36 The Three Dancers (Picasso), 22, 72 Tobey, Mark, 76, 109 Universal Field. 110-11 Tomlinson Court Park (Stella), 170 Toulouse Lautrec, Henri de, 90 tradition of the new, 10 Tzara, Tristan, 68

U

Uccello, Paolo, 71
Unfurleds (Louis), 146,
156
Unique Form of
Continuity in Space,
(Boccioni), 32
Universal Field (Tobey),
110-11

V

Van Gogh, Vincent, 26, 27, 32, 40 Vauxcelles, Louis, 26, 28 Veils (Louis), 156 Velazquez, Diego, 118 Venturi, Lionello, 36 Veristic Surrealists, 73-6, 114 Vermeer, Jan, 82 Verrocchio, Andrea, 17 The Violin (Gris), 10-11 Violin (Picasso), 52 Violin and Guitar (Picasso), 54 Visual Surrealism, 78 Vlaminck, Maurice de, 26, 27, 40, 130 Vollard, Ambrose, 14 Vorticism, 34, 86; 35 Vox Angelica (Ernst), 101 Vuillard, Edouard, Maillol at Work on Cézanne's Memorial, 75

W

Wadsworth, Edward, 34, 76, 86-9 L'avant port, Marseilles, 86; 87-9 Dazzle Ships in Drydock at Liverpool, 86 Honfleur: Entrance to Harhour, 86; 88 Warhol, Andy, 146-9, 164-7, 172 Marilyn Diptych, 149, 164; 165-7 Waterlilies (Monet), 146 Whaam! (Lichtenstein), 148, 173 Whistler, James Abbot MacNeill, 23 Wilenski, R.H., 25 With Sun (Kandinsky), 56 Wols 114 Workers and their Pictures (Sharrer),

Zola, Emile, 36

Arnason, H.H. History of Modern Art, Thames and Hudson (1969)

Bradbury, Malcolm and McFarlane, James (eds) Modernism 1890-1930, Penguin Books (1978)

Callen, Anthea Techniques of the Impressionists, Orbis (1982)

Chipp, Herschel B. (ed) Theories of Modern Art, University of California Press (1968)

Dube, Wolf-Diter The Expressionists, Thames and Hudson (1972)

Duthuit, Georges The Fauvist Painters, Wittenborn (1950)

Elderfield, John Fauvism and its Affinities, Museum of Modern Art, New York (1976)

Fermigier, André Pierre Bonnard, Thames and Hudson (1970)

Golding, John Cubism: A History and an Analysis, 1907-14, Faber (1959)

Gombrich, E.H. The Story of Art, Phaidon (1950)

Gowing, Lawrence Lucian Freud, Thames and Hudson (1982)

Gowing, Lawrence Matisse, Thames and Hudson (1979)

Haftmann, Werner The Mind and Work of Paul Klee, Faber (1967)

Haftmann, Werner Painting in the Twentieth Century, Lund Humphries (1961)

Harrison, Charles David Hockney at Kasmin, Studio International, vol 175, no 896 (Jan 1968)

Hughes, Robert The Shock of the New, British Broadcasting Corporation (1980)

Januszczak, Waldemar (ed) Techniques of the World's Great Painters Phaidon (1980)

Jean, Marcel and Meizei, Arpad History of Surrealist Painting, Weidenfeld and Nicholson (1960)

Kandinsky, Wassily and Marc, Franz (eds) The Blaue Reiter Almanac, Thames and Hudson (1974)

Lippard, Lucy R. Pop Art, Praeger World Art Series (1966)

Nadeau, Maurice The History of Surrealism, Cape (1968)

Nichlin, Linda Realism, Penguin Books (1971)

Richter, Hans Dada: Art and Anti-Art, Thames and Hudson (1968)

Rothenstein, John Modern English Painters — Vol II: Lewis to Moore, *MacDonald and Jane's* (1976)

Rothenstein, John Modern English Painters — Vol III: Wood to Hockney, MacDonald and Jane's (1976)

Rubin, William (ed) Cézanne: The Late Years, Thames and Hudson (1978)

Rubin, William Frank Stella, Museum of Modern Art, New York, (1976)

Stangos, Nikos (ed) David Hockney, Thames and Hudson (1976)

Taylor, Joshua C. Futurism, Museum of Modern Art, New York (1967)

Waldman, Diane (intro) Roy Lichtenstein, Thames and Hudson (1979)

Welsh, Robert Piet Mondrian 1872-1944, Toronto: The Art Gallery (1966)

ACKNOWLEDGEMENTS

Page 9 Tate Gallery, London/photo Mike Fear; 10 Whitney Museum of Modern Art, New York; 11 Kunstsammlung Nordrhein-Westfalen, Dusseldorf; 12 Tate Gallery, London/photo Mike Fear; 13 Private Collection/photo Mike Fear, © ADAGP Paris 1983; 15 Tate Gallery, London/photo Mike Fear; 16-17 Kunstsammlung Nordrhein-Westfalen, Dusseldorf, © SPADEM Paris 1983; 19 Philadelphia Museum of Art, © ADAGP Paris 1983; 20 Anthony D'Offay Gallery, London; 21 Tate Gallery, London/photo Mike Fear; 22 Musée National d'Art Moderne, Centre Georges Pompidou, Paris, © SPADEM Paris 1983; 23 Graves Art Gallery, Sheffield; 24 National Gallery, London; 25 Montpellier, Musée Fabre/photo Claude O'Sughrue; 26 Museum of Fine Arts, Boston; 27 National Gallery, London/photo Mike Fear; 28 Musée de Grenoble/photo Ifot, Grenoble, © SPADEM Paris 1983; 29 Bridgeman Art Library; 30 Yale University Art Gallery; 31 National Gallery, London; 32 British Library; 33 top Cinématèque Français, Paris; 33 bottom Victoria and Albert Museum; 34 Stadtische Kunsthalle, Manheim, © ADAGP Paris 1983; photo © Cosmopress; 37, 37, 39 Courtauld Institute of Art, Home House Trustees; 41, 42, 43 Tate Gallery, London/photo Mike Fear, © ADAGP Paris 1983; 45, 46, 47 Museum of Modern Art, New York, Gift of Nelson A. Rockefeller; 49, 50, 51 Tate Gallery, London/photo Mike Fear, © ADAGP Paris 1983; 53, 54 bottom, 55 Museum of Modern Art, New York, © SPADEM Paris 1983; 54 right Philadelphia Museum of Art, © SPADEM Paris 1983; 57, 58 top, 59 Guggenheim Museum, New York, © ADAGP Paris 1983; 58 bottom Arthothek/Bayerlische Staatsgemaldesammlungen, © ADAGP Paris 1983; 61, 62 top, 63 Private Collection/photo Mike Fear © ADAGP Paris 1983; 62 bottom Museum of Modern Art, New York, © ADAGP Paris 1983; 65, 66, 67 Tate Gallery, London/photo Mike Fear, © ADAGP Paris 1983; 69 Tate Gallery, London, © ADAGP Paris 1983; 70 Tate Gallery, London, © SPADEM Paris 1983; 71 Norton Simon Museum of Art at Pasadena; 72 Museum of Modern Art, New York, acquired through the Lillie Bliss Bequest; 73 Museum of Modern Art, New York; 74 Museum Ludwig, Koln; 75 Musée du Petit Palais, Paris/photo Hubert Josse, © SPADEM Paris 1983; 76, 77 Museum of Modern Art, New York, SPADEM Paris, 1983; 79 Museum of Modern Art, New York, © ADAGP Paris 1983; 83, 84 Escher Foundation, Haags Gementemuseum, The Hague, © SPADEM Paris 1983; 85 Tate Gallery, London; 87, 88 top, 89 National Maritime Museum, London: 88 Graves Art Gallery, Sheffield; 91, 92, 93 Tate Gallery, London/photo Mike Fear; 95 Norton Simon Museum of Art at Pasadena, © ADAGP Paris 1983; 97 Kunst-Museum, Bern, © ADAGP Paris 1983; 99, 100, 101 top City of Manchester Art Gallery, © SPADEM Paris 1983; 101 bottom Acquarella Galleries, New York/photo Otto Nelson, New York; 103, 104, 105, Tate Gallery, London/photo Mike Fear; 106, 107 Musée National d'Art Moderne, Centre Georges Pompidou, Paris; 108 Tate Gallery, London/photo Mike Fear; 109 Courtauld Institute Art Galleries; 110, 111 Whitney Museum of American Art, New York, © ADAGP Paris 1983; 113 Tate Gallery, London/photo Mike Fear, © SPADEM Paris 1983; 114 Museum of Modern Art, New York: 115 Collection University of Nebraska Art Galleries, Gift of Nathan Gold; 116, 117 Private Collection; 119, 120, 121 Tate Gallery, London/photo Mike Fear; 123, 124, 125 Musée National d'Art Moderne, Centre Georges Pompidou, Paris, © ADAGP Paris 1983; 127, 128, 129 Museum of Modern Art, New York; 131, 132, 133 Tate Gallery, London/photo Mike Fear, © SPADEM Paris 1983; 135, 136, 137 Lefevre Gallery, London, © ADAGP Paris 1983; 139, 140, 141 Museum of Modern Art, New York; 143, 144, 145 Tate Gallery, London/photo Mike Fear; 147 Private Collection; 148 Tate Gallery, London; 150 Collection of the Artist (on loan to the National Gallery of Art, Washington DC): 152 Tate Gallery, London/photo Mike Fear; 153 Anthony D'Offay Gallery, London; 154 Courtesy of the Artist; 155 Waddingtons/Courtesy of the Artist; 157, 158, 159 Private Collection, London; 161, 162, 163 Museum of Modern Art, New York, © SPADEM Paris 1983; 169, 170 top, 171 Tate Gallery, London/photo Mike Fear; 170 bottom photo Courtesy Knoedler Gallery, London; 173, 174, 175 Scottish National Gallery of Modern Art, Edinburgh; 177, 178, 179 Tate Gallery, London/photo Mike Fear; 181 Tate Gallery, London; 183 Courtesy of the Artist, reproduced by permission of The Chatsworth Settlement Trustees.